50 Fast Digital Photo Projects

GREGORY GEORGES AND LAUREN GEORGES

50 FAST DIGITAL PHOTO PROJECTS

WILEY

Wiley Publishing, Inc.

50 Fast Digital Photo Projects

Published by

Wiley Publishing, Inc.

111 River Street

Hoboken, NJ 07030-5774

www.wiley.com

Copyright © 2005 by Wiley Publishing, Inc., Indianapolis, Indiana

ISBN: 0-7645-7447-7

Manufactured in the United States of America

10 9 8 7 6 5 4 3 2 1

1K/SQ/QX/QV/IN

Published by Wiley Publishing, Inc., Indianapolis, Indiana

Published simultaneously in Canada

For general information on our other products and services or to obtain technical support, please contact our Customer Care Department within the U.S. at 800-762-2974, outside the U.S. at 317-572-3993 or fax 317-572-4002.

Wiley also publishes its books in a variety of electronic formats. Some content that appears in print may not be available in electronic books.

Library of Congress Control Number: 2004112350

Trademarks: Wiley and the Wiley Publishing logo are trademarks or registered trademarks of John Wiley & Sons, Inc. and/or its affiliates. All other trademarks are the property of their respective owners. Wiley Publishing, Inc. is not associated with any product or vendor mentioned in this book.

When I wrote my first book, I decided to exclusively dedicate every book that I ever write to my wife Linda. She has substantially and without reservation, supported me in my creative endeavors for more than twenty-five years. With our daughter as my co-author of this book, it seems most appropriate to dedicate this book to my wife Linda for having been co-creator of our daughter Lauren.
— Gregory Georges

To my daddy — who has taken me on many adventures and has helped me to see the world through a camera lens. Through my many years as your sherpa I have learned so much about photography and the neat things that can be done with photographs. Thank you for asking me to be your co-author!
— Lauren Georges

PREFACE

We live in a magnificent new world of digital photography where a digital photo can be taken and then shared and enjoyed in hundreds of ways — *that is if you know how!* As you read more of this book, you will learn that *learning how* is really not that difficult. The real challenges are learning *what can be done* and *what tools and/or services are best* to get the projects done easily and well. So, the first goal of this book is to provide you with a good look at fifty different projects that you can complete so that you have an excellent view of what is possible. The second goal is to provide you with step-by-step instructions for completing each project. Most of these projects can be completed in more than one way and with more than one tool or service. In each of these 50 projects, you will enjoy the benefit of our careful and lengthy process of identifying the best products, services, plus tips and techniques to complete each of the projects.

Our hope is that in addition to giving you many wonderful ideas for getting more enjoyment and use (or income if you are a professional or aspiring photographer) from your digital photos that you can also save lots of time by not having to do all the research we have done to make sure your projects are as good as they can be.

WHO IS THIS BOOK WRITTEN FOR?

Our carefully calculated bet is that it has been written for you. If you have digital photographs and you want to share them and get more value from them — this book will save you time doing just that. No matter if you are a skilled professional photographer who earns a living from taking photographs or a person who is just about to buy your first digital camera — or any level of photographer in between — this book has projects that contain oodles of recommended products and services, and tips and techniques that will help you to complete fifty projects that are likely be useful to just about everyone who wants to enjoy and share digital photos.

If you need to learn about downloading, managing, and archiving your digital photographs, you learn all that you need to know in Chapter 1. Do you want to learn about photo editing or how to use digital photos in printed documents? Chapters 2 and 3 have those topics covered. If you need to make prints, Chapter 4 has four projects for making

prints on your own photo-quality printer. In Chapter 5, you learn about the many possibilities that exist for ordering online everything from inexpensive one-hour style photos to fine art prints that have been matted and framed to your exact specifications. Sharing photos electronically in e-mail or on an instant messenger, and much more is the topic of Chapter 6. Chapter 7 provides six projects that show you how to display digital photos on the Internet. If you have plans to create digital albums and slideshows, Chapter 8 shows you six super-cool projects. The book concludes with a chapter of projects that can help you learn more about digital photography and how you can get more enjoyment from your photographic efforts.

ACKNOWLEDGMENTS

Writing a book like this book requires help from many different people and it is their willingness to help that has made this book the book that it is. Each of the following people deserves a round of applause and a big "thank you!"

Linda Georges. *The* supporting spouse (of one of the co-authors) and mother (of the other co-author) for all that she does — and all that she tolerates. If you have ever tried to sneak a new camera, lens, or printer into the house without getting advance spousal or parental approval — you will know how lucky we are!

Mike Roney. The most amazing Acquisition Editor at Wiley Publishing who appears to have survived the fallout that our late submissions have brought upon him. Hey — you can't write all books on schedule, can you, Mike?

John Wyman. A friend, the water lily expert who grew and allowed us to take photos of the many water lilies in this book, and the technical editor for this book. Not only did he ask many questions that helped us present 50 useful projects — that all work — but he completed many of his own projects using the information from this book. His enthusiasm kept us moving forward until we had 50 projects; then, he kept making suggestions for more!

Tim Borek. The Project Editor who has for the third time allowed himself to be assigned to work on a book with Gregory. Will he allow this to happen again? His other most-excellent work can be seen in *Digital Photography: Top 100 Simplified Tips & Tricks*, and *50 Fast Digital Photo Techniques with Photoshop Elements 3*.

Cara Buitron. Cara served as Development Editor to make sure we stayed true to our audience. We couldn't have gotten this book started without her!

Jerelind Charles. The Copy Editor who helped make sure *i*'s were dotted and *t*'s were crossed in all the right places.

The **Many People** who have been caught on the other side of the camera and who were willing to allow the resulting photos to be put into this book. Special thanks go to our cats who work only for cat food and who do not require model releases. We hate getting model releases.

Georges and **Swinson** families. Would you allow candid Christmas holiday photos of you opening packages to be put into a book if your hair was bent? No? Most families wouldn't either. That is why we have a special thanks to the Georges and Swinson families as they allowed the important family style photos to be included. Oh yes — special thanks also go to **Graham Georges** — the lacrosse playing son and brother to the authors. His charming face, his Chapel Hill High School teammates, and their lacrosse coaches made wonderful photos for those that are into sports photography.

Vendors and service suppliers who have provided us with *some* of the hardware, software, and services that were needed for many of the projects in this book. Because we first picked the products and services we wanted to present — we still had to pay cash for those products and services that were not provided to us free of charge. We can't be bought as we both have solid ethics.

To the readers of this book. *We have truly enjoyed writing this book and creating all the projects that you find throughout the 50 projects. We hope you enjoy the book and the projects that you complete.*

CONTENTS AT A GLANCE

CONTENTS

Chapter 1: Downloading, Managing, and Archiving Digital Photos 1

Monday, June 07, 2004

Dear Mom,
 You warned me and I promised to be careful
not to let your grandchild take a fall. Remember
when you left me on the bed to answer the
telephone. While you were talking, I made my
first crawl to the edge of the bed and promptly
fell off and got a black eye.
 Guess what? Yes—your grandchild took a
hike to the edge of the bed and fell off while I was
talking on my cell phone. He managed to get by
with just a small cut on his face. He got that
when he hit the edge of the dresser. He is Ok and
I've learned my lesson!
 See you on Monday for lunch.
 Love Sara

CHAPTER 4: MAKING YOUR OWN PRINTS 129

Chapter 5: Ordering Prints Online 161

CHAPTER 8: CREATING
SLIDESHOWS & DIGITAL
ALBUMS 271

Chapter 9: Getting More Enjoyment from Digital Photography 309

INTRODUCTION

Imagine the possibilities. You have a few friends come to your home to visit and they ask if you have any new photographs. Sure, you could take them to your computer and have them all try to look over your shoulder as you display your most recent photographs — digitally. Or, you could hand them a beautiful leather bound portfolio album that features your best photographs on fine art paper.

Next time you take a trip, imagine being able to quickly create an online photo gallery and be able to send a link via e-mail to your friends and family to show them where you are and what you've done and seen — *before* you come home.

Are you in need of a special present for a friend? Consider picking one of your favorite photos and uploading it to a Web site that allows you to not only specify the type of fine art paper that will be used to make the print, but, also the mat and picture frame. Within a few days, the framed and matted print could be delivered to your friend's door.

This book is filled with these and other ideas, along with all you need to know to complete each of the 50 projects that are included. You may want to read the first chapter if you have not yet learned how to manage and archive your digital photos. But, after that, you can just pick and complete any project in any order that you'd like. This book was written to be an exceptionally fun book that will help you give great joy to others by providing them with a view into your world via your photographs.

ANSWERS TO A FEW QUESTIONS YOU MAY HAVE BEFORE BEGINNING THE PROJECTS

Our experience tells us that there are a couple of "big picture" questions that you may have that are not covered in the projects part of this book. That is why we have this section.

What software should you buy?

Buying software and paying to keep up with the latest and greatest release can be expensive. The good news is software vendors are constantly adding features to their software in order to compete with other vendors. This means you can buy an image editor and get an image manager, an image downloader, a Web page creation tool, an archiving tool, and much more all in one product. As you read many of the projects in this book, you learn

about one product that can be used to complete the project. If you don't have the recommended software and you don't want to purchase it, you should check to see if there is a similar feature in a software product you already own. You should also check to see if your digital camera, scanner, or computer came with software that meets your needs. Many excellent software products get bundled with hardware products.

One of the one most important software-related questions you need to answer is: Which image editor should you purchase and use? The other most important question to answer if you have a large digital photo collection is: Which image manager should you buy? These are both tough questions and you may have to get some experience with a few products before you can answer them. However, being the bold people we are — we are going to try to provide some guidelines that will help you get the right answer for your needs.

First, it is important to note that there are many excellent image editors. We highly recommend any of the full-versions of Adobe Photoshop (for example, 5.5, 6, 7, CS, and CS2), Adobe Photoshop Elements 3, Paint Shop Pro, and Ulead Photo Impact. The unquestionable leader in the image editor category for photo editing is Adobe Photoshop CS2. It is arguably the best tool to use for editing images, coverting RAW files, and for managing digital photos. It does however also cost an amount of money equal to the cost of the proverbial arm and a leg at around $650. If you don't want to pay that much now or in the future, you are likely to be quite satisfied with any of the other full-featured image editors. Paint Shop Pro, Ulead PhotoImpact, and Adobe Photoshop Elements are powerful image editors that can be purchased for a reasonable amount of money.

While Adobe Photoshop Elements 3.0 is an excellent image editor, it is an unofficial "lite" version of the more expensive Adobe Photoshop CS2 and it is missing some key features, such as Curves and layer masks to mention just two. Depending on your needs, you may not need those features and therefore Elements 3.0 may be a good choice for you. If you do need those features, you will find them in Paint Shop Pro and Ulead Photo Impact.

Finally, even if you have the money for Adobe Photoshop CS2 you may not want to undergo the substantial learning curve that will be required to be a proficient user of that product. In that case, you may want to consider buying one of the other image editors. While they are feature-rich products, they have been designed for novices and can be easier to learn to use.

Now on to the question of, which image manager you should buy. That is an easy question. Read Project 3: Choosing a Tool to Manage Your Digital Photos. We feel that choosing an image manager is such an important decision that we made a project for precisely that.

What digital camera should you buy?

Making a recommendation to you as to what the best digital camera would be for your purposes is impossible as we don't know your budget, what you like to shoot, or what experience you have. Nor do we have the insight and answers to many other questions that we would ask if we were to help you pick the "best" camera for your needs. However, we

have a few good tips for you. First, establish a budget for your camera. There are many excellent digital cameras that cost as little as $300. For around $1,500 you can buy professional-grade digital SLRs (a camera with interchangeable lenses). Or, you can spend $4,500 and up for just the camera and then have to buy lenses on top of that.

After you have a budget in mind, visit `www.dpreview.com`. This wonderful Web site reviews just about every digital camera that is made. The Web site has a feature that allows you to pick and compare several different cameras on a detailed feature-by-feature basis. You can even look at sample photos taken with the cameras and get some feedback on a forum by users of the specific model of camera you are considering.

If you are serious about getting the best possible photographs from your digital camera you should make sure that you only consider models that have a histogram feature and that allow you to save the digital photos as RAW files. If you already have SLR lenses, you may want to consider purchasing a digital SLR from the vendor that makes your lenses. If you spend a little time researching the cameras you are considering on the Internet, and you visit a local camera store to see and feel the cameras — you are quite likely to get a camera that will suit your needs.

GOOD ADVICE FOR BECOMING A BETTER PHOTOGRAPHER

Photography can be addictive! The more you get into it — the more you run the possibility of being obsessed by it. By being obsessed, we mean the more you are likely to strive to get the ultimate photograph. The wonderful thing about photography is that shooting the ultimate photograph is an elusive objective. What makes a photograph look good to you one day is likely to become yesterday's old idea as you work to get something even better today.

So, how do you get better photographs? You work hard by learning how to see, how to develop your own vision, and your own style. As far as we know, the only way to do that is to take photographs. The more photographs you take — the better you are likely to get if you study them and you keep on shooting. Too many of today's aspiring photographers spend way too little time taking photographs and way too much time editing them, or in learning about and buying photography technology. The Internet is a wonderful source of knowledge that will undoubtedly help you take better photographs and to learn more about the incredible technology that is available. But, if your goal is to take better photographs, your time is better spent *taking* photographs!

As you take more photographs, you will learn that you will have to do less editing to them as they will be better to begin with. You will also have more photographs from which to choose and learn. Next time you head out to shoot, you will have that experience behind you to help you take your *next* "best" photograph.

When you are not able to spend time shooting and you have time for reading, make sure you read all of the documentation that came with your camera. Learning how to use all of the features on your digital camera is valuable — very valuable in fact. As you move from

taking snapshots to having a vision of the photograph that you want before you take it, your knowledge of how your camera works will be essential for turning your vision into the photograph you want. So, read, read, and re-read the manuals that come with your digital camera. You'll be glad you did.

Does today's camera and software technology make it too easy for everyone to take extraordinary photographs?

One question we often get, which makes us laugh is: Doesn't all of today's digital photography technology make it easy for everyone to take excellent photographs? Well — sort of. If you buy a good digital camera (as we said earlier a good one could cost as little as $300), you learn how to use it, you shoot RAW, you use the camera's built-in histogram, and you edit your images well — you can probably get some excellent photographs providing that you keep taking them until you get what you want. But, as the technology has gotten better, so have other photographers and so has photography in general! Good photographers are taking better photographs today using digital cameras than they did with film cameras. Digital camera technology offers a more useable and powerful set of tools you can use to capture the vision you have. Without some skill and a vision, you will just get technically good photographs. As you learn to use the new tools, you will find that you can be far more creative than was ever possible using film.

The moral of that story is that tools do not make good photographs — it is the photographer that makes the photograph with the tools. Furthermore, you don't even need much more than a compact digital camera to get wonderful photographs. If you have a reasonably good camera and you are not happy with the photos you have taken — keep shooting. Don't get into the false logic that you need to buy more camera gear. It won't automatically make you a better photographer.

CHAPTER 1

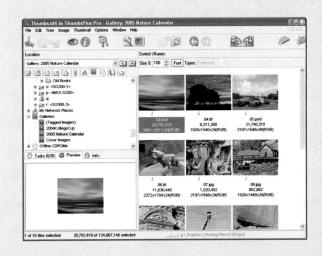

DOWNLOADING, MANAGING, AND ARCHIVING DIGITAL PHOTOS

Most people that take pictures with a digital camera quickly learn that their digital photo collection grows faster than they have ever imagined. Over time, as more photos are taken, the entire process of shooting, downloading, managing, and archiving can become quite time-consuming. Yet, if each of these steps is not done carefully, the collection is not easily useable and frustration takes the place of what should be a fun process.

In Project 1, you learn some valuable tips for downloading your digital photos from your camera to your computer. Creating a useful filing system is the topic of Project 2. You learn about a few image managers and how to choose one to suit your needs in Project 3. In Project 4, you learn about eight power features that you find in ThumbsPlus Pro 7.0. Project 5 covers the essential topic of archiving your digital photos so that you can minimize the chance of losing any of your digital photos.

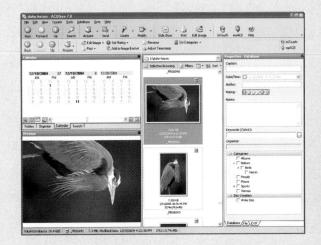

DOWNLOAD DIGITAL PHOTOS FROM YOUR CAMERA TO YOUR COMPUTER

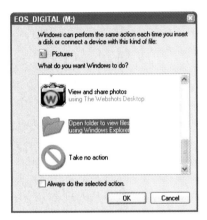

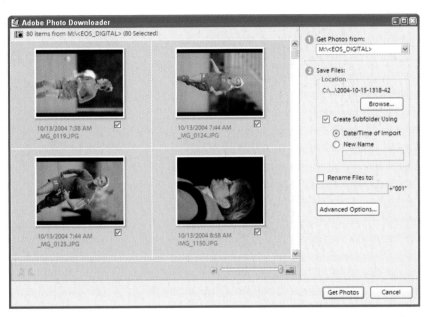

1.1 Recent computer operating system features (such as the Microsoft Scanner and Camera Wizard) and digital photo applications (Adobe Photoshop Elements 3.0) make it easy to download digital photos from your camera to your computer's hard drive.

WHAT YOU'LL NEED

Appropriate digital photo media card reader for your camera ($20 and up)

After you take photos with your digital camera, the digital photo files are on the digital photo media card in your camera. You have two different ways to get those files onto your computer's hard drive. Many digital cameras come with a cable that allows you to connect your digital camera directly to your computer so that you can transfer the files. Or, you can purchase one of the many digital photo media card readers and transfer your files by removing the photo media card from the camera and inserting it into the reader. In this project, you learn tips and techniques for getting your digital photos onto your computer easily and safely — and with the filenames you want.

STEP 1: REMOVE DIGITAL PHOTO MEDIA CARD FROM CAMERA

After reading the name of this step, you may be wondering why you should not just connect your digital camera to your computer and download digital photos directly without using a reader. While many digital cameras come with a cable that can be used to connect the digital camera directly to a computer, transferring digital files this way is not generally a good idea. Before more explanation is provided, let us qualify that statement. If you take very few photos, you use a relatively small capacity card (under 128MB), and you are careful to only transfer photos when you have a well-charged battery in your camera or when it is connected to an AC power supply, it is okay for you to connect your camera directly to your computer to download images. Otherwise, you should use a digital photo media card reader.

The process of transferring digital photos directly from a digital camera to a computer is inherently more risky, and it can create problems that you won't have if you use a reader. Not only are most card readers far faster at transferring files than a direct-connect transfer, but also, you do not run the risk of getting a corrupt digital photo media card. This can result from the camera's battery becoming fully discharged during the transfer process. You also avoid many of the problems that can occur when your computer's operating system has to interact with the operating system in your digital camera. This is especially true if you are using a Windows operating system that is older than Windows XP.

STEP 2: INSERT DIGITAL PHOTO MEDIA CARD INTO READER

■ To begin the download process, remove the digital photo media card from the camera and insert it into the reader.

Now comes the tricky part. After you insert a card into the reader, your computer's operating system will likely take one or more actions. The trick is to get it to perform the action you want. What action do you want? Take a look at the five choices shown here and then pick the action you want. After you select the action you want, you should read the appropriate section below and perform the steps that need to be taken to set up your computer to automatically perform that action each time you insert a card into the reader.

1. **Use Windows XP Explorer.** This is the simplest, most commonly used, and least flexible way of downloading files. Use this approach when you just want to download the files to your hard drive without renaming them or adding the images to any image management database.

2. **Use Windows XP AutoPlay.** If you take different approaches when downloading digital image files, you may want to consider using the AutoPlay feature. It enables you to choose how you want to use the image files each time you insert a digital photo media card into the reader. You can choose from actions, such as copy pictures to a folder using Microsoft Scanner and Camera Wizard, view a slideshow of the images, print the pictures, open Windows XP Explorer folder to view files, or you can import the image files using any of the third-party image managers that support the Wizard, such as ACDSee 7 (www.acdsystems.com).

3. **Use Adobe Photoshop Elements 3.0 Downloader.** This may be the choice you want if you plan on using the Adobe Photoshop Elements 3.0 Organizer.

4. **Use a third-party downloader application.** This is the choice you want if you plan on using a software tool that is designed for downloading image files. Good examples of flexible

downloader tools are Breeze Systems Downloader Pro (www.breezesys.com) and the downloader that comes with ACDSee 7.

5. Use Windows XP Scanner and Camera Wizard. The Scanner and Camera Wizard is a useful and relatively unknown Windows XP feature that facilitates the downloading of image files *only* when you have a direct connection between your digital camera and your computer. You can designate where you want the photos to download, what the destination folder name should be, and how the files should be renamed once they are written to the destination folder. This is a good option to use if you are not using any other application that has a downloader feature and when you want to automatically rename the image files and place them into folders with names you choose. Because we don't often recommend a direct camera-to-computer download, this approach is not covered any further.

With those actions to consider, we suggest you pick one approach and then set up Windows XP to work the way you usually want to download your digital photos.

Lexar Compact Flash reader

TIP

Dozens of digital photo media card readers are available. You can buy a reader that reads only one format of media, such as the Lexar Compact Flash media reader. Or, you can buy a "multi-format" reader, such as the Lexar 8-in-1 USB 2.0 reader. This reader can read CompactFlash, SmartMedia, Memory Stick, Memory Stick Pro, MMC, SD, and xD cards. Many new computers, such as HP Media Center PCs, come with a multi-format media reader already built in. The HP Media Center PCs feature handy Front Productivity Ports that include two USB 2.0 ports, one FireWire port, and a 9-in-1 card reader.

Lexar 8-in-1 USB 2.0 Reader

IF YOU WANT TO USE WINDOWS XP EXPLORER

You can take three approaches to launch Windows XP Explorer if that is your tool of choice for downloading digital photo files from an inserted media card. First, you can set up the Windows XP AutoPlay feature to automatically launch a Windows XP Explorer window any time a media card is inserted into the reader. You can also set up the Windows XP AutoPlay feature to give you a list of your choices for downloading image files, which includes a choice for launching a Windows XP Explorer window. We cover that approach in a minute. Or, you can simply launch a Windows XP Explorer window yourself.

■ To set up Windows XP to automatically launch an Explorer window when a digital photo media card is inserted into a reader, double-click **My Computer**. Under **Devices with Removable Storage**, right-click the media card device and then click **Properties**. Click the **AutoPlay** tab. Click in the **multimedia type** box and choose **Pictures**. Under **Actions,** click **Select an Action to Perform**. Click on the slider and scroll down until you see the **Open Folder To View Files** icon. Click that icon to select it, as shown in Figure 1.2. Click **OK** to close the dialog box and apply the settings.

If you perform these steps in the future, whenever you insert a media card into the reader, you will automatically get a Windows XP Explorer window that is set to the media card folder. To download the files, perform the following steps.

■ You should now see a folder named **\DCIM**, which contains all of the image files. This is the default folder name that digital cameras automatically create and use to store image files. Click the folder to select it, as shown in Figure 1.3. If your Explorer window looks different, you may need to click the **Folder** icon in the **Icon** menu, and/or click the **Views** icon and choose **Details** to get a similar view. The objective now is to copy this

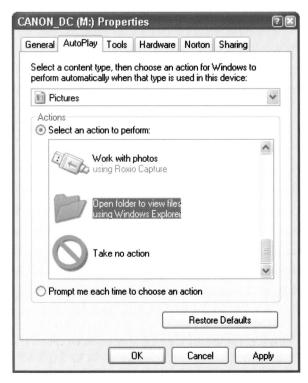

1.2

folder — which contains one or more folders with digital photo files — to an appropriate folder on your computer. You are now faced with a simple challenge. If you try to copy the **\DCIM** folder to a destination folder that already has a folder of the same name, you will not be able to do so because each folder name must be unique. The solution to this challenge is to right-click on the **\DCIM** folder; then, select **Rename** from the pop-up menu. You can then type in a unique name for the folder. For example, for a folder containing photos from a soccer game, you can type in the name of the opposing team, the date of the game, the city where the game was played, or any other meaningful name as long as it is unique and won't match the name of any other folder in the destination folder.

1.3

■ After you rename the folder, right-click on the folder and select **Copy** from the pop-up menu.

■ You now need to select a folder to use for downloading the files. If you want a new folder, click the drive you want to use in the Windows XP Explorer window to make it the active drive. Choose **File ➢ New ➢ Folder** and you will see a new folder with a highlighted "**New Folder**" name. Type the name you want to use for the folder and press **Enter**.

■ To begin downloading the files into the new folder, right-click on the new folder and choose **Paste** from the pop-up menu. You should now see a dialog box that shows the files being downloaded.

IF YOU WANT TO USE WINDOWS XP AUTOPLAY

If you are using the default settings of Windows XP, you should get the dialog box shown in Figure 1.4. If you don't get the AutoPlay dialog box, you can set it up by performing the following steps.

■ To set up Windows XP to automatically launch the AutoPlay feature when a digital photo media card is inserted into a reader, double-click **My Computer**. Under **Devices with Removable**

Storage, right-click the media card device and then click **Properties**. Click the **AutoPlay** tab. Click in the **multimedia type** box and choose **Pictures**. Select the **Prompt me each time to choose an action** by clicking the radio button that you find below the Actions box. Click **OK** to close the dialog box and apply the settings.

Next time you insert a digital photo media card, you will get the AutoPlay dialog box where you can see all the options you have available for downloading and using the digital photos on the inserted card. If you have installed applications, such as Adobe Photoshop Elements 3.0 or ACDSee, you may be able to click an icon for that application and use it for downloading and managing the photos.

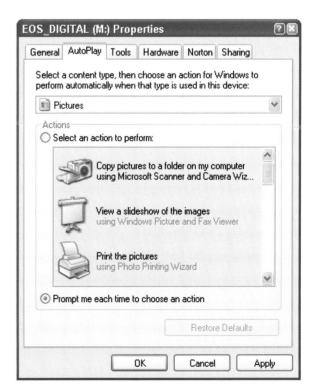

1.4

IF YOU WANT TO USE ADOBE PHOTOSHOP ELEMENTS 3.0 DOWNLOADER

When you install Adobe Photoshop Elements 3.0, you also install Adobe Photo Downloader, which is a wonderful feature that makes it simple to transfer photos from an inserted media card to your computer and into the Elements 3.0 Album of your choice. Here are the steps to take to download image files using the Downloader.

■ When you insert a digital photo media card into a reader, you get the Adobe Photo Downloader window shown in Figure 1.5. To choose your destination folder click **Browse** to get the Browse For Folder dialog box shown in Figure 1.6. You can now click the drive and/or folder you want to use. If you need to make a new folder, click the **Make New Folder** button and type in the new folder name. Click **OK,** and you should see the selected folder noted in the dialog box. Alternatively, you can also create a new subfolder using either a name comprised of the date and time of the import, or a new name of your choice by choosing the option you want.

■ If you choose to rename the files as they transfer, you can also have that done automatically for you. Click in the box next to **Rename Files to** (see Figure 1.5) and type in a name. For example, these soccer photo files can be named "Carolina" and each file would automatically be renamed "Carolina" plus an incrementing three-digit number starting with "001".

■ If you want to automatically add these digital photos to a Catalog in Adobe Photoshop Album, click the **Advanced Options** button (see Figure 1.5) and choose an existing Catalog or name a new Catalog.

■ As soon as your settings are how you want them, click **Get Photos** to transfer the photos as you have specified — it is that easy! If you have switched on the feature to add the photos to a Catalog, your image files will also be added to the Adobe Photoshop Elements 3.0 Organizer's database.

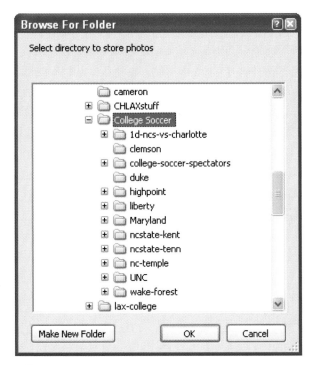

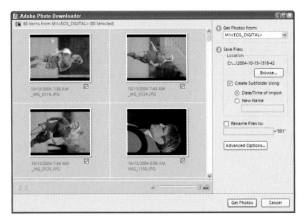

1.5

1.6

IF YOU WANT TO USE A THIRD-PARTY DOWN-LOADER APPLICATION

Several applications are specifically designed to download digital image files to a hard drive. Our favorite downloader, which Gregory uses often, is the Breeze System Downloader Pro (`www.breezesys.com`). You can either launch the application yourself, or set the options to have it launch automatically when a card is inserted into a reader. Downloader Pro allows you to add text data to each file that is downloaded as well as rename the file using a highly flexible, user-specified file naming feature. Figure 1.7 shows the Credits/Status tab of the NAA/IPTC Data dialog box that specifies the copyright information applied to all of the downloaded images. In the background, you can see the name of the images on the card and the name and download path where the images get stored. This is a fantastic application that makes it easy to rename your files, add textual content to the files, and download them to a folder of your choice.

STEP 3: CONFIRM YOU TRANSFERRED ALL THE PHOTOS

At this point, no matter which of the five approaches you take to download your image files, you are quite likely to have transferred all of your photos onto your chosen drive. However, if you have just transferred photos that are valuable to you, it is always worthwhile to confirm that they have positively transferred.

■ To confirm the complete transfer of the photos using Windows XP, right-click the **Start** button and click **Explorer** to get Windows Explorer if it is not already open. Click the **Card Reader** icon to select it. Click the **Plus** icon (the Expand button) to open the folder. Right-click the **\DCIM** folder (or other name if you renamed it in the previous Step 2) and choose **Properties** to get a properties dialog box, such as the one shown in Figure 1.8. You can now read how many files and folders it contains. In this case, it was "141 Files, 4 Folders".

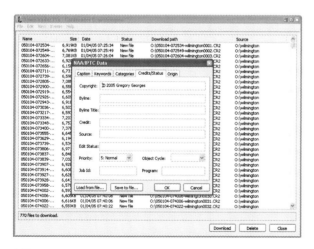

1.7

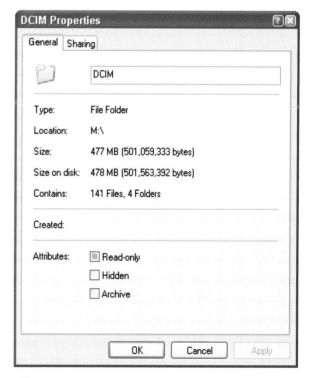

1.8

■ Leaving that dialog box open, do the same thing with the destination folder by opening a new Windows Explorer window and checking to see if the number of files and folders are exactly the same. If so, you know that you successfully downloaded all of the digital photo files.

STEP 4: FORMAT DIGITAL PHOTO MEDIA CARD

After you have downloaded all of your image files to your computer and confirmed that they have all downloaded, you should always reformat the card with your camera's format feature. Why is this so important? First, a digital photo media card is very similar to a hard drive. Like a hard drive, the card can get highly fragmented as many image files get written and erased, over and over. The more fragmented the card gets, the slower the card is when reading or downloading files.

If you use your camera's erase feature instead of the format feature, you will simply be contributing to the fragmentation of the card. Also, digital cameras have simple operating systems, and they only erase files that are in the \DCIM folder, which is a standard folder name for storing digital photos written by a digital camera. Therefore, if you renamed the \DCIM folder during the download process and you use your camera's erase feature to erase the files, you will not actually erase any of the files that were in the original \DCIM folder. Instead, the camera indicates that there are no camera images; but the storage capacity of the card is reduced by the amount of capacity that

is taken up by the renamed \DCIM folder. When this happens, you may shoot a few photos and then find your card is full. Without having access to a computer, you have no way to retrieve the full capacity of the card without formatting the card, which causes you to lose the new photos. On a trip, where you have limited storage capacity, this can be an aggravating and costly mistake.

TIP

Some digital photo media readers are much faster at transferring files than other readers. The primary factor that determines data transfer speed is the interface. The two most common interfaces are USB (Universal Serial Bus) and FireWire. The USB 2.0 interface can yield data transfer rates that are up to 13 times as fast as USB 1.1. While USB 2.0 has a slight edge in data transfer speed over FireWire, differences in architecture give FireWire a slight edge when used for connecting external hard drives. It is important to note that your computer must support the interface version of your card. Attaching a USB 2.0 reader to a USB 1.1 interface only allows data to transfer at the USB 1.1 rate. If you don't have a USB 2.0 or FireWire interface on your computer, you can purchase a relatively inexpensive card from Adaptec (www.adaptec.com). They even offer dual USB and FireWire cards for about $80.

2

CREATE A FILING SYSTEM FOR YOUR DIGITAL PHOTOS

2.1 An organized filing system makes it easy to find, view, and use your digital photos, and to ensure that they are properly archived.

WHAT YOU'LL NEED

Windows Explorer or an image manager, such as Cerious Software ThumbsPlus Pro v7 (standard version $50, pro version $90; `www.cerious.com`).

As much as we would like to tell you there is a super-fantastic, one-strategy-fits-all way of categorizing and managing all your digital photos, it is simply not true. The best system for you is one that works well for the kinds of photos you take, the way in which you choose to categorize and access them, and the volume of photos in your collection. Deciding how you want to categorize and access your files is the first step you need to take before you decide how to name the folders. Deciding whether, or how, you should rename the files, or whether you want to add textual data to the files or an image manager's database, are additional steps you may take if you really want to create a detailed filing system.

11

In this project you get plenty of ideas, tips, and techniques for creating a digital-photo filing system that perfectly suits your requirements. You also learn about some tools that can make electronically organizing your files easy compared to the time and effort it may take for you to organize them manually.

STEP 1: DECIDE HOW YOU WANT TO CATEGORIZE YOUR DIGITAL PHOTOS

How many photos do you currently have? How many photos do you expect to add to your collection in the next two or three years? Are you likely to find yourself searching for specific photos, or are you more likely to browse folders to find what you want? Do your photos fit neatly into a few categories, or are you one who will need dozens of categories? Will you allocate a little or a lot of time to organizing your photos? Without doubt, so many questions need to be answered. The truth, however, is that getting answers to those and other questions is absolutely necessary for you to be able to create a filing system for your photo collection that works for you now, and in the future.

Lauren has had good success with her photo collection by organizing them into events and subfolders for each digital photo media card she uses. For example, if she spends a day taking mostly butterfly photos in the Sandhills in North Carolina, she will create a folder named "Sandhills." Then, she creates a subfolder for each digital storage media card she uses and places the images from each card into folders named "Sandhills1," "Sandhills2," and so on. This is a good strategy because folders with large numbers of image files can be slow to access.

When she is traveling with her college soccer team, she places each set of photos into a folder named "Soccer" and then a subfolder of the year, and then a subfolder by opponent. The advantage to this approach is that it is very easy to do. Finding the photos is also relatively easy when she needs them if she can remember the event where she took them.

For example, if she wants to make a print of a photo of a teammate she played with in 2003 taken at a game against University of Virginia, she can easily find the image in the folder "d:/MyPhotos/Soccer/2003/Virginia." Notice from the full folder name that all the photos are stored in a folder she has named "MyPhotos." This folder makes it easy for her to back up all of her photos by choosing that folder. To learn more about archiving your digital photos, read Project 5.

In sharp contrast to Lauren's approach, Gregory uses a combination of approaches depending on the type of photographs he takes and how he is likely to use them. On the same Sandhills trip with Lauren, Gregory took photos of butterflies, birds, dragonflies, and many other subjects and scenes. Because of his interest in the photos in some of these categories, he uses ThumbsPlus Pro v7 (www.cerious.com) to visually select photos and drag them into folders in categories, such as Butterflies, Dragonflies, and Birds. However, before dragging and dropping the photos into folders that are appropriately labeled, he attaches keywords to the files, which are kept in the ThumbsPlus Pro v7 database. Adding the keywords "Dragonflies" and "Sandhills" makes it easy for him to later look at all his dragonfly photos, irrespective of where they were taken, and the photos that he took in Sandhills, North Carolina, irrespective of the subject matter of the photos. Or, he could just as quickly do a search for all of the dragonfly and butterfly photos taken in Sandhills, North Carolina, even if those photos are no longer in the Sandhills folder.

While Gregory's approach allows much more refined searches, his approach also takes considerably more time. Adding keywords to the ThumbsPlus Pro v7 database takes time. As his collection and the database grow, the investment in time increasingly "locks" him into using the same image manager.

With those ideas for organizing photos, you now need to decide how you want to organize your photos. Some categories you may want to consider are:

■ **By Camera:** If you have purchased a series of digital cameras over the past few years, you may find that you want to categorize your photos by the camera that was used to take them. Image size and quality of photo may make this approach a good one depending on how you want to use your photos.

■ **By Client:** If people pay you money for taking photographs, you should create a folder for clients and take special care in protecting those images from loss.

■ **By Date:** One of the most obvious and often used approaches to categorizing photos is by date. Some image managers, such as Adobe Photoshop Elements 3.0 Organizer and ACDSee 7 even offer timelines and calendar views of photos to facilitate searching for and using photos by date.

■ **By Event:** Photos taken at birthday parties, family get-togethers, and sporting events are just a few of the kinds of events that can be categorized by placing them in event-named folders.

■ **By Location:** One of the most descriptive category names can often be the name of the location where the photos were taken.

■ **By Person:** Because a very large percentage of photos that get processed at one-hour photo processing labs are of people, it makes good sense to create categories for photos by specific people.

■ **By Subject:** If you shoot subjects, such as spiders, toads, flowers, old cars, or other subjects, you may want to create categories by those subjects.

■ **By Trip:** If you travel, categorizing your photos by trip may be an excellent way to store your travel photos.

STEP 2: DECIDE ON FILING STRUCTURE

After you have an idea of how you want to categorize your files, you have one more important decision to make. That is: Will you use a folder-based system, a "flat file" system with unique filenames, or a combination of both? Odds are you have never even contemplated this question. Are we correct?

Believe it or not, it is a significant question that you must consider, and the right answer for you is very much dependent upon which image manager you choose to use. Furthermore, this may be a long-term decision as it may be very costly (in terms of time and effort) if you later decide you want to use a different image manager. You read more about choosing an image manager in Project 3.

FOLDER-BASED FILE SYSTEM

A folder-based filing system is the most common way of storing digital photos. After putting digital photo files into folders with meaningful names, you can then use software, such as ThumbsPlus Pro v7, ACDSee 7, or even Windows XP Explorer to view and access the files by clicking a folder using those applications. If you take the time to organize your photo files into folders with descriptive names — as you learn to do in Step 3 — the filing and accessing of photo files will be straightforward, without your having to take any extra time to add keywords, categories, tags, or other textual data to the database to make it easy to find them later.

FLAT FILE SYSTEM

In sharp contrast to the folder-based filing system is the flat file system. Adobe Photoshop Elements 3.0 Organizer and Extensis Portfolio 7 use this system, as well as several other image managers. The concept behind a flat file system is that all of the photos (irrespective of the folder in which they are located) are brought into one large group of images. Even though you start off by putting digital photo files into folders when using these applications, after you import a folder of image files into the database, you cannot access the files using the image manager by folder — unless you add the folder name to the database when

the files are imported. That is generally not a good idea if you move images around in their folders.

Instead, when you import image files, you should take time to put them into categories or add keywords to the images so that you can find them later by those categories or keywords. Flat file systems can be powerful filing systems, but you need to be relatively compulsive about making sure to add the necessary categories, tags, or keywords to the photos when they are imported. Otherwise, you simply have a large "flat file" containing many photos — in spite of the fact that you placed them into folders with descriptive folder names. Figure 2.2 shows the Tag feature found in Adobe Photoshop Elements 3.0 Organizer, which is used for searching the database for images with a specific Tag; in this case, the tag is for "Heron."

You may now be wondering how a flat-file system keeps track of the image files. At the time image files are imported into the database, flat-file image managers create thumbnail images and a "pointer" that keeps track of the location of the image files on your hard drive. If you move the image files around with Windows XP Explorer or any other application other than the image manager, the location of the image files gets out of synch with the database, and you won't be able to locate your files without going through a resynching process.

As you may now see, the implications here are pretty significant. If you choose to use any flat-file image manager, it may not make sense to take too much time to organize your image files into folders with meaningful names as you will also have to add each photo to a category, a tag, or other organizing feature.

STEP 3: CREATE FOLDERS FOR YOUR FILES

If you choose to use descriptive folder names for your photo collection, you need to create a folder structure

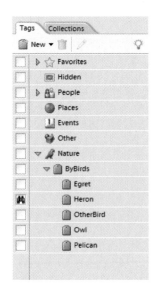

2.2

for handling folders and digital photo files. The process of creating folders can be done either with Windows XP Explorer or with your image manager.

A partial listing of Gregory's folder structure is shown here. The first folder is named "_ToFile." The underscore is created by pressing and holding **Shift** while pressing the "-" key. This character forces the "_ToFile" folder to be listed at the top of the list of folders. It is in this folder that all new images are downloaded until he has time to add keywords and sort the files into the appropriate folders. In his folder naming structure, any folder beginning with "By" is a major category folder. Depending on how many photos are in each of the folders, there may be one or more subfolders. In the case of the Nature folder, which includes two more sub-levels allowing the nature folder to have a subfolder for Birds and another level of subfolders with a folder for: egrets, herons, pelicans, owls, and other bird species. You can see an example of a folder and its multiple subfolders here.

```
\_ToFile
\ByEvent
\ByLocation
\ByNature
 \ByBackground
 \ByBird
   \egret
   \heron
   \pelican
   \other
   \owl
 \ByBug
 \ByDragonfly
 \ByFlower
   \daylily
   \iris
         \private-garden
         \public-garden
   \other
   \waterlily
 \ByFrog
 \ByInsect
 \ByScenic
 \ByTurtle
\ByPeople
\BySport
\BySubject
```

After you create your folder structure, you are ready to fill it with other folders and image files.

STEP 4: DECIDE ON FILE-NAMING CONVENTIONS

After you decide how you want to categorize your photos, you should decide if, and how, you should rename the files. Digital cameras write files with cryptic file names, such as HM3S8278.jpg, 4A2V5628.tif, or DSCN0286.jpg. Typically, the last four digits are a sequential series starting with 0001 and going to 9999,

> **WARNING**
>
> The faster your digital photo collection grows and the larger it becomes, the more important it is for you to carefully choose the right image management system for your needs from the beginning. If you choose an image manager that is folder-based, such as ThumbsPlus Pro v7 or ACDSee 7, and you take the time to place all your images into folders that accurately categorize their content, you will lose the value of that structure if you change to a flat-file image manager, such as Adobe Photoshop Elements 3.0 Organizer. Likewise, if you add textual data to an image manager's database, or you use features, such as tags, collections, and keywords, you are likely to lose the value of your efforts if you change to another image manager. Also, after image files are added to the database, you can destroy the value of an image management database if you move folders and image files with any other application other than your image manager. Moving folders and files with your image manager maintains the links between the database and the image files.

before starting over again. Or, some cameras have a user-selectable setting that can specify that each new card begins with 0001. In either case, it is possible to end up with more than one file with exactly the same name. Duplicate filenames are perfectly okay providing that you don't attempt to place them into the same folder.

If you want to make your filenames more meaningful, you can rename them. Several file-naming conventions are shown here.

Here are a few additional tips for file-naming conventions.

■ While long filenames can be more meaningful than short filenames, if they are too long, all of the filename may not be visible in your image manager, especially in thumbnail view.

■ When the year is added to a filename, consider using two digits for the year instead of four (for example, 1999 would be 99, and 2006 would be 06).

■ Even though each original digital photo file contains the shoot date in the EXIF data (textual data written by the camera inside the actual image file itself), adding the date to a filename is a good idea as it helps avoid duplicate filenames. It also ensures that the shoot date is available even if an image editor is used that does not save the EXIF data, or the file is saved in a format that does not contain EXIF data.

■ Use the underscore (_) character as a separator in your filename. To type the _ character, press and hold **Shift** while pressing the – key.

■ Add optional suffix file modifiers to indicate what actions have taken place on the image. Good suffix modifiers include: "-e" for files that have been edited, "-s" for a file that has been sharpened for its current size, and "-r" for files that have undergone image resampling. For example, after a file named "iris-duke_349.tif" has been edited, name it as "iris-duke_349-e". When the same file is edited, the resolution is changed, and it is sharpened, the file's name would be "iris-duke_349-ers.jpg".

After you determine the file-naming convention you want to follow, you need to make sure that it is one you can actually use. Renaming all your files manually would be a nightmare. The easy way to rename files is to use an image manager with automatic renaming capabilities, use a downloader program with file-renaming features, or get a file-renaming utility. When you install some image managers, such as Adobe Photoshop Elements 3.0 or ACDSee 7, a downloader program also installs that you can use to automatically rename files as the images

TABLE 2-1

FILE-NAMING CONVENTIONS

FILENAME	DEFINITION
iris-349.jpg	Descriptive word followed by a sequential 3-digit number.
20040512iris_349.jpg	Year, month, and day followed by a descriptive word and then a sequential 3-digit number.
iris-duke_349.jpg	Descriptive word, followed by a sub-category word, followed by a sequential 3-digit number.
can06_349.jpg	Camera ID (for example, my sixth Canon camera) followed by a sequential 3-digit number.
yellowstone_01-349.jpg	Descriptive word, two-digit media card number, followed by a sequential 3-digit number.
20050519_172019-349.jpg	Year, month, day, hours, minutes, seconds followed by a sequential 3-digit number
yellowstone_gg_02-349.jpg	Descriptive word, photographer's initials, two-digit media card number, followed by a sequential 3-digit number.

are being downloaded to your hard drive. Many other image managers have flexible file renaming features, such as the Rename feature found in ThumbsPlus Pro v7, which you learn more about in Project 4. Finally, you can use a file renaming utility, such as the Cognitial Software Name Dropper utility (`www.cognitial.com`). Name Dropper is particularly useful if you want to rename your files using the year, month, and day (and hour, minute, and second, if you choose) the photo was taken. It can be set to read the EXIF data in the image file and use that data for renaming the file. Compared to the effort it would take to do this manually, at $20, it is quite a bargain. If you want a more expensive and flexible downloader, you may want to consider Breeze Systems Downloader Pro, which can also rename RAW files (`www.breezesys.com`).

TIP

When you shoot with more than one digital camera, or if you shoot along with another photographer, and the goal is to store all of the photos in the same collection, you should set the date and time on all of the digital cameras to be the same. Using the date and time data stored in each image file, you can rename all of the files starting with the date and time. Then you can view them as a single series of photos over time regardless of the camera that was used, the card that was used, or the photographer who took them.

STEP 5: DECIDE IF YOU SHOULD ADD TEXT-BASED CONTENT TO YOUR COLLECTION

Another significant decision to make when setting up a filing system for your digital photos is whether you want to add textual information to your collection, and should you decide to, how to do it. You can do this two ways. Many of the image managers have databases that hold all kinds of textual information about each digital photo. Figure 2.3 shows the ThumbsPlus Pro v7 File Properties dialog box where you add annotations, keywords, user fields, and much more. Once again, it is important to realize that if you add content to a database, it "locks" you into the application for years to come unless you are willing to do the work to replace that content in your new image manager or go without it.

The second way to add textual data to your photo collection is to write the content directly into the image file.

2.3

Figure 2.4 shows the ThumbsPlus Pro v7 IPTC/NAA Editor. This editor follows industry standards that allow other applications that read and write to the same standards to access this data in the image file, which allows you to add textual content to a file without having to worry about problems created by changing image managers in the future. Most, but not all, image managers read and write specific content to image files using an industry standard. However, there is a serious limitation if you shoot RAW files, as a growing number of digital savvy photographers do. Because RAW files are proprietary to each camera vendor, and, in some cases, to each specific camera model, and, because there are no industry standards for adding textual content to RAW files, you can actually destroy the image file if you attempt to write data to a RAW file with an application that does not write correctly. We therefore recommend that you not write textual content to RAW files unless you know for a fact that the application you are using works perfectly on the image files created by your specific camera. Even then, the camera vendor can provide an update to firmware that may cause problems when you least expect it. To be safe you simply should not add textual content to RAW camera files.

There can be a solution to this problem if the majority of camera vendors accept the Adobe proposal for a "digital negative" file standard. The extension for this proposed file is .dng. If camera vendors write to this standard, any software that follows that standard can read and write to the data portion of the .dng file. In the meantime, be exceedingly careful if you choose to write data to a RAW file.

STEP 6: DECIDE ON A BACKUP STRATEGY

Because this is a project used for creating a filing system for your digital photos, it is essential to note the importance of, and to cover the topic of deciding on and implementing a backup strategy. However, as we view archiving as being extremely important, we cover that topic in a separate project. In Project 5, you

learn how to back up your digital photo collection and how to decide on the most appropriate media and storage devices.

> **WARNING**
>
> If you are using an image manager to add textual data to the image manager's database, it is important to make sure that you back up the database in the same manner you back up your image files. If the drive that contains the database failed, you would lose all that added content for your entire collection. You can also lose the database content without a hard drive failure if the database gets corrupted and cannot be repaired. Most image managers have an option that allows you to choose the folder where the database is stored. Access this feature to learn the name of the database file and where it is stored. As soon as you determine the file or files that need backing up, you should regularly back up the file when you back up your photo collection. If you use any automatic archiving software, make sure to include the database in one of the regular backup processes.

2.4

3

CHOOSE A TOOL TO MANAGE YOUR DIGITAL PHOTOS

3.1 Carefully choosing a digital image manager is one of the most important decisions you can make to become a productive digital photographer.

WHAT YOU'LL NEED

High-speed Internet connection to download trial versions of image managers and three to five hours for evaluating different image managers.

When we first decided to write a project for choosing an image manager, we incorrectly assumed it was going to be straightforward, like all the others in this book. After considerable discussion and "too much" time spent using over a dozen of the best image managers, we decided to take a different approach to this project. The fact is that choosing an image manager is absolutely like choosing a long-term relationship — it is a personal thing. Look and choose carefully because once you are in, you may find yourself committed. The longer you have a relationship with one image manager, the more difficult it will be to change. Attempting to enjoy two or more at once may be really traumatic!

With those thoughts in mind, we decided to cover characteristics that may differentiate one image manager from another. Then, we provide a list of a half-dozen of the best image managers available today. To choose a tool

19

to manage your digital photo collection, we highly recommend that you download trial versions of each application you think you may like, and try them out for yourself. We even give you a list of ten things to do with each image manager. With that approach, you are sure to get one that will suit your needs, and we won't get caught having made a recommendation for one image manager that you later learn was not the right one for you. Good luck and enjoy the hunt!

STEP 1: DECIDE IF YOU NEED AN IMAGE VIEWER OR AN IMAGE MANAGER

Before we get started, we need to be clear about the difference between an image viewer and an image manager. In simple terms, image viewers are limited to functionality that allows you to view folders of digital photo files by looking at the files as thumbnails (tiny images) and as larger "previews." Some image viewers can also be used to convert RAW files and to view any shooting data (EXIF data) that gets written to the image file by the camera when the photo was taken.

The least functional image viewer for PC users is Windows XP Explorer. It can be set up to show some types of digital photo files as thumbnails. You can learn more about this capability in Project 1. Using Windows XP Explorer, you can move files between folders and rename one file at a time. More sophisticated image viewers are typically bundled with digital cameras. Canon offers the EOSViewerUtility for their lower-end digital cameras and Digital Photo Professional for their digital SLR cameras. Most other digital camera vendors ship similar software with their digital cameras.

Breeze Systems, BreezeBrowser, and BreezeBrowser Pro (`www.breezesys.com`), and Bibble Labs' Bibble are excellent image viewers that are also able to convert RAW files created by a growing number of digital camera vendors. When compared to the RAW conversion tools provided by the camera vendors, these RAW converters with image-viewing capabilities

3.2

are often viewed as being able to provide superior RAW conversions. Figure 3.2 shows BreezeBrowser Pro in Filmstrip View with the EXIF window open.

There are also many low-cost or free image viewers that are usually (but not always) limited to viewing .jpg, .tif, or .bmp files. Good examples include Picasa (`www.picasa.com`) and Preclick (`www.preclick.com`). Then, there is the wonderful FlipAlbum (`www.flipalbum.com`), which you read about in Project 44. It makes browsing through image folders as much fun as flipping pages in a printed photo album providing that the files are .bmp, .jpg, or .tif files. A quick search for "image viewers" on `www.cnet.com` or `www.pcmag.com` provides you with dozens of more image viewer choices, such as the feature-rich IrfanView (`www.irfanview.com`).

If all you want to do is click through various digital photo folders and view the images and be able to drag and drop images between folders, then all you need is an image viewer. Or, you can purchase a full-featured image manager and just use the functionality that you need. On the other hand, if your goal is to create a database rich with content you add to make your photo collection more useable, you will want a full-featured image manager.

STEP 2: LEARN WHAT DIFFERENTIATES ONE IMAGE MANAGER FROM ANOTHER

In Step 2, you download free trial versions of two or more image managers. When you are taking them for a test-drive, we suggest that you consider the following when deciding which is best for you.

■ **Cost and availability:** Digital photography has a way of consuming as much cash as you make available for it. Before making an investment in an image manager, carefully consider the capabilities that you may already have. Most of the first-rate image editors come with an image manager that ranges in quality from pretty decent to excellent. For example, Adobe Photoshop Elements 3.0 has the Organizer, Ulead PhotoImpact XL comes with the powerful PhotoImpact Album XL, and Paint Shop Pro Studio comes with Photo Album, Standard Edition. If you are using Adobe Photoshop CS or CS2, you have the incredible power of the File Browser or Adobe Bridge.

■ **RAW files:** If you are either shooting RAW, or you plan to shoot RAW (and, in our opinion, it is something you will want to do if you are serious about photography), then you need to make sure that the image manager you choose is able to display the RAW files your camera writes. Supporting the growing number of RAW files from all the camera vendors has been a difficult challenge for many of the vendors that offer image managers. At the time of writing, many image management vendors were not able to support RAW files created by many digital cameras. We suspect that the list of unsupported RAW files will decrease over time.

■ **File architecture:** Image managers have databases that fall into two broad categories. They can be flat-file systems or folder-based systems. The architecture of the database has serious implications for how you access your files. To learn more about these two very different systems, read Project 2, Step 2.

■ **Features:** Over time, the feature set of competing software products usually gets pretty equal in a highly competitive category such as image managers. However, after some use of one product, you may find a feature that you absolutely must have. Features such as those covered in Project 4 are good examples of useful features that may appeal to you.

■ **Interface:** Interface, or the way the application presents its functionality to the user, is often what really differentiates one image manager from another. Our preference is for a simple interface that is mostly filled with thumbnails or previews, yet one that allows easy and quick access to the full feature set. Figure 3.3 shows the ACDSee 7 application window with most of the optional windows and icon bars turned on. As soon as you have set it up to meet your workflow, ACDSee 7 is a wonderfully flexible image manager that is quite suited to work just about any way anyone would want to work.

■ **Ability of software to mirror your work style:** Does your image manager work the way you want it to work, or do *you* have to work the way it is built? Some image managers offer many different ways

3·3

to view images and ways to customize the interface, such as being able to add quick access icons to your favorite features.

■ **Speed and ability to handle large photo collections:** Many image managers are simply too slow. The larger the collection gets, or the larger the images get, the slower these image managers get. Take time to make sure you do not purchase one that slows you down.

STEP 3: DOWNLOAD TRIAL VERSONS AND TRY THEM

Admittedly, we may have failed to mention one or more other good image managers; however, we are confident that all seven of the following image managers are excellent! They are rich in functionality and are offered by vendors that we expect to be around for a long time. In other words, if one of these products meets your needs, you have made a good choice.

WARNING

Choosing an image manager is a BIG decision. After you begin using an image manager, you become more locked into it as you add digital photo files to the collection and add useful textual data to the database. During your selection process, take the time to download trial versions of several of the leading products that are within your budget and make your own decision as to which one is best for you. Read, but be wary of, any comments that get posted to online forums or e-mail groups about how one image manager is better than another. As you will find out, as soon as you have learned how to use one well, the others will not seem as good to you. Also, picking image managers is a personal thing — what meets the needs of one photographer may not meet your needs. As there are never-ending arguments over which model of car is best, there will be continuing arguments over which image manager is best, too.

TABLE 3-1

IMAGE MANAGERS

IMAGE MANAGER	WEB SITE	STREET PRICE
ACDSee 7.0	www.acdsystems.com	$50
Adobe Photoshop CS/CS2	www.adobe.com	$650
Adobe Photoshop Elements 3.0 Organizer	www.adobe.com	$70
Extensis Portfolio	www.extensis.com	$200
ThumbsPlus Pro v7	www.cerious.com	$50–90
Paint Shop Pro Photo Album	www.jasc.com	$45–50
Ulead PhotoImpact XL	www.ulead.com	$50

After you download and install a few of these image managers, you should at least do the following ten things with each one you install. We recommend that you spend at least one hour or more with ACDSee 7.0, ThumbsPlus Pro v7, and Adobe Photoshop Elements 3.0 Organizer. If you use Paint Shop Pro, you should try out Paint Shop Pro Album, and if you use PhotoImpact XL, you should try out the PhotoImpact XL Album. If you have, or plan to have, a collection of photos in the tens of thousands, you will also want to try out Extensis Portfolio, as it is truly an "industrial-strength" application, and it is also available in a network version if that is something you need now or in the future.

1. Add about 2,000 or more image files to the image manager's database. Watch how long it takes for the thumbnails to be created.
2. Learn how to browse through a folder or category of images and find the best few photos. See if you can tag the best ones as you browse and if it is possible to view the folder or category with just the best few you selected. Is it is easy to view two images side-by-side? This is something you will want to do often when shooting digital.
3. Add keywords, categories, or tags to a few dozen images.
4. Perform a quick search based upon the keywords, categories, or tags you just added.
5. Add copyright information to an entire folder of images.
6. Learn about all the ways you can view your collection (for example, filmstrip view, small view, large view, custom view, and so on).
7. Go through all the menu items and look for features that may interest you. Are there features for creating virtual galleries, viewing by date, and storing thumbnails and data for offline media and drives?
8. Carefully check the software, the Help menu, and the vendor's Web site to learn if the package supports RAW files from your digital camera.
9. How easy is it for you to drag and drop folders and files from one folder to another?
10. Are there any features for archiving your digital photo collection and the database?

Remember, choosing an image manager is a long-term decision. If you don't have time to properly evaluate at least three of these products, put off your purchase until you have more time. You'll be glad you did.

MANAGE YOUR PHOTOS WITH AN IMAGE MANAGER

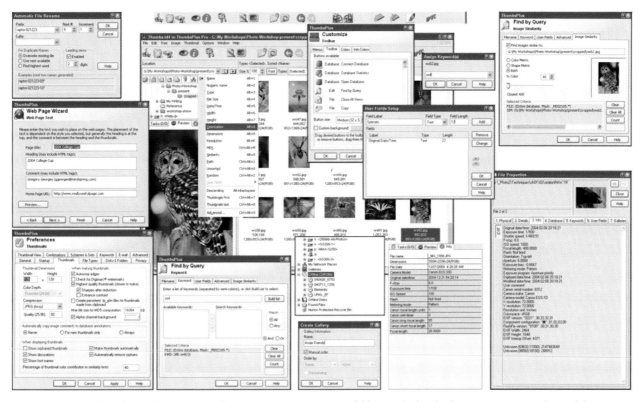

4.1 These are just a few of the dialog boxes that allow you to access the many useful features in ThumbsPlus Pro v7 to manage, view, and share your digital photos.

I n Project 3, you learned about many of the software tools that are available to manage your digital photo collection. You also learned about some features that may or may not be essential to you so that you can choose an image manager that can meet your needs. In this Project, you learn how to use some of the more advanced features found in the Cerious Software ThumbsPlus Pro v7. At the end of this project, you will have completed eight tasks using the Cerious Software ThumbsPlus Pro v7. Once you have completed this project using ThumbsPlus, you should complete these same tasks with any other image manager you are considering. Additionally, you should take time to learn about other features that may make it easier for you to accomplish what you want to do with your photo collection.

STEP 1: RENAME A BATCH OF DIGITAL PHOTO FILES

In Project 2, you learned how valuable it can be to rename your digital image files. If you have chosen a filing system where you are faced with the task of having to rename all the digital photo files you add to your collection, you'll like this feature. Renaming each of the files manually is a daunting task. ThumbsPlus Pro v7 offers an Automatic File Rename feature that makes renaming files quick, and it offers reasonable flexibility in naming the files.

- To rename files, you must first select the files you want to rename by clicking on them to select them. To select all the files in a folder, choose **Edit** ➣ **Select All** (**Ctrl+A**).
- Choose **File** ➣ **Auto Rename** to get the dialog box shown in Figure 4.2. Type in a prefix in the **Prefix** box. In the example in Figure 4.2, the year and month are followed by a hyphen and the word **waterlily**. Type **1** in the **Next #** box and set **Increment** to **1**. **Leading Zeros** should be enabled and **Digits** should be set to **2**. These settings create a series of files names such as "2005Mar-waterlily_01". Click **OK** to rename all of the selected files.

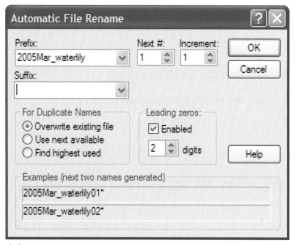

4.2

STEP 2: TAG FILES

A quick tag feature makes it easy to look through a folder of images and view only the photos you have previously tagged. If your goal is to choose a few photos to print, to use in a slide show, to edit, to e-mail, or to use any other purpose, a tag feature is useful.

- To tag files using ThumbsPlus Pro v7, click the thumbnail (or, to select more than one photo at a time, hold the **Ctrl** key while you click each photo) you want to tag and choose **Edit** ➣ **Tag Selected**. After you tag a file, you see a flag icon next to the thumbnail. You can also add an icon to the icon bar for the Tag and Untag feature for quick access.
- After you tag files, you can select them all by choosing **Edit** ➣ **Select by Tagged** (**Ctrl+Alt+T**). After your tagged files are displayed, you can do whatever you choose to do with them without having to view all of the other images in that folder or folders. If you change folders or close ThumbsPlus Pro v7, the tags will show again when you open the folder that contains the tagged files.

STEP 3: ASSIGN KEYWORDS TO ONE OR MORE DIGITAL PHOTOS

As your digital photo collection grows, you may want to add keywords to your files to make it easy to find the photos you want. For example, you may want to

> **TIP**
>
> If the time and date are accurately set in your camera, you can use a software utility such as Name Dropper (www.cognitial.com) to automatically rename files with the date (and time if you like) that is contained in the EXIF data in each image file.

view all the photos of pelicans that you have taken over the past few years, regardless of what folder they have been stored in. Depending on how you store your digital photos, this may be an easy task, or it may be a tedious manual task that can take more time than it is worth.

One step you can take to make your photos more accessible is to assign keywords to your photos. There are two very different approaches to assigning keywords. You can assign keywords that are kept in the image manager's database, or you can actually write the keywords to the image file itself. There are pros and cons to both of these approaches, and it is beyond the scope of this book to cover that topic in depth. You should, however, recognize which approach you take and the implications of that approach. If you write textual information to an image file it will always stay with the image file. If, instead, you use an image manager that writes the textual information to a database, that information may easily become out of sync with the image files if the image files are moved.

■ To assign keywords to the selected image file or files using ThumbsPlus Pro v7 by writing the keywords to the ThumbsPlus database, choose **File ➢ Properties** to get the File Properties dialog box. Click the **Keywords** tab and type in the keywords, as shown in Figure 4.3. In this example, we assigned three keywords: Mack truck, old truck, and SC. If we assigned keywords to all of the images in the database, it would be possible to do a search by one or more of these keywords and almost instantly retrieve all the image files that have matching keywords.

■ To assign keywords to the selected image file or files using ThumbsPlus Pro v7 by writing the keywords to the image file or files, choose **Edit ➢ Edit IPTC Info** to get the IPTC/NAA Editor dialog box. You can now type in any keywords you want added to the Keywords box, as shown in Figure 4.4. Click **OK** to apply them to all of the selected images.

4·3

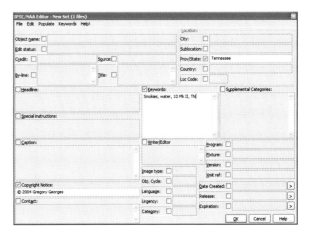

4·4

STEP 4: FIND A DIGITAL PHOTO IN A COLLECTION

■ If you applied keywords to your image files by adding them to the database or to the image files, you can easily retrieve them by choosing **Edit ➢ Find by Query** to get the Find by Query dialog box. Click the **Keyword** tab. You can now either type the keywords in the box, or you can select from the available keywords, as shown in Figure 4.5. Notice that you can perform a search by requiring that either all or any of the keywords match. Click **OK** to perform the search. After the search is complete, you are presented with a window containing all of the images that have matching keywords.

4.5

STEP 5: CREATE A FOLDER OF VIRTUAL DIGITAL PHOTOS

One of our favorite ThumbsPlus Pro v7 features is the Gallery feature. After you clearly understand how to use it, it can become invaluable, and, as an extra bonus, it saves you hard drive space. For example, imagine that our goal is to pick thirteen photos to use to make a photo calendar, as is done in Project 21. Instead of browsing through the folders and making a copy of the photos you want to use in a new folder, you create a "virtual" gallery and add the photos to the gallery as you find them. ThumbsPlus Pro v7 galleries don't actually contain any photos. They are merely folders that contain thumbnails with a pointer or link to the actual file. This means that you can add hundreds of image files to a Gallery while not needing to have all those extra copies take up your disk space.

■ To create a Gallery, right-click the first image that you want to add to the Gallery and choose **Gallery Create** to get the Create Gallery dialog box shown in Figure 4.6. Type in **2005 Nature Calendar** in the **Name** box. Make sure to check **Manual Order**. This useful feature allows you to drag the thumbnails around to place them in the order you want in your calendar. This makes it easy to make sure you have the right images for the right month. Click **OK** to create the Gallery.

■ To add more files to the Gallery, right-click the images you want to add and choose **Gallery ➢ Add To ➢ 2005 Nature Calendar**.

■ Any time you want to view the images, re-order them, or begin using them, you click the **2005 Nature Calendar Gallery** and they will display, as shown in Figure 4.7.

4.6

STEP 6: COMPARE TWO IMAGES

One of the major benefits of shooting with a digital camera is that you can take many photos and then select the best ones to share. Such a selection process often requires that you carefully compare two images side-by-side. This comparison is easy to do with ThumbsPlus Pro v7.

■ When using ThumbsPlus Pro v7, you can view two images side-by-side by clicking on them to select them. Right-click either of the images and choose **View Synched**. Both images then display side-by-side, as shown in Figure 4.8. As you zoom in or zoom out on one image, the other image zooms in the same manner. You can also move around in one image and have the other image scroll in the same manner. This synched view makes it easy to compare two similar images so you can choose the better of the two.

4.7

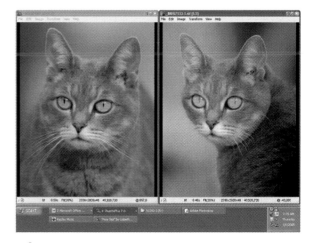

4.8

STEP 7: SEND DIGITAL PHOTOS VIA E-MAIL

You have many ways to send digital photos, but ThumbsPlus Pro v7 makes it as easy as it gets — and it can all be done by working with thumbnail images while browsing through folders.

■ To send one or more digital photos as attach-ments to an e-mail, you must first select them. To select a single file, click a thumbnail image. If you want to send more than one file, press the **Ctrl** key and click on any other files you want to send.

■ After you select the file or files you want to e-mail, choose **File ➢ Send by E-mail** (**Ctrl+M**) to get the dialog box shown in Figure 4.9. Click in the box next to **Convert Images** and choose **.jpg**. Choose a **JPEG Quality** and set the **Maximum size** to the size you want. Click **Compute** to see how large the files will be. You can even combine the files into a single ZIP file. Click **OK,** and the images are created and attached to a new e-mail message in your default e-mail program.

Now that was easy. With a feature like this, there is no reason not to share more of your photos. No need to select them and open them up in an image editor and manually resize them, save them to a file, and then hunt around using the Browse function in your e-mail application to attach them to an e-mail.

4.9

STEP 8: CREATE OFFLINE MEDIA FOLDERS

Our last task is to create offline media folders. An offline media folder is a folder just like any other folder in the ThumbsPlus Pro v7 database, except the hard drive or the removable media (CD-ROM or DVD-ROM) is no longer available. Making an off-line media folder is as easy as creating a folder by selecting the drive or the media when it is online. Disconnect the drive or remove the media, and you have an offline media folder. This is a wonderful feature to use if you want to keep track of all your digital photos on backup drives or on backup discs. To find an image, you can search through the thumbnails to find the images you want. Then, you can connect the correct drive or insert the correct media to access the files. Figure 4.10 shows several offline CDs. Thumbnails from the selected CD are shown in the window on the right.

These are just a sample of the dozens of features that you find in ThumbsPlus Pro v7. You can find these and many other features in most of the other image managers listed in Project 3. Attempting these tasks with some of the other image managers is a good way to get some experience with them so that you can choose the one best suited for your needs.

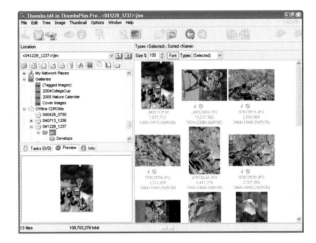

4.10

5

ARCHIVE YOUR DIGITAL PHOTOS

5.1 Archiving digital photos, such as your favorite family photos, should be done so they can be preserved and enjoyed for many generations.

Bad, bad things can, and do, happen! Hard drives do fail. Computer operator errors (often caused by even the most competent computer users) can, and do, occasionally cause valued digital photos to be irretrievably lost. CD-ROMs and DVD-ROMs do mysteriously become unreadable. Fires, storms, and theft can also cause you to suffer from the loss of photos that you value. Properly archiving your digital photo collection becomes increasingly important as your photo collection grows and as it becomes increasingly valuable to you. Therefore, if you have not already done so, you should take steps as soon as you can to archive your digital photo collection.

In this project you learn how to archive your digital photos so you can be assured that they will be available for as long as you want them. You also learn how to archive in such a way that it will be easy for you to find photos when you want them.

33

STEP 1: ORGANIZE YOUR DIGITAL PHOTO COLLECTION

Creating a backup copy of a poorly organized digital photo collection is a good thing to do if you do not have time to organize your collection first and you have a lot of photos that are currently at risk of being lost. However, as your collection grows, backing up an unorganized collection can become increasingly complex and, at some point, you will find that it will be hard to figure out which photos were or were not already backed up. You are also likely to have more copies of some photos than you need, and you may not have any backup copies at all of other photos. This is a horrible state to be in — we know — we've both been there!

Keeping an organized digital photo collection becomes more important as your photo collection grows and as the value of your collection increases. Our strong recommendation is that you first carefully organize your photo collection and then begin a routine backup process. You can learn more about organizing your digital photo collection in Project 2, Project 3, and Project 4.

STEP 2: DECIDE WHICH FILES NEED TO BE ARCHIVED

Keeping two or more copies of every digital photo you have may or may not be a good objective for you. You may want to do some math to determine if you have sufficient storage space or if you want to spend the amount of money it will take to buy enough backup storage to back up all of your photos. Many people take dozens of photos just to get one they are happy with. The obvious question here is: Is it worth saving all of the photos or just the good ones? A better objective for many people is to select the best photos to archive and avoid the cost associated with backing up the rest. However, you have to decide what is best for you. After you decide which digital photo files you need to archive, you will know how much backup space you will need, and you can then decide on the media or storage devices that will be needed.

If you decide just to back up the best photos you've taken, you should make copies of those photos and save them to a "best photos" folder or set of folders. Later, when you begin the archive process, you can back up that folder, which simplifies the archiving process.

STEP 3: DETERMINE WHERE THE FILES WILL BE ARCHIVED

Where should you archive your digital photos? The answer to that question depends on what you decided to back up in Step 2, the amount of money you are willing to spend on backup storage, and how much effort and time you are willing to put into the backup process. There is a mind-boggling amount of new hardware and software available that you can use to archive your digital photos. Our backup hardware recommendation is that you use CD-ROMs or DVD-ROMs, or internal or external hard drives. The reason to use this type of media, or type of storage device, is that you are more likely to find support for them in the long term. If you look back, even just a few years, you can find many technically interesting storage devices that are no longer made or supported. Such devices are not good choices for long-term archiving of your digital photo collection. Because of the prevalence of music CDs and DVD movies, and the common use of internal and external hard drives, it is highly unlikely that you will have any problems accessing the photos that are stored on them for years into the future.

With a little math you can decide how much backup storage you need, and then you can decide on the media type to use. First, you should make an estimate of the number of photos you take a year. You also need to determine how many photos you currently have that need to be archived and their total file size. The following table should give you a good idea of the storage requirements for digital photos taken

TABLE 5-1

MEDIA STORAGE REQUIREMENT COMPARISON

MEDIA	5-MP.JPG (2.1MB)*	5-MP RAW (5.2MB)*	8-MP.JPG (2.7MB)**	8-MP RAW (7.5MB)**
640MB CD-ROM	300	125	240	85
700MB CD-ROM	335	135	260	95
4.7GB DVD-ROM	2,240	900	1,740	625
40GB Hard drive	19,000	7,700	14,800	5,300
200GB Hard drive	95,200	38,500	74,000	26,700

*Approximate file size for a 5-megapixel camera. **Approximate file size for an 8-megapixel camera

with 5- and 8-megapixel cameras. Notice that RAW files require substantially more storage space.

You may laugh when you examine the table and find that you can store 26,700 RAW files on a 200GB hard drive. While that may seem like a lot of photos, we know many people that have that many photos after only a year or so of shooting digitally. Also, if you shoot RAW files and you open them in 16-bit mode and save them during the editing process, you can be working with 40MB and larger files.

If your storage requirements are relatively small, you may wonder if you should get a CD burner or a DVD burner. We always recommend DVD burners because not only does a DVD-ROM have more capacity than a CD-ROM, but all DVD burners can burn CDs. CD-only burners won't burn, or even play, DVD media of any kind. With the price almost equal, it is always smart to buy a DVD burner.

If you do plan on using CD-ROMs or DVD-ROMS, you need to learn how to take care of them. The National Institute of Standards and Technology has a free 50-page document titled *Care and Handling Guide for the Preservation of CDs and DVDs* that you can download and covers just about everything you need to know about them. To learn more about

expected life, proper storage, rewritable versus write-once discs, labels and markers, scratches and fingerprints, and more, download the document at `www.clir.org/pubs/reports/pub121/pub121.pdf`.

> **WARNING**
>
> The price of high-capacity hard drives has dropped so much it is tempting to buy 300GB or even larger drives. In many cases, these high-capacity drives are good choices providing that you routinely perform backups. Just be aware that the more digital photos you have on a single drive, the more you lose if the drive fails. You should also consider using external drives as backups, as you can easily unplug them and place the drive separately from your computer. Keeping backup drives as far away from your computer as possible adds increased protection to your photos should there be a computer theft, a flood, a fire, or other disaster.

WARNING

When you choose to back up your digital photos onto CDs or DVD media, you should buy the highest quality media available. However, it is not that easy to determine which ones are good and which are not so good. While the branding may be the same on two different boxes of CDs or DVDs, the manufacturing process or the batch may be different and therefore the reliability may be entirely different. The best approach is to buy two different brands of discs and perform your backup process twice — using two entirely different discs. This strategy decreases the chance that two discs go bad at the same time, or that both fail because of some manufacturing flaw. If you decide to use CDs or DVDs as backup media, you should absolutely *not* use "rewritable" media, as it is known to suffer from more frequent problems and have a considerably shorter shelf life than "write once" media. Rewriteable media includes: CD-RW, DVD+RW, DVD-RW, and DVD-RAM. We recommend CD-R, CD+R, DVD-R, or DVD+R, depending on the drive you have and the format that it writes.

STEP 4: CREATE CONTACT SHEETS OR THUMBNAIL IMAGES

If you want to suffer some serious aggravation, you should try finding a couple of photos that are on one of a dozen or more CD-ROMs or, worse yet, on even a few full DVD-ROMs. Most CD and DVD readers are very slow (when compared to hard drives) when reading image files, and you can spend more than a few minutes browsing images on a CD-ROM or DVD-ROM while attempting to find what you are looking for.

You can take several different approaches to avoid the aggravation of browsing through image files contained on slow-to-read media. You can create contact sheets of all the images you have on the media and place these contact sheets in a folder on the media. When you need to find an image, you can rapidly browse through a few contact sheets instead of all the image files. Figure 5.2 shows a contact sheet that was created using ThumbsPlus Pro v7. Notice that the name of the DVD-ROM that contains the photo is the title of the contact sheet. Another good option is to keep a set of these contact sheets on your main hard drive in a folder that is named the same as the media.

If you don't want to make contact sheets, you should consider making a Web photo gallery instead. Creating a Web photo gallery using a program, such as Adobe Photoshop Elements 3.0, is easy and it provides a gallery with thumbnails that can be viewed in an Internet browser on any computer platform. To learn more about creating a Web photo gallery, read Project 36.

5.2

One other alternative is to create an offline media or disk folder in an application like ThumbsPlus Pro v7, as is shown in Project 8 in Step 4. These offline folders allow you to search for photos across any media or disk that you have catalogued, even if it is not currently in a reader or online. Because ThumbsPlus Pro v7 saves thumbnail images in its database along with any data you have entered, such as keywords, you can search the database to determine which media or drive contains the needed images.

STEP 5A: SET UP AND PERFORM THE BACKUP PROCESS TO A CD-ROM OR DVD-ROM

If there were an award for the chapter in this book with the most options, it would surely go to this first chapter. As you may have guessed, that means there are many ways to perform a backup. How you choose to perform the backup process depends on a number of factors. If you are backing up to CD- or DVD-ROM, we highly recommend that, if you are using a PC, you purchase a copy of Roxio Easy Media Creator (`www.roxio.com`) for $80 and, if you are using a Mac, Roxio Toast 6 Titanium for $80. Because there are so many variables involved in writing to a CD-ROM or DVD-ROM — including the software, the formats, and the many different drives — we highly recommend that you use one of the Roxio products because they are excellent and you can count on support if you need it. Other products may write your files to the media, but you may find out years later that reading them with currently available software is not possible.

■ After launching Roxio Easy Media Creator, click the folder that contains the files you want to back up. For our example here, we are going to back up the entire folder of photos we took during the Christmas holiday in 2004. That folder also contains a folder that holds all of the files created for

making an online Web photo gallery. Plus, we are going to add a folder that contains contact sheets for quickly viewing the images on the disk. After clicking the folder named "christmas2004," click the green down-arrow in the middle of the window to add the folder to the list of files that are to be burned to a disc. Notice that we have not yet said if the disc is to be a CD- or DVD-ROM because, up until now, we did not know how much storage space is required. In Figure 5.3, you can see the Easy Media Creator window. Notice the blue bar at the bottom of the window. It shows that it would take almost three 700MB CD-ROMs to back up these files. This is one of the strengths of Easy Media Creator. It allows you to "span volumes" in case you choose to perform a backup that requires more than one disc.

■ Instead of using three CD-ROMs, click the Disc Size box and select 4.7GB. You can now see that the files use less than half of a 4.7GB DVD-ROM. Next, insert a new DVD-ROM into the drive. Type in **Christmas2004** in the **Disc Name** box.

5.3

■ To add the folder containing the contact sheets, click the **ContactSheets** folder and then, once more, click the green down-arrow to add that folder to the list of files to burn. Both folders should now show in the lower file box.

■ Click the **Burn** icon to get a dialog box that allows you to specify the record method and options, as well as write speed. Click **Burn** to start the burn process.

■ If you want to print a label for the DVD-ROM, click **Start Label Creator** and follow the steps to make a perfect label suitable for a valuable family photo archive disc. If you decide to use labels, use care when applying them to a disc so that they are accurately centered to avoid possible problems that an off-centered label can cause with a high-speed reader.

That is all it takes to make a DVD-ROM archive disc featuring contact sheets and the photo collection.

STEP 5B: SET UP AND PERFORM THE BACKUP PROCESS TO A HARD DRIVE

If you want to back up files to a hard drive, you have several more choices. You can use Windows XP Explorer, or the Windows XP backup utility, or you can use any backup software that may have come bundled with your external disk drive.

IF YOU USE WINDOWS XP EXPLORER

■ To back up a folder to a hard drive using Windows XP Explorer, you simply right-click the folder you want to back up and select **Copy** from the pop-up menu. Then, right-click the destination drive (or folder) and choose **Paste** from the pop-up menu. You then are presented with a dialog box that gives you an estimated time until the backup is complete.

When using Explorer, if you want to back up many folders that are at the same level, you may want to drag and drop all of the folders into a single temporary folder on the source drive. You can then easily Copy and Paste a single folder onto the backup drive. After you confirm that all folders and image files have been copied, you can drag and drop the folders back to their original place on the source drive. If you do several Copy and Paste actions at the same time, the backup process can take considerably longer as the drive heads will be jumping around far more than if they were performing one action at a time.

IF BACKUP SOFTWARE CAME WITH YOUR EXTERNAL HARD DRIVE

Many external hard drive vendors provide a "lite" version (software with a subset of features found in the full version) of backup software with their drives. One excellent product is Dantz Retrospect Express (`www.dantz.com`). If your drive came with Retrospect Express, or a similar product, it is worth your time to learn how to set it up and use it on a regular basis.

Some external drives, such as those made by Maxtor (`www.maxtor.com`) and Seagate (`www.seagate.com`), have a button on the front of the drive, as shown in Figure 5.4. When this button is pressed, it initiates a backup process that you specify using the backup software that comes with the drive. The button makes it easy to perform routine backups.

5.4

IF YOU WANT TO USE THE WINDOWS XP BACKUP UTILITY

Windows XP comes with a useful backup utility that you can run in Wizard mode (to set up a backup or do a restore, you simply have to answer questions) or from the dialog box shown in Figure 5.5. You can launch the utility by clicking **Start ➢ All Programs ➢ Accessories ➢ System Tools ➢ Backup**. After you have chosen what is to be backed up and where it is to be stored, you can even set up a schedule for the backups to be done automatically. A good strategy, depending on how often you add photos to your hard drive, is to have the backup occur late at night when you are not likely to be on the computer. The Windows XP Backup Utility is a reasonably flexible utility that can make your archiving process painless.

STEP 6: PROTECT AND STORE BACKUP MEDIA

After you make a backup copy of your photo collection, you should put any media or hardware devices in a place as far away from your computer as is possible. Keeping your backup collection away from your computer decreases the chance that you will lose the original and backup copies if your computer is stolen or it suffers damage from a storm, fire, or other undesirable event.

One of the disadvantages of adding a second or third internal disk drive for backup purposes is that your originals and their backup copies are all in the same computer housing. This provides protection from the loss of a hard drive, but leaves you vulnerable in the event that your computer is stolen or damaged in some way that renders all the drives inaccessible.

You have now reached the end of Chapter 1 — an important chapter that makes it easier for you to complete the rest of the projects in this book. In the next chapter, you read about six exciting image-editing projects.

TIP

As soon as you download digital photos to a hard drive on your computer, you are vulnerable to losing those photos until they are backed up. Unless you are an incredibly compulsive photographer and you always organize and back up photos immediately after you download them, you should make a temporary copy on a second drive. A good approach to take is to download all image folders and files to a folder named something similar to "ToFile." After you download the images, you should, without delay, copy the "ToFile" folder to another drive to protect your new photos. Later, when you have time to organize the photos and back them up properly, you can delete the "temporary" sets of files in the "ToFile" folders. This strategy keeps you abiding by the First Rule of Archiving: *Always* have two or more copies of every valuable digital photo.

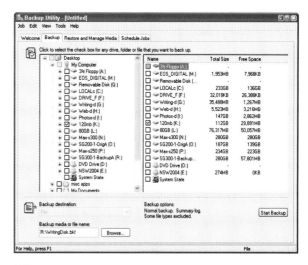

5.5

2

DIGITAL PHOTO
EDITING PROJECTS

When you take digital photos, there are so very, very many things that you can do with them. In this chapter, you complete six digital-photo editing projects that show you the vast possibilities that are within your reach when using an image editor, such as Adobe Photoshop Elements. Making the best possible photo for selling something on eBay is the topic of Project 6. In Project 7, you learn how to transform an ordinary photo into a wonderful print using a graduated color effect. Project 8 shows you how to digitally hand-tint a photo. Get out some of your own digital photos and make your own 20" x 30" photo poster by following the steps in Project 9. If you want to have copies made of a traditional paper-based scrapbook, Project 10 shows you how to make wonderful printed copies that rival the original album pages. Project 11 shows how to make digital mats and frames to make your photos look as good as they can.

DUKE GARDENS WATER LILIE

MAKE A PERFECT PHOTO FOR eBAY

6.1

6.2

A well-edited photo can sell your merchandise for more money than a poorly-edited photo.

When you want to sell something online at an online auction site, such as eBay, you can dramatically increase the chance of success of your sale and the amount you get by displaying high-quality photos. The photos need to be well lit, properly exposed, and edited so that they show sufficient detail to let prospective buyers feel comfortable that they are buying a good item. While many lighting equipment solutions, ranging in cost from inexpensive to expensive, are available for creating photos for online auctions, you can get excellent results by shooting in good available light and by performing a few editing steps with an image editor, such as Adobe Photoshop Elements.

Some of the best light for shooting objects for eBay is outdoor light on a slightly overcast day. Because the entire sky works like one large soft light box, it is easy to shoot without getting lots of unwanted shadows and overly bright highlights. If you need a small amount of light to bring out some detail or to light areas that are in shadow, try using an on-camera flash if your camera has one. In this project, you learn how to edit the photo shown in Figure 6.1 to look like the photo shown in Figure 6.2.

STEP 1: OPEN FILE

■ You can download **camera-before.jpg** by entering `www.reallyusefulpage.com/` `50fastpp/camera-before.jpg` in the address box of Internet Explorer. After the photo is displayed in the Web browser, right-click on the display to get a pop-up menu; choose **Save Picture As** to display the Save Picture dialog box. On a Mac press **Ctrl+Option** and click to get a pop-up menu; select **Download Image to Disk** to get the Save dialog box where you can choose a folder to save the image. Choose a temporary folder and click **Save** to save the file to your chosen folder. Remember the name of the folder. Close Internet Explorer.

■ Using Photoshop Elements 3.0, choose **File ➢ Open** (**Ctrl+O/Command+O**) to display the Open dialog box. After double-clicking the folder you just used to save **camera-before.jpg,** select it and then click **Open.**

STEP 2: DETERMINE EDITING STEPS

Before you make any edits, first decide what needs to be done. The background should be mostly white with a few shadows to give the image some dimension. The camera body needs to be a little lighter to show more detail. The image needs to be cropped and sized to meet the eBay picture size requirements, and it needs some sharpening for display as a Web image. The image currently looks to have a cool (or blue) tone, and I prefer to warm it up by making the subtle light tone warmer (or more toward the red color range) simply because I prefer a warm-toned image.

STEP 3: CROP IMAGE

■ Because the only use of this photo is for display on a Web page, crop it to make it a smaller file, and show a larger picture of the camera and less background. Because eBay allows images up to 400 x 300 pixels and supersize images up to 800 x 600 pixels, first crop the image to be 800 x 600 pixels. After you edit the image, you can duplicate it and reduce the copy to get a 400 x 300 pixel image, too.

■ Choose the **Crop** tool (**C**) in the Toolbox. Type **800 px** in the **Width** box and **600 px** in the **Height** box. These settings give the image the desired proportions of 800 x 600. Type **72** in the **Resolution** box because that is the value to use for computer screen-displayed images. The Options bar should now look like the one shown in Figure 6.3.

■ To crop tightly around the image, click once just to the upper-left of the camera and drag the selection marquee down toward the right to select an area similar to the one shown in Figure 6.4. To center the selection marquee on the camera body, click inside the selection marquee and drag it to where you want it. You can also press the arrow keys to move the selection marquee one pixel at a time. Press **Enter/Return** to commit the selection. The image is now 800 x 600 pixels.

6.3

TIP

Each online auction site has specific size requirements for images. For example, at the time of this writing, eBay allows images up to 400 x 300 pixels. For an additional cost, it also allows images up to 800 x 600 pixels. These super-sized pictures cost $0.75 extra. You can also purchase a Picture Pack, which allows you to have up to six pictures for $1.00, or for $1.50 you can have between seven and 12 pictures. Before editing your images, check the Web page of the online auction site to learn what size your images should be.

STEP 4: ADJUST TONAL RANGE AND MAKE BACKGROUND WHITE

■ Choose **Enhance ➢ Adjust Lighting ➢ Levels** (**Ctrl+L/Command+L**) to get the Levels dialog box. Click the **Shadow Slider** (the black triangle near the bottom-left of the histogram, *not* the black triangle below the **Output Levels** spectrum) and drag it toward the right to about **13** to increase contrast and make the black camera body black.
■ Click the **highlight slider** (the white triangle near the bottom-right of the histogram) and drag it toward the left to about **200** to make the background near white and to further increase contrast.
■ Click the **midtone slider** and drag it toward the left a small amount to **1.06** to lighten the midtones and reveal more detail in the camera body. The Levels dialog box should now look like the one shown in Figure 6.5.

6.4

6.5

- Click **OK** to apply the settings. The image now looks much, much better. The blue tone has even been improved to the point where you don't need to bother making any additional color changes.

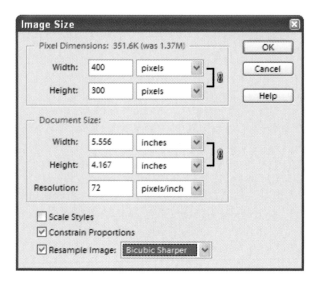

6.6

STEP 5: DUPLICATE AND SIZE NEW IMAGE

- All that is left to do to this image is to sharpen it; but, you should only sharpen an image when it is at its final size and you have performed just about all the other edit steps that are needed. Because a 400 x 300 pixel image is also needed, the image should first be duplicated before it is sharpened. Choose **File ➢ Duplicate** to get the **Duplicate Image** dialog box; click **OK** to get a duplicate image.
- Choose **Image ➢ Resize ➢ Image Size** to get the Image Size dialog box. Make sure that **Constrain Proportions** and **Resample Image** are checked. In the **Pixel Dimensions** area, click in the **Width** box and type **400** and **Height** automatically changes to **300** — just what you want. Click in the **Resample Image** box and choose **Bicubic Sharper**, which is the best interpolation method for down-sampling an image for use on a Web page. Your Image Size dialog box should now look like the one shown in Figure 6.6. Click **OK** to resize the image.

STEP 6: SHARPEN BOTH IMAGES

- Now, sharpen the image. Choose **View ➢ Actual Pixels** (**Alt+Ctrl+0/Option+Command+0**) to show the image at 100 percent as it is best to view an image at full size when determining the best sharpening settings.

- Choose **Filter ➢ Sharpen ➢ Unsharp Mask** to get the Unsharp Mask dialog box. When sharpening low-resolution Web images, it is typically best to use a high **Amount** value and a very low **Radius** value. Set **Radius** to **.3** pixels and **Amount** to **400%**. You can see the effects in both the preview window and in the image in the workspace. Now, click the **Amount** slider and slide it toward the left until you like the sharpening effect. I thought **250%** was just about right. To view the "before" and "after" effects, click **Preview** in the Unsharp Mask dialog box. Your Unsharp Mask dialog box should now look like the one in Figure 6.7. Click **OK** to apply the settings.
- Now do the same thing with the 800 x 600 pixel image. After clicking the **camera-before.jpg** image to make it the active image, make sure to view the image at **100%** zoom. Setting **Amount** to **350%** and **Radius** to **0.3 pixels** in the **Unsharp Mask** dialog box looks just about right.

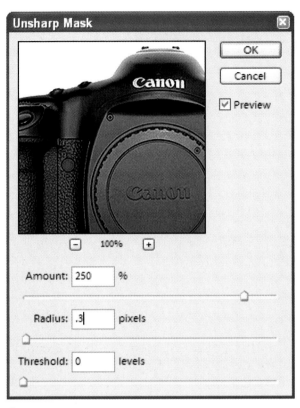

6.7

STEP 7: SAVE IMAGES

■ Your editing is now complete and you are ready to save the images for use on a Web page. While you may think you should use the **Save As** feature, you are close, but not quite correct. You get a better image for use on a Web page by using **Save for Web**. **Save for Web** has far more setting choices than the **Save As** dialog box and it has been purposefully designed to optimize images for display on Web pages. Choose **File ➤ Save for Web** (**Alt**+**Shift**+**Ctrl**+**S** /**Option**+**Shift**+ **Command**+**S**) to get the Save for Web dialog box.

■ Click in the left preview box and drag the camera until you can see the EOS-1 logo in the 800 x 600 pixel image. This is a good area to view while choosing image compression settings. The goal is to get the smallest image size you can while not allowing any visible image degradation due to excessive image compression. In the **Preset** box, choose **JPEG Medium**. Just beneath the right image, you see that the image is around 52K with these settings. Now carefully look for differences between this image and the one you get when you select **JPEG Low** in the **Preset** box. The image is now approximately 32K. As there is not that much difference in size, and because I don't like the small amount of loss of texture of the rubberized part of the camera body, change the **Preset** back to **JPEG Medium**. If you want to have even finer control over image quality and image size, you can click in the **Quality** box and choose a numerical setting **0** to **100** instead of just the five choices you have in the preset box (for example, **Low**, **Medium**). Your Save for Web dialog box should now look similar to the one shown in Figure 6.8.

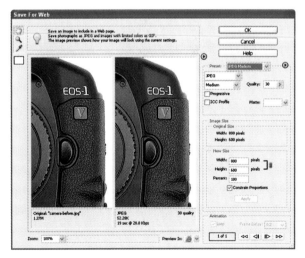

6.8

■ Click **OK** to apply the settings. You now have a wonderful 800 x 600 pixel image to use to get top dollar at an online auction site.

■ Do the same thing to the 400 x 300 pixel image. My choice of compression quality setting for this image is **JPEG High**. At this higher setting, the image still measures fewer than 32K because it is a smaller image.

ADDING A GRADUATED COLOR EFFECT

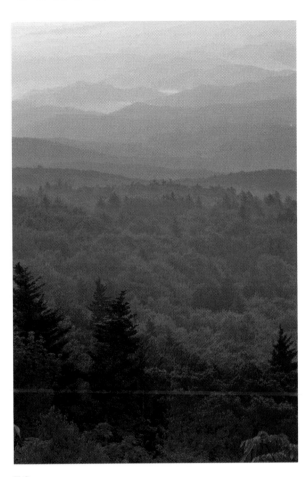

7.1 **7.2**

Apply a digital, color, graduated neutral density filter using Adobe Photoshop Elements 3.0 to transform your images into works of art.

The photo in Figure 7.1 was taken in late afternoon at Grandfather Mountain in North Carolina. The distant hills were covered in a fog that transformed them into subtle, soft, monotone hills instead of the green rolling hills that they really were. The pre-shoot vision for this scene was to enhance the contrast of the distant hills and to make the green foreground trees transition into a green-blue area in the middle of the image and then into a soft blue mountain range and sky, as shown in Figure 7.2.

Many "purist" photographers are quick to say, "Hey, you can't do that! It is not photography and not natural." We, however, are always quick to point out how some of the most respected and talented photographers have, for years, tinted their most sought-after photographs with colored filters that they attached to their lenses. Visit www.singh-ray.com and check out all the photo filters that are available and who uses them. When you also consider that these same photographers choose color film, such as the remarkable Fuji Velvia, to get dramatic and vivid colors, it is hard to explain why such a film-based approach may be "right" and this digital approach is "wrong." In any case, we happily color our images as we choose because we like them that way, we enjoy making them, and many people enjoy looking at them. We hope you enjoy this technique and create prints that you are proud to have created — after all, digital photography is a new art form and it allows interpretative effects like this one any time you'd like to apply them.

STEP 1: OPEN FILE

■ You can download **gfmtn-before.jpg** by entering www.reallyusefulpage.com/50fastpp/gfmtn-before.jpg in the address box of Internet Explorer. After the photo is displayed in the Web browser, right-click on the image to get a pop-up menu; choose **Save Picture As** to get the Save Picture dialog box. On a Mac press **Control+Option** and click to get a pop-up menu; select **Download Image to Disk** to get the Save dialog box. Choose a temporary folder and click **Save** to save the file to your chosen folder. Remember the name of the folder. Close Internet Explorer.

■ Choose **File ➢ Open** (**Ctrl+O/Command+O**) to display the Open dialog box. After double-clicking the folder you just used to save **gfmtn-before.jpg**, select it and then click **Open**.

STEP 2: DARKEN DISTANT HILLS AND SKY

■ To show more detail in the distant hills and sky, choose **Enhance ➢ Adjust Lighting ➢ Shadow/Highlights** to get the Shadow/Highlights dialog box shown in Figure 7.3. Click the **Darken Highlights** slider and move it toward the right to **16%**. Midtone contrast can be increased a slight amount by sliding the **Midtone Contrast** slider to the right to **+2**. Click **OK** to apply the settings.

STEP 3: CREATE A COLOR GRADATION LAYER

■ Choose **Layer ➢ New ➢ Layer** (**Shift+Ctrl+N/Shift+Command+N**) to get the New Layer dialog box; click **OK**.

■ Click the **Gradient** tool (**G**) in the Toolbox.

■ Click in the **Gradient** box in the **Options** bar to get the **Gradient** palette shown in Figure 7.4. If the Gradient palette does not look like this one, click the **More** button in the upper-right corner of the Gradient palette and choose **Reset Gradients** in the **Presets** box. Click the **More** button once more and choose **Small Thumbnail**. Click the **Violet, Orange** gradient. Click **OK**.

7·3

7.4

the line is slightly sloped to the right to make the gradient match the landscape. The gradient should look similar to the one shown in Figure 7.6.

7.6

■ Click the **Linear Gradient** icon in the **Options** bar and make sure that **Mode** is set to **Normal** and **Opacity** to **100%**. **Reverse** should not be checked. **Dither** should be checked. The Options bar should now look like the one shown in Figure 7.5.

■ Choose **View** ➤ **Fit on Screen** (**Ctrl+0/Command+0**) so that it is possible to control the placement of the gradient. Click just below the image and hold and drag the cursor to just above the top and slightly to the right so that

7.5

■ Click in the **Blend Mode** box in the **Layers** palette and choose **Color**. The Layers palette should now look like the one shown in Figure 7.7. You should now be able to see the gradient on the image.

STEP 4: ADJUST COLOR

■ The image, as it is now, is a bit on the colorful side. To modify the colors, create an adjustment layer that allows you to go back and change your settings if needed later in the edit process. Choose **Layer ➢ New Adjustment Layer ➢ Hue/Saturation** to get the New Layer dialog box; click **OK** to get the Hue/Saturation dialog box shown in Figure 7.8. Set **Hue** to **–155**, **Saturation** to **–50**, and **Lightness** to **–8**. Click **OK** to apply the settings.

■ Now, bump up the contrast of the entire image a slight amount using a **Levels** adjustment layer. Choose **Layer ➢ New Adjustment Layer ➢ Levels** to get the New Layer dialog box; click **OK** to get the Levels dialog box shown in Figure 7.9. Set **Input Levels** to **9, 0.91,** and **225**. Notice that you increased the contrast some, but not so much as to cause the sky to become overly bright and the distant hills to have too much contrast. Click **OK** to apply the settings to complete the image.

Because you used adjustment layers for both Hue/Saturation and Levels, you can go back at any time and click them and modify your earlier settings without having the image suffer from any unwanted image degradation, which can occur with excessive image editing. Figure 7.10 shows the current Layers palette. Ah, the advantage of adjustment layers — use them often. After you have the settings you want, you

7.7

7.8

7.9

should choose **Layer ➢ Flatten Image** to flatten the layers to reduce the file size before saving the image.

This is a technique that can be used on many photos to create excellent images that make wonderful prints. Figure 7.11 shows an image of Merchant Mill Pond in North Carolina in fog after this same technique was applied. The entire original image was monotone gray.

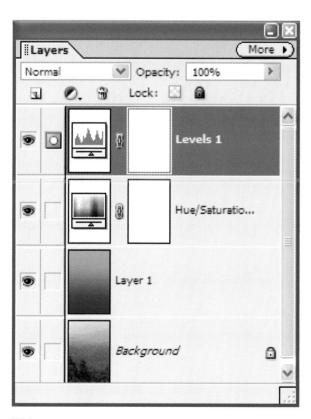

7.10

7.11

HAND-COLOR PHOTOS WITH DIGITAL TINTS

8.1

8.2

Digitally tinting a black-and-white photograph gives you far more options and control than you ever had when tinting a black-and-white print by hand using photographic paints.

WHAT YOU'LL NEED

Adobe Photoshop Elements 3.0 (PC: $100, $80 upgrade; Mac: $90), image file from `www.reallyusefulpage.com/50fastpp/crabshack-before.jpg`

S ince the early days in the history of photography, photographers have added color to monochrome images by hand-coloring them with special photo colors. Companies such as Marshall, Eastman Kodak, Peerless, and Roehrig-Bielenberg have, over the years, offered a variety of products in varying colors and strengths. Some of these colors are still available as oils and pencils. You can create similar effects without using such photo colors by digitally painting with Adobe Photoshop Elements 3.0. The great news here is that you don't have to worry about having all the equipment and facilities it takes to paint; plus, you can avoid the smell. Best yet — you can make copies after you paint a digital image. In this project, you learn how easy it is to digitally hand-color an image. You also learn a couple of other tricks that can make your prints look wonderful.

As for some inspiration, I suggest you check out the work of one of the most well known creators of hand-colored photographs. Jill Enfield's work has not only appeared in galleries and permanent collections all over the world, but she is also a wonderful writer and educator who has written several must-have photography books. You can learn more about Jill Enfield and her work at `www.jillenfield.com`.

STEP 1: OPEN IMAGE

■ You can download **crabshack-before.jpg** by entering `www.reallyusefulpage.com/50fastpp/crabshack-before.jpg` in the address box of Internet Explorer. After the photo is displayed in the Web browser, right-click on the image to get a pop-up menu; choose **Save Picture As** to get the Save Picture dialog box. If using a Mac, press **Ctrl+Option** and click to display a pop-up menu; select **Download Image to Disk** to open the Save dialog box. Choose a temporary folder and click **Save** to save the file to your chosen folder. Remember the name of the folder. Close Internet Explorer.

■ Choose **File ➤ Open** (**Ctrl+O/Command+O**) to display the **Open** dialog box. After selecting the folder where you just downloaded the **crabshack-before.jpg** file, click the file to select it and then click **Open**.

STEP 2: LIGHTEN IMAGE

The first step you need to take is to lighten the image so that the colors can be seen on the black-and-white image.

■ Choose **Enhance ➤ Adjust Lighting ➤ Levels** (**Ctrl+L/Command+L**) to get the Layers palette. To increase the brightness of the highlight areas, click the **Highlight slider** (the white triangle icon just below and to the right of the histogram) and

slide it toward the left to the end of the histogram. To lighten the midtones, click the **midtone** slider and slide it toward the left a small amount. Input **Levels** in the **Levels** palette should now be **0**, **1.17** and **233**, as shown in Figure 8.3. Click **OK** to apply the settings.

STEP 3: CREATE A COLOR PALETTE

To keep the photo simple, you now create a color palette to make choosing and controlling colors easy. Choose about six to eight colors.

■ Create a new document by choosing **File ➤ New ➤ Blank File** (**Ctrl+N on the PC/ Command+N on the Mac**) to get the New dialog box. Type **Colors** in the **Name** box. Click in the **Preset** box and select **2 x 3**; click **OK**.

■ Click the crab shack image to make it active and choose **View ➤ Actual Pixels** (**Alt+Ctrl+0/ Option+Command+0**). Viewing the image at **100%** will make it easier to pick good colors.

■ Click the **Eyedropper** tool (**I**) in the **Toolbox**. In the Options bar, click in the **Sample Size** box and select **5 by 5 Average**. This, too, makes it easy to pick good colors. Now, click the red door and move the

8.3

cursor around while you watch the color in the **Foreground** box at the bottom of the **Toolbox**. When you get a nice, rich red color, click the **Colors** document to make it active. Press **B** to change to the **Brush** tool and paint a small area with the red color.

■ Click the crab shack image again, press **I** (to get the **Eyedropper** tool), and click to select another color; then, click the **Colors** document, press **B** (to get the Brush tool), and paint a small area. Repeat this until you have all the colors you want to use. When you have eight to ten colors, your **Colors** document looks similar to the one shown in Figure 8.4.

Those of you who have used the Color Swatches palette may be wondering why we have you painting colors on a new document instead of adding the colors to a Color Swatch. If you are one of those wondering why, we commend you — it is a good thought to ponder. The colors were put in a new document because you can make some simple global changes to them, which you see in Step 7.

STEP 4: DUPLICATE BACKGROUND AND REMOVE COLOR

■ Click the **crabshack-before.jpg** document window to make it the active document. Choose **Layer ➢ New ➢ Layer Via Copy** (**Ctrl+J/Command+J**). You should now see **Layer 1** in the Layers palette, as shown in Figure 8.5.

■ Choose **Enhance ➢ Adjust Color ➢ Remove Color** (**Shift+Ctrl+U/Shift+Command+U**) to get a black-and-white image. You have several other ways to convert a color image to a black-and-white image, but this is the simplest way and it suits our purposes for now.

8.4

8.5

STEP 5: ADD TINT TO ENTIRE IMAGE

While hand-tinting black-and-white photographs is common, many tint colors work better with a slightly colored monochromatic image than a black-and-white image. In our opinion, the colors often blend in more and seem to "fit better" with the rest of the image. Try this technique and see what you think.

■ Next, you add some color to the image. Choose **Filter ➢ Adjustments ➢ Photo Filter** to get the wonderful new-to-Photoshop Elements 3.0 Photo Filter dialog box, shown in Figure 8.6. Click in the **Filter** box and choose **Deep Yellow**. Make sure to uncheck **Preserve Luminosity**. Click next to **Color** and then slide the **Density** slider up to about **35%** to get a nice yellow-toned image. Click **OK** to apply the settings.

8.6

STEP 6: LIGHTEN SHADOWS

■ The image is just about ready for tinting with the exception of the dark shadow areas where some of the color that needs to be applied are still too dark to allow much color to shine through. So, lighten the shadows a small amount. Choose **Enhance ➢ Adjust Lighting ➢ Shadow/Highlights** to get the Shadow/Highlights dialog box shown in Figure 8.7. Click the **Lighten Shadows** slider and drag it to about **15%**. Click the **Darken Highlights** slider and slide it to about **+4%**. Click **OK** to apply the settings.

STEP 7: MAKE GLOBAL CHANGES TO COLORS

Now you can do some really, really cool and creative coloring. In Step 3, we said there would be good

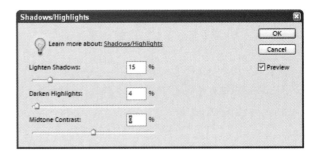

8.7

DODGING AND BURNING WITH PEN TABLETS

When doing detailed painting, or dodging and burning, using a pen tablet is best. Some of the better pen tablets are made by Wacom (www.wacom.com). Wacom offers several models in many different sizes starting at around $200. A 6" x 8" Intuos3 tablet is perfect for digital photographers with limited desk space. One additional benefit of a pen tablet over a mouse is that many pen tablets, such as the Intuos3 tablets, are pressure-sensitive, which gives you far more

reason to take the time to create a separate Colors document instead of using Color Swatches, or even more simply just using the colors in the original document. As this tinting technique is about using your creative sense of color, your Colors document will be of great help.

■ To make global changes to the Colors document, click it to make it the active document. Choose **Enhance ➢ Adjust Color ➢ Adjust Hue/Saturation (Ctrl+U/Command+U)** to get the Hue/Saturation dialog box. To suit my color preference for the crab shack image, you need to both lighten the colors and to increase the saturation a small amount. Set **Hue** to **+3**, **Saturation** to **+9**, and **Lightness** to **+20**, as is shown in Figure 8.8. Click **OK** to apply the color changes. If you are thinking that these colors are too light, just trust me. Those new to the hand-tinting process often use too-bright colors. Traditional hand tinting is usually done with subtle colors that blend into the photograph.

STEP 8: PAINT EACH COLOR ON ITS OWN LAYER

Now comes the fun part. You have a wonderful color palette. You have a wonderful toned image of the famous Maine crab shack. And, now you get to paint in the color. The process of adding color to the image is quite easy. Take a little extra effort and go for a first-class technique where you paint each color on its own layer, rather than painting all the colors on the same layer, or, even worse, over the tinted image.

The steps you should take for each color follow.

■ Make sure you first click the crab shack image to make it the active image. Create a new layer by choosing **Layer ➢ New Layer (Shift+Ctrl+N/ Shift+Command+N)**. Type the color name in the **Name** box. Click in the **Mode** box and choose **Color**; click **OK**. If you forget to choose **Color** as the **Mode**, click in the **Blend** mode box in the

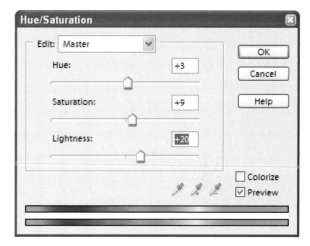

8.8

control over your work. A pen tablet really makes it fun to paint, and to dodge and burn digitally, and your work will look much better because of the extra control you have over the painting. If you use a pen tablet, make sure to set up the Brush Table Options by clicking the Tablet Options box in the Options bar when the Brush tool is selected. You get the dialog box shown in Figure 1.

Layers palette and choose **Color,** as shown in Figure 8.9. It is very important that you not miss this step. You must choose the **Color** mode!

■ Click the **Eyedropper** tool (**I**) and click the color you want to use in the Colors document.

■ Click the crab shack image to make it the active window.

■ Click the **Brush** tool (**B**) and choose an appropriate size brush from the **Brush** palette that is accessed from the **Options** bar. Make sure that **Mode** is set to **Normal** and **Opacity** is set to **100%.**

■ When painting, it is best to work at **100%** view mode by choosing **View ➢ Actual Pixels** (**Alt+Ctrl+0/Option+Command+0**) and to have an uncluttered screen. Paint in the color. Anytime you want to remove some of the paint, click the **Eraser** tool (**E**) and erase the unwanted paint. Continue painting until you have used all the

colors you selected and you have finished painting all that you want to paint. When painting, relax and your results will look better. You don't have to paint every item in your painting the same color as it was in the original photograph. Paint to make your work look good and match your style.

STEP 9: MAKE FINAL COLOR ADJUSTMENTS

After you paint all the color you want in the image, you can go back and fine-tune each color. That is the reason why you added a new layer for each color. For example, assume that the grass is a bit too green for the image.

■ Click the green layer in the **Layers** palette to make it the active layer.

■ Choose **Layer ➢ New Adjustment Layer ➢ Hue/Saturation** to get the New Layer dialog box shown in Figure 8.10. Make sure to click in the box next to **Group With Previous Layer.** This feature limits the color adjustments you make to just the green layer. Click **OK** to apply the adjustments.

■ Click any other color layer that you want to adjust and add a new adjustment layer. Using adjustment layers allows you to go back and fine-tune any color until the image is as you want it. When all colors are as you want them, flatten the image by choosing **Layer ➢ Flatten Image.**

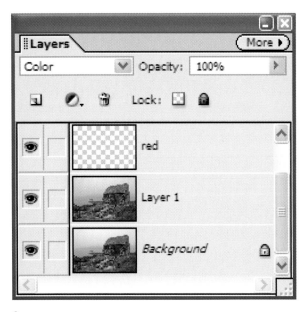

8.9

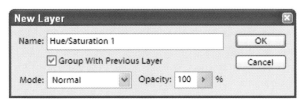

8.10

Figure 8.11 shows the final Layers palette with a Hue/Saturation adjustment layer for both the green and red colors. Notice that there is also a copy of the original image at the bottom of the palette. This background image is useful because it enables you to see the original colors. Simply click the **Layer Visibility** icon to the left of each of the layers to reveal the original image. Click the icons again to once again view the painted image.

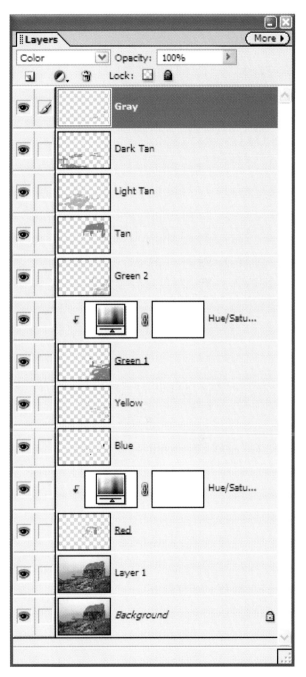

8.11

MAKE YOUR OWN
20" x 30" PHOTO POSTER

9.1

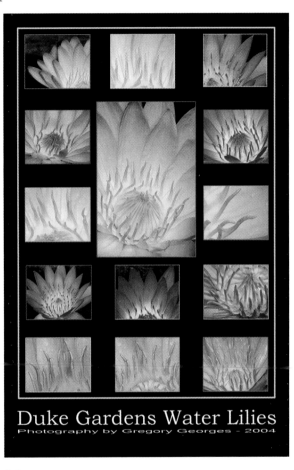

Duke Gardens Water Lilies
Photography by Gregory Georges - 2004

9.2

Choose some of your favorite photographs and make your own 20" x 30" poster that you can get printed for under $25.

WHAT YOU'LL NEED

Adobe Photoshop Elements ($80) and 14 of your own digital photos

One of the best bargains in digital photography is a 20" x 30" poster print. Making a large poster to hang on your wall is an excellent and inexpensive way to fill up empty wall space. Online photo-printing services, such as Kodak EasyShare (www.kodakgallery.com) and Shutterfly (www.shutterfly.com) offer 20" x 30" prints for under $25, as you learn in Project 24. They are mailed to you in a protective mailing

63

tube a few days after you upload the digital file to their Web site. Equally inexpensive 20" x 30" frames are available at the large discount stores, such as Costco, Wal-Mart, and Target.

In this technique, you learn how to take your own photos and use them to make a 20" x 30" poster similar to the one shown in Figure 9.2. As you use 14 photographs to make the poster, you find that you have plenty of image resolution to make a high-quality 20" x 30" print you'll be proud to hang on your wall.

STEP 1: CREATE NEW DOCUMENT

Many of the consumer-oriented, online printing service Web sites recommend that you have an image that is at least three megapixels or larger to make a 20" x 30" print. However, 300PPI (for Fuji Frontier printers) or 320PPI (for Noritsu printers) is the recommended dpi for the printers they typically use. Because you are creating a new document from scratch using lots of smaller images plus text, you should create a document with 300PPI to get the best print possible. If you find that your computer is too slow to process a file this large, or you don't have sufficient RAM or hard drive space, you can create a

document with considerably less than 300PPI and still get a decent print.

For the rest of this project, we refer to lily photographs that we used to create the water lily poster shown in Figure 9.2; however, the photos you choose to use from your own collection can feature subjects of your choice.

■ To create a 20" x 30" document at 300PPI, choose **File ➢ New ➢ Blank File** (**Ctrl+N/ Command+N**) to get the New dialog box shown in Figure 9.3. Type **Lily Poster** in the **Name** box. Type **20** in the **Width** box and make sure increment is set to **inches**. Type **30** in the **Height** box. Type **300** in the **Resolution** box and make sure that **increment** is set to **pixels/inch**. Click in the **Background Contents** box and choose **White**. Set **Color Mode** to **RGB Color**. Notice that you are creating a 154.5MB image that is 6,000 x 9,000 pixels! Click **OK** to create the document.

■ Choose **Edit ➢ Fill Layer** to get the Fill Layer dialog box shown in Figure 9.4. Click in the **Use** box and choose **Black**; click **OK**.

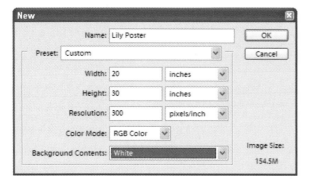

9.3

9.4

STEP 2: SET UP GRID AND RULERS

■ If the rulers are not currently displayed, choose **View** ➢ **Rulers** (**Ctrl+R/Command+R**) to turn them on.

■ If a grid is not currently displayed, choose **View** ➢ **Grid**. Choose **View** ➢ **Snap to Grid** if there is not already a check mark next to **Snap to Grid**.

■ Choose **Edit** ➢ **Preferences** ➢ **Units & Rulers** to get the Preferences dialog box. Click in the **Rulers** box and choose **inches**.

■ Click **Next** to get the Preferences dialog box shown in Figure 9.5. Click in the **Color** box and choose **Light Gray**. Click in the **Style** box and choose **Dots**. Click in the **Gridline every** box and type **1** and set **increments** to **inches**. Click in the **Subdivisions** box and choose **4**. Click **OK** to apply the settings. Your new document should now look similar to the one shown in Figure 9.6. Notice you have a ¼" grid of white dots against the black background to help you place text, lines, and images. With the snap to grid feature turned on, the selection marquee and images you are placing snap to the grid.

9.5

STEP 3: PLACE ONE IMAGE

You should choose all of the digital photos you want to use in this project and put them in a folder for easy access. Each of the photos should already be edited, but not cropped, sized, or sharpened. To make it easy to access your selected photos, you should put them in a single folder. We assume that you named the folder **\poster-photos**.

9.6

Before adding a decorative border line that can be helpful for placing images, first place one image to use as a source for picking border line colors.

■ Choose **File ➣ Open** (**Ctrl+O/Command+O**) to display the Open dialog box. Double-click the **\poster-photos** folder to open it and then click one of the images to select it. Click **Open** to open the file.

■ Click the **Move** tool (**V**). Click the image and drag it onto the **Lily Poster** document. Place it in the middle of the image.

■ Click the digital photo image you just put on the poster document and choose **File ➣ Close** (**Ctrl+W /Command+W**) to close the file as it no longer is needed.

STEP 4: ADD OUTSIDE BORDER LINE

■ Click the **Eyedropper** tool (**I**) in the **Toolbox**. Click a part of the image that has a color you want to use as the color for a border line to go around the outside of the poster. As you click and move the cursor around, watch the **Foreground Color** box at the bottom of the Toolbox. Try to select a bright, bold color, which you can use for the border line that encompasses all the images.

■ Click **Background** in the **Layers** palette so that you place the border line on the Background.

■ Click the **Rectangular Marquee** tool (**M**) in the **Toolbox**. Make sure that the **New Selection** icon is checked in the **Options** bar, that **Feather** is set to **0 px**, and **Mode** is set to **Normal**.

■ Choose **Window ➣ Images ➣ Maximize Mode** to maximize the image.

■ Choose the **Zoom Out** or **Zoom In** icon until the **Zoom** size reads **12.5%** in the **Navigator**. At this size you should be able to easily see the grid dots. Click in the **Selection Box** in the **Preview** window in the Navigator and drag it down toward the bottom-right so that you can view the bottom-right corner of the image. The Navigator should now look similar to the one shown in Figure 9.7.

■ The objective now is to place a selection marquee 1" from the top, 1" from the left, 1" from the right, and 4" from the bottom of the poster. This selection is used to add the decorative border line. Using the **Rectangular Marquee** tool (**M**), click the intersection of four grid squares up, and one from the right, as shown in Figure 9.8. Drag the selection up toward the left corner of the image and the image should automatically scroll when your cursor reaches the top of the workspace; release the cursor button after placing the cursor on the grid point that is 1" (four dots or one square) down from the top and in 1" (four dots or one square) from the left.

■ Choose **Edit ➣ Stroke (Outline) Selection** to get the Stroke dialog box shown in Figure 9.9. Type **40 px** in the **Width** box. The color should be the color you picked earlier. Click **Center** and leave **Mode** set to **Normal**. Click **OK** to apply a yellow decorative border to the image. To remove the selection marquee, choose **Select ➣ Deselect** (**Ctrl+D** on a PC/**Command+D** on a Mac).

9.7

STEP 5: PLACE PHOTOS

The design of this poster includes 13 photos that have width-to-height proportions of 10 x 8 and they are 4.5" wide — all at 300PPI. After you select the photos you want to include on your poster, you can either crop and size them all to these same proportions and put them in your temporary \poster-photos folder, or you can put them in the folder as they are and save the cropping and sizing for when the photos are placed on the poster image. Because of the large image you are working on and the fact that you have 16 layers and a background, I suggest that you open, resize, place, and close one image at a time to conserve on memory, disk space, and computer processing.

9.8

9.9

■ Choose **File ➢ Open** (**Ctrl+O/Command+O**) to display the Open dialog box. Double-click the **\poster-photos** folder to open it and then click a file to select it. Click **Open** to open the file. This photo should be placed in the upper-left corner, as shown in Figure 9.2, ½" in from the border you just created.

■ If you have not already resized your images, choose **Image ➢ Resize ➢ Image Size** to get the Image Size dialog box. Click in the **Width** box and type **4.5** and set **increments** to **inches**. Make sure that you set **Resolution** to **300 pixels/inch**! Turn on **Constrain Proportions** and **Resample Image**. Click in the **Resample Image** dialog box and choose **Bicubic Sharper** as it is the best algorithm to use to down-sample a photographic image. The **Image Size** dialog box should now look like the one shown in Figure 9.10. Click **OK** to resize the image.

9.10

■ Click the **Move** tool (**V**) in the **Toolbox**. Click the digital photo image you just loaded and drag it onto the **Lily Poster** image. Carefully position it, as shown in Figure 9.11.

■ You can now click the digital photo image and choose **File** ➢ **Close** (**Ctrl+W/Command+W**) to close the file as it no longer is needed.

■ Repeat this step for each of the remaining photos.

STEP 6: ADD BORDERS

■ Click the **Move** tool (**V**) in the Toolbox. Make sure that there is a check mark next to **Auto Select Layer** and **Show Bounding Box**. These options allow you to pick a layer by simply clicking an image and then the selected image shows a bounding box to confirm that you have selected the image. Click the top photo to make it the active layer.

■ Click the **Eyedropper** tool (**I**) in the Toolbox. Click in the selected image layer to select a contrasting color to use for the border for that photo. The color you select becomes the Foreground Color and you can see it in the Foreground Color box at the bottom of the Toolbox.

■ Click the **Magic Wand** tool (**W**) in the Toolbox. Click just outside the selected photo to select the transparent part of the layer. Choose **Select** ➢ **Inverse** (**Shift+Ctrl+I/Shift+Command+I**) to invert the selection to just the photo. You should now see a selection marquee around the selected photo.

■ Choose **Edit** ➢ **Stroke (Outline) Selection** to get the Stroke dialog box. Type **15 px** in the **Width** box. The Color box should show the color you

selected with the Eyedropper tool. To place the border outside the selection marquee, click **Outside**. **Blending Mode** should be set to **Normal**. The Stroke dialog box should look like the one shown in Figure 9.12. Click **OK** to apply a colored border.

■ Choose **Select** ➢ **Deselect** to remove the selection marquee.

■ You should repeat this step for each of the remaining photos. Take care in choosing the border color to work well with each of the photos. The easy way to repeat this process is to learn the shortcut keys for each action. This makes the process a simple and quick sequence of keystrokes and mouse clicks: **V**, **I**, select color, **W**, **Select** ➢ **Inverse**, **Edit** ➢ **Stroke** — that's it! Choose **Select** ➢ **Deselect** and repeat again for the next photo.

9.11

STEP 7: ADD TEXT

■ Click **Background** in the **Layers** palette to make it the active layer.

■ Click the **Horizontal Type** tool (**T**) in the Toolbox. Click in the **Font Family** box in the Options bar and select a font such as **Bookman Old Style**, or another similar font if you do not have that font. Set the **Font Style** to **Regular**. Click in the **Font Size** box and choose **72 pt**. Click on **Left Align Text**. Click in the **Color** box and choose **White**. The Options bar should now look similar to the one shown in Figure 9.13.

■ Click below the yellow border line and type the heading text: **Duke Gardens Water Lilies**. Click the **Commit Current Edits** icon (the check mark at the far right of the Options bar). Press and hold **Shift** and click one of the selection marquee handles and stretch the text to be as long as the width of the yellow border line. You can click in the text and drag it to position it. You can also press the **Up**, **Down**, **Right**, and **Left Arrow** keys to move the text one pixel at a time.

■ Use the same process for the second line of text only choose a simple **Font** such as **Arial** or **Helvetica** and set **Font Size** to **36 pt**. Using the **Horizontal Type** tool, type in the last line of text. For example, you can choose to type: **Photography by: Gregory Georges – 2004**. After committing the text, click one of the handles (without pressing **Shift** to keep the text proportions the same) on the end of the selection marquee and drag the text out to the same length as the main title text. After some alignment and sizing, your text should look like the text in Figure 9.14.

9.12

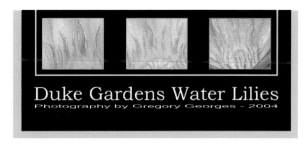

9.14

9.13

■ Provided you are satisfied with the poster, you can now choose **Layer** ➢ **Flatten Image** to dramatically reduce the file size (it is now around 150MB). Your final image should look similar to the image shown in Figure 9.15, only it will feature your photos.

Good poster design is art. Now that you know how to place images on a poster, try a more creative design of your own. The choice of layout, border effects, font design, background color, and texture are all important aspects of a poster. If you produce a nice design, we'd like to see it if you'd like to send it to us with the longest side not more than 800 pixels. You can find out how to contact us in the appendix.

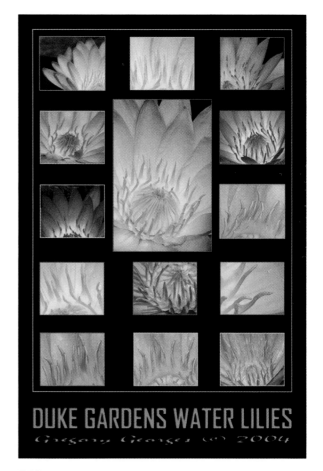

9.15

MAKING COPIES OF A TRADITIONAL SCRAPBOOK ALBUM

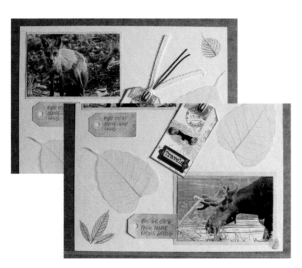

10.1

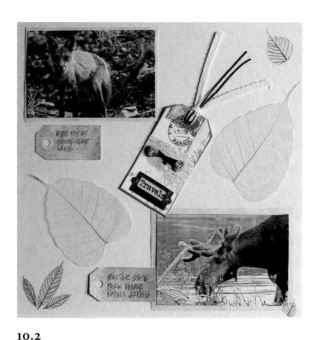

10.2

No doubt about it — traditionally made, hands-on, paper-based scrapbook pages can be wonderful. Because of all the elements you can add, such as buttons, fabrics, tags, clippings, and much more, your pages can feature wonderful photographs and other elements with texture and depth that make them fun to view. The downside to creating traditional paper-based scrapbooks is that it is just about as much work to make each copy of the scrapbook as it was the original. So, when you are making a family scrapbook and you want to give a copy to several family members, your workload may be more than you want. That is, unless you follow the steps in this project!

You can make excellent copies of traditionally made, paper-based scrapbook pages by taking photographs of them with a digital camera, or by scanning each page with a desktop scanner — and then editing the images, and printing them out on archival paper using an inkjet printer. One complicating factor is that you may find that you need more resolution to make a good print than your digital camera offers. Or, if you decide to use a desktop flatbed scanner to get digital images to use to make copies, you may find that the scanning bed is not wide enough to scan an entire page.

In this project, you learn how to use Adobe Photoshop Elements 3.0 to combine two or more images to make one perfect image that you can use to make excellent prints — one that even shows excellent texture and depth!

STEP 1: DETERMINE IMAGE SIZE

The first step in making copies of a paper-based scrapbook is to determine the size of the image that you need. In this example, assume that you want to make 12" x 12" prints, which is the standard scrapbook page size. Also assume that you are using an inkjet printer, which needs at least 240 pixels per inch (ppi). Doing a little math, you learn that you need an image that is 2,880 x 2,880 pixels. That is 12" x 240PPI or 2,880 pixels.

While we have made an assumption about your printer, you should check to see what your printer vendor recommends as the minimum ppi. While many Canon and HP printers recommend a minimum 300PPI, and Epson suggests 240PPI, you can often get excellent prints with less resolution. You may want to experiment if you find that getting the full recommended ppi forces you into taking extra scans or photos of each page to meet that minimum

recommended ppi. Sometimes, the tradeoff in quality is not worth the effort it takes to make the extra scans, or take the extra photos.

STEP 2: SCAN OR TAKE DIGITAL PHOTOS OF YOUR SCRAPBOOK PAGES

You can get the digital images that you need to make printed copies of your traditional paper-based scrapbooks by scanning them with a desktop flatbed scanner, or you can use your digital camera. If you have the choice between a flatbed scanner and a digital camera, you may want to experiment with both to make a decision based upon the amount of time it takes to make the images, and the quality of prints that you get.

If your scrapbook pages are 8½" x 11", you likely can scan a full scrapbook page in a single pass. Depending on the megapixel count of your digital camera, you may or may not have enough pixels to get the needed resolution with a single photograph. However, if your scrapbook pages are the standard 12" x 12" pages, you may find that your pages don't fit on the scanner bed and that you need two or more photos to get the resolution needed to make a 12" x 12" print. Not to worry! Adobe Photoshop Elements 3.0 has a Photomerge feature that allows you to take two or more digital photos or two or more scans of a scrapbook page and then merge them into a single image.

The images we used for this project were taken with an 8-megapixel digital camera. Even with an 8-megapixel camera, it took two shots to get enough pixels to make the required 2,880 x 2,880 pixel image required. A tungsten work light purchased at a hardware store was used to add the shadows and overall light.

If you use a digital camera to take photos of your paper-based scrapbook pages, here are a few tips to help you get better images:

- Make sure you tack or tape the scrapbook pages to a flat, rigid surface so that they remain flat when you take photographs.
- Shoot with the slowest ISO setting your camera offers to minimize *digital noise* (a usually undesirable grain effect created by a digital camera's image sensor) that is caused by higher ISO settings.
- Shoot with your camera mounted on a rigid tripod. Avoid using any more center extension tube than is needed. The use of a center extension tube generally dramatically increases the chance of camera shake, which results in a blurred image.
- Make sure you use the same camera settings (focus, shutter speed, and aperture) each time you take a photo in a series that is to be combined to make a single page.
- Take every step you can to ensure that the camera is still when shooting. Pressing the shutter release button can often cause your camera to move while the shutter is open, which causes the image to be blurred. To reduce this movement, use your camera's delayed timer feature so that the camera can take a photo without you having your hands on it.
- If your camera has a mirror-lockup feature, use it to further reduce camera shake.
- Because it is important to get images that show album pages with corners that are 90 degrees, you must keep the camera lens plane parallel with the scrapbook page you are shooting. The easiest way to do this is to place your scrapbook page on a rigid board and then place it on or against a wall.
- When you need to shoot more than a single photo to capture an entire page, use a support so that you can easily move your page up (or over) the needed distance to get additional images.
- Choose a well-lit space to shoot where there is even and consistent light across the entire scrapbook page.

- If you want to capture the dimension in your scrapbook pages, you need to have a light shining on the pages from a 30-degree angle to add a small shadow line to any element or texture that your page may feature. You can find a good choice of inexpensive lights at home improvement supply stores. Tungsten work lights with adjustable stands are excellent and using them helps to minimize any effort you may need to take to color correct your images.
- If you don't have good lights, and you don't want to buy any, you can get very good results by shooting outdoors on a slightly overcast day.
- Don't be overly concerned about some light *falloff* (that is, where one side of a page looks darker or lighter than the other side) across the page as it makes the page look more like a traditional page in natural light.
- When shooting photographs to be merged, shoot so that you overlap the images by at least one-third to one-half, which makes merging the final images much easier.

Okay — so, that was a long list of tips. However, they are worth reading and following, as they can help you to get better photos. After you make a quality copy of a scrapbook album page or two, doing the rest is easy.

STEP 3: OPEN FILES

In this project, we assume that you have taken two digital photos of one of your scrapbook pages and that you have saved those two digital photo files in a folder on your hard drive.

- Choose **File ➤ Open** (**Ctrl+O/Command+O**) to display the Open dialog box. After double-clicking the folder where you saved the two files, press and hold the **Ctrl** key on the PC (the **Command** key on the Mac) and click both files to select both images. Click **OK** to open both files.

STEP 4: DIGITALLY STITCH IMAGES

■ To digitally stitch the two images together, choose **File ➢ New ➢ Photomerge Panorama** to get the Photomerge dialog box shown in Figure 10.3. Press and hold **Ctrl** (**Command** on the Mac) and click the files shown in the **Source Files** box to select the two files that were opened in Step 3.

■ Click **OK** to begin the merge process. You should now see the images merged in the preview box in the Photomerge dialog box shown in Figure 10.4. If Photomerge had difficulties matching one or more images, you can click them and arrange them as needed. Make sure that the **Snap to Image** box is not checked; otherwise, you won't be able to arrange your images as needed. Also, make sure that **Settings** is set to **Normal**. If you have taken good photos under consistent lighting, your images should blend well; if not, you can click **Advanced Blending** and see if that feature improves the stitched image. Click **OK** to stitch the images.

STEP 5: CROP STITCHED IMAGE

■ To crop the image, click the **Crop** tool (**C**) in the **Toolbox**. In the **Width** and **Height** box in the **Options** bar, type **12 in**. Clear any value that may be in the **Resolution** box. The Options bar should now look like the one shown in Figure 10.5.

■ Click just inside the upper-left edge of the scrapbook album page and drag the selection marquee down toward the right to select as much of the page as is possible. After you have a selection marquee, you can click inside the marquee and drag it. Or, you can tap the arrow keys to move the marquee one pixel at a time. You can also resize the selection marquee by clicking and dragging the handles in the corners of the marquee.

■ Press **Enter/Return** to apply the crop.

STEP 6: EDIT IMAGE

Now is the time to perform any edits to the image that may be needed. If you take time and effort to take good photographs of your scrapbook album pages, you will have very little image editing to do.

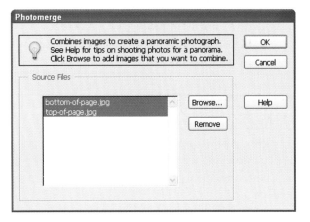

10.3

10.4

10.5

■ In this case, you have a nice crop where the sides of the photographs are parallel to the edges of the album page. If you use a camera lens that adds distortion (some lenses make a square look like a barrel or a pin-cushion) or you shoot without taking care to make the face of the lens parallel to the album page you are shooting, you will end up with an "out of square" album page. To fix this kind of distortion, choose **Image ➢ Transform** and select one of the transform features, such as **Free Transform** (**Ctrl+T/Command+T**) or **Perspective**.

■ If your original album page has photographs that are dark to begin with and they show up dark in your digital photo, you still need to make some tonal corrections with tools, such as **Levels**. First select the photographs using the **Rectangular Marquee** tool (**M**). Then apply your edits.

■ As is the case with most digital photos, our images need to be sharpened. Before sharpening, you should first do what? Yes — make sure you zoom in on the image to 100 percent by choosing **View ➢ Actual Pixels** (**Alt+Ctrl+0/ Option+Command+0**). To sharpen the images choose **Filter ➢ Sharpen ➢ Unsharp Mask** to get the Unsharp Mask dialog box shown in Figure 10.6. Try setting the **Amount** to **200%**, **Radius** to **.7 pixels**, and **Threshold** to **2 levels**.

STEP 7: RESIZE AND SAVE IMAGE FILES

■ To properly size the final page image file, choose **Image ➢ Resize ➢ Image Size** to view the Image Size dialog box shown in Figure 10.7. In Step 1, you determined that you needed an image that was 2,880 x 2,880 pixels. Make sure that **Constrain Proportions** is checked and that **Resample Image** is checked and set to **Bicubic Sharper**. Type **2880** in the **Width** box in the **Pixel Dimensions** area. The same value is automatically entered into the **Height** box. Type **240** in the **Resolution** box and click **OK** to apply the settings. Remember that these images were not the full-size images and that they were down-sampled to make it faster to download them and to edit them, so the quality of the image file at this size is not that good.

10.6

10.7

■ You can now save your image. While it would be best to save the file in the .tif or .psd file format as those formats are lossless formats (that is, a file format that does not compress the image file size), you can, if you need to have smaller files, also save the file in the .jpg format using a **Medium** or **High** image **Quality** setting (a lossy format where file size compression can result in lost picture quality). Before saving the image, you must first flatten it by choosing **Layer ➤ Flatten Image**. To save the file in the .tif format, choose **File ➤ Save As** (**Shift+Ctrl+S/Shift+Command+S**) to get the Save As dialog box. Click in the **Format** box and choose **TIFF**. Type in an appropriate filename, choose a folder, and click **Save**.

You now know how to make an excellent image to use to make prints on a photo-quality inkjet printer. Figure 10.8 shows a small portion of the full-size image. Because a light shining across the page from the right side created shadows when the original photos were taken, you now notice that there is a good sense of depth on the edges of the tags, photos, and paper.

With that one page completed, you can see how easy it is to make multiple copies of an entire scrapbook. It is as easy as shoot, Photomerge, perform a small bit of editing, and make prints!

TIP

You can use the Adobe Photoshop Element 3.0 Photomerge tool to digitally stitch two or more images together seamlessly to make copies of scrapbook pages and even fine art, such as oil or watercolor paintings. If you need more image resolution than you can get with just two images from a digital camera or flatbed scanner, take four pictures (in a 2 x 2 pattern or larger pattern if needed) and let Photomerge automatically stitch them together. To get the best stitching results, make sure you take photos that overlap by as much as, or more than, one-third of the image. This overlap is necessary to get good results.

10.8

CREATE DIGITAL FRAMES AND MATS

11.1 The addition of digital mats and frames can dramatically enhance the look of your photographs as shown in this set of matted and framed digital photographs.

Most photographs; no matter how good they look, can be made to look even better if they are properly framed and matted. In this project you will learn five different techniques for creating a digital frame and mat using Adobe Photoshop Elements. If you are inclined to dismiss this project because you like to use real frames and mat boards to frame your photos you should still take the time to complete this project. As you read you will learn how to make many special effects that can be used even if you later add a real (not digital) frame and mat to your photo. Also, these same techniques can be used to create digital frames and mats that will make your photos look as good as possible when they are displayed on a Web page, digital slide show, or in a printed document.

The purpose of showing five variations is to get you to creatively think about how to design your own digital frames and mats. Framing is as much art as is photography and in this project you will learn how to get very creative with your framing and matting.

TECHNIQUE 1: ADD SIMPLE FRAME WITH WHITE MAT

In this technique, you add a 1" white mat board border to a 4" x 6" photo of an Irish farm house, and then add a simple metal-like frame that is the same color of blue that can be found in the image.

- Using Photoshop Elements, select **Image ➢ Resize ➢ Canvas Size** to get the Canvas Size dialog box shown in Figure 11.2. Type **6** (4 + 2) in the **Width** box, and **8** (6 + 2) in the **Height** box. Click in the **Canvas** extension color box and choose **White**. Click **OK** to add a 1" wide white mat.
- To set the Foreground Color to be the desired frame color, click on the **Eyedropper Tool** (**I**) in the Toolbox. Click in the image and drag the cursor around in a dark blue area until you see the blue color you want in the **Foreground Color** box at the bottom of the **Toolbox**.

11.3

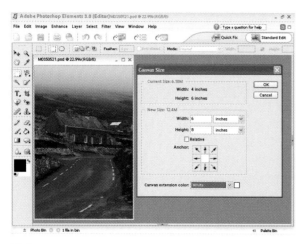

11.2

11.4

- If the **Styles and Effects** palette is not showing, select **Window** ➤ **Styles and Effects** to get the dialog box shown in Figure 11.3. You also may need to click in the **Category** box and choose **Effects**, and then click in the **Library** box and choose **Frames**. Double-click on **Foreground Color Frame** to create a dark blue frame complete with shadow effects as shown in Figure 11.4.
- Select **Layer** ➤ **Flatten Image** and you are ready to save and use your framed image.

TECHNQUE 2: ADD EDGE EFFECT AND SIMPLE FRAME

For this photo, which was taken in the Smokey Mountains, you will create a similar frame as was used in Technique 1, but you will first add an edge effect to the image that will be shown on the white background.

- If the **Styles and Effects** palette is not showing, select **Window** ➤ **Styles and Effects** to get the Styles and Effects dialog box. You also may need to click in the **Category** box and choose **Effects**, and then click in the **Library** box and choose

Frames. Double-click on **Spatter Frame** (or **Strokes Frame**) to create a rough edge effect as is shown in Figure 11.5.
- Select **Layer** ➤ **Flatten Image**.
- Select **Image** ➤ **Resize** ➤ **Canvas Size** to get the Canvas Size dialog box. Type **8** (6 + 2) in the **Width** box, and **6** (4 + 2) in the **Height** box. Click in the **Canvas extension** color box and choose **White**. Click **OK** to add a 1" white mat.
- To set the Foreground Color to be the desired frame color, click on the **Eyedropper Tool** (**I**) in the **Toolbox**. Click in the image and drag the cursor around in a dark blue area until you see the blue color you want in the **Foreground Color** box at the bottom of the **Toolbox**.
- If the **Styles and Effects** palette is not showing, select **Window** ➤ **Styles and Effects** to display the Styles and Effects dialog box. You also may need to click in the **Category** box and choose **Effects**, and then click in the **Library** box and choose **Frames**. Double-click on **Foreground Color Frame** to create a dark blue frame complete with shadow effects as shown in Figure 11.6.
- Select **Layer** ➤ **Flatten Image** and you are ready to save and use your framed image.

11.5

11.6

TECHNIQUE 3: ADD TWO COLORED LINES

If you need to add a frame to lots of different images for display in a photo gallery on a Web page you may want to consider just adding a few simple colored lines to your image. Additionally, this technique can be used in conjunction with other framing approaches as well. Some time back, it was quite common for the better framers to add hand-drawn lines on an image or on a mat board before adding a frame. Adding lines of different widths and colors can be a nice addition to a framed photograph.

■ Select **Image ➢ Resize ➢ Canvas Size** to get the Canvas Size dialog box. For this image you will first add a ¼" white mat to the image. To add ¼" to all sides of the canvas Type **6.5** (6" +.5") in the **Width** box, and **4.75** (4.25" + .5") in the **Height** box. Click in the **Canvas extension color** box and choose **White**. Click **OK** to add the white mat.

■ To choose the color for the first line, click on the **Eyedropper Tool** (**I**) in the Toolbox and then click in the image and drag the cursor where you see a medium green color. As you drag the cursor watch the color that is being shown in the **Foreground Color** box at the bottom of the Toolbox. When you have selected a good color, release the mouse button.

■ To add the first line, choose **Select ➢ Select All** (**Ctrl+A/Command+A**) to select the entire image.

■ Select **Edit ➢ Stroke (Outline) Selection** to get the Stroke dialog box shown in Figure 11.7. You should see the green color in the Color box you chose earlier. Click in the **Width** box and type **5 px**. Choose **Inside** in the **Location** part of the dialog box. Click **OK** to apply the green line.

■ Select **Image ➢ Resize ➢ Canvas Size** to once again get the Canvas Size dialog box. You will now add a 1" white mat to the image. To add 1" all around the canvas, type **8** (6 +2) in the **Width** box, and **6.75** (4.75 + 2) in the **Height** box. Click in the **Canvas extension color** box and choose **White**. Click **OK** to add the white mat.

■ To add the second line, choose **Select ➢ Select All** (**Ctrl+A/Command+A**) to select the entire image.

■ Select **Edit ➢ Stroke (Outline) Selection** to once again get the Stroke dialog box. This time, choose the color for the line using this dialog box. Click in the **Color** box to display the Color Picker. You can now either choose the color from the Color Picker, or you can click in the image and drag the cursor to pick a color from the image. Try selecting a relatively dark (but not black) blue color. Click **OK** to close the Color Picker. Type **35 px** in the **Width** box to make a wide color line. Choose **Inside** as the Location. Click **OK** to apply the wide blue line. Your image should now look like the one shown in Figure 11.8. Notice how the extra wide white space with the fine green line enhances this image.

If you plan on making colored lines on a print that you intend to frame with a real frame, consider adding a set of two to five lines in varying widths and colors. You can even try adding a colored line inside the actual image, too.

11.7

TECHNIQUE 4: USE PART OF THE IMAGE TO MAKE A MAT

This technique is the digital equivalent of a complex double mat cut that is sometimes used on high-end portraits. Rather than using a mat board for the mat, a double beveled cut is actually made in the print itself leaving a ¼" or ⅜" gap. This approach only works on images where there is sufficient image to use as the mat. For this technique you will use the image of the Maine crab shack that was hand-painted in Project 8.

■ Click on the **Rectangular Marquee Tool** in the Toolbox.
■ Click once in the upper-left corner of the image ½" from the top and from the left side of the image, and drag the selection marquee down toward the bottom right corner ½" from the bottom and from the right side of the image. If you have difficulty making an accurate selection, you can use either the Rulers or the Grid. To turn these features on,

choose **View ➢ Rulers** or **View ➢ Grid** — or both. You can set up the grid by choosing **Edit ➢ Preferences ➢ Grid**. **View ➢ Snap to Grid** makes it easy to select exactly on a grid line. Once your selection is made, you should see a selection.
■ If the Styles and Effects palette is not showing, select **Window ➢ Styles and Effects** to display the Styles and Effects dialog box. You also may need to click in the **Category** box and choose **Effects**, and then click in the **Library** box and choose **Frames**. Double-click on **Cut Out** to cut out the inside of the image as shown in Figure 11.9.
■ Click on the **Magic Wand Tool** (**W**) in the Toolbox. Make sure that **Tolerance** is set to **0** and **Anti-aliased** and **Contiguous** are all turned off in the Options bar, as shown in Figure 11.10.
■ Click in the center of the image with the **Magic Wand Tool** to select the center of the image.
■ Select **Edit ➢ Cut** (**Ctrl+D/Command+D**) to cut out the center of the image and display the image below.

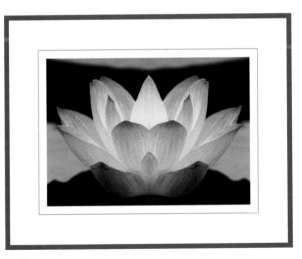

11.8

11.9

11.10

■ To make the outer mat darker select **Layer ➢ New Adjustment Layer ➢ Levels** to display the New Layer dialog box shown in Figure 11.11. Click inside the box next to **Group With Previous Layer** to limit the Levels settings to just the top layer.

■ Click **OK** to get the Levels dialog box. Click on the **shadow slider** (the tiny black triangle beneath the histogram at the left side) and drag it toward the right until the first box after **Input Levels** shows **60**. Click on the **mid-tone slider** (the center slider beneath the histogram) and drag it toward the right until the second box after **Input** levels shows **0.60**. The Levels dialog box should look like Figure 11.12. Click **OK** to apply the settings.

■ Select **Layer ➢ Flatten Layer**. Figure 11.13 shows the final framed image.

TECHNIQUE 5: ADD A TEXTURED MAT WITH TWO ACCENT-COLOR MATS

For this last technique you will add two colored mats that will feature a mat-like texture and shadow on one mat and a second mat that makes a good accent color. The goal is to make a nice mat for a photo of a football player that was digitally painted using Corel's Painter software (www.corel.com).

■ Select **Image ➢ Resize ➢ Canvas Size** to display the Canvas Size dialog box. For this image, you first add a narrow red mat to the image. To add the mat to all four sides of the canvas, type **4.375** (4" +.375") in the **Width** box, and **6.375** (6" + .375") in the **Height** box. Click in the color

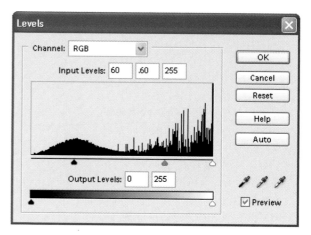

11.12

11.11

11.13

box after the **Canvas extension color** box to open the Color Picker. You can now choose a color using the Color Picker, or you can click inside the image and choose a color from the image. For this image, try selecting a bright red color from the football player's jersey. Click **OK** to choose the color. Click **OK** to add the red mat.

■ Once again, select **Image** ➢ **Resize** ➢ **Canvas Size** to get the Canvas Size dialog box. Now you add a wide blue-colored mat to the image. To add the mat to all four sides of the canvas, type **6.375** (4.375" + 2") in the **Width** box, and **8.375** (6.375" + 2") in the **Height** box. Click in the color box after the **Canvas extension color** box to get the Color Picker. You can now choose a color using the Color Picker, or you can click inside the image and choose a color from the image. For this image, select a dark blue color from the opposing player's pants. Click **OK** to choose the color. Click **OK** to add the blue mat.

■ Select **Layer** ➢ **Duplicate Layer** to create a second copy of the entire image.

■ Click on the **Magic Wand** tool (**W**) in the Toolbox. Make sure **Tolerance** is set to **0** in the Options bar. Click inside the blue border to select it.

■ Select **Select** ➢ **Inverse** (**Shift+Ctrl+I/ Shift+Command+I**).

■ If the Styles and Effects palette is not showing, choose **Window** ➢ **Styles and Effects** to display the Styles and Effects dialog box. You also may need to click in the **Category** box and choose **Effects**, and then click in the **Library** box and choose **Frames**. Double-click on **Cut Out** to cut out the inside of the image.

■ Select **Select** ➢ **Reselect** to reselect the blue border.

■ Select **Select** ➢ **Inverse**.

■ If the Styles and Effects palette is not showing, select **Window** ➢ **Styles and Effects** to get the Styles and Effects dialog box. You also may need to click in the **Category** box and choose **Effects**, and then click in the **Library** box and choose **Frames**. Double-click on **Cut Out** to cut out the inside of the image.

■ Click on the **Magic Wand** tool (**W**) in the Toolbox. Make sure **Tolerance** is set to **0** in the Options bar. Click inside the white area in the middle of the image.

■ Select **Edit** ➢ **Cut** (**Ctrl+X/Command+X**) to cut out the white and reveal the image.

■ Click on the **Magic Wand** tool (**W**) in the Toolbox. Make sure **Tolerance** is set to **0** in the Options bar. Click inside the blue mat.

■ Make sure **Tolerance** is set to **0** in the Options bar. Click inside the blue border to select it. Choose **Filter** ➢ **Texture** ➢ **Texturizer** to display the Texturizer dialog box shown in Figure 11.14. Set **Scaling** to **100%**, **Relief** to **4** and click **OK** to apply the texture.

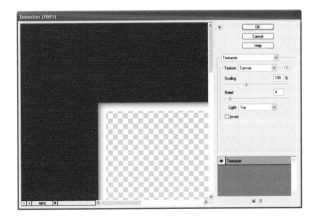

11.14

■ Choose **Layer** ➢ **Flatten Image** You now have a nice dark blue mat with a matte-like texture and a drop shadow as shown in the detail image in Figure 11.15.

Good-looking frames, mats, and edge effects can undoubtedly enhance the images you present no matter how you choose to present them. While you can create many wonderful effects using an image editor such as Adobe Photoshop Elements, you may find that you want a tool that gives you more possibilities. There are a number of "edge effects" software programs available. The most powerful and complete suite of edge effects is unquestionably Photo/Graphic Edges 6.0 (www.autofx.com). Photo/Graphic Edges 6.0 works as a stand-alone imaging application as well as a plug-in that can be used with image editors such as Adobe Photoshop Elements, Paint Shop Pro, and other Adobe Photoshop plug-in compatible applications.

Figure 11.16 shows just one of the thousands of edge effects that are available in Photo/Graphic Edges 6.0. A more exotic edge effect is shown in Figure 11.17. Photo/Graphic Edges 6.0 was used to create this entire image except for the portrait of the girl. It can even be used to create complex picture frames like the one shown in Figure 11.18.

11.15

11.16

Photo/Graphic Edges 6.0 is a relatively expensive product that sells for about $180. If you want to try it before you spend your money, you can download a trial version from the vendor's Web site. If you like using edge effects, this is the product to have if your budget allows such an "investment."

You have now reached the end of Chapter 2. In the next chapter, you find six projects that show you how to use digital photos in printed documents.

TIP

If you plan on creating a digital frame and mat for an image that will be placed on a Web page, you should first resize the image to be the final size; then, make the digital frame and mat. If you use a larger image and then scale it down to fit on a Web page, you may lose important details such as shadows, fine lines, etc.

11.17

11.18

CHAPTER 3

USING DIGITAL PHOTOS IN PRINTED DOCUMENTS

Many photographers share a common trait: they are perfectionists — no matter what kind of project they are working on, they want their finished projects to be as perfect as possible. Unfortunately, many photographers who take wonderful photos want to use their photos in many different kinds of documents — and that is where frustration may begin. As most software applications grow richer and richer with features, their level of complexity grows as well. Often this complexity makes the simplest of tasks not so simple.

In this chapter you will learn how to perfectly position digital photos into many different types of documents. Project 12 shows how to insert photos into a personal letter. Adding watermark photos is the topic of Project 13. You learn to create a recipe page with photos in Project 14. Projects 15 and 16 cover two different ways to add photos to scrapbook album pages. In Project 17 you will learn how to get printed reports with photos that catalog your valuable possessions.

May 26, 2005

Dear Tom,

I thought that writing to you about the newest additions to our farm might prompt you to drive down and visit us again soon. We have two new and very entertaining goats. The oldest, a stocky and sturdy beard-growing grey goat named Rufus eats and hangs out while waiting to be petted by any one that comes his way. That's him standing on a telephone wire spool on the right. He has a fiery and energetic little companion who is a white-colored female goat named Cassandra who acts like a mountain goat as she is always climbing on everything in her pen, including the gate when she wants to get out into the yard to chase the dogs.

Other major additions to the farm are the two new Chincoteague pony foals named Bella and Rocco. Bella was born about a week ago and Rocco arrived very early this morning. The two were born to mares Stella and Raspberry respectively with no complications this time thank goodness. Stella and Bella are shown in the photo on the bottom right. Sadly, Raspberry (you remember her sassy attitude I am sure) was not quite ready to be a mother and we had to call in Dr. Stevens to sedate her so that Rocco could nurse.

Bella and Rocco are so adorable and entertaining as they are just learning to walk and run. They are very gentle ponies and would walk up to you if their mothers did not prevent them. When anyone sees them the first thing they say is "awwwww!" I'll bet you said that out loud when you saw their photo below—now didn't you?

We also added a new fancy show chicken to our collection too. He's the little fella shown at the bottom left. I hope all is well over at your place and that you will have all the flowers you are hoping to have in your garden this year. I would love to come photograph them soon. Let me know when to visit—I'll bring my homemade cheesecake!

Sincerely your animal loving friend,
Kathryn Rex

From the Kitchen of Lauren Georges **Pasta**

Mama's Farfalle with Marinara

Preparation time: 10 minutes
Total Cooking time: 15 minutes
Serves: 6
Fat per serving:

This is a quick and easy recipe that my mamma used to prepare on evenings where we were all hungry and she did not have much time to prepare a meal. While using fresh ingredients really makes this a good main course, it can also be prepared with standard ingredients from your kitchen. You will also want to serve a nice green salad with it. A common traditional vegetable to be served with this course is fresh spinach topped with pine nuts, olive oil and a small amount of fresh ground pepper.

Ingredients
2 teaspoons olive oil
1 onion, chopped
2 cloves garlic, crushed
½ cup (125 ml/4 fl oz) red wine
2 tablespoons tomato paste
4 medium tomatoes, chopped
1 cup bottled tomato pasta sauce
1 tablespoon each of chopped fresh basil and oregano
1 lb. Farfalle (bowtie) pasta
Grated Parmesan or Romano cheese, for serving

ADD PHOTOS TO A PERSONAL LETTER CREATED WITH MICROSOFT WORD

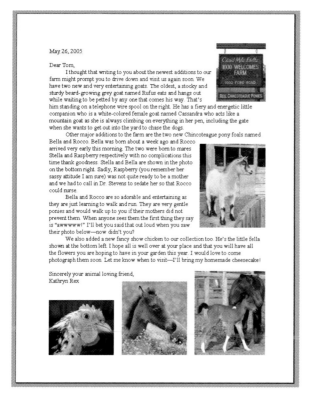

12.1 Next time you want to write a letter that features photographs, consider using Microsoft Word to create your letter.

It is hard avoiding the use of the all-too-often cited cliché, "A picture is worth a thousand words" when describing why you might want to include digital photos when you write a personal letter. Adding one or more good pictures to a printed letter is well worth the time it takes when you know how to put your pictures exactly where you want them using Microsoft Word. In this project you will learn what image resolution, file format, and file size you need to make excellent printed documents. With this knowledge you can easily create holiday letters, newsletters, advertisements, and any other kind of document you want to create with one

or more photos when using Microsoft Word. The goal of this first project is to insert the photos shown in Figure 12.2, which have been cropped and sized, into the Microsoft Word document that is shown in Figure 12.1.

Many people attempt to insert photos into their Microsoft Word documents and, in doing so, they struggle unsuccessfully to get the results they want. The photos never seem to end up where they are wanted and text goes everywhere but where it should be. When dragging images, the images get stretched out of shape and frustration sets in! You, however, do not need to struggle as there are some Microsoft Word features that admittedly are not obvious, but can be used to quickly and easily get your photos where you want them while your text stays where it should. You'll learn about these features and get a few other tips that will make you want to include your digital photos whenever it is appropriate to include them in your personal letters or other documents.

STEP 1: SELECT AND PREPARE IMAGES

A number of different image file formats can be included in Microsoft Word documents. Some of the acceptable formats are: .jpg, .bmp, .tiff, and a few others, including .pct and Kodak Photo CD pictures if you install optional filters. The best way to prepare and use digital photos in Microsoft Word documents is to create .jpg images that are 300PPI and are sized in inches to be approximately the size you want them to be in your printed document. It is not essential that they are exactly the right size as Microsoft Word has features that allow you to easily scale the images as needed.

■ Select an image you want to use and open it in Adobe Photoshop Elements 3.0.
■ Select **Image ➢ Resize ➢ Image Resize** to get the Image Size dialog box shown in Figure 12.3.

12.2

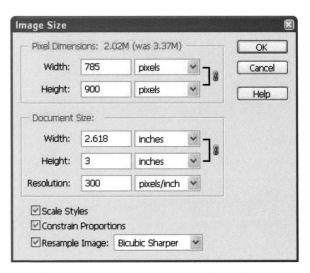

12.3

■ Make sure there is a check next to **Constrain Proportions** and **Resample Image**. Set **Resample Image** to **Bicubic Sharper** if you are down-sizing the image; otherwise, set it to **Bicubic Smoother**. Type **300** in **Resolution** and make sure it is set to **pixels/inch**. Type the approximate size in inches of the image you want to insert into a Word document in either the **Width** or **Height** box. Because the **Constrain Proportions** box is checked, Elements will automatically adjust the second setting to keep the proportions the same as the original image. Click **OK** to apply the settings.

■ Select **File ➢ Save As** (**Shift+Crtl+S / Shift+Command+S**) to get the Save As dialog box shown in Figure 12.4. Choose an appropriate folder and file name. Click in the **Format** box and select **JPEG**. Click **Save** to get the **JPEG Options** dialog box shown in Figure 12.5. Click in the **Quality** box and choose **Medium**. Click **OK** to save the file to your chosen folder. Your image is now ready to be inserted into a Word document.

■ Repeat this step to resize and save each of the other images.

12.4

12.5

STEP 2: FORMAT PAGE

- Using Microsoft Word **Select File ➤ New** (**Ctrl+N/Command+N**) to create a new document.
- Choose **File ➤ Page Setup** to get the Page Setup dialog box shown in Figure 12.6. Type **1"** into the **Top**, **Left**, **Bottom**, and **Right** boxes to set the margins to be 1". Click **OK** to apply the settings.

STEP 3: TYPE TEXT

There are two approaches you can take to insert photos into a Microsoft Word document. You can either type some text and then insert a photo where you want it to appear; or, alternatively (I prefer this approach), simply type your entire letter and then insert the photos where you want them to be.

- Type all of the text you want to include.

STEP 4: INSERT PHOTOS

Now that all of the text has been typed, you can add each of the photos.

- To insert the farm sign photo in the upper-right corner of the page, click right after the date to set your cursor.
- Select **Insert ➤ Picture ➤ From File** to get the Insert Picture dialog box. Choose the folder where you saved the cropped and sized images in Step 1 and click on the farm sign image. Click **Insert** to insert the image into your document. Don't fret if it is too big or it is not exactly where you want it to be.
- **Right-click** on the image you just inserted and select **Format Picture** from the menu to get the Format Picture dialog box. Click on the **Size** tab shown to get the dialog box shown in Figure 12.7. Make sure **Lock aspect ratio** is checked and type **45%** in the **Height** box. Microsoft Word will automatically adjust **Width** to **45%** to keep the aspect ratio the same as the original image.

12.6

12.7

■ Click on the **Layout Tab** to get the dialog box shown in Figure 12.8. It is in this dialog box that you find the "layout magic!" In the **Wrapping style** area you are given many different choices for determining where an image will go relative to the text. You can have it in line with the text, or have text automatically format around the image in a square layout, or be tight against the image. You can even place text behind or in front of the image. In this case, click on **Tight** and click on **Right** to align the photo to the far top right of the page. If you want even more control, you can click on the **Advanced** button and experiment with those features too. Click **OK** to place the photo — ah, notice how it goes right at the top right as we wanted! But, you can have even more control over where the image goes. With the image still selected, tap any one of the arrow keys to move the image up or down, or to the right or the left.

You can now add the rest of the images in this same manner. Remember that it is best to first click on the end of a paragraph that is closest to where you want to place a photo. After inserting the photo using **Insert ➢ Picture ➢ From File**, right-click on the image to get a pop-up menu, and choose the size in the **Size** tab; then, choose the **Wrapping** style and the **Alignment**.

STEP 5: MAKE FINAL ADJUSTMENTS TO LAYOUT

Once you have typed all the text and you have the photos approximately where you want them, you can click on each image and move it using the arrow keys; or, you can right-click on the image and make any needed changes to the **Wrapping** style or **Alignment**.

12.8

CREATE PERSONAL STATIONERY WITH A WATERMARK

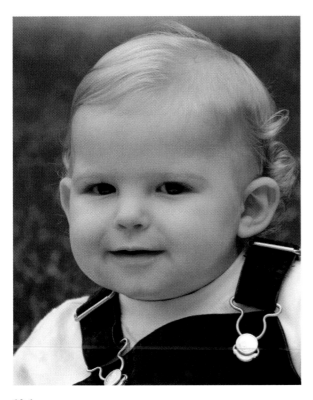

13.1

Monday, June 07, 2004

Dear Mom,

You warned me and I promised to be careful not to let your grandchild take a fall. Remember when you left me on the bed to answer the telephone. While you were talking, I made my first crawl to the edge of the bed and promptly fell off and got a black eye.

Guess what? Yes—your grandchild took a hike to the edge of the bed and fell off while I was talking on my cell phone. He managed to get by with just a small cut on his face. He got that when he hit the edge of the dresser. He is Ok and I've learned my lesson!

See you on Monday for lunch.

Love Sara

13.2

WHAT YOU'LL NEED

Microsoft Word ($230) www.microsoft.com, an image editor such as Adobe Photoshop Elements ($80) www.adobe.com, a photographic inkjet printer ($150 and up), and high-quality inkjet printer paper.

I n today's fast-paced world, the computer printed letter often replaces the carefully thought-out, beautifully handwritten personal letters that were once written with flowing ink pens on fine stationery with watermarks. The image that this conjures up in my mind is one we often see in movies. A person sitting at a traditional desk in a room lit by warm yellow candlelight using a crow-quill pen with a feather attached to it. The author of the letter dips the pen into a shallow, open bottle of ink and after careful thought takes time to delicately construct each letter of each word on a parchment paper with a watermark that becomes visible when the paper is held up to a bright light.

If you are like me and you value Microsoft Word's spelling skills over your own and you don't have the time or the inclination to use the open ink bottle and the crow-quill pen — then you will like this project. You will learn how to select one of your digital photos and use it to add a faint watermark to a high-quality ink jet paper, and then to pick an appropriate font to make a beautiful personalized letter — that can be completed quickly with no spelling errors.

STEP 1: CHOOSE PHOTO

Many photos do not make good watermark images; those that do, usually require some image editing to turn them into images that make excellent watermarks. So, what makes one image a good one for use as a watermark and another one a bad image? That is not an easy question. Sometimes the best way to determine if an image will make a good watermark is to edit it and see what you get. Good watermark images usually are contrasty images that show only important detail after the image has been considerably lightened.

Figures 13.3 through **13.6** show a variety of watermark images that have sufficient contrast that the image may be seen beneath text while allowing the text to be easily read. Figure 13.3 is a full color image that has been placed in a vignette. Figure 13.4 is the same image, but it has been converted to a black and white image, then toned blue. The iris photo shown in Figure 13.5 makes a wonderful full-color watermark that might be best displayed in the center of the page. The hotel shown in Figure 13.6 has been cropped and edited to cover an entire page, except the border areas where most printers cannot print.

STEP 2: EDIT PHOTO

Once you have selected a photo or two to use as watermarks, you will need to edit them. In this case, let's use Adobe Photoshop Elements 3.0 and let's create the two watermarks shown in Figure 13.3 and Figure 13.4.

13.3

13.4

13.6

13.5

■ To open an image in Adobe Photoshop Elements 3.0, select **File ➢ Open** (**Ctrl+O /Command+O**) to get the File Open dialog box. After selecting the folder, click on the image file you want to use and click **Open** to open the image in Adobe Photoshop Elements 3.0.

■ Click on the **Elliptical Marquee** tool (**M**) in the **Toolbox**. Click once in the upper-left corner of the image where you want to begin selecting the portion of the image you want to use and drag the cursor to the bottom-right corner until the selection includes all of the image that you want. Once you have a selection marquee, you can click inside the selection and drag the selection to contain precisely the part of the image you want.

■ Click on **Select ➢ Inverse** (**Shift+Ctrl+I/ Shift+Command+I**) to invert the selection so that we can feather (i.e. soften the edge of) the selection outside of the selected area.

■ Select **Select** ➢ **Feather** (**Alt**+**Ctrl**+**D**/**Option**+**Command**+**D**) to get the Feather dialog box shown in Figure 13.7. Type in a value for the **Feather Radius** in pixels that gives you the feather effect you want. For this image, we used **35** pixels. Click **OK** to feather the selection.

■ Select **Edit** ➢ **Cut** (**Ctrl**+**X** /**Command**+**X**) to cut out the feathered selection leaving a feathered edge portrait of the child.

■ To reduce the file size and to make the image easy to insert in Word, click on the **Crop** tool (**C**) in the Toolbox. Click once in the upper-left corner of the area you want to crop and drag the selection marquee down to the bottom-right to select just the part of the image you want.

■ Select **Image** ➢ **Crop** to crop the image.

■ Next, you will need to lighten the image. This is easy to do with the **Levels** tool. Select **Enhance** ➢ **Adjust Lighting** ➢ **Levels** (**Ctrl**+**L**/**Command**+**L**) to get the **Levels** dialog box shown in Figure 13.8. Click on the **Output Levels Shadow** slider (the black triangle at the bottom left of the Levels dialog box) and slide it toward the right until the image is light enough to allow text to show through, while still keeping important detail and color in the image. For this image **165** was a good value. Click **OK** to apply these settings.

■ Save the photo by selecting **File** ➢ **Save As** (**Shift**+**Ctrl**+**S** /**Shift**+**Command**+**S**) to get the Save As dialog box. Choose an appropriate folder and file name and click **Save** to save the file.

That last step completed the transformation of the colored image of the baby boy into a lightly colored watermark. Another technique you may want to try is to tone an image. For example, to make the boy image a blue-toned image (blue is for boys and pink for girls, right?) you must first convert the image to a black-and-white image and then tone it blue. The steps for blue toning using Adobe Photoshop Elements 3.0 are:

■ Select **Enhance** ➢ **Adjust Color** ➢ **Remove color** (**Shift**+**Ctrl**+**U**/**Shift**+**Command**+**U**) to convert the color image into a grayscale image.

■ Now, we'll create a color layer and add an adjustment layer so that we have complete control over the blue toning process. Select **Layer** ➢ **New** ➢ **Layer** (**Shift**+**Ctrl**+**N** /**Shift**+**Command**+**N**) to get the new Layer dialog box; click **OK**.

■ Select **Edit** ➢ **Fill Layer** to get the Fill dialog box shown in Figure 13.9. Click in the **Use** box in the **Contents** area and choose **Color** to get the **Color Picker** shown in Figure 13.10. Click once in the blue area of the vertical color spectrum to get blue. You can now click in the large color square to pick a specific blue. I chose a blue that gave me **R**, **G**, and **B** values of **0**, **18**, and **255** respectively. Click **OK** to select the color. Click **OK** once again to fill the layer with the selected color.

13.7

13.8

NOTE

While you might be tempted to adjust an image's brightness with Adobe Photoshop Elements' **Brightness/Contrast** tool, you will get far superior results if you use **Levels**. When using Levels, note that there are both Input and Output sliders. To lighten an image slide the Shadow slider in the Output area toward the right. Experiment with the Brightness/Contrast tool and the Levels tool while watching the Histogram to confirm this tip for yourself.

■ To blend the blue with the underlying image, click in the **Blend** mode box in the Layers palette and choose **Color** from the pop-up menu and the image will now have a blue tint. The Layers palette should now look like the one shown in Figure 13.11.

■ Now that the image has been toned blue, you may decide to change the color, so let's add an adjustment layer. Select **Layer ➢ New Adjustment Layer ➢ Hue/Saturation** to get the New Layer dialog box; click **OK** to get the Hue/Saturation dialog box shown in Figure 13.12. You can now adjust the **Hue**, **Saturation** and **Lightness** by sliding each of

13.9

13.11

13.10

13.12

the sliders to get the effect you want. I chose **-14**, **-4**, and **+25** for each of those settings. Click **OK** to apply them and to get a nice blue-toned face.

The real benefit of taking the time to use a **Hue/Saturation** adjustment layer is that you can go back at any time and double click on the **Hue/Saturation** layer in the Layers palette as is shown in Figure 13.11 to once again open up the Hue/Saturation dialog box where you can fine-tune your settings. Go ahead and try it.

- Once your image looks as you want it to look and you don't plan on changing colors again, select **Layer** ➢ **Flatten Image** to flatten the image.

STEP 3: SIZE PHOTO

Most likely you will not need to change the size of your photos. The only exception may be if your photo is far larger or far smaller than it needs to be. Now you might be wondering how large or small it should be. Most common photo-quality inkjet printers have what is known as optimal PPI (Pixels Per Inch). Most HP and Canon printers use 300PPI as the optimal PPI while Epson printers print well with only 240PPI. This means that your image should be somewhat close to having the right amount of PPI for the size of image you will want to have in your document. For example, if you want a watermark to fill most of the center of an 8½" x 11" page, you will want to have an image that is 7.5" x 240PPI, or about 1,680 pixels wide if you are using a printer with 240PPI optimal print target.

Because the watermarks are printed as light images, it is OK to use Microsoft Word's picture scaling feature to increase the image size up to about double the original size. The only reason you would want to down-sample an image is because your image is so large that it needlessly increases the size of the Word document.

- If you find that you need to resize an image, click on **Image** ➢ **Resize** ➢ **Image Resize** to get the Image Size dialog box in Figure 13.13. Type your printer's optimal PPI setting in the **Resolution** box in the **Document Size** area, while making sure that **Resolution** is set to **pixels/inch**. Make sure that **Constrain Proportions** is checked. Then type in either the **Width** or **Height** in **inches** in the Document Size area and click **OK** to resize your image.
- You should now save your file by selecting **File** ➢ **Save As** to get the **Save As** dialog box. After choosing an appropriate folder and file name, and after selecting **JPEG** as the file format; click **Save** to save your file.

STEP 4: PLACE PHOTO AS WATERMARK

- To insert your edited watermark image as a watermark in a Microsoft Word document, select **Insert** ➢ **Picture From File** using Microsoft Word to get the Insert Picture dialog box. Select the folder and the image that you saved in Step 3 and click **Insert**.

13.13

- To get an accurate view of the page, select **View ➤ Print Layout** if you are in any other view mode.
- Right-click on the image to get a pop-up menu; select **Format Picture** to get the **Format Picture** dialog box and then click on the **Layout** tab to get the dialog box shown in Figure 13.14. Click **Behind text** under Wrapping style and then **Center** beneath Horizontal alignment to place the photo in the middle of the page.
- If you need to change the size of the image, click on the **Size** tab to get the dialog box shown in Figure 13.15. Make sure that **Lock aspect ratio** is checked. You can now adjust the size of the image by either entering a percentage in **Height** or **Width**, or by typing the size in inches in either the **Height** or **Width** boxes. You can even rotate the image if you'd like by choosing an angle in **Rotation**. Click **OK** to apply the settings.
- To fine-tune the location of the image, you can now click on the image to select it and either drag and drop it with your cursor, or you can tap the **Up**, **Down**, **Right**, or **Left** arrow keys to move the image in small increments.

STEP 5: TYPE TEXT

- You are now ready to type any text you want to add to your personalized and watermarked stationery. Before you begin typing, you may want to choose a font that looks like handwriting. When choosing a font, be careful to not choose a font that is hard to read. One common font for Windows users that both looks like handwriting and is easy to read is **John Handy LET**. Mac users may want to try the Bradley Hand ITC or Lucida Handwriting fonts. When you choose such a font, make sure to also choose a font size that makes it large enough. For the letter in Figure 13.2, the **John Handy LET** font was used in the **24** size and it was made **bold**.
- To enter text, simply begin typing and, as you type, the text will flow over the watermark. If at any time you decide you want to change the location of the watermark image or its size, just click on it to get the pop-up menu and make the changes you want in the **Format Picture** dialog box.

13.14

13.15

In this project you learned how to create a personal watermarked letter. Using the same approach, you can create a set of watermarked stationery and use a pen to write the letter instead of your computer and printer. A set of stationery that features your photos can also become a valued gift item that friends and family will enjoy. The use of high-quality inkjet paper will dramatically increase the appeal of your watermarked stationery. When using an Epson printer, I have found that the Epson matte papers make wonderful paper. Many other media vendors offer equally nice paper too.

MAKE YOUR OWN RECIPE PAGES

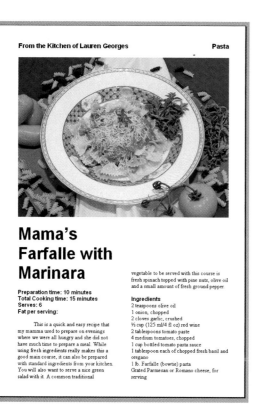

14.1

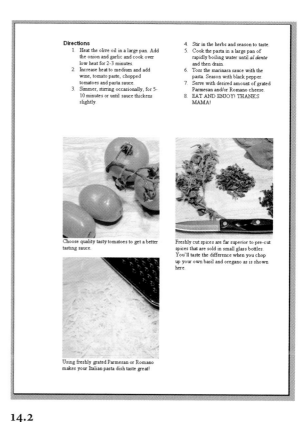

14.2

Microsoft Word ($230)
(www.microsoft.com),
quality inkjet paper, a digital
camera ($150 and up), and
an inkjet printer ($150).

Do you enjoy cooking and sharing your recipes with others? If so, consider throwing out the standard store-bought recipe cards and creating your own recipe pages. In this technique you will get good tips on how to use your digital camera to get delicious-looking photos of your favorite recipes; then, you'll learn how you can use Microsoft Word to format and print recipe pages that feature your photographs that you'll love sharing with friends and family.

If you make a good page layout that you can use for many years, you may find after a few months or years, you can print out your own cookbook full of recipes. You can also use Microsoft Word "styles" and easily reformat a recipe

to be a page in a cookbook or simply a recipe page that you can give to friends and family that has a heading like: "From the kitchen of 'your name here.'" Once you have a recipe, you're ready to begin shooting and creating the first page in your very own cookbook. You can download dozens of Office-style templates for cooking from `www.microsoft.com`. Just look for Office downloads and then templates for cooking and entertaining.

TAKING FOOD PHOTOGRAPHS

Taking great photos of food is challenging enough that some photographers specialize in food photography. But, don't let that dissuade you from taking your own food photographs and making your own cookbook — getting good photographs of food you prepare and cook can be fun and is in the realm of the possible. As is true with all photography, finding and using good light is key — even more so, with food photographs. One of the best ways to get wonderful light for free (that is, without having to buy any photography lights) is to pick an overcast day and to shoot outside. Pick a mat board that works well with the food that you are shooting and make sure to add a cutting board and or tablecloth and table accessories where it is appropriate for color and to make your photos realistic. Also, make sure to use a tripod and set your aperture to get as much depth-of-field as is needed to keep your entire image in focus.

If you don't want to shoot outdoors, you can get very good light by using one of the inexpensive halogen workshop lights that can be found at home and building supply stores. You can also use a halogen desk light. These light sources will give you accurate color and if you don't like the color, you can change it with one of the many tools found in your image editor.

Your recipe pages will look better if you take the time to shoot one or more additional photos that illustrate key steps in the cooking process. If you recommend fresh spices, you may want to take a picture of a knife chopping fresh basil, for example. Or, if there is an important step in rolling the edge of a pizza, for example, show that too.

CREATE RECIPE PAGES

STEP 1: DESIGN LAYOUT

This is one step that you may be tempted to skip. However, anytime you are going to take the time to make a complex page layout, it is always wise to make a sketch of what you want the page to look like before attempting to create it with your chosen software application. For this project we will be creating a recipe page that will go in a cookbook. The recipe is for a fictitious (as in don't follow these directions if you plan on eating it) Mama's Farfalle with Marinara Sauce. Figure 14.3 shows the quick sketch that was used to begin the layout process.

TIP

When taking photos that will later be cropped and sized to fit available space in a printed document, you should allow plenty of space around your subject so that the final cropped image will fit in the space that it needs to fit. Filling an image up with your subject when you take pictures is likely to leave you with a less than optimally sized image or one that cannot be cropped; thereby, leaving you with no choice but to shoot again. This is particularly true of subjects that are square and will ultimately have to fit in a rectangular space.

Notice that an 8½" x 11" page size has been chosen and it will have a 1½" inch margin on the left side so that there is room for holes for a 3-ring binder. The top, right, and bottom margins should all be ½". With this layout, there will be a 6½" wide space for the top photo. The height of the photo will then become what is needed to maintain the same aspect ratio as the original. It is important to do some planning, or you may end up with photos you cannot use, and if you have already eaten the prepared food, you will have to start from scratch to get new photos. I've done that! Working hard and cooking always makes me hungry.

STEP 2: CREATE AND FORMAT NEW DOCUMENT

You can use many different software applications to create your recipe pages. Because of the need to type text without spelling errors and because Microsoft Word is a common application, Word has been chosen as the software to be used. If you want, you could also use Adobe Photoshop Elements or a page layout program such as Microsoft Publisher if you have them; but, you may not have the benefit of having grammar- and spell-checking with some of these other software applications.

- Launch Microsoft Word.
- Select **File ➢ New Document** to create a new blank page.
- Select **View ➢ Print Layout** so that you can see how the page items are laid out.
- Select **File ➢ Page Setup** to get the Page Setup dialog box as is shown in Figure 14.4. Set **Top**, **Bottom**, and **Right** margins to be ½" by typing **.5** in each box. Set the **Left** margin to **1.5**.
- Click **OK** to format the page with these settings.

14.3

14.4

STEP 3: ENTER TEXT AT TOP OF PAGE

- Type whatever top heading you would like. For this example, we'll use **From the Kitchen of Lauren Georges.**
- Now we want to add a food category to the top right of the page. To do that, we need to set a tab that right-justifies the text ½" from the right edge of the paper. Select **Format** ➤ **Tabs** to get the Tabs dialog box. Type **6.0** in the **Tab** stop position box and click on **Right** in the **Alignment** area to align the text "**Pasta**" a half-inch from the right side. The reason we chose 6" for the tab position is that Word does not count the 1.5" left margin when computing tab positions. Your **Tabs** dialog box should look similar to the one shown in Figure 14.5. Click **OK** to create the new tab.

- Press **Tab** and then type **Pasta**.
- The last step for the top text is to choose a font and font size. Quickly double-click on the text **From the Kitchen of Lauren Georges** to select the entire line. Select **Format** ➤ **Font** to get the **Font** dialog box shown in Figure 14.6. Choose any font and size you want. In this case, we selected **Arial** and used size **14**.

STEP 4: INSERT TOP PHOTOGRAPH

As our recipe page design has a photo at the top of the page, we'll insert it next.

- After using the arrow keys to move the cursor to the end of the word "Pasta," press **Enter** twice to drop down two lines to where the photograph of the tasty pasta dish will be added.

14.5

14.6

■ Select **Insert ➢ Picture ➢ From File** to display the Insert Picture dialog box. After choosing the folder and the image you want to use, click **Insert** to insert the image in the document.

■ If your image is not the size you want it to be, right-click on the image to get a pop-up menu; click **Format Picture** to get the **Format Picture** dialog box shown in Figure 14.7. Click on the **Size** tab. Make sure there is a check next to **Lock aspect ratio** and then set the **Width** or **Height** to be as you want it. In this case we will type **6.5"** in the **Width** box and **Height** will automatically be changed to **4.72"**. Click **OK**.

■ Press **Enter** twice to move the cursor down two lines.

STEP 5: CREATE TWO-COLUMN LAYOUT

As our design calls for the remaining portion of this page and the next page to have two columns, we can make the entering of text easy by changing the page format to a two-column layout.

14.7

■ To format the page to have two columns from below the top photo, select **Format ➢ Columns** to get the Columns dialog box shown in Figure 14.8. Click on **Two** under the column Presets heading and then set **Apply to** to **This point forward**. From now on, the text will be entered into two columns, on this page and any subsequent pages.

STEP 6: TYPE TITLE

■ Type the recipe title in now as **Mama's Farfalle with Marinara**. Select all of the title text and then choose an appropriate font. I used 36-point Arial. Notice how the text is automatically arranged to fit into the left column.

STEP 7: ADD TEXT

It is easy to now add an overview of the recipe, the ingredient list, and the directions. Simply type these in. When you get to a place where you want a break in the column, select **Insert ➢ Break** to get the Break dialog

14.8

box shown in Figure 14.9 **Click Column break** when you want to start new text at the top of the next column. If you need to insert a page break, you select **Page break**.

STEP 8: ADD IMAGES

Adding images is as easy as selecting **Insert ➤ Picture ➤ From File** and then choosing the appropriate folder and image file. Once an image has been inserted, its position can easily be changed by clicking on the image with the cursor and dragging and dropping it; or, you can also select an image and move it by tapping on the **Up**, **Down**, **Right**, and **Left** arrow keys. To add captions below the images, click on the image; then, press **Enter** once or twice and type in your text. The two-column format will continue to guide your text, captions, and images.

14.9

Once you have added the final images and captions, your first recipe page is complete. When making additional recipe pages, keep adding them to the same Word document in the order you want. In doing this, you will automatically be creating a cookbook.

STEP 9: ADD FOOTER TEXT

If you want to add page numbers to the footer, select **View ➤ Header and Footer** and you will get a pop-up menu bar similar to the one shown in Figure 14.10. Click on the **Switch between Header and Footer** icon. You can now type any footer information that you want at the bottom of each page. If you want to automatically insert "**Page X of Y**", click on **Insert Auto Text** in the pop-up menu bar and select **Page X of Y**. Word will now automatically number all of your pages for you.

> **NOTE**
>
> Many vendors make beautiful bound scrapbooks and scrapbook pages in a variety of sizes including 8½" x 11" and 12" x 12". Consider using one of these scrapbook binders instead of the standard 3-ring binders to make your own bound cookbook complete with your favorite recipes and your best color photographs. You can even add colorful chapter dividers by selecting from the incredible variety of scrapbook pages found online or at scrapbooking stores. If you save all of your recipe files that you create in Microsoft Word, you can also easily print additional cookbooks for family and friends. You can even e-mail your Microsoft Word-created recipes so that the recipients can make their own printed copies.

14.10

PRINT PHOTOS FOR SCRAPBOOK PAGES

15.1 Use Adobe Photoshop Elements to make the perfect-sized photographic prints for your traditionally-made scrapbook album pages.

WHAT YOU'LL NEED

Adobe Photoshop Elements ($80), a photographic-quality inkjet printer, and archival-quality photo paper

It surprised us when we learned that "scrapbooking" is a billion dollar business. It seems that many, many people have gotten into documenting their family histories, trips, and other important events and are hard at work preserving their photographs in a big way. If you are one of those people and you want to use a computer to create photographic prints for your scrapbook album pages, this project will be a useful one for you.

When making a scrapbook page, there are several approaches you can take. You can make scrapbook album pages the traditional way, which is a very manual and creative process of cutting and pasting a variety of items including photos on to a scrapbook album page. Or, you can create an entirely digital scrapbook page as shown in Project 16, which can then be printed on archival paper to create a long-lasting album page. If you plan

on creating a traditional album you can be much more flexible in your design if you use an image editor to transform your digital photos into the perfect-sized prints to match the requirements of your page layout. No longer will you be forced to cut out parts of 4" x 6" photos.

In this project, you learn how to use Adobe Photoshop Elements 3.0 to edit, crop, and size your photos to be exactly as you need, and how to place as many of them as possible on a single piece of paper to save on your printing costs.

STEP 1: CROP AND SIZE PHOTOS

Before we get started, we have to agree on a few things. First, let's assume the target printer is an Epson printer that has an optimal PPI rating of 240PPI. Let's also assume that we need to make photographic prints for a single scrapbook album page with the following specifications.

- Photo 1: 8" wide x 3" tall with text to be used for a title photo
- Photo 2: 3" x 2" elliptical-shaped photo
- Photos 3–5: Three 2" x 2" photos

The challenge: Take the photos shown in Figure 15.2 and crop and size them so they can be printed and placed on a traditional scrapbook page. And, we want to make these prints on a single piece of 8.5" x 11" paper to save money. Furthermore, we want to be able to do all of this very, very quickly as our scrapbook will have 24 pages and these are the photos that will be used on only one 12" x 12" scrapbook album page.

- Open the first photo in Adobe Photoshop Elements.
- Click on the **Crop tool** (**C**) in the **Toolbox**. As the goal is to crop an image that will be 8" x 3", in

the **Width** box of the Options bar, type **8 in** and, in the **Height** box, type in **3 in**. Type **240** in the **Resolution** box . Make sure **pixels/inch** is selected in the box to the right of the Resolution box. The Crop tool Options bar should now look like the one shown in Figure 15.3.

- It is easier to use the **Crop** tool if the document image is maximized by clicking on the **Maximize** icon, and when the image is fully visible in the workspace. Select **View ➤ Fit on Screen** (**Ctrl+0/ Command+0**) to make the entire image visible.
- You can now crop the image by clicking anywhere you want to start the crop and by dragging the selection to where you want the crop to end. The Crop tool is a wonderfully flexible tool. Once you have made an initial selection, you can click inside the selection marquee and drag the selection marquee where you want it. If you need to increase or decrease the size of the selection marquee, you can do that by clicking on and grabbing one of the corner handles. This flexibility not only makes it very easy for you to select the exact area you want

15.2

15.3

to crop, but you will also have a perfectly-sized image at the specified PPI setting once you are done. Click on the **Commit current crop operation** icon (the bold check-mark icon) in the Options bar, or select **Image ➢ Crop** to crop the image.

■ To add text, click on the **Text tool (T)** in the Toolbox. Click in the image and type the text you want to add. You can change font style and font size by clicking in the appropriate boxes in the Option bar. Select **Layer ➢ Flatten Image**.

■ Select **Image ➢ Resize ➢ Image Size**. A quick look shows that the image is now 8" x 3" at 240PPI, as shown in Figure 15.4 Click **Cancel** to close the dialog box. The final image looks like the one shown in Figure 15.5.

15.4

15.5

■ You can now perform the same procedure on the image that needs to be an elliptical shape. Only instead of choosing the **Crop** tool, click the **Elliptical Marquee** tool in the Toolbox. Make sure to choose **Fixed Aspect Ratio** in the **Mode** box in the Options bar; enter **3** in the **Width** box, and **2** in the **Height** box. Click and drag a selection to be where you want it.

■ Select **Image ➢ Crop** to crop the image. Select **Select ➢ Inverse** (**Shift+Ctrl+I/Shift+Command+I**). Select **Edit ➢ Cut** (**Ctrl+X/Command+X**) to cut out the image. The image should now look like the one shown in Figure 15.6.

■ To make the image be the correct size (i.e., sized at 3" x 2" at 240PPI), select **Image ➢ Resize ➢ Image Size** to get the Image Size dialog box. Make sure that there are check marks next to **Constrain Proportions** and **Resample Image**. Type **3"** in the **Width** box in the **Document Size** area. The **Height** value will automatically change to **2** inches. Type **240** in the **Resolution** box. If you look at the top of the Image Size dialog box you will notice the image size was 4.62M and it will be 1,012.5K, which means the image will be down-sampled. When you down-sample it is best to

15.6

choose the Bicubic Sharper interpolation method in the box following Resample Image. The **Image Size** dialog box should now look like the one shown in Figure 15.7. Click **OK** to apply the settings.

The last three photos need to be sized to make 2" x 2" prints. You can repeat the same process that was used earlier in this step to crop and size the photo with the text on it — only use 2" for both the width and height settings when cropping.

STEP 2: PLACE ALL PHOTOS IN ONE DOCUMENT

■ When you have all five images cropped and sized as you want you need to put them in one document to print. To create a new document select **File ➢ New ➢ Blank File** (**Crl+N/ Command+N**) to get the New dialog box shown in Figure 15.8. Make sure the increment box following **Width** is set to **inches**. Type **8.5** in the **Width** box, **11** in the **Height** box, and **240** in the **Resolution** box. **Color Mode** should be **RGB Color** and **Background Contents** should be set to **White**. Click **OK** to create the new document.
■ Assuming you have all of the cropped and properly sized images still open in the workspace, you can now click on each image with the **Move** tool (**M**) and drag it onto the new document. If you want to make it easy to cut out the photographs after they have been printed you should turn on the grid by selecting **View ➢ Grid** to place a check mark next to the Grid menu item. Then, click on **View ➢ Snap to Grid** — it too should be checked. Once the snap to grid feature is on the photos will line up precisely on the grid when moving each

image with the Move tool, thereby making it easy to make one cut and cut the edge of multiple images. Figure 15.9 shows how we laid out the images to make it easy to cut out the photographs.

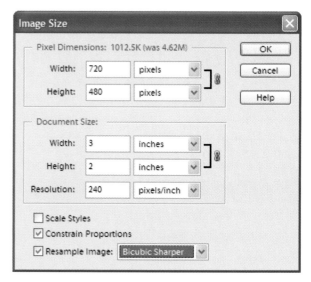

15.7

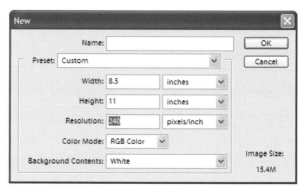

15.8

15.9

15.10

■ You are now ready to print the page by selecting **File ➤ Print** to get the Print Preview dialog box shown in Figure 15.10. Most of the settings should be correct. If you want to use a color profile for your specific printer, ink, and media make sure there is a check mark in the **Show More Options** box. Click in the **Print Space** box and choose the appropriate color profile. To learn more about color profiles, read Project 18. Click **Print** to begin printing.

If you don't have a photo-quality printer you can get prints made by uploading the files to an online printing service. See Project 22 to learn more about using online printing services such as Shutterfly. If you do choose to use an online printing service, make sure that you create a document that matches the same size as one of the print service's print sizes (e.g., 8" x 10" or 5" x 7").

CREATING A BASIC SCRAPBOOK ALBUM PAGE

Do that again, I don't belive you.

Why did the cat bite my finger?

In Grandfather's garden on January 5th, 2006

16.1 You can create outstanding scrapbook album pages digitally by using an image editor and a few of your digital photos — plus, it is easy to make multiple copies of your completed album.

WHAT YOU'LL NEED

Adobe Photoshop Elements ($80) and a couple of your own digital photos suitable for placement on a scrapbook page

I f you are one of the many people who have an interest in making scrapbooks and you want to use a computer to create stylish all-digital scrapbook album pages, this project will be a useful and fun one for you.

Making a scrapbook album page using Adobe Photoshop Elements 3.0 is easy. Sure, you need to have some design skill and a reasonable sense for choosing colors, patterns, textures, and shapes — but, you don't have to be a design expert to create wonderful scrapbook pages that can be enjoyed for generations.

In this project, we show you how easy it is to create a basic scrapbook design, add stamps, add digital photos, and add depth to all of the elements on a page. After you complete this project, you can pick a few of your own favorite photos, decide on a theme, and then create your first digital scrapbook album page.

STEP 1: PLAN LAYOUT

Assume the target printer has an optimal print resolution of 240PPI and that you are making the page to fit in a standard 12" x 12" scrapbook. The goal is to take a couple of your own photos, then crop and size them so they can be printed and placed on the scrapbook page you create in this project.

STEP 2: CREATE NEW PAGE

- With a quick bit of math, you find that you need an image that is 2,880 x 2,880 pixels (240PPI × 12" = 2,880). To create the new image, choose **File ➤ New ➤ Blank File** (**Ctrl+N/Command+N**) to display the New dialog box shown in Figure 16.2. Type **2880** in the **Width** and **Height** boxes, and make sure increments for both are **pixels**. Type **240** in **Resolution** and make sure the increment is **pixels/inch**. Alternatively, you could set **Width** to **12 inches**, **Height** to **12 inches**, and **Resolution** to

240 pixels/inch and get the same results. **Color Mode** should be set to **RGB Color** and **Background Contents** should be set to **White**. Click **OK** to create the new document.

STEP 3: CREATE BACKGROUND

- Adobe Photoshop Elements 3.0 offers several tools for creating backgrounds. One way is to choose **Edit ➤ Fill Layer** to open the Fill Layer dialog box shown in Figure 16.3. If you click the **Use** box and choose **Pattern**, you can then choose one of several different palettes of patterns including Artist Surfaces, Nature Patterns, or Texture Fill. Click in the **Custom Pattern** box to select one of the palettes, such as the **Artist Surfaces** palette shown in Figure 16.4. Click **Cancel** to close the **Fill Layer** dialog box as there is a different technique that will be used for this project.
- Let's fill the image with a cloud-like background made of soft pink and blue. To select the two colors, click the **Set Foreground Color** icon at the bottom of the **Toolbox** to get the Color Picker shown in Figure 16.5. Make sure **Only Web Colors** is not checked. Type **132**, **167**, and

16.2

16.3

220 in the **R**, **G**, and **B** boxes respectively to select a baby blue color; then, click **OK**. Now click the **Set Background Color** icon at the bottom of the **Toolbox** to get the **Color Picker** again. Make sure you have clicked on the Background color and not the Foreground color. This time, type **233**, **149**, and **194** respectively in the **R**, **G**, and **B** boxes to get a pink color; click **OK**.

■ Choose **Filter** ➢ **Render** ➢ **Clouds** to fill the background with the two colors. You should now see a nice pink and blue background.

STEP 4: CREATE NEW BLUE LAYER

■ Now add a new layer and fill it with blue. Choose **Layer** ➢ **New** ➢ **Layer** (**Shift+Ctrl+N/ Shift+Command+N**) to display the Layer dialog box; click **OK**.

■ Click the **Lasso** tool (**L**) in the Toolbox. Click the image toward the bottom left and create a selection such as the one shown in Figure 16.6.

■ Choose **Edit** ➢ **Fill Selection** to display the Fill Layer dialog box. Click the **Use** box and select **Foreground Color** to pick the blue color. Click **OK**. The selection area is now filled with the blue color.

16.5

16.4

16.6

■ To add an edge to the layer, open the **Styles and Effects** palette by choosing **Window ➤ Styles and Effects**. Click in the **Category** box and choose **Layer Styles**. Click in the **Library** box and click **Bevels** to get the palette shown in Figure 16.7. Click the **Simple Emboss** style to add a nice soft bevel. To remove the selection, choose **Select ➤ Deselect** (**Ctrl+D/Command+D**).

■ Click the **Styles and Effects** palette and move it out of the way of the image, but leave it open as you'll use it again shortly.

STEP 5: ADD PHOTOS

■ Now we add the two photos shown in Figure 16.8. Choose **File ➤ Open** (**Ctrl+O/Command+O**) to display the **Open** dialog box. After double-clicking the folder that contains the two photos that will be used, click one of the image files to select it. Press and hold the **Ctrl/Command** key and click a second file to select both images. Click **OK** to open both files.

■ Click the **Move** tool (**V**) in the **Toolbox** and then click the first file to make it the active file. Click in the image and drag the cursor onto the background image to place the image in your newly created album page.

■ To scale the size of the photo, choose **Image ➤ Resize ➤ Scale**. Press and hold **Shift** and click one of the corner selection marquee handles to reduce or enlarge the size of the image. Pressing **Shift** keeps the width and height proportions the same as the original. If you want to move the image, you can click inside the selection marquee and drag the image where you want it. Press **Enter/Return** to commit the size change.

■ Follow the same process to place the second image. If you want to crop the image, you can do so using the **Rectangular Marquee** tool (**M**). After making a selection, choose **Select ➤ Inverse** (**Shift+Ctrl+I/Shift+Command+I**); then choose **Edit ➤ Cut**.

STEP 6: ADD BACKGROUND PAPER TO EACH PHOTO

■ Your Layers palette should now look like the one shown in Figure 16.9. Now, add a pink background paper layer beneath one of the photos. In the **Layers** palette, click **Layer 2**, which is the layer

16.7

16.8

with the beveled blue element. Clicking here will make the new layer appear behind the first photo. Choose **Layer ➢ New ➢ Layer** (**Shift+Ctrl+N/ Shift+Command+N**) to display the New Layer dialog box; click **OK**.

■ Choose **Edit ➢ Fill Layer** to view the Fill Layer dialog box. Click in the **Use** box and choose **Background Color** to pick the pink color; click **OK**. You should now have a pink layer.

■ Click the **Rectangular Selection Marquee** tool (**M**) in the **Toolbox**. Carefully click and drag a selection marquee around the first photo while leaving a nice pink border.

■ Choose **Select ➢ Inverse** (**Shift+Ctrl+I/ Shift+Command+I**) to reverse the selection.

Choose **Edit ➢ Cut** (**Ctrl+X/Command+X**) to remove the extra pink background. Your image should now look similar to the one in Figure 16.10 only it features your photos.

■ To add a shadow to the pink background, click the **Simple Outer** style in the **Styles and Effects** palette.

■ You should repeat the previous steps to add a blue-colored background to the second image.

STEP 7: ADD TEXT

■ Click the **Horizontal Type** tool (**T**) in the **Toolbox**. Click the image where you want to add text. In the **Options** bar, choose a font style and set size to about **24 pt**. The **Foreground color** is the color of the text. If you want a different color, you can choose it by clicking the **Color** box in the **Options** bar, or by changing the **Foreground Color** at the bottom of the **Toolbox**. Type the text

16.9

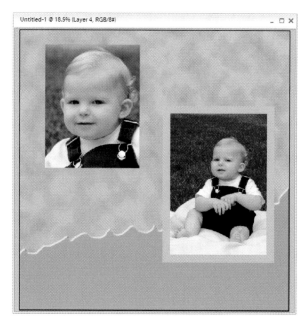

16.10

you want to display and press **Enter/Return** to commit the text. If you want to move the text, use the **Move** tool (**M**).

■ Notice that you can press **Enter/Return** to get a new line of text. Also, the text can be set to be left- or right-justified, as well as centered. If you add one or more lines, you need to set the **Leading** on the **Options** bar to be at least the size of the font you are using.

■ When you have all the text on the image where you want it, you can reduce the number of layers by clicking the **Link** icon to the left of all the text layers in the **Layers** palette; then choose **Layer ➢ Merge Linked** (**Ctrl+E/Command+E**).

STEP 8: ADD STAMPS

Some common features of traditionally made paper-based scrapbooks are the stamps, tags, and other elements that are usually glued onto a scrapbook page. Now you can add a few simple elements to the page. How about adding three or four butterflies?

■ Click the **Cookie Cutter** tool (**Q**) in the **Toolbox**. Click in the **Shapes** box in the Options bar to display the Shapes palette shown in Figure 16.11. If the palette looks different, click the triangle icon in the upper-right corner and choose **Small Thumbnail**. Click the triangle icon once again and select **Animals**. Click the **Butterfly 2** icon. It is very important that you remove any check mark that may be in the **Crop** box on the **Options** bar, as shown in Figure 16.12 or you will crop out the entire scrapbook page that is not covered by the stamp!

■ You now need to make a new blue layer for each of several butterflies. Because you want the butterflies to be on the very top layers, click the very top layer in

the Layers palette. Choose **Layer ➢ New ➢ Layer** (**Shift+Ctrl+N/Shift+Command+N**) to summon the New Layer dialog box; click **OK**. Choose **Edit ➢ Fill Layer** to display the **Fill Layer** dialog box. Click the **Use** box and select **Foreground Color** to pick the blue color. Click **OK** to create the new blue layer.

■ Using the **Cookie Cutter** tool (**Q**), click in the image and drag the cursor to form the size and shape of butterfly you want. You can also type values in the boxes in the Options bar to pick a preset size or an angle of rotation. After the butterfly looks the way you want, press **Enter/Return**. If you need to move the butterfly, you can click in the butterfly with the **Move** tool (**V**) and move it where you want it.

■ To add a bevel, click the **Simple Outline** style in the **Styles and Effects** palette that you used earlier.

16.11

16.12

To add more stamps, create a new layer for each one and fill the layer with the background color you want. After you have all the stamps sized and placed where you want them, you can merge them all into a single layer and apply a **Styles and Effects** effect to them. To merge the layers, use the **Link** feature in the **Layers** palette and choose **Layer ➢ Merge Linked** as you did with the text in Step 7.

STEP 9: FLATTEN LAYERS AND SAVE FILE

■ When you have all the text, layers, stamps, and everything else you want where you want it, you can choose **Layer ➢ Flatten Image** to flatten all of the layers. You can then save the page to a file that is much smaller than if you had not flattened it. Or, if you want to make changes later, make sure to save the file as a .psd file and make sure you check the box next to **Save Layers**.

While you may claim that this scrapbook album page won't win any design awards, you must give us credit for using this project to give you a good tour of many of the Adobe Photoshop Elements 3.0 features that are useful for making a good scrapbook album page. You have learned how to work with layers, add photos, add stamps, add background papers, and add bevels to various elements, and this is just the beginning. With that knowledge alone, you can create some wonderful scrapbook album pages. Pick some of your photos and create a few pages.

If you want to see some truly inspired, fully-digital designs that rival any traditional scrapbook album page, visit Cheryl Barber's Web site at www. cbdigitaldesign.com. Figure 16.13 and Figure 16.14 show two of her creative designs. Her useful Web site offers a scrapbooking forum, many sample designs, tips, a newsletter, and an online store where you can buy a variety of digital scrapbooking items such as background paper, design templates, overlays, alphabets, and much more.

16.13

16.14

CREATE A PRINTED COLLECTION CATALOG WITH PHOTOS

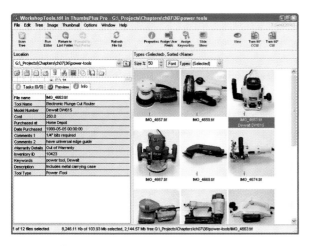

17.1 One of the easiest ways to create an inventory of items such as power tools is to create a photographic database using your digital camera and an image manager like ThumbsPlus Pro.

WHAT YOU'LL NEED

Cerious Software's ThumbsPlus Pro (www.cerious.com), or a similar image management application, and an inkjet printer for printing out catalog pages.

Do you have a valuable silver dining service set? Are you fortunate enough to have an expensive collection of jewelry or watches? Maybe you have an incredible collection of Beanie Babies — they are still being collected, aren't they? Ever wonder how many power tools you have and how much money you have invested in them all? Do you ever worry about not having serial numbers and a good inventory of your collectables? Wouldn't you like to have a photographic database of all the flowers you have had in your garden over the years? Would you like an easy way to catalog your music CD collection that does not involve keying in the name of every artist and CD title? If your answer to these and many other similar questions is yes, then this is a project that will be useful to you.

If you ever lose some or all of the items in a collection and you have to report the loss to an insurance company, one of the first things your insurance agent will ask you is: Do you have a written record of your collection?

In this project you will learn how easy it is to create a printed photographic record of your favorite possessions for insurance reasons or just to document the items you have and keep track of other appropriate information such as purchase dates, age, serial numbers, design, vendor, species (are there different species of Beanie Babies?), etc.

TAKE PHOTOS

How you go about getting the best photos for your inventory or collection record depends on what you are documenting and how you plan on using the images. If you are creating a database of the tropical water lily collection you have grown in your pond, you will probably want to take considerable time and effort to shoot each lily against a contrasting background using a digital camera mounted on a solid tripod. Not only can these carefully taken images be used in your lily collection database, but you will also have large images that can be used to make wonderful prints like the one shown in Project 9.

If your objective is to simply have an insurance record of power tools for example, you can quickly take snapshots using a consumer-level camera. Pick the best light you can find and shoot the power tools against a light-colored mat board taking care not to underexpose the images and to avoid getting "blown-out highlights." You can even save yourself some time and increase the accuracy of your database if you use your camera's macro mode feature to take a close-up photo of any serial number plates that may be found on your inventory items. Figure 17.2 shows the "quick and dirty" style of cataloging woodworking tools with photos that we use in this project.

STEP 1: CREATE NEW DATABASE

While it is possible to use the same database that you use for managing your digital photos, you really ought to create a new and separate database for each collection you want to record. This allows you to create user fields that have been created specifically for each of your collections.

■ Using ThumbsPlus Pro 7.0, select **File ➣ Database ➣ New Database** to get the dialog box shown in Figure 17.3. To keep the ThumbsPlus database with all of the woodworking tool photos, choose the folder where the images are stored. Type **Workshop Tools** in the **File Name** box. Set **Width** and **Height** in the **Thumbnail dimensions** area to **256** so that ThumbsPlus will create large

17.2

thumbnail images that are easy to view. Type in **Workshop Tool Inventory** in the **Database Description** box and click **Save** to create a new database.

STEP 2: GENERATE THUMBNAILS

■ Click on the folder where the workshop tools were stored and ThumbsPlus will automatically generate thumbnail images of all of the images in the folder.

STEP 3: CREATE USER FIELDS

Now is the time to truly customize your new photo database to meet your specific requirements. ThumbsPlus allows you to create your own data fields and then add information to these fields.

■ Select **File ➢ Database ➢ User Fields** to get the User Fields Setup dialog box shown in Figure 17.4.
■ Click in **Field Label** and type **Tool Name**. Click in **Field Type** to select **Text** as the field type. Type **30** in the **Field Length** box and click **Add**.
■ You can now add more fields in the same manner. Make sure to choose the right field type for the data you want to enter. Figure 17.4 shows all the fields we used and the parameters we set for each of those fields. Once all your fields are entered, you can click the up-arrow or down-arrow scrolling buttons to place the fields in the order that you want.
■ Once all the fields have been entered, click **OK**.

17.3

17.4

You do not have to enter all of the fields that you want all at once. If you find that you need to add or delete fields, you can do so at any time.

STEP 4: ENTER USER FIELD DATA

■ You can easily enter data into the user fields that were defined in Step 3 by right-clicking on any thumbnail image in the ThumbsPlus thumbnail pane to get the **File Properties** dialog box. Click on the **6. User Fields** tab to get the dialog box shown in Figure 17.5. Type in any of the data you want to enter. The best part of this approach is that you can open up an image and type in the serial number, product number, and any other information you can read on any labels that might be visible in your digital photo.

■ Click **Close** when you have completed filling in the fields.

■ Continue entering the user field data for other images in the same manner.

> **WARNING**
>
> The more time you take to enter textual information such as serial numbers, purchase price, and purchase date into an image manager application, the more important it may be to keep the original software disk and to back up your data files along with the image files. The loss of either the software or the data files will make waste of all your hard work and invested time unless you have backups.

STEP 5: VIEW DATABASE ITEMS

With a little more setup effort you will be able to view all of the workshop tool thumbnails and view the user fields for one item at a time.

■ Click on the **Info** tab in the **Folder View** area. Right-click anywhere in the **Info** tab area to get a pop-up menu and choose **Select Items** to display the Select Items dialog box. Click on the **Fields** tab to show the fields that were created in Step 2. You can now select the fields that you want to show by clicking on them and then clicking the right-arrow button.

■ Once you have selected all the fields that you want, you should type a name in the **Items set name** box and click **Save** to save your choices. The **Select Items** dialog box should now look similar to the one shown in Figure 17.6.

■ Click **OK** to create the view.

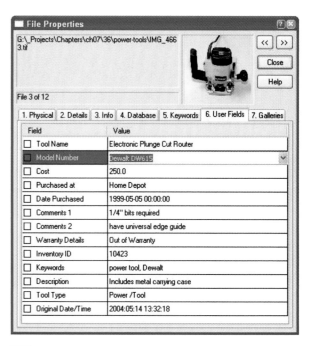

17.5

You can now click on any thumbnail image and read all the user field data as is shown in Figure 17.7.

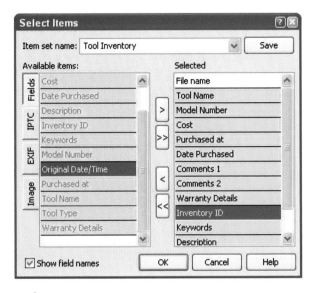

17.6

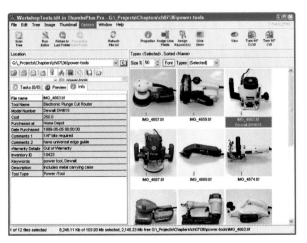

17.7

STEP 6: PRINT INVENTORY

There are many options available for getting a printed inventory. Not only can you use a number of features found in ThumbsPlus, but you may also export all the database information to a text file that can be read by spreadsheet or database software, which gives you incredible report printing capabilities.

■ To get a printed copy of the workshop tool photos and data, select **File** ➢ **Print** to display the Print Settings dialog box and click on the **Text & Option**s tab to get the dialog box shown in Figure 17.8.

■ Click on **Select Items** to display the Select Items dialog box and then click on the **Fields** tab to get the customized fields that were added earlier in Step 2. Click in the **Item set name** box and select **Tool Inventory** to select all the fields in the order that was chosen in Step 4. Click **OK** and click **OK** again to being printing the report.

17.8

■ If you want to export the database as text to use in a spreadsheet, Word document, or other type of textual report, select **File ➢ Database ➢ Export** to get the Export dialog box shown in Figure 17.9. Using this dialog box you can choose the name of the export file and where it should be saved, the records that are to be exported, and the specific fields that are to be exported.

Once you have digital photos of all of your items and you have created and entered appropriate user field data, you will be able to do many other things with the photos and the information you've entered including:

■ Search for specific fields
■ Create Web pages showing images and textual information
■ Run slideshows of your collection, and much more.

That concludes this chapter. In the next chapter you'll learn how to make your own prints.

17.9

TIP

Have you always wanted a quick and easy way to catalog all of your music CDs, record albums, tapes, or books? Using a digital camera, you can quickly take a photograph of the front and back of each item to be stored in an image management database. If you want to add textual content such as title, recording artist, author, etc., you can do so by simply looking at the photo image you have stored and typing the information contained on it into the database.

ALTERNATIVE APPROACH

Using an image manager like Cerious Software's ThumbsPlus 7.0 is a simple and quick way to create a photographic record of items in your collections and it can also be used to make a printed record too. Should you need to have a much more sophisticated system that can sort by specific fields, add up the values of fields such as purchase price, or categorize items in various ways; you may need to use a database application like Microsoft Access (included in the Microsoft Office Professional Edition suite or it can be purchased separately) or Filemaker, Inc.'s FileMaker Pro 6.0. Both of these database applications have a variety of features like wizards that make it fairly easy for you to create your own customized database with digital photos, and to generate the screen and printed reports to meet your needs. You do not need to be a database expert to be an expert at managing your collection catalogs with these tools, but do plan on spending some time creating the system you want.

MAKING YOUR OWN PRINTS

About that notion that grass is always greener on the other side...

Being able to share digital photographs electronically is one of the best aspects of digital photography. You can shoot and then share your photos with anyone in the world who has a connection to the Internet, almost instantly. However, there is nothing like a carefully made photographic print of a well-edited image, or even a few quickly made prints to share with others. In Project 18, you learn how to make fine art prints on fine art paper. The topic of Project 19 is how to easily and quickly print a batch of 4" x 6" prints. Pick your favorite photos and make greeting cards to suit the recipients by following the steps in Project 20. Learn how to make your own personalized calendar by following the steps in Project 21. If you have an inkjet printer, get ready to make prints!

January **2006**

Mon	Tue	Wed	Thu	Fri	Sat	Sun
						1
2	3	4	5	6	7	8
9	10	11	12	13	14	15
16	17	18	19	20	21	22
23	24	25	26	27	28	29
30	31					

MAKING FINE ART PRINTS ON FINE ART PAPER

IRELANDSCAPE 2004 Gregory Georges '04

18.1 To make outstanding prints suitable to frame and hang on a wall, consider making an inkjet print using a pigment-based inkjet printer and fine art paper.

WHAT YOU'LL NEED

Adobe Photoshop Elements ($80), a photo-quality printer, fine art inkjet paper, and an edited photo of your choice

Glossy photo papers have long reined as the photo papers of choice for traditional chemically-processed prints. As inkjet printers have become more popular, their ability to print on fine art paper is fast making fine art paper the preferred paper for many digital photographers. Some of the currently available combinations of inkjet printer, ink, and fine art paper can be used to make photographic quality prints that rival chemically printed prints in all ways. If you have not yet tried making a print on fine art paper and you have a printer that can do so, you should try making one.

131

For this project, we chose an image that was made by digitally stitching eight photos together using the PhotoStitch software that is included free with many of the Canon digital cameras. The photo, which was taken on the west coast of Ireland, is almost 60MB and is 5,972 x 3,496 pixels. Using a printer setting of 360PPI, this image makes a nice print that is 9.7" x 16.6". To make a print this large, you need to use a printer that can print on 13" x 19" paper.

WHAT INKJET PRINTER SHOULD YOU BUY TO PRINT ON FINE ART PAPER?

If you don't already have an inkjet printer you may be wondering which one you should buy. Admittedly, answering that question is not an easy thing to do as there are about as many opinions about what inkjet printer is best as there are opinions on whether it is better to use a Mac or a PC, or to eat an apple or banana when you get hungry. The best inkjet printer for you also depends on how you want to use one and we don't know anything about your intentions. However, if we agree to narrow your selection of inkjet printers down to just those that can be used to make long-lasting archival prints on fine art paper (not glossy photo paper) with excellent tonality and color, you have rapidly narrowed the choice down to pigment-based inkjet printers. At the time this book was written, the Epson Stylus 1800, shown in Figure 18.2, the Epson 2200, and the Epson Stylus R800 were the only pigment-based inkjet printers on the market under $1,000. So, for that reason we recommend that you consider choosing an Epson Stylus Photo 1800 if you want to print on up to 13" x 44" paper, you want a pigment-based inkjet printer, and you have around $550 for the printer. It is our printer of choice and it makes wonderful prints on fine art paper and glossy photo paper, too. If you are willing to limit your print size to 8.5" x 44", the Epson R800 is an exceptional printer. Not only does it use the Epson 8-color UltraChrome Hi-Gloss pigment ink, but it can also print borderless

prints up to 8" x 10". At around $400 it is one of the best printers you can buy for printing on matte papers. If your intent is to print primarily on glossy photo paper, you can find many excellent inkjet printers for as little as $100 and up. To learn more about selecting an inkjet printer for making glossy photos, read Project 19.

STEP 1: CHOOSE A FINE ART PAPER

Choosing a fine art paper is not an easy task. There are many fantastic papers on the market and the paper that works best for one kind of image may not be the best paper for another kind of image. Sometimes the ideal paper is one that allows you to print deep, rich, highly saturated colors on a smooth surface. Or, you may want something that allows for a soft, subtle, tonal range that makes a print that looks like a muted watercolor-painting on textured watercolor paper. If you are into a seriously creative mode,

18.2

you may even want to print on some of the transparent Japanese inkjet papers, such as rice paper. So, your "vision" is the most important factor to consider when selecting a paper.

There are many paper characteristics that you also want to consider when choosing a paper including: texture, brightness, color, print longevity, availability, weight (paper thickness), availability of color profiles, and cost. If you plan on selling prints or you want to have confidence that the prints will last for a long time, you should choose a paper that has been tested by an independent testing service. To learn more about paper and ink set testing, visit `www.wilhelm-research.com`. This is the Web site of Henry Wilhelm, the recognized expert in print longevity. You can find all kinds of valuable information about inkjet printing on this site and you can get print permanence data for many inkjet printers and popular papers.

The testing and trying out of many papers can not only be tedious and time-consuming but more importantly, the whole process can be frustrating and reduce the time you have to take photographs. To learn more about inkjet printing and which papers to use in a supportive and active online forum, visit Harold Johnson's Digital Fine Art forum `http://groups.yahoo.com/group/digital-fineart`. His Web site, `www.dpandi.com` is worth an occasional visit and he has written a fine book on digital printing titled *Mastering Digital Printing, Second Edition* (Thomson Course Technology PTR, 2005).

For our printing purposes, we chose the following fine art papers to use with an Epson Stylus Photo 2200 printer (which is a similar printer to the newer Epson Stylus 1800) using the Epson Matte Black ink.

- Epson Enhanced Matte Paper (`www.epson.com`)
- Epson Velvet Fine Art Paper (`www.epson.com`)
- Moab Paper Entrada Fine Art Bright White or Natural (`www.moabpaper.com`)
- Crane Museo Digital Print Making Paper `www.crane.com/museo`

TIP

The temptation to continuously try different fine art papers is one that should be resisted unless you have lots of time, and a considerable amount of money for paper and ink. The best approach for getting good prints on your inkjet printer is to buy one or more sample paper packs and experiment with the papers that you like until you find one to three papers that suit your printing needs. Obtain and install appropriate color profiles (see Step 3 in Project 18) and learn how to get the best results with a well-selected and limited set of papers. Over time you will get very consistent results while saving time and money.

One advantage of buying papers from Epson, Moab, and Crane is that they provide free color profiles for their papers when used with many different ink sets and inkjet printers. Epson only offers color profiles (an essential file that helps your prints match what you see on your computer screen) for Epson printers as you may expect, but the Epson papers are some of the best papers you can buy for Epson printers.

Many other companies make and/or sell excellent fine art papers and they usually sell sample packs that allow you try out different kinds of papers without having to buy an entire package to try a few sheets. Other good sources of paper and other photo-related products are:

- `www.designjet.hp.com/supplies`
- `www.digitalartsupplies.com`
- `www.hahnemuhle.com`
- `www.hawkmtnartpapers.com`
- `www.legionpapers.com.`
- `www.moabpapers.com`
- `www.redriverpapers.com`

STEP 2: CALIBRATE YOUR MONITOR

One of the most significant challenges to making the perfect photographic print using your computer and an inkjet printer can be to get the colors and tonal range of the print to match the colors and tonal range you see on your computer screen. You can get prints that match the screen image by pure luck or by hard work. If you are lucky, your prints will match the images on your screen without your having to do anything! We have known many people who have purchased a quality computer screen and just started editing images and making prints that matched. This is just pure good luck and if you are pleased with how your prints turn out, then please count your blessings and jump to Step 3.

If you are one of the unlucky ones, you will have to calibrate your monitor, or you may even have to buy a new monitor. Not all monitors have the controls that you need to adequately calibrate them and some monitors simply are not capable of giving you the view you need to accurately control the color in your images.

Efforts by computer screen vendors are now being focused on making flat-panel screens and it is a good bet that they will become the computer screen of choice in the near future. However, when this book was written, there were only a few flat-panel screens that were worth buying if you are picky about color and tonal range when editing your digital photos. Those flat-panel screens cost more than $1,500.

If you need to calibrate your monitor, you can take two different approaches. First, you can run the Adobe Gamma application that gets installed when you install Adobe Photoshop Elements 3.0 on a PC. You can find this application in the Control Panel. It can be used in a Wizard mode that provides pretty good instructions as to how it should be used. If you are using a Mac, you should run the Display Calibrator Assistant, which you find in Systems Preferences. Admittedly, both of these utilities may, or may not give you satisfactory results. Don't give up on them until you have tried using them a couple of times.

If you fail to get the results you want with Adobe Gamma or the Display Calibrator Assistant, you need to use a hardware device called a colorimeter. Figure 18.3 shows the MonacoOPTIXXR Monitor Calibration System, which is placed on your computer screen. At around $300, the MonacoOPTIXXR is an excellent tool to use to calibrate your screen. You can learn a tremendous amount about color management, but our suggestion is to simply be lucky, or to get a colorimeter and run the simple software utility that comes with it to calibrate your screen. If you want to learn more about monitor calibration, visit Ian Lyon's Web site, `www.computer-darkroom.com` and `www.xrite.com`, the Web site of the vendor that makes the MonacoOPTIXXR colorimeter. Another vendor that makes excellent colorimeters is Gretag Macbeth (`www.gretagmacbeth.com`).

18.3

STEP 3: OBTAIN AND INSTALL COLOR PROFILE

If you think about the process of an inkjet printer spraying ink on different kinds of paper with different paper characteristics, color, texture, and inkjet print coatings, understanding how one image prints differently on different kinds of papers is easy. So, with that thought in mind, you may be quick to wonder how you can use one printer and get the right colors and tonal range when printing on a wide variety of inkjet papers. The answer is: You must use a color profile. In simple terms, a color profile is data used by your computer and inkjet printer to get consistent color. You need a color profile for each printer, ink set, and paper that you use. All color profiles are not created equal. In other words, some color profiles can give you better results than others.

> **NOTE**
>
> **Getting the color and tonal range of your prints to match that of your computer screen can be challenging. The process of making color match between devices and prints is known as *color management*. Color management is one of the more complex topics in digital photography today. However, if you have a quality computer screen that has been properly calibrated either with Adobe Gamma (for a PC) or Display Calibrator (for Mac), or you have used a colorimeter, and you are using an appropriate color profile for your printer, ink set, and media, you should be able to get prints that you like. You do not have to become a color management guru to get prints with colors that match the colors on your computer screen.**

Where do you get color profiles? You can pay to have them custom created for you for your chosen paper, and your specific inkjet printer, and ink set. Many paper vendors are now providing free color profiles for their papers. If the paper vendors do not provide color profiles, many of the more progressive media suppliers, such as Digital Art Supplies (`www.digitalartsupplies`) make limited sets of color profiles for the more popular papers they sell and more commonly used printers. Likewise, many printer vendors provide free color profiles for their printers, ink sets, and media. Or, you can buy expensive hardware and software and create your own color profiles. We have had pretty good results with the free color profiles and expect that you will, too. It is the rare case that we have had good results using a paper without a color profile.

For this project, we printed the Ireland image using all four of our favorite fine art papers that were listed previously. In each case, we used color profiles that were available free from the vendors' Web sites. All four prints were excellent, but the print made on the Epson Velvet Fine Art Paper had darker shadows, which resulted in the image having a little more contrast. So that is the paper we use here as an example of how to use a color profile when printing from Adobe Photoshop Elements 3.0 and when using an Epson Stylus 2200 printer. If you are using a different printer or paper, the process will be the same — just make sure you select an appropriate color profile for your printer, ink set, and paper.

To get the color profile for Epson Velvet Fine Art Paper for use with an Epson Stylus 2220 go to `www.epson.com` and look for the ICC Printer Profiles for the Epson Stylus Photo 2200. After downloading the profile to your hard drive, you can install it by following the simple directions that get downloaded with the profile. You should also download any help files that may be available, too, as they may contain important printer settings that you need in addition to the color profile. The process of installing profiles depends on your operating system.

STEP 4: PRINT IMAGE

With a properly calibrated monitor, an installed color profile for the chosen combination of printer, ink set, and paper — you should be ready to make a print that matches your computer screen. See if that is truly the case.

- Launch Adobe Photoshop Elements 3.0 and choose **Edit and Enhance Photos** to get the Editor.
- Choose **Edit ➢ Color Settings** (**Shift+Ctrl+K/ Shift+Command+K**) to get the Color Settings dialog box shown in Figure 18.4. Click **Full Color Management** if it is not already selected. Click **OK** to close the dialog box.
- Open the image that you want to print.
- Choose **File ➢ Print** (**Ctrl+P/Command+P**) to get the Print Preview dialog box.

- Click **Page Setup** to get the Page Setup dialog box. Click **Printer** to get the Page Setup dialog box shown in Figure 18.5. Click in the **Name** box if the correct printer is not showing. In this case, we choose **EPSON Stylus Photo 2200**. Click **OK** to apply the settings and return to the Page Setup dialog box.
- Click the drop-down arrow in the **Size** box and choose **Super B (13 x 19 in)**. Click the drop-down arrow in **Source** and choose **Manual** because the **Epson Velvet Fine Art Paper** is so thick that it must be fed manually into the back of the printer. Click **Landscape**. The dialog box should now look like the one shown in Figure 18.6. Click **OK**.
- You should now be back in the Print Preview dialog box, as shown in Figure 18.7. The preview image should now accurately reflect how the image will be printed on the 13" x 19" paper. Click in the **Print Space** box and choose the printer

18.4

18.5

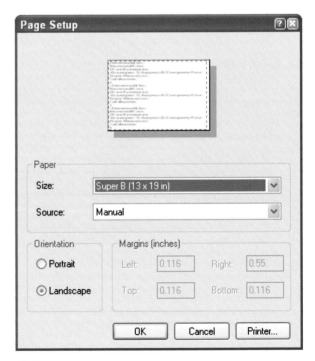

18.6

profile that you downloaded in Step 3. The printer profile we downloaded from the Epson Web site when this book was written was labeled, "**SP2200 VelvetFineArt 1440MK.icc**". When you download the profile, it may be labeled differently.

■ Click **Print** to get the Print dialog box. Click **Properties** to get the Epson Stylus Photo 2200 Properties dialog box. Make sure that you choose **Velvet Fine Art Paper** in the second box below **Paper & Quality Options**. The box just below that one should be set to **Photo – 1440dpi**. Click **ICM** in the **Color Management** area and choose **No Color Adjustment** in the **ICC Profile** area. To get the useful, paper-saving Print Preview dialog box, make sure there is a check mark next to **Print Preview**. The dialog box should now look similar to the one shown in Figure 18.8.

■ Click the **Page Layout** tab to get the dialog box shown in Figure 18.9. Click in the box next to **Centered** to center the image in the page. Click **OK** to close the dialog box.

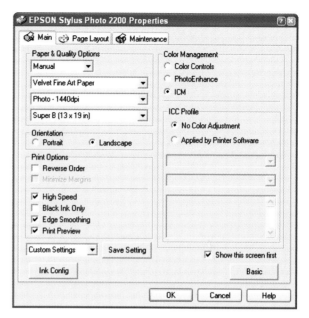

18.8

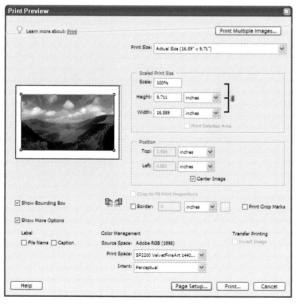

18.7

18.9

■ Click **OK** to get the Print Preview dialog box shown in Figure 18.10. Don't worry if the colors don't look correct — they never are correct! Just use this image to ensure that you have the settings correct to place the image on the page correctly and that it is sized as you intended. This valuable Print Preview dialog box is a useful feature to help you avoid printing an image that has not been sized properly, or one that is about to be printed with incorrect paper size settings. If the image does not look correct, click **Cancel** and check your settings. If the image looks correct you can click **Print** to begin printing your image. You should now have a print that closely matches the tonal range and color of your computer screen.

STEP 5: PROTECT PRINT

After you make a print, you should protect it from being damaged. Inkjet prints are vulnerable to more than just fingerprints. The ozone in the air, light, and the act of sliding prints on top of other prints can ruin your prints. After letting the prints dry for a day, we

have made it a routine to place them in protective archival quality 3mil. Polypropylene sleeves made by Clear Bags, Inc. (`www.clearbags.com`). You can also buy these sleeves in a variety of sizes and styles from Digital Art Supplies (`www.digitalartsupplies`) and Print File (`www.printfile.com`). These vendors make sleeves for most common paper sizes.

18.10

PRINTING A BATCH OF 4" x 6" PHOTOS

19.1 Use Adobe Photoshop Elements 3.0 and your photo-quality inkjet printer to quickly print a batch of photos and save yourself a trip to your local one-hour photo lab.

WHAT YOU'LL NEED

Adobe Photoshop Elements ($80), a photo-quality printer, **4" x 6" glossy inkjet paper, and a selection of your favorite photos**

Many photographers using film cameras enjoy getting fast turnaround on their prints by dropping the film off at a one-hour photo lab. Most one-hour photo labs usually do a *pretty good* job on *most* of the prints. Rarely are the prints excellent, and rarely are they all printed perfectly. But, that was acceptable in the film days. What is strange to us is that many of those same people are now shooting digitally and they won't make a print unless they spend hours editing, cropping, and making their prints perfect.

If you are shooting digitally and you have your own photo-quality inkjet printer, don't pass on making your own prints because you don't have the time to edit each image and make perfect prints. There is a time and place for "quick" prints and Adobe Photoshop Elements 3.0 has several features that

139

can help you to get *pretty good* prints *most* of the time with little effort. In this project, you learn how to print a batch of photos using the Adobe Photoshop Elements 3.0 QuickFix and Print Multiple Photo features.

WHAT INKJET PRINTER SHOULD YOU BUY FOR MAKING GLOSSY PRINTS?

Ah-ha — there is that nasty question again! What printer should you buy? When we answered that question in Project 18, the goal was to make a print on archival-quality fine art paper — and therefore the question was much easier to answer. In this project, the goal is entirely different. The goal now is to rapidly print a batch of snapshots on 4" x 6" glossy paper. With this goal in mind, there are many, many acceptable printers that cost as little as $90 and up.

The good news is that there is a wide range of printers that are being made by vendors who are intent on giving you exactly what you want. The frequency of the introduction of new models is so short that it is not possible to make specific brand and model recommendations. However, we have generally found that printers from Canon, Epson, HP, and Sony are usually good choices.

Admittedly, that was not very helpful for you if you are ready to buy an inkjet printer. However, we will tell you about three different kinds of inkjet printers you may want to consider. Once you've decided what kind of printer you want you should visit `www.cnet.com` or `www.pcmag.com` to learn more about the currently available printers and where you can buy them.

If you only want to make 4" x 6" prints and you don't want to use a computer

There are a good number of camera and printer vendors that have worked together to provide all kinds of software and hardware technology that makes it as easy as possible to simply shoot and make pretty good prints without your having to own or use a computer. To make prints you just connect your digital camera to the printer or you insert a digital photo media card into the printer's media reader. Good examples of inkjet printers that don't require a computer that print 4" x 6" prints include the Canon CP-330, the Epson PictureMate Inkjet Printer, or the HP Photosmart 375 Compact Photo Printer. All three of these printers sell for around $200.

If you want to print high-quality glossy prints up to 8.5" wide

The next category of inkjet printers are those that print on paper up to 8.5" wide and generally 19" or longer. There are more inkjet printers in this category than in any other category. Most printer vendors make many different printer models in this size category. At the time this book was published we liked the Canon Pixma iP5000 ($175), the Epson Stylus Photo 320 ($175), and the HP Photosmart 8450 ($220).

If you want to be able to print high-quality glossy prints up to 13" wide

If you are shooting with a 5-megapixel or larger digital camera you may want to consider getting a printer that prints on paper up to 13" wide. Once again, there are a good number of excellent printers in this category. When this book was published we liked the Canon i9900 ($450), the Epson Stylus 1280 ($400), and the HP DesignJet 30 ($700). All of these printers are dye-based inkjet printers and the prints typically don't last as long as the prints that are made by a pigment-based inkjet printer such as the wonderful Epson 1800, which does make pretty good prints on glossy paper in addition to terrific prints on fine art papers. We use a Canon i9900 to get outstanding glossy prints. However, at the time this book was published we were not aware of any published data on the longevity of the prints.

STEP 1: SELECT PHOTOS

The first step is to choose the photos you want to print. There are easy ways and hard ways to select the photos you want to use. To learn more about the easy ways and how to manage your digital image files, read Projects 2, 3, and 4. After you select the photos you want to print, you

CAUTION

Many image editors have automated features that allow you to process (that is, edit) a batch of digital photos. When using such a feature, such as the QuickFix editing feature in Adobe Photoshop Elements 3.0, make sure that you do not process a batch of photos that include your original files as they will be replaced with an edited version. *Always* run batch processes on copies of your original digital photo files unless you have a good reason to do otherwise.

must put a copy (not the originals) of each image file into a new folder. You may want to create a new subfolder named "\to-print4x6" in the folder where you chose the photos, or in an entirely different folder or drive. The reason you should make copies of the image files is because you will be using an automated feature that will write over and, therefore, replace your original files.

STEP 2: DETERMINE EDITING STRATEGY

Before we look at image editing strategies, first consider the issue of image size versus print size. The most common one-hour photo size is a 4" x 6" print. There are many inexpensive, mass-produced photo albums, mat frames, and picture frames that are made for 4" x 6" prints so that standard is a good one to use for quick prints. In the film days, making a 4" x 6" print was easy because the width-to-height proportions were the same as 35mm film. Odds are good that the width-to-height proportion of your digital image files don't match any standard photo paper size. For example, the 36 photos that we chose to print for this project were taken with a 5-megapixel Canon S60 digital camera that writes images that are 1,944 x 2,592 pixels. These images have a 4" x 3" proportion. That problem really does make the whole automated printing process a bit more challenging as each photo has to be manually cropped to fit on a

4" x 6" print or they automatically get cropped without consideration given to composition!

So, the first question is: How quickly do you want to edit your photos and how much work effort are you willing to expend? Using Adobe Photoshop Elements 3.0, you can choose from the following alternatives that are listed in order of the amount of time required to complete the editing.

Method 1: Print digital photos straight to the printer from your camera

While this approach may seem like the worst possible approach to take if you care about the quality of your prints, that is not necessarily the case. Many camera and printer manufacturers have worked to create technology that can often make the "straight to the printer from the camera" approach produce excellent results. The Camera & Imaging Product Association has established an industry standard for direct printing from digital cameras. This standard is known as PictBridge and it is enjoying growing support by both camera and printer vendors. Check the documentation that came with your camera and with your printer to see if they support PictBridge. If so, you may be able to make nice prints by printing your digital photos straight to your printer from your digital camera. Many of the printers supporting this technology have LCD screens that allow you to do some basic image editing and cropping.

Method 2: Print digital photos straight to the printer using an image editor

Most image editors, such as Adobe Photoshop Elements 3.0, have features that enable you to print a batch of photos straight to an inkjet printer. Depending on a variety of factors, including the quality of your photos, and the difference in width-to-height proportions between a 4" x 6" print and your print, you may be able to get nice prints by simply batch printing them to your printer. However, you can usually get better results spending a little additional time on editing and cropping.

Method 3: Use the Photoshop Elements 3.0 Auto Smart Fix Selected Photos feature

You can automatically process any digital photo files that you select in the Photo Browser by choosing **Edit ➢ Auto Smart Fix Selected Photos**. This feature does a relatively good job on reasonably well-exposed photos that were taken using a low ISO setting (for example, ISO 50 or ISO 100). Poorly-exposed photos and photos using high ISO settings on some of the less expensive compact digital cameras can and usually will produce pretty awful results. While automatically processing your photos is a timesaving approach to editing, there is no option to crop the image to fit on a 4" x 6" print; instead, the image automatically gets cropped during the print process or there is white space where there is no image.

Method 4: Use the Photoshop Elements 3.0 QuickFix feature

If your photos are fairly well-exposed and you want to get prints with the minimum amount of effort while being able to manually crop each image, you should use the QuickFix feature in Adobe Photoshop Elements 3.0. Using this feature is most similar to the process that is used by lab technicians at one-hour photo labs. The editing process is automated, but it allows manual intervention when needed to correct colors and lighting, rotate the image, increase image sharpness, and crop the photo.

Method 5: Edit each photo individually using the Photoshop Elements 3.0 Editor

Because the goal of this technique is to make a set of *pretty good* snapshot prints quickly, we can dismiss the strategy of individually editing each photo with the Photoshop Elements 3.0 Editor. But, you should recognize this as the best way to get as good a set of prints as is possible from your inkjet printer.

With those strategies in mind, you now learn how to batch process and print digital photos using the Photoshop Elements 3.0 QuickFix feature, which is Method 4 that was noted previously.

STEP 3: BATCH PROCESS IMAGES USING QUICKFIX

■ Launch the Adobe Photoshop Elements 3.0 Photo Browser. If the photos you want to print have already been cataloged in the Photo Browser, select them. If they have not yet been cataloged, choose **File ➢ Get Photos ➢ From Files and Folders** (**Ctrl+Shift+G**) to get the dialog box shown in Figure 19.2. Mac users don't have a Photo Browser so they must choose **File ➢ Process Multiple Files** and then choose a folder. Click in the **Look in** box and choose the folder where you stored the copies of the photos that you want to edit and print. Click the first file; then, press and hold the **Shift** key and click the last file to select all the files. Click **Get Photos** to open the selected files in the Photo Organizer.

■ Choose **Edit ➢ Select All** (**Ctrl+A**) to select all the photos. They should now be highlighted by a blue frame border, as shown in Figure 19.3.

■ Choose **Edit ➢ Go to QuickFix**. All of the selected images will now be opened one image at a time in the **QuickFix** dialog box shown in Figure 19.4. Notice that you have a "before" and "after" image, and a set of adjustment controls down the right side of the window. Because it is easy to use some "auto" settings and get results you don't like,

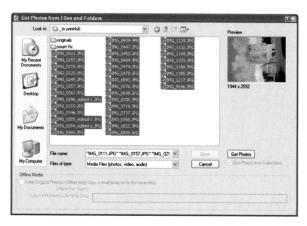

19.2

you may find that you frequently want to click **Reset** to start over again. For this reason, you should do all of your editing first and save the crop step as the last step. That way, you won't have to go through the crop process more than once. In the four palettes on the right side, you find five **Auto** buttons. You can click any of those **Auto** buttons and have the software attempt to automatically make improvements to the photo. If you don't like the results, you can either click the **Reset** button above the **After** image, or you can manually readjust the settings using the sliders below the **Auto** button that you clicked when you got results you didn't like. For the photo of the ship, we chose to increase Midtone Contrast and add a small amount of sharpening — that was all that was needed.

■ To crop an image, click the **Crop** tool (**C**). To set the Crop tool up to make 4" x 6" prints, in the **Width** box, type **4 in**, and in the **Height** box, type in **6 in**. Clear any value that may be in the **Resolution** box. The **Options** bar should now

look like the one in Figure 19.5. You can now click in the image and drag the selection marquee to where you want to crop the image. After you select an area, you can click one of the four handles and drag the selection marquee to make it larger or smaller. To position the selection marquee, click inside it and drag it to where you want it. After it is as you want, press **Enter** to crop the image.

■ When the image looks ready for printing, choose **File ➢ Save** (**Ctrl+S**) to get the Save As dialog box. If you click **Save** without renaming the file or choosing another folder, you will be writing over the file that you started with and saving this edited file. This is why it is important that you work on a folder that contains *copies* of the original photos — not the original photos.

■ Choose **File ➢ Close** (**Ctrl+W**) to close the file. You now are presented with the next photo. Repeat this step for each of the photos that you want to use for making prints. When you close the last file, the Photo Browser becomes the active window.

19.3 **19.4**

19.5

NOTE

Knowing the capabilities of your printer is important when printing a batch of 4" x 6" prints. Some printers can print all the way to the edge of the paper. This is called borderless printing. Other printers are not able to print all the way to the edge and they may have a much wider border at the bottom of the print where the paper last leaves the printer than at the top of the print. Before you take the time to manually crop all of your photos to print as 4" x 6" prints, make sure you know if your printer can print borderless 4" x 6" prints or you may be wasting your time.

STEP 4: BATCH PRINT IMAGES

■ All of the digital photos that you edited in Step 3 should still be selected and showing in the Photo Browser. Choose **File ➢ Print** (**Ctrl+P**) to get the Print Selected Photos dialog box shown in Figure 19.6.

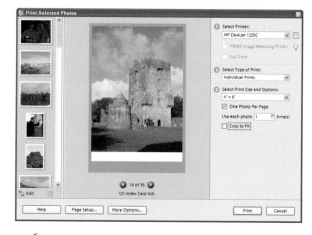

19.6

1

2

3

■ Click in the box below **Select Printer** and choose your printer. Click in the box beneath **Select Type of Print** and choose **Individual Prints**. Click in the box beneath **Select Print Size and Options** and choose **4" x 6"**. Make sure a check mark is next to **One Photo Per Page** and that **Use each photo** is set to **1 time(s)**. The **Crop to Fit** feature is an important feature. Because you have taken the time to crop each photo in Step 3 with QuickFix, it does not matter if you set **Crop to Fit** on or off because each image should fit precisely on a 4" x 6" print assuming you are using a printer that can print

borderless 4" x 6" prints. However, if you are using a printer that does not print borderless prints (or print all the way to the edge of 4" x 6" paper), you may find some benefit in turning the **Crop to Fit** feature on as it crops the photo in such a way as to print on all of the printable area of the paper. If **Crop to Fit** is off, the entire image prints, which usually means that there is some white space on the print as you can see at the bottom of the castle print in Figure 19.6. Notice the gray area around the print. This represents the non-printable area of the 4" x 6" paper for the selected printer.

TIP

Each time you take a photo you should consider the size of prints you may want to make so that you frame the scene to allow for cropping if needed. For example, if you are not careful when shooting with a camera that has an image sensor that creates files that have a 3 x 4 height-to-width ratio, you may not be able to make a 4" x 6" print without cutting out part of the subject and ruining your original composition. One of the advantages of larger megapixel cameras is that you can shoot farther back from your subject (or zoom out if you are using a zoom lens) and still have enough room to crop to suit and still meet any necessary height-to-width proportions. Figure 1 shows the original image with the subject framed too tightly to allow much cropping. Figure 2 shows a 4" x 6" crop and Figure 3 shows a 5" x 7" crop.

■ Click **Page Setup** to get the Page Setup dialog box shown in Figure 19.7. Click in **Size** and choose **US Index Card 4" x 6"**. You may have different settings available depending on the type of printer you are using. Click **OK**.

■ Click **More Options** to get the More Options dialog box shown in Figure 19. 8. Here you have the options of adding a **Label** (date, caption, or file name), or you can add a **Border** by specifying the line width and color. You can also choose the

19.7

19.8

Print Space. If you have a color profile for the paper you are using, you should select it now in the Print Space box. To learn more about printing with color profiles, read Project 18. Click **OK** to close the dialog box.

■ Before clicking **Print**, make sure you have loaded enough 4" x 6" paper in your printer to print the images you selected; then, click **Print** to begin printing the images to the target printer.

IF YOU ARE CONCERNED ABOUT PRINT LONGEVITY

If you plan to use your snapshots for a purpose where print longevity is important to you, you should be careful to choose inkjet paper that will last as long as you want it to if such paper is available. To learn more about the longevity of various photo papers, visit Henry Wilhelm's Web site at `www.wilhelm-research.com`. At the time this book was written, he had a very useful free document titled, "Display Permanence Ratings for Current Products in the 4x6-inch Printer Category" available on his Web site. According to this report, printers in the 4" x 6" category have paper ratings from four years to over 104 years! So, choosing the right brand of printer, ink set, and paper is important.

TIP

Project 19 shows how you can use Adobe Photoshop Elements 3.0 to quickly batch process and print a collection of 4" x 6" photographs on your own inkjet printer. Another "quick" approach for getting prints made includes writing your digital photos to removable storage media (for example, CompactFlash Card or CD-ROM) and taking it to a nearby one-hour photo-lab. You can also upload your images to one of the online photo-printing services, such as **Shutterfly** (`www.shutterfly.com`) or **KodakGallery** (`www.kodakgallery.com`). Project 22 shows how to order prints online using Shutterfly and Adobe Photoshop Elements 3.0.

PRINTING YOUR OWN FINE ART GREETING CARDS

20.1 Choose one or more of your favorite photos and make a fine-art greeting card that perfectly suits the recipient.

Do you have a sick friend you want to cheer up? Did you just change jobs to be able to eat the greener grass on the other side of the pasture and you now want to show your former co-workers how green the grass is, or isn't? Have you recently taken a trip and would like to share your best photo with friends and family? Does a special friend deserve a special greeting card from you? Or, have you ever received a custom-made fine-art greeting card yourself and now want to make a few for others? If not, you have missed sharing your photos in one of the most fun ways we know. Choose a card and envelope, add one or more of your photos, and begin sending your own greeting cards that will mean much more than if you send a store-bought card. As is true with most things in life, there are easy ways to make photo greeting cards and hard ways. In this project, you learn a few of the easy ways.

149

STEP 1: CHOOSE YOUR CARDS

Choices, choices, and more choices — you have so very many choices when it comes to choosing fine-art greeting cards to make your own personalized cards. We have tried many of them and can tell you about some of our favorites. But, first you should learn to choose cards yourself. Some are good and some are not so good, depending on what you are looking for. Following is our checklist that should help you distinguish between the good greeting cards and the poor cards and aid you in choosing a few that will meet your needs.

- **Paper quality:** If you want to make greeting cards that display your best digital photos well, you will want quality paper. If you are very picky about color, you may even want to make sure you buy cards from companies that provide color profiles (see Project 18) so that the colors on your computer screen precisely match the colors on your greeting cards. Many of the less expensive greeting card packs found in office supply stores may or may not work well with your printer. If you need to buy more than a pack or two, you should first try them out on your printer to see if you like the results. If you already have inkjet paper that you want to use, or you want to order photographic prints from a photo lab or online photo-printing service, consider buying a greeting card that allows you to insert or attach a printed photo to the greeting card instead of one that requires that you print directly on the card.
- **Surfaces:** Some greeting cards have a single side that is suitable for inkjet printing while others have two sides that are equally suited for images and text. If you want to use your inkjet printer to print a photo and text on the outside and inside of the card, you need to make sure that both sides of the card have inkjet print quality surfaces.
- **Method of attaching photo:** You can display printed images in several ways on greeting cards besides being printed directly on the card. Some

greeting cards have die-cut windows and various ways to insert, stick on, or attach a print to display through the window.
- **Fold:** The quality of fold, or lack of fold, may not sound like a point worth worrying about, but it is. A card that has an uneven fold or a fold that looks like it was hand-made does take away from the overall look of a card. A good fold is an essential part of a quality greeting card.
- **Size:** There are many different greeting card sizes and each size of greeting card may, or may not have a window or other defined area for displaying images. Make sure to choose greeting cards that have an available print area that will accommodate the size of photo you want to print.
- **Extra features:** Deckled edges, text quotes, a variety of borders and border effects, watermarks, various colored papers and envelopes, embossed designs, die-cut windows of all shapes and sizes, and embossed recessed areas for prints are just a few of the many extra features that you can find on greeting cards. Some of these extra effects make some cards look exceptionally nice. They can also increase the overall cost of the cards, too.
- **Envelope:** The quality of envelope is as important as the card. Some cards come with matching envelopes while other cards come with different colored and/or textured envelopes or even envelopes that are semi-transparent so that you can see the photo on the card inside.
- **Cost:** Some greeting cards are very expensive. Depending on how you want to use your greeting cards, your budget may or may not be a factor when selecting greeting cards.

Here are a few of our favorite greeting cards and envelopes, and the reasons why we like them.

- **Photographer's Edge greeting cards:** At the top of our list of favorite greeting cards are the reasonably-priced cards made by Photographer's Edge, which you find at www.photographersedge. com. Besides being printed in recycled cardstock

(we like that notion), these unique cards have an adhesive liner that is used to permanently mount your printed photos so that the greeting card looks like it was professionally made. Because of this design you can use any photo-quality paper you choose to make the photos. All of the designs are made for 4" x 6" photos. Not only do they have many different styles of cards with varying window openings, borders, and quotes, but you can order your own text to be printed on the cards if you order 50 or more cards. If you visit their Web site, you can learn more about how the cards work and you can request their wonderful 50-plus page catalog and a free sample greeting card and envelope. Figure 20.2 shows a horizontal design with a black line border.

■ **Crane Museo #6 Two-Sided Digital Printable Artist Cards:** The 4 ½" x 5 ¹⁵⁄₁₆" folded cards found at www.crane.com come in a traditional velina finish for photographs and fine art images. Both sides are printable and they are made with the excellent Museo paper (one of our favorite fine art inkjet papers) without optical brighteners to ensure that the image will look, for many years, just like it did when you printed it. Because we use the Museo paper for fine art prints and because Crane provides free color profiles for the Museo paper, it is easy to print images on Museo paper that are nearly identical to the images seen on our computer screens as well as larger fine art prints. If you don't have an image editor to add your digital photo and text to a card, you can find a Web browser-based application on Crane's Web site that can be used to make your cards. You can find this useful application by clicking Print Center and Printing Templates on the front page of the Web site.

■ **Strathmore Photo Frame Cards:** Strathmore papers, www.strathmoreartist.com, have long been many artists' favorite papers. These same papers are now used for greeting cards and they have a die-cut window for displaying a photograph, as shown in Figure 20.3. They are wonderful cards

20.2

20.3

if you want to print your photos on a paper of your choice and insert them into a "framed" card made of high-quality paper. Our favorite Strathmore greeting cards are the black-and-white Strathmore Photo Frame Cards, which come with matching envelopes. When a first-rate photograph is inserted into the greeting card, these matching card and envelopes make some of the most elegant greeting cards that we have seen.

■ **Hahnemühle Digital Fine Art Papers, "Postcard" Style:** Digital Art Supplies, `www.digitalartsupplies.com`, offers five different Hahnemühle "postcard" style cards that can be ordered with white or translucent vellum envelopes. These cards are thick 5" x 7" cards that can be printed on both sides. If you want an unusual way to make a photo note, you'll enjoy using these cards.

Other suppliers that offer nice-looking greeting cards include the following:

■ Red River Papers: `www.redrivercatalog.com`
■ Digital Art Supplies: `www.digitalartsupplies.com`
■ Legion Paper: `www.legionpaper.com`

STEP 2: PRINT GREETING CARD

How you choose to print your greeting cards depends on the design of the card that you have selected and the printer you have. If the card design requires that you simply slip a photographic image into a sleeve or beneath a window opening, you can use Adobe Photoshop Elements 3.0 or any other image editor to print the photos, you can order prints using an online printing service, or you can take your digital photos to a local photo lab to make the prints.

If, on the other hand, you choose to make your own greeting card design and you want to print text and photos on the card, you can use Adobe Photoshop Elements 3.0 Editor or other image editor to design and print the card. Just for fun, we chose to make a humorous greeting card featuring a donkey that we found stretching to eat the proverbial "greener grass" on the other side of the fence. Our design for the card shown in Figure 20.4 included a small amount of text on the outside of the card plus a single photo, and a small amount of text on the inside of the card.

The steps you need to take to create a greeting card similar to the one featuring the donkey using Adobe Photoshop Elements 3.0 Editor are very similar to those steps that are explained in Project 9. The only difference is you are likely to be only adding one photo, a border, and a line of text.

After choosing a few excellent photographs and making a breathtaking box or two of greeting cards, many photographers believe that they can sell their photographs as greeting cards and make lots of money! There is no question that there is a market for quality greeting cards. You can often even find local stores or specialty shops that will sell your photos for you if your photos are suitable for their customers. However, the economics behind making and selling quality greeting cards in small volumes makes it nearly impossible to make enough money to even cover your time. If you add up the cost of ink, paper, envelopes, boxes or protective coverings for the cards, and some markup (about 50%) for the

store that sells your cards, you will find you have to charge more for your cards than *you* have ever paid for a greeting card!

While our intent is not to be the bearers of grim news, we do want you to realize that making money by printing your own greeting cards is challenging. However, the joy you will have and the joy you will give to others when creating personalized greeting cards for people you know is worth more than riches. Buy a few sample sets and make a few greeting cards to share your work. Make sure to include your name and a copyright date on the card so that the recipient knows that you have taken the photo and created the card, too. You'll be happy that you make your own greeting cards. We'll be happy, too, if you send us one. In today's fast-paced world of e-mail, we'd love to receive a printed greeting in our mailbox and see your work and the card that you chose. You can find our contact information the appendix if you want to send us a greeting card.

About that notion that grass is always greener on the other side...

20.4

TIP

To save money, you can sometimes purchase printing supplies including greeting cards, ink, and fine art paper from distributors that carry products from many different suppliers. Such distributors often offer specials and every-day prices that are lower than those charged by the vendors. Some of the better companies offering good prices and quality products are: Digital Art Supplies (www.digitalartsupplies), InkJetArt.com (www.inkjetart.com), B&H Photo (www.bhphoto.com), and Hunt's Photo and Video (www.huntsphotoandvideo.com). All of these reputable companies have Web sites where you can order online and you can always call them and speak with their helpful staff if you have questions.

PRINTING A PHOTO CALENDAR

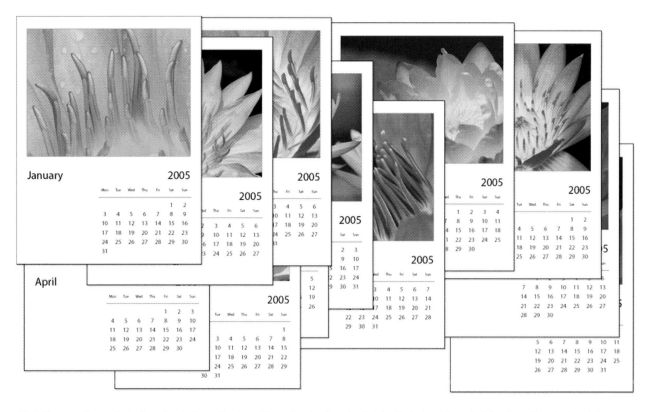

21.1 Choose a dozen of your favorite photos and make a 12-month calendar using Adobe Photoshop Elements 3.0 and a desktop inkjet printer.

Adobe Photoshop Elements ($80), a photo-quality printer, 12 sheets of inkjet paper, and a dozen of your favorite photos

Would you like to have a calendar that features your own photos to hang on a wall in your home or office? Do you need a calendar to put on your refrigerator that can be used to note all your family's upcoming events? Do your holiday plans include giving a printed calendar to friends and family members? If so, you can make a printed calendar that begins and ends on months that you choose in less than thirty minutes. Printed photo calendars make wonderful gifts that show off your best digital photos for an entire year. In this project, you learn how to use Adobe Photoshop Elements 3.0 to make a calendar to suit your needs.

STEP 1: SELECT CALENDAR DESIGN

The first step to creating a printed calendar is to decide on the design of the calendar so that you know what size image you need, and if the photos should be vertically or horizontally oriented. It is reasonably easy to use an image editor such as Adobe Photoshop Elements 3.0 to create your own calendar layout that shows one or more photos per page, plus a calendar, and any other information you may like to display. However, creating accurate calendar pages for 12 months is tedious and time-consuming. For this reason, in this project you use the Wall Calendar feature found in Adobe Photoshop Elements 3.0 to complete the layout of the twelve calendar pages in less than one minute!

To choose a calendar layout, you click the Create button in the Adobe Photoshop Elements 3.0 Editor and run the Wall Calendar Wizard. Because we go through that step a little later, for now, just assume we use the Modern Vertical style. To determine the size of the images that you need, we completed the Wall Calendar Wizard and made a print of a one-month calendar. Using a ruler, we were able to determine that a 5.25" x 7" photo is needed for the Modern Vertical style.

STEP 2: CHOOSE IMAGES AND PLACE COPIES IN A NEW FOLDER

Keeping in mind that you need images that will fill a 5.25" x 7" space, choose the photos you want to use and make a copy of them and place them in a separate folder. The advantage of this approach is that you can make any edits or crops to the selected images, and then size them for the space that is available on the printed calendar page without worrying about damaging the original image files.

STEP 3: CROP AND RESIZE IMAGES

■ Open one of your selected images in the Photoshop Elements 3.0 Editor.

■ Choose **View ➢ Fit on Screen** (**Ctrl+0/ Command+0**) to view the entire image.

■ Click the **Crop** tool (**C**). In the Options bar, in the **Width** box, type **7 in**, and in the **Height** box, type in **5.25 in**. Type in **240** in the **Resolution** box. 240 pixels per/inch is a good setting to use for Epson printers. If you are printing with a Canon or HP printer, you should type in **300**. If you are using another brand of printer, read the documentation that came with your printer to learn what PPI resolution is recommended for your specific printer model. The Options bar should now look like the one shown in Figure 21.2.

■ Using the **Crop** tool, you can now click the image and drag the cursor to select the area you want to display on a calendar page. To move the selected area, you can click inside the selection and drag the selected area. To resize the selection, click one of the four handles found at each corner of the selection and click and drag on the handle to resize the image. If you want to rotate the selection, you can move the cursor just outside of the selected area near one of the handles to get a two-headed arrow; as you click and drag, you rotate the selected area. After you select the area you want to display, press **Enter** or click the **Commit**

Current Crop Operation icon (the check mark icon) on the Options bar to crop the image and resize it for the printer you are using.

■ Choose **File ➢ Save** (**Ctrl+S/Command+S**) to save the file. Choose **File ➢ Close** (**Ctrl+W/Command+W**) to close the file.

■ Repeat this step for each of your chosen images.

STEP 4: RUN WALL CALENDAR WIZARD

With your folder full of properly cropped and sized images, you are now ready to run the Wall Calendar Wizard.

■ The easy way to use the Wall Calendar Wizard is to first load the images that you edited in Step 3 into the Photo Browser. From the Photoshop Elements 3.0 Editor, click **Photo Browser**. Choose **File ➢ Get Photos ➢ From Files and Folders** (**Ctrl+Shift+G**). Click in the **Look in** box and choose the folder you used to store the images in Step 3. Click the first image; then, press and hold the **Shift** key while you click the last image to select all the images, as shown in Figure 21.3. Click **Get Photos** to load them into the Photo Browser.

■ To select the images you want to use in the Photo Browser, slide the Thumbnail Size slider so all the photos are visible. Press and hold the **Ctrl** key and then click each individual photo you want to select. The selected photos highlight with a blue frame border, as shown in Figure 21.4.

■ To run the Wall Calendar Wizard, click the **Creations** icon in the Icon bar just below the main Menu bar in the Photo Browser to display the Creation Setup dialog box, as shown in Figure 21.5.

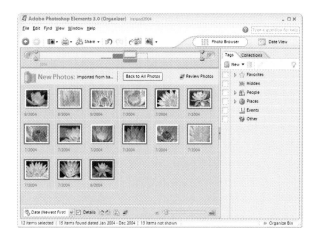

21.4

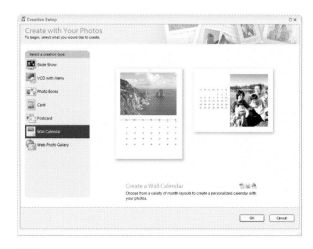

21.5

21.3

■ Click **Wall Calendar** to get the Create a Wall Calendar dialog box and Click **OK** to get the Step 1: Creation Set-up dialog box shown in Figure 21.6. On the right side of the dialog box, click and scroll down to find and then choose the **Modern Vertical** style. If you want to make a title page for your calendar, click in the box next to **Title Page**. If you added Captions to your images using File Info in the Adobe Photoshop Elements 3.0 Editor or another application and you want to automatically add the captions embedded in the image files, you should click in the box next to **Captions** to turn that feature on. Click in the two boxes following **Starting** and **Ending** to select the month and year you want to use for the starting and ending months of the calendar.

■ Click **Next Step** to get the dialog box shown in Figure 21.7 where all the photos you selected now are displayed. If you want to move any of the images to a different month, you can click any image and drag it to the month where you want it to be.

■ After your photos show in the order you want, click **Next Step** to get the Step 3: Customize dialog box shown in Figure 21.8. If you want to add any text, click **Add Text** to get the Text dialog box. You can type in any text you want to add as well as change font characteristics. After you click **Done**, you can click and move the text to position it where you want. Click the **Next Step** or **Previous Step** buttons to view any month you want to customize.

■ Click **Next Step** to get the Step 4: Save dialog box. Type a name for your calendar in the box beneath **Wall Calendar Name**. The dialog box should now look like the one shown in Figure 21.9.

■ Click **Save** to get the **Step 5: Share** dialog box shown in Figure 21.10. Here you can choose to create a PDF file, send the calendar straight to

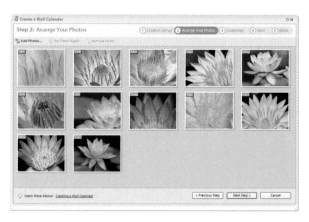

21.7

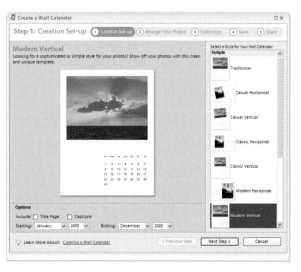

21.6

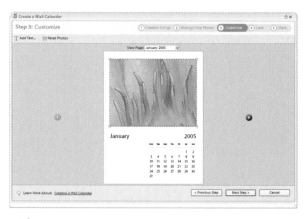

21.8

your printer, or e-mail the calendar. Because the goal of this project is to make a printed calendar, click **Print** to get the Print dialog box shown in Figure 21.11 where you choose your printer and print settings. Click **Preferences** to get the Printing Preferences dialog box for your printer. Figure 21.12 shows the **Printing Preferences** dialog box for an Epson Stylus Photo 2200. After you choose the appropriate settings, click **OK**. Then, click **Print** to begin printing your calendar.

■ When your calendar finishes printing, click **Done** to close the dialog box.

21.11

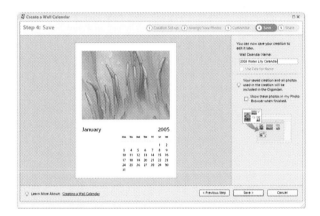

21.9

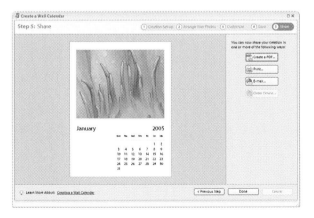

21.10

21.12

Several vendors make special paper and binders for making calendars that feature your photographs. Photographer's Edge, Inc. (`www.photographersedge.com`) offers a calendar that works similar to their greeting cards. You insert your printed photos into a folded page and fasten the photo to the page with a special double-sided tape. These calendars are for 4" x 6" photos and you can order horizontal and vertical calendars for under $6. The nice feature of these calendars is that they come with a spiral binder.

Strathmore (`www.strathmoreartist.com`) also makes a digital photo calendar kit that is 8.5" x 11" and includes clear plastic covers and 15 sheets of 2-sided photo paper and an easy-to-use spiral binding mechanism.

We hope that you have taken the time to make a calendar or two to share or have made a few nice prints on fine art paper. This is the last of the projects in Chapter 4. Next up is a chapter on ordering prints online.

NOTE

You can choose from many types of media for making a printed calendar. If you take the time to choose twelve of your best photos, edit them, and create a calendar, you should print on a quality paper. You can use high-quality glossy photo paper to make excellent calendars that display your photos well, but glossy paper is not easy to write on. If you expect the calendars to be used to note events, you should use a matte paper that is easy to write on with pen or pencil.

ALTERNATIVE APPROACH

Project 21 shows how the Wall Calendar feature in Adobe Photoshop Elements 3.0 can be used to make printed photo calendars with your own inkjet printer. Project 23 shows you how you can order a photo calendar using the ImageStation's online service (`www.imagestation.com`). Ritz Camera and Wolf Camera along with many other one-hour photo labs offer photo calendar printing services at their stores or as part of their online services. You can choose from a variety of calendar templates from the Microsoft Web site by using Microsoft Word 2003 and choosing File ➢ New and clicking Templates on Office Online. Alternatively, you can visit the Microsoft Web site (`www.microsoft.com`) directly and download the .doc files that serve as templates for dozens of calendar layouts.

CHAPTER 5

ORDERING PRINTS ONLINE

2002-03 Chapel Hill High School Lacrosse

You can order just about any kind of photographic prints you can imagine using a computer connected to the Internet. In this chapter, you read eight projects that tell you about some of the best and most innovative online photo printing services that are available. Project 22 shows you how to order "one-hour-style" prints online and pick them up in one hour, too. If you want a nicely bound photo calendar, Project 23 tells you how to get one. The goal of Project 24 is to order a 20" x 30" poster print online featuring your photos. You order holiday photo cards in Project 25. Project 26 covers laying out photos and adding captions for a printed book that you can order online. Learn how to put your photos on photo gift items, such as a coffee cup, hat, or t-shirt in Project 27. Project 28 tells you how you can upload a digital image file and specify a printed, matted, and framed photo online that is mailed to you. Project 29 shows you how to order online what many phtographers consider to be the ultimate photographic print — a Lightjet 5000 print.

ORDER "ONE-HOUR-STYLE" PRINTS ONLINE

22.1 You can get "one-hour-style" photos by uploading your digital photo files to an online photo-printing service such as Shutterfly and get your prints back in the mail within three to five days.

WHAT YOU'LL NEED

A connection to the Internet and a few digital photo files (cost is around $0.30 or less per print)

One of the great benefits of shooting with a digital camera if you have a high-speed Internet connection is that you can upload digital photos from your computer and order prints online. One of the better and more competitively priced online printing services is offered by Shutterfly. In this project, you learn how to quickly and easily order prints online using the Shutterfly service.

Shutterfly was selected as the service to use for this project for three important reasons. First, the Shutterfly online service is excellent for getting "one-hour-style" prints made from your digital camera images. Shutterfly uses state-of-the-art digital printers designed for professional

photofinishers. These printers expose Fuji Crystal Archive photographic paper by using red, green, and blue lasers to produce some of the sharpest prints available. The exposed photographic paper is chemically processed in the same way as in traditional photo labs. Second, Shutterfly has an option that allows you to turn off all their "intelligent processing" features so that your prints may be printed as you intended to have them printed — rather than being further manipulated for color, contrast, and image sharpness. This is a useful feature if you edit your photos before uploading them to be printed. Third, Shutterfly offers lots of "20% off sales" on a wide-range of products and services, which are already reasonably priced. These special sales make it worthwhile to wait for sales to order from them.

While we offer strong praise for the Shutterfly service, please be aware that this is a low-cost, high-volume automated service. Do not expect to get the same results that you get from premium photo-printing services, such as those offered by Calypso, Inc., which you can read about in Project 29.

WHERE DO YOU GO TO GET THE LEAST EXPENSIVE PRINTS?

If you want to get the least expensive prints from a "one-hour-style" online photo-printing service, you need to shop around and compare prices each time you want to place an order. Or, you can pick one of the top online photo finishers and wait to order when there is a "sale." To learn about any sale pricing, you usually have to sign up for a free e-mail newsletter. It is usually through these newsletters that you learn about the "sales," which can be as much as 20 percent or more off the regular prices. If you order when special pricing is available, you are not likely to find a much lower price simply because it is a very competitive market. If you want to save the cost of shipping and handling, which amounts to around $2 to $3 per order of 25 photos, you can order from a company

that has a local store (if one is available) where you can pick up your prints.

At the time this book went to press, the cost for printing photos at Shutterfly was: $0.22 for a 4" x 6", $0.79 for a 5" x 7", and $3.19 for an 8" x 10". Besides offering online photo printing services, Shutterfly also offers a large assortment of photo gift items and additional photography services including their innovative Snapbook. You can even order 16" x 20" or 20" x 30" poster prints. To learn more about Shutterfly and their offerings, visit `www.shutterfly.com`.

ARE THERE SERVICES WHERE YOU CAN UPLOAD YOUR IMAGE FILES AND PICK UP THE PRINTS IN AN HOUR?

If you like the convenience of uploading digital photo files and placing orders online, but you want to be able to pick up your photos within a few hours at a local store, you may be able to do that depending on how far you are from the nearest photo lab that offers such a service. The largest chain of camera stores in

> **NOTE**
>
> Do you want to take photos in one city and get prints to someone else in another city within an hour or two? Such incredible service is possible depending on what city you want the photos to be picked up in. Using an online photo-printing service such as that offered by RitzPix (`www.ritzpix.com`), you can upload your photos via the Internet and then pay to have the photos printed at a local store in the city where you want them to be picked up. Imagine taking photographs at a family event and then making them available to a family member that was unable to make the event! Just tell them to pick up the photos at their local Ritz Camera or Wolf Camera retail store. There is no extra cost for this service.

the U.S. is the Ritz Camera/Wolf Camera group of retail stores. Many, but not all, of these stores offer such a service. To find the nearest store, visit www.ritzpix.com and look up the stores by city to see if they offer an Internet service. You can save several dollars per order by picking up the photos instead of paying for shipping and handling if they were to be mailed to you. Plus, you get them within an hour or two instead of having to wait for the mail service to deliver them.

Ritzpix offers a free downloadable Internet Browser-based application called Easy Uploader that makes it easy to select, upload, and order your photos from the Ritzpix Web site as you can see in Figure 22.2. Simple drag-and-drop facilities make it easy to place an order within a minute or two.

STEP 1: COPY IMAGES YOU WANT TO PRINT TO A NEW FOLDER

The easy way to edit, upload images, and order prints online is to place a copy of all the photos of which you want prints made into a new folder. For example, create a folder named **\shutterfly** and then each time you place a new order, create subfolders named **\order1**, **\order2**, and so on. After you select and copy

22.2

all of the images you want to use to get prints made into a new folder, you are ready to edit them. Because Shutterfly offers you an option to print the filename on the back of each photo, you may want to consider renaming the files with names, places, dates, or other identifying text — but do make sure that the file names are unique.

Ideally, if the images you copy into a folder for ordering prints are already edited and cropped, they should be saved as JPEG files. If the images require some editing or cropping, then it is best to use a folder of files that are in one of the lossless image file formats such as TIFF, PSD, or BMP as it is best not to save an image as a JPEG more than once — that is, unless the original files were saved as JPEG files.

STEP 2: PREPARE IMAGES FOR UPLOADING

You can prepare your prints to have prints made in many different ways. The first and maybe less obvious option is to *not* prepare your images at all. Yes, that is an increasingly good option. Much of today's camera and printing technology is being designed so that you can print your photos without first having to take time to edit them. Some photo labs have printers that are so sophisticated that they can read the EXIF data (the embedded textual information written to a camera image file by the camera) and determine what kind of camera was used to take the photo, what ISO setting was used, what white balance was selected, and much more. Using this information, the printer is able to make a better print than it can without this information.

If you decide that you do want to edit your images, you then have several more choices. To learn more about the many approaches to editing a batch of digital photo files, read Project 19. In addition to editing steps that make your photos look better, you need to have a plan for dealing with the aspect ratio (that is, the ratio of the images' height and width) and you need to save the files in .jpg file format.

First, consider aspect ratio. Any time you use an automated printing service, you must submit images that can be printed on "standard size" papers (4" x 6", 5" x 7", 8" x 10", or 11" x 14"), or you may get prints back that are cropped in ways that you did not want. You once again are faced with options. You can either use an image editor such as Adobe Photoshop Elements 3.0 to add "extra canvas" to your image file so that the aspect of the image file matches your target print size. Or, you can look for a feature in the online printing service that allows you to specify how each image is to be cropped.

- If you choose to crop your images before uploading them, use a Crop tool such as the one in Adobe Photoshop Elements 3.0. After clicking the **Crop** tool (**C**), you are presented with the Crop Options bar shown in Figure 22.3. In the **Width** box, type in **5 in** and, in the **Height** box, type in **7 in**. Make sure to clear any value in the **Resolution** box.
- You can now click in the image and drag the selection marquee to where you want to crop the image. After you add a selection, you can click inside the selection marquee and drag it to precisely position it. You can also increase or reduce the size of the selection marquee by clicking one of the corner handles and dragging it until you have the size you want. After you have the selection marquee as desired, press **Enter** to commit

TIP

If you want to make a variety of different size prints of the same photo, you can do so easily by using the Adobe Photoshop Element 3.0 Picture Package feature by choosing **File ➤ Automate ➤ Picture Package**. This feature enables you to either choose from preset package layouts, or you can even design your own. After you create an image, save it to the folder you use to order prints from Shutterfly and place your order online.

the crop. Your image is now cropped to meet the aspect ratio that you set in the Options bar.

- Because the Shutterfly service only accepts .jpg images (as is the case with most other similar services), you must save your files in the .jpg format. To save a file as a .jpg image, choose **File ➤ Save As** (**Shift+Ctrl+S/Shift+Command+S**) to get the **Save As** dialog box. After choosing the folder where you want to save the image, click in the **Format** box, choose **JPEG**, and click **Save** to get the JPEG Options dialog box shown in Figure 22.4. Set **Quality** to **High** and click **OK** to save the file. You need to perform these same steps on any other image that is not a .jpg file or that needs to be cropped.

22.3

STEP 3: CHOOSE UPLOAD STRATEGY AND BEGIN UPLOADING FILES

You are now ready to upload the image files to Shutterfly and you can do this in one of two different ways. You can upload from the Shutterfly Web page, or you can download the free Shutterfly Express application that runs only on a PC. We strongly prefer using Shutterfly Express because you can work faster using an application on your computer than you can when using an Internet browser-based application. To download the software, visit `www.shutterfly.com` and sign in. You need to register if you have not

already done so. Click the **Add Pictures** tab and then click **Get Free Software** to download Shutterfly Express.

- After you download and install Shutterfly Express, launch the software.
- Click **Get Pictures** and choose the folder where you saved your image files. Click **Get Pictures** to load the images into Shutterfly Express. The application should now look similar to the one shown in Figure 22.5. Notice that you have features for zooming, rotating, and performing simple image adjustments, including removing red-eye.

22.4

22.5

■ To upload the images to the Shutterfly service, click **All** to select all images. You should now see a red check mark next to each image you choose to upload. Click **Upload** to get the Sign In dialog box. Click **Next** to get a dialog box that allows you to add the photos to an existing album or to create a new album. After clicking **New Album**, click **Next** to begin uploading your images. Depending on the speed of your Internet service and the number and size of your image files, the upload process can complete in under a minute or it can take considerably longer.

■ After all of the images have uploaded, you get a dialog box asking what you want to do next. Click **Go to the Shutterfly Website and view my pictures** and then click **Finish**.

■ You should now be looking at a Web page that looks similar to the one shown in Figure 22.6. Most of the features you find on this Web site are pretty straightforward, so we won't take space here to explain them. However, in the next step we do cover how to turn off VividPics®, Shutterfly's automated processing system.

STEP 4: TURN OFF IMAGE ENHANCEMENTS

Shutterfly created and uses a proprietary image processing system called VividPics. VividPics reads the EXIF data in an image file to see if it can identify what kind of digital camera was used and what settings were used so that Shutterfly printers can make the prints with the best sharpness, clarity, and consistency of color. If you upload unedited photos straight from a digital camera, VividPics can read the metadata and use it to make better photos than you would get from a system that does not have a similar kind of feature. However, if you spent time editing your images with an image editor, such as Adobe Photoshop Elements 3.0 and then you save the file — not only may you lose the metadata, but you probably do not want the VividPics feature to make more corrections to your already corrected images. In this case, you should turn the VividPics feature off. Here is how you do that.

■ To turn off **VividPics**, you first must select the photo or photos that you do not want **VividPics** to further enhance. On the "View & enhance" screen on Shutterfly.com, click **All** to select all images, and then click **Enhance / Fix Pictures**. Then, click the **Effects** tab and place a check mark in the "**Don't apply automatic corrections to picture**" box that you find on the left-side of the Web page, as shown in Figure 22.7. If you want to selectively turn VividPics back on for one or more images, you can do so in the same manner; but make sure that you do not have all the pictures selected. This little-known feature can help you to get better prints if you have taken the time to edit your photos with an image editor and you want to avoid having VividPics make additional automated edits to your images.

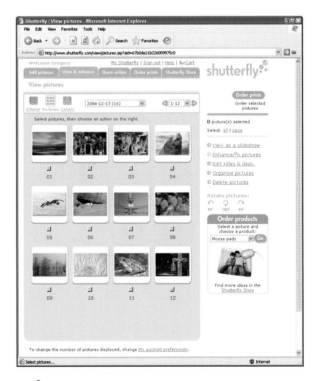

22.6

STEP 5: PLACE ORDER

- After you turn off **VividPics** for these photos you don't want to be further enhanced, you can make any other changes to the images you choose and then place your order. To specify order details, click the **Order Prints** tab. Click the **Next** button on the right side of the Web page to get a Web page similar to the one shown in Figure 22.8. Here you can specify how many prints you want made in each of the available sizes for each image. You can even see how the image will be cropped when selecting different sizes by clicking **Print Preview**.

- After specifying the quantity of each size you want to print, continue with the ordering process by clicking the **Select Recipients** button to specify the address where you want the photos sent. After selecting a mailing address, continue on to **Checkout** to complete your order.

You may want to try several other online photo-printing services, including the following: Kodak EasyShare (`www.kodakgallery.com`, formerly Ofoto.com),

PhotoWorks (`www.photoworks.com`), SnapFish (`www.snapfish.com`), and Sony ImageStation (`www.imagestation.com`).

TIP

In addition to ordering prints for your own use, Shutterfly also offers Shutterfly Pro Galleries and a "pro" printing service. Those who do event photography, such as sports and wedding photographers, can use it to sell their photos from online photo galleries. This service allows you to "markup" your photos and to charge a different amount of money for each offering for each event you shoot. All you have to do is upload the photos and you receive payment from Shutterfly for any photos you sell. Shutterfly takes care of all the order handling, the printing, packaging, shipping, customer service, and so on. It is a great service if you want to just take photos and sell them online. There is a small annual fee for this service. Read Project 40 to learn more about the service.

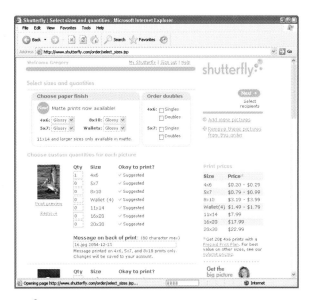

22.7

22.8

CREATE AND ORDER A PHOTO CALENDAR ONLINE

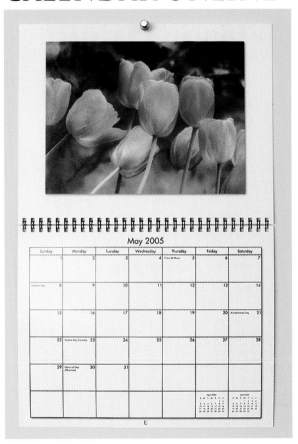

23.1 Order online a 12-month calendar featuring your favorite photos next time you need a calendar or need to give a personal gift.

In Project 21 you learned how to use Adobe Photoshop Elements 3.0 to create a photo calendar that you can print on your own desktop inkjet printer. While that is a useful project for those wanting to make a photo calendar who have Adobe Photoshop Elements 3.0 and a desktop inkjet printer, what do you do if you don't have Adobe Photoshop Elements 3.0 or you don't want to print it yourself? In this project, you can learn how to get just what you want by using the Kodak EasyShare (`www.kodakgallery.com`) online printing service.

We like using the Kodak EasyShare service because you can order a 12-month calendar starting with any month you choose. When you need a calendar in May you no longer have to buy a calendar that starts with January of the same year. Kodak EasyShare calendars are printed on heavyweight, glossy cardstock that is easy to write on, and is bound in the middle with twin-loop wire. The finished, folded size of each calendar is 10.25" x 15.6". You can choose from several templates that display from one to four photos, for each month. You also get to create your own custom cover with a photo and a caption for your personalized calendar. Adding captions below each monthly photo is an option, too. Ordering a dozen or more calendars is as easy as ordering just one, and they make excellent gifts.

STEP 1: CHOOSE IMAGES AND PLACE COPIES IN A NEW FOLDER

You can make any edits or crops to the selected images and then size them for the space that is available on the printed calendar page without worrying about damaging the original image files.

STEP 2: EDIT IMAGES AND SAVE THEM AS .JPG FILES

If you are picky about the layout of each photo, you may want to edit and crop them using an image editor so that the width-to-height ratio is 4" x 6". However, if your photos already have a width-to-height ratio that is approximately 4" x 6", you may be happy with the results you get using Kodak EasyShare's automatic or manual cropping features. After you upload all the photos you want to use in the calendar, you have an option to make some adjustments to layout. After clicking a photo, a tool appears that allows you to rotate, zoom in or out, and move the image up or down, or right or left so that you can crop the picture as well as possible. Figure 23.2 shows how that feature was used to zoom in on a photo of a lacrosse player for a tightly cropped image.

Kodak EasyShare and most other online photo-finishing Web sites only accept .jpg files, so if your files are RAW or .tif files, you first need to convert them and then save them as .jpg files before they can be uploaded. Also, you may want to take the time to rename the image files in the order you want them displayed. It is easier to rename the files and order them on your computer using an image management application, such as Adobe Photoshop Elements Organizer 3.0, than it is to reorder them using Web-based applications.

STEP 3: UPLOAD PHOTOS TO AN OFOTO ALBUM

■ The easy way to create a photo calendar using Kodak EasyShare online service is to upload all of the needed photographs into an album and then use Autofill to use the photos in the album to fill the calendar. To add photos to an album using Kodak

23.2

EasyShare, you have three choices. You can use the Web-based file upload feature, or download and use the OfotoNow for PC or Ofoto Express for Mac software, or use the free downloadable KodakEasyShare software. If you plan on ordering from Kodak EasyShare frequently, we recommend that you use the OfotoNow for PC or Ofoto Express for Mac software. All three downloadable applications are available from www.kodakgallery.com.

STEP 4: RUN WALL CALENDAR WIZARD

As soon as your photos upload to an Kodak EasyShare Album, you are ready to run the Kodak EasyShare Web-based photo calendar wizard.

- Using Internet Explorer, go to www.kodakgallery.com. If you are not yet signed in you must sign in. Click the Kodak EasyShare **Store** tab. Click **Photo Calendars**. After clicking

Create Calendar, you get a Web page similar to the one shown in Figure 23.3. Choose the **starting month** and **year**. Click the **style** of your choice and click **Next**. Click **Autofill** when asked: Would you like to Autofill your calendar (which means that the software will automatically load all of your chosen images into the calendar)? After choosing the Album that contains the photos you want to use and the layout style, click **Next**. The calendar now is loaded with the photos. Have patience as it may take a few minutes before you get a Web page that shows the title page of the album, as shown in Figure 23.4.

- Type in any text you want printed for the title and the photographer. If you want, you can now step through each page and add a caption or change the orientation of the picture. You can even change the order of the photos, if needed. After you are happy with the calendar, click **Order**.

23.3

23.4

■ You now have one last opportunity to review each page of your calendar on a Web page similar to the one shown in Figure 23.5. After checking all the pages, including photos and captions, enter the number of photo calendars you want to order in the **Quantity** box and click **Add to Cart**.

23.5

■ When your calendar is checked and you determine the calendar is exactly as you want it, click **Done** to close the dialog box. The next dialog box allows you to review your order. Click **Checkout** to get a dialog box where you can enter a shipping address. Click **Next** to select shipping method. At the time this book was written, the U.S. Postal Service shipping service was $4 with a three- to seven-day delivery time. Click **Next** to complete the checkout process including entering your credit card number and reviewing your final order on a page similar to the one shown in Figure 23.6. After clicking **Place Order,** you are presented with an order confirmation number. You have now completed the order process. Within a few minutes you receive a confirmation e-mail. In a few days, your calendar will arrive via the shipping service you selected.

Most of the online printing services offer printed photo calendars. If you don't find a style or format to your liking on Kodak EasyShare (www.kodakgallery.com), you may want to check Ritzpix (www.ritzpix.com), Shutterfly (www.shutterfly.com), or Snapfish (www.snapfish.com).

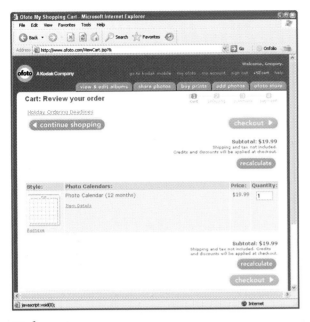

23.6

TIP

Most online photo-printing services periodically offer sales or discounts on one or more of their products and services. To learn more about any applicable discounts, check their Web pages. Some discounts are only provided to those that sign up for or agree to receive free newsletters. The discounts are often 15 to 40 percent or more. When discounts are available, a discount code is usually provided. To get the discount, you have to remember to enter the discount code in the discount code box when you place an order. Getting caught up in the ordering process and forgetting to enter your discount code is easy, which means that you won't get the advertised discount.

ORDER A 20" x 30" PHOTO POSTER PRINT

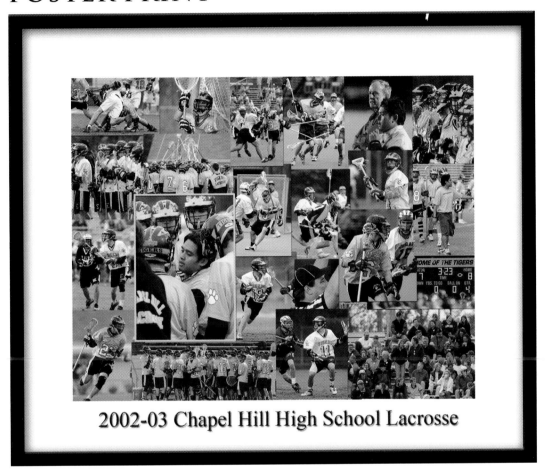

2002-03 Chapel Hill High School Lacrosse

24.1 Design your own poster using Adobe Photoshop Elements 3.0 and then order a print online from Shutterfly. At around $25, it is one of the best values around.

Your first reaction to our suggestion of ordering a 20" x 30" poster print may be: Why in the world would I want a print that large? Or, you may also be wondering where you can get digital photos that you can use to make a print that large. In this project you learn the answers to those questions, and you learn how to order a 20" x 30" poster print online at Shutterfly (www.shutterfly.com).

177

If, after reading this project, you still feel that a 20" x 30" print is too large, Shutterfly and other online printing services offer smaller-size prints for reasonable amounts. A 16" x 20" prints costs about $18 and an 11" x 14" is around $8. Before editing an image and ordering a print, carefully consider how it will be used. If you keep the print sized to match standard frame sizes, you find that you can save considerable money on mats and frames. Custom cut mats and frames cost more money.

STEP 1: DECIDE WHAT YOU WANT ON YOUR POSTER PRINT

Besides believing that the 20" x 30" poster prints are one of the best values in photography, we think that you can use these giant-sized prints for many purposes for which smaller size prints are ill-suited. Below are a few ideas you may want to consider.

MAKE A COLLAGE

If you don't have a photo that has enough resolution to make a 20" x 30" print, consider making a photo collage that shows many of your photos. Each year, at the end of the lacrosse season, parents, players, and coaches get together for a season-ending barbecue and to thank the coaches for their work during the season. For several years, we have created photo collage prints that show action photos and a photo of each coach. After finding an inexpensive standard-size frame, we created a collage to fit the frame and we left about 3" of white space around the outside of the photos. Each player then signed his name and added his jersey number to the white space around the outside of the print. The final signed and framed collage was then given to the coaches as a "thank you" gift. You can see an example of one of those lacrosse photo collages in Figure 24.1. You can make similar collages for family get-togethers, vacation photos, or other major events that you want to document with photos and hang on your wall.

Another good use for a 20" x 30" print is to make a series of images such as those shown in Figure 24.2. A series can show action, as can be seen in the lacrosse action photos, or you can show a series of photos taken of a flower over time as it blooms, or maybe the same landscape scene shot during each of the four seasons. With a little thought, we bet you can come up with several good ideas for adding two or more photos to a poster print.

ADD MULTIPLE PANORAMAS

Another wonderful use for a 20" x 30" poster print is for making multiple panoramic prints. Only a few desktop inkjet printers print on paper as wide as 30". If you don't have a printer that does, or if you do, but you don't want to buy and store an entire package of paper for panoramic prints, then you should put several prints on one image and order one large print. Figure 24.3 shows a 20" x 30" print that has four separate panoramas on it. One of these photos was made by digitally stitching 22 photos together. Each image is anywhere from about 3" tall to 6" tall, and 30" wide. Using a steel straightedge and a suitable blade to cut individual images from a single large print is easy. They can then be mounted and framed as you choose.

24.2

CREATE A POSTER PRINT

Posters are popular items for covering large wall spaces in children's bedrooms and in college student's rooms. Fine-art posters are also popular amongst adults and are framed and placed on the walls of homes and offices, too. If you have one or more good photos, you should consider making a poster print. Many poster prints have wide white areas around the image and well-chosen fonts that are laid out with much skill. You can see many examples of some of the better posters available in stores that specialize in poster prints. There is usually one such store in each large mall. You can also view hundreds of poster prints on the Internet. A couple of Web sites you may want to visit include All Posters (`www.allposters.com`), Art.com (`www.art.com`), and Totally Posters (`www.totallyposters.com`). After getting a few design ideas, find a few of your own photos and make a poster print.

For example, we have a neighbor who is a sculptor. After having spent several years and thousands of hours carving twenty sculptures out of heavy blocks of marble, she was faced with a depressing thought. All of her wonderful sculptures, which she had stored in her home, were about to be taken to an open house and later to an art gallery where they would be sold. Admittedly, the goal was to sell them. But, she really hated to see them all be removed from her home as she had become quite attached to them. So, Lauren took some of the photos we had taken of each sculpture and made the 20" x 30" poster print that is shown in Figure 24.4.

Our friend John Wyman is not only a photographer (and technical editor of this book), but he is also an

24.3

24.4

expert on tropical water lilies. He donates considerable time each year to the Sarah P. Duke Gardens to help them grow some amazing water lilies. After having been asked many times about the names of each of the water lilies in the ponds he decided to create the water lily identification poster shown in Figure 24.5. No matter what you are into, there is likely to be a poster you can make that you and others will enjoy.

STEP 2: CREATE AN IMAGE FILE FOR UPLOADING

Most of the photo printers used by companies that make 20" x 30" prints make better prints when images are used with 300PPI. At 300PPI, a 20" x 30" print is 6,000 x 9,000 pixels and such a print weighs in at about 155MB in an uncompressed format. That is a huge print and a huge file for sure. However, you don't need that much resolution to get a good print from a photograph. How much do you need? We wish there

was an easy answer. If you want to make a 20" x 30" print from a single photograph, you should have an image that was taken with a four- or five-megapixel camera, at least. Depending on the characteristics of the image, the quality of the image, and your acceptance of print quality, you can find that you can get wonderful 20" x 30" prints from an image that is far

24.6

24.5

smaller than you thought you could use. Or, you can choose a poster design that includes more than one photo, like the poster that is created in Project 9. That 20" x 30" poster is shown in Figure 24.6. Because this poster features so much type, it was created at 300PPI. When using type on a poster, it is best to provide as much resolution as possible up to 300PPI. The completed image was uploaded to Shutterfly as a .jpg file that was around 2MB. This file was used to make an excellent print.

STEP 3: UPLOAD AND PLACE ORDER ONLINE

We hope you now have an idea for a poster print, and that you are about ready to order one. In this final step, you learn how easy it is to upload and order a 20" x 30" print at Shutterfly. You can place your order using the Shutterfly Web site, or you can download and install the free Shutterfly Express software. We prefer using the Shutterfly Express application.

■ After downloading and installing Shutterfly Express, launch the application. Click **Get Pictures** and find the image that you want to use to make a 20" x 30" print. When you select the image you want to use, the Shutterfly Express application window should look similar to the one shown in Figure 24.7.

■ Click Order to get the Shutterfly Express Order Wizard dialog box shown in Figure 24.8. Enter a **1** in the **Quantity** box next to **20x30** and make sure that all other quantities are set to **0**.

■ Click **Next** to select or enter the recipient's mailing address. Click **Next** to review your order and to choose the shipping method. After entering your payment information, the order is placed. How easy is that? Shortly after you place an order, you get an e-mail confirming the details of your order. Within three to five days, you get your poster print rolled up inside a mailing tube to protect your print.

24.7

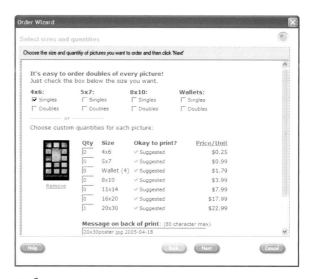

24.8

TIP

If you have Adobe Photoshop Elements 3.0, you can create and order a 20" x 30" print online directly from Kodak EasyShare by choosing File ➢ Order Prints from the Adobe Photoshop Elements 3.0 Editor. The dialog box shown in Figure 24.9 then displays. Placing an order is a simple and quick six-step process. Most other online printing services also offer large-print services.

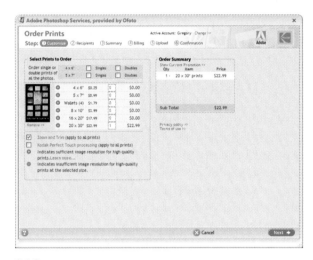

24.9

ORDER HOLIDAY PHOTO CARDS

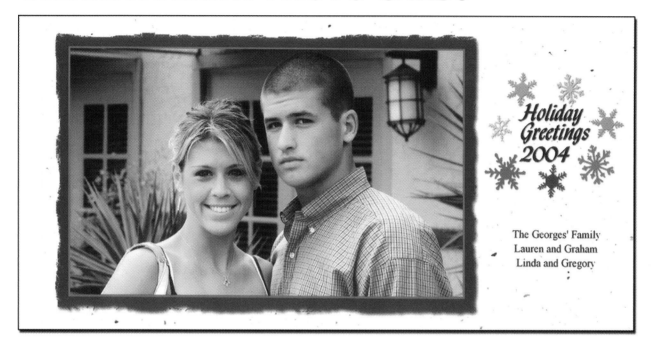

25.1 Make the process of creating and sending holiday greeting cards as easy as it can be by ordering greeting cards online that feature one of your photos. You may even be able to pick them up at a local store in an hour.

We love the holiday season. But, we can't say we love everything about it. Some of our favorite holiday traditions require plenty of work and some of that work is not fun. Our family has sent out several hundred holiday greeting cards and notes to friends and family for many years. The process of creating the cards and letters, picking a photo, stuffing and adding addresses to the envelopes, and putting a stamp on that many greeting cards is work — hard work and time-consuming work.

This year we made the process easy. We picked a photo and did some minor edits to it. We then placed an order on the RitzPix Web site (www.ritzpix.com). We chose RitzPix over the many other online printing services because we can place an order online and pick it up at a store that is within six miles of our home. As you may expect, we are picky (as in enormously picky) about the quality of prints, especially with an order of 300 cards. So, after we placed the order online, we called the store where we planned on picking up the order and asked them to print a single

183

card. After a visit to see that the card was as good as we had hoped, they printed the other 299 cards and we picked them up after having lunch at a local restaurant. After getting a $10 mail-in rebate for holiday photo cards, we paid $.47 for each card and envelope. What a bargain! In previous years we paid well over $2.50 per card, envelope, and a 4" x 6" print.

RitzPix and many other online printing services offer a vast variety of greeting card formats. Next time you want to make greeting cards to announce a move, a new baby, a new grandchild, or other announcement, you should consider ordering greeting cards online that feature a suitable photo.

STEP 1: SELECT AND PREPARE IMAGE

Before you select a photo to use, you should take a look at the greeting cards that are available from the Web site where you want to place your order. Look to see what formats are available and check out all of the optional styles and borders. After a quick look, you will know what aspect ratio you will need and if the image should be horizontal or vertical.

Most of the card offerings from other online printing services are like those on RitzPix where an image with a 4" x 6" aspect ratio is perfect. We chose to use the photo shown in Figure 25.2 for our greeting card. After the image was edited for tonal range and color, we cropped it to be 4" x 6" at 300PPI. While most of the online services can make a greeting card with fewer pixels, an image with 300PPI is optimal. Using Adobe Photoshop Elements 3.0, you take the following steps to crop, size, and save your image.

■ To crop an image to have a 4" x 6" aspect ratio, click the **Crop** tool (**C**) in the **Toolbox**. In the **Width** box of the Crop Options bar, type in **6 in** and, in the **Height** box, type in **4 in** as shown in Figure 25.3. Clear any value that is in the **Resolution** box. Click the image and drag the selection marquee around the part of the image you want to use as shown in Figure 25.4. If you need to position the marquee box, click inside it and drag it to where you want it. If you need to enlarge or shrink the selection, click one of the handles at the corners and drag it. After you have the crop as you want, press **Enter** to commit the crop.

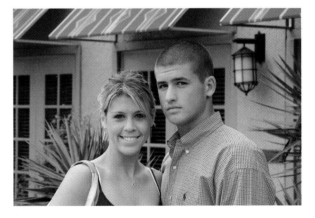

25.2

25.3

■ Choose **Image ➢ Resize ➢ Image Size** to get the **Image Size** dialog box shown in Figure 25.5. It shows the settings we used to reduce the image size. Notice that the **Constrain Proportions** box is checked and that **Width** is set to **6 inches**. Because we down-sampled (reduced the size of) the image, we checked **Resample Image** and chose **Bicubic Sharper** because it is the best resampling algorithm to use when down-sampling an image. If the image you want to use needs to be larger than it is, use the same settings except choose **Bicubic Smoother** in the **Resample Image** box. Resolution was set to **300 pixels/inch**.

■ To save the file, choose **File ➢ Save As** (**Shift+Ctrl+S / Shift+Command+S**) to get the Save As dialog box. After choosing a folder, choose **JPEG Format**. After clicking **Save**, you get the **JPEG Options** dialog box shown in Figure 25.6. Set **Quality** to **High** and click **OK** to save the file.

25.5

25.4

25.6

STEP 2: UPLOAD PHOTO TO WWW.RITZPIX.COM

- Open up your Internet browser and visit `www.ritzpix.com`.
- Before you can upload images and order prints and frames, you first must register if you have not previously joined. To log on, click **Login** and enter your username and password.
- The upload process is easy. Click **Upload Pictures**; then, click **Browse** and find the files you want to upload on your hard drive. Or, you can drag and drop files from an image manager or Windows Explorer onto the box shown on a Web page similar to the one shown in Figure 25.7.
- After the photo you want to upload is showing in the Internet browser, click **Upload Pictures** to upload them to the RitzPix Web site.

STEP 3: ORDER PHOTO CARDS

- Click **Turn Your Photos into Art**. Click **Add Photos**.
- Click **Browse** and choose the image file you want to print and frame. Click **Upload** to upload the image.

STEP 4: ORDER GREETING CARDS

- Click **Order Prints & Gifts** and then click **Order Greeting Cards**. Click the album that contains the photo you want to use and click **Continue**.
- Select the greeting card style you want to use by clicking it. You are then presented with a Web page similar to the one shown in Figure 25.8. It is on this Web page that you choose a vertical or

25.7 25.8

horizontal format. You specify how many cards you want and the caption that is to be printed on the card. To see a larger version of the card, click **Preview** and you are presented with a new dialog box with a larger preview image. As soon as your card is as you want it, click **Add to Cart**.

■ Figure 25.9 shows our shopping cart with an order for a 20-pack of holiday greeting cards and a coffee mug featuring the same photo. Click **Checkout** to go through a simple checkout process. After you complete the checkout process, you are given an opportunity to print out an invoice. After the order is submitted, you receive an e-mail confirming your order. We printed out a copy of the invoice and took it to our local Ritz Camera store when we picked up our order.

Was that easy enough? If you think the ordering of the cards was easy enough, but you still don't want to take the time to address them, stamp them, and mail them, you can have all that done for you by Shutterfly (`www.shutterfly.com`). Their online service allows you to build up an online address book so that you can easily order photos and have them sent to whomever you choose from any computer with a connection to the Internet and an Internet browser. If you still find it too much work to enter all those addresses, they have a solution for that, too! You can import addresses directly from Microsoft Outlook or from your Palm PDA (Personal Digital Assistant). When you master your digital camera and the Internet, your life really does get easier.

25.9

> **NOTE**
>
> Before placing an order for greeting cards, you should decide if you want a *photo* card or a *photo greeting* card. Many online photo-printing services and local photo labs offer both types of cards. A greeting card is usually 5" x 7" and it is folded and made of heavy card stock. A photo card is usally 4" x 8" and it is usually made of high-quality, glossy photo paper. Greeting cards cost about three times as much as photo cards. If you want something even fancier and you have time the and the money, you may want to print your own greeting cards on fine-art paper using your own desktop inkjet printer. To learn more about making your own greeting cards on fine-art paper, read Project 20.

CREATE AND ORDER A BOUND BOOK ONLINE

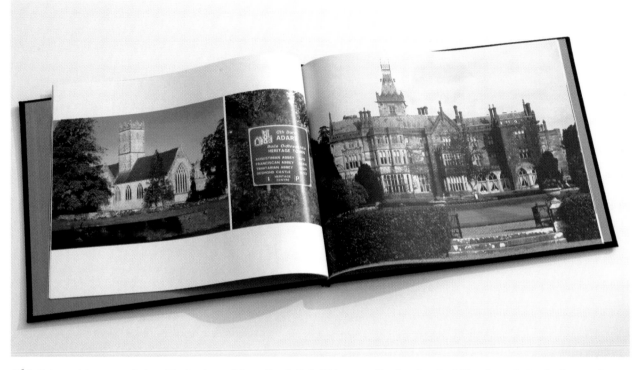

26.1 Enjoy and share your photos with a hard- or soft-bound book. MyPublisher.com offers free downloadable software that makes it easy to layout and customize your books so they are just as you want them.

WHAT YOU'LL NEED

Internet connection and a few digital photos to put in a printed book.

With the incredible advances in book publishing and printing, the new rage in sharing digital photos is to order prints in a bound book. Yes, you really can order a bound book for as little as $10 by uploading your images to an online printing service and get your custom photo book printed, bound, and shipped to you within a week or so. MyPublisher (www.mypublisher.com) is one of the leading photo book publishers. When this book was written, they offered 6" x 8" Pocket Books with 20 pages and up to 80 photos for only $10. You can add additional pages for only $0.49 each. Their 9" x 12" Hardcover Photo books with 20 pages and up to 160 photos are only $20 and you can add additional pages for only $1 each. And, if you want a really big book, they offer a giant

12" x 16" full-bleed book with edge-to-edge printing, plus a hardcover binding made of imported linen for only $3 per page. A 20-page book costs around $60.

Just imagine how much joy you can give to others when you take photos at a family get-together and then send out a printed photo book to all that attended. Or, you may want to make your own 12" x 16" hardcover coffee table book featuring your top 40 photos. We have decided to make one Hardcover Photo book for each major photography trip we take. In a few years, we will have a nice photo collection in hardbound books showing our favorite photos. When will you publish your own photo book? In this project, you learn how you can get your photos published today.

STEP 1: CHOOSE IMAGES AND PUT THEM IN A FOLDER

When using BookMaker, you can use page layout styles that allow one to four photos per page. The basic book comes with 20 pages and you can choose to print on one or both sides of each page. To fill all of the pages, you need approximately 20 to 80 photos depending on how you lay out each page.

To get the best prints, you should crop and edit each photo with an image editor such as Adobe Photoshop Elements, and then save the images in .jpg format. Alternatively, you can use the basic image editing features found in BookMaker by clicking the Enhance tab. You can rotate an image, flip it, convert it to black-and-white, apply auto adjustment and auto fix, and zoom in or out to display more or less of the image.

STEP 2: DOWNLOAD AND INSTALL MYPUBLISHER BOOKMAKER

Most of the work that you must do to create and order a book from the MyPublisher Web site is done with their free BookMaker downloadable software.

- Visit www.mypublisher.com and click the **Get Started** tab to download the MyPublisher BookMaker software. After you download and

install the software, you are ready to begin designing your book.

STEP 2: CREATE PHOTO BOOK

The fun comes after you select the photos you want, and you are ready to create each page. BookMaker automatically lays out your entire book. You can then go to each page and make any changes you want.

- Launch BookMaker.
- Click the **Get Photos** tab and select the folder that contains the images that you want to use. They should now be displayed in BookMaker, as shown in Figure 26.2. Press **Shift** and click the first image; then, while still holding the shift key, click the last image to select all the images. Click and drag the selected photos into the **Add Photos** pane below.
- Click the **Organize** tab. You can now drag-and-drop the photos to put them in the order you want. Click the **Enhance** tab to rotate, sharpen, or edit a photo.
- Click the **Book** tab to create the book pages. Click **Theme** to change the style and page layout options, as shown in Figure 26.3. If you want to add text to a page you must use either the Modern or Traditional style. When using one of those

26.2

styles, you can click in the text box and type in a caption below an image. Make sure you add text to the cover page and title page. To preview the book one page at a time, click **Preview** and then click the **Back** or **Next** tabs. You can also add or delete pages when needed or change the order of the pages at any time.

■ As soon as your book is as you want it, click the **Purchase** tab. If you have not already registered, you must do so now. After you register, the order process is simple. You click to specify how you want your book published, as shown in Figure 26.4. If you have a discount coupon, make sure you enter it now. If you have a discount coupon, our experience has proven that you can get caught up in the order process and place an order before you realize that you have not entered the coupon code so you will not get the discount to which you may have been entitled.

■ Click **Continue** to fill out the shipping information. Click **Pay** to enter your payment information. Click **Submit Order** to place your order. And that is all you need to do to create and order your own printed photography book.

For this project we used photos that were taken from a photographic tour of the west coast of Ireland. The completed book was printed surprisingly well and it was shipped in a protective storage box with the book inside a reusable plastic sleeve. All MyPublisher books are printed on the highest-quality digital offset four-color presses with real ink. MyPublisher uses 100-pound glossy, archival-quality, acid-free paper. MyPublisher hardcover books are bound in the highest-quality imported linen cloth, not suede paper, or paper that looks like cloth. You can see the cover in Figure 26.5. MyPublisher claims to ship each book within 24 hours. We had our book within a few days.

26.4

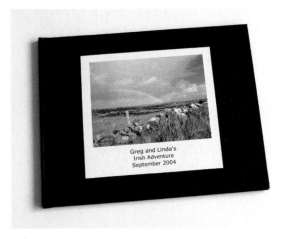

26.5

26.3

WHAT OTHER COMPANIES OFFER QUALITY BOOK-PRINTING SERVICES?

As printing photo books becomes more popular, you are likely to see more companies provide photo books with more creative options. At the time this book was written, the following vendors offer photo books: Kodak EasyShare (www.kodakgallery.com), PhotoWorks (www.photoworks.com), Shutterfly (www.shutterfly.com), SnapFish (www.snapfish.com), and Sony ImageStation (www.imagestation.com). In addition to offering photo books, Shutterfly also offers what they call a Snapbook. A Snapbook is a mini-album that is protected in a clear matte finish color and it has clear spiral bindings. Snapbooks can be ordered in either a 4" x 6" or 5" x 7" size.

All book-printing services are not created equal. Before ordering a large quantity of books, you should order one first to see if you are happy with the quality. We have ordered photo books from several vendors and have seen widely varying print qualities. We highly recommend MyPublisher because of the software, the paper quality, the book styles, the quality of the cover, and the quality of the print.

If you are a Mac user, you can create and order printed books directly from the Mac iPhoto application by clicking the Book tab. When this book was written, the cost for a 10-page hardcover bound book was $30. iPhoto uses the Kodak EasyShare online printing service.

> **NOTE**
>
> If you want to make your own photo books using a paper of your choice and a desktop inkjet printer, you can do so by purchasing a photo book cover made for this purpose. You can learn more about these book covers in Project 50. In particular, the ArtZ (www.artzproducts.com) Coffee Table Books and the Red River Paper (www.redrivercatalog.com) Custom Book Kits make excellent photo books that can feature your photos printed on your favorite inkjet paper using a color profile and printed to perfection. The innovative "self-binding" features of these and other photo books provide you with a photo book that you can be pleased with. The ArtZ 7" x 7" wonderful Digital Bookmaker is shown in Figure 26.6.

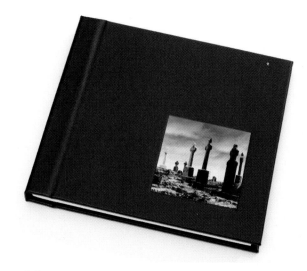

26.6

PUT YOUR PHOTOS ON PHOTO GIFT ITEMS

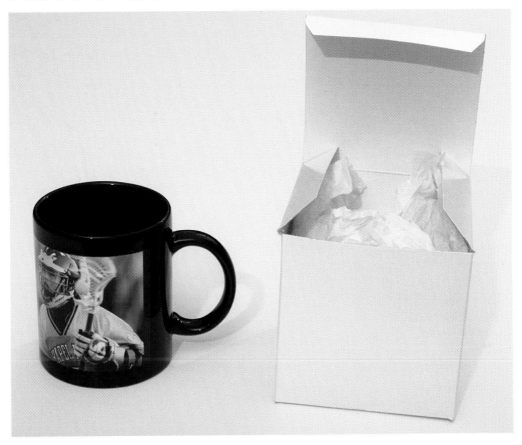

27.1 You can easily and quickly order online photo gifts such as a coffee mug that features one or more photos. Next time you need to give a gift, pick a photo and order a photo gift item to make an extra special gift or order one for yourself.

WHAT YOU'LL NEED

An Internet connection and one or more digital photos.

I f we had to select one project in this book as our favorite project, this project would be a good contender. Nope, we are not as crazy or silly as it may seem to those who take their photography seriously like we both do. In fact, we think you will have the same reaction to the gift items you create as we have had for those that we have created. For starters, we ordered two matching coffee cups that

were way cool. Then, we ordered a couple of t-shirts and a mouse pad. Our original plan was to give these as gifts, but after we received them, we decided that we liked them so much we kept them for ourselves. So, our initial idea of these being photo *gift* items was not accurate. Because our initial orders were saved on the Web sites, we found it easy to go back and order a few more to be given as gifts. Even if you are not into gift giving, you can design and order a few photo items to make your photography more visible to you and other people.

STEP 1: DECIDE WHAT YOU WANT TO ORDER

When we wrote this book, the following online printing services offered the photo gift products listed here.

- www.imagestation.com – Photo books, photo mugs, photo calendars, photo greeting cards, AlbumPrint Photo Books, photo bags (purse, handbag, and tote bag), confections (picture cookies, chocolate photo pops, photo chocolates, photo lollipops, and Rice Krispies Photo Pops), playing cards in a tin, 11" x 14" photo puzzle in a tin, coaster set, photo mouse pad, photo magnet, and 5" x 7" and 8" x 10" laminated photographs.
- www.kodakgallery.com – Photo books, photo cards, photo calendars, frames, albums, poster-size prints, mugs, t-shirts, mouse pads, aprons, sweatshirts, playing cards, albums, scrapbooks, and photo ornaments, too.
- www.ritzpix.com – Greeting cards, 100% cotton t-shirt, small portrait pack, large portrait pack, poster picture, photo puzzle, mouse pad, and ceramic coffee mug.
- www.shutterfly.com – Hardcover and softcover photo books, Snapbooks, calendar, coffee mug, mouse pad, note cards, t-shirt, frames, tote bags, and aprons.
- www.snapfish.com – SnapFish offers so many products that we suggest you visit the Web site. Make sure you check out the clothing items.

For some really wild stuff or for a wide variety of canvas prints, visit PhotoWow (www.photowow.com). If all those choices leave you wondering what you should get, we recommend that you order a couple of mugs for your favorite hot drink. The t-shirts and mouse pads are way cool, too, and nearly everyone needs a t-shirt or a mouse pad. There is a reason they call these products photo gifts. They make brilliant gifts that will delight those who are lucky enough to get them. If you still don't know what to order, we suggest that you search online using www.google.com and enter the phrase, "photo gift items." You soon find that you can order jewelry, ceramic tile, wood boxes, sculptures, watches, personalized baby gifts, photo birth announcements, and much, much more. Many malls have small kiosks that offer specialized photo gift items. If you want a photo on a specific item, chances are good that you can find a place that can put one on for you.

STEP 2: PICK A PHOTO OR TWO

After you know what gift item or items you want to order, you can pick one or more appropriate photos. Once again, you face the challenge of matching the aspect ratio of the photo with the gift items you want to order. When placing an order for coffee mugs at www.imagestation.com, you can choose from several different layouts. Gregory chose a format that used two square photos, one photo for each side of the cup. Figure 27.2 and Figure 27.3 show the two selected photos. One is a photo of Lauren playing soccer, and the other is a photo of her brother playing lacrosse. The coffee mugs made wonderful gifts for their mother and for their grandparents — and yes — Gregory drinks from one occasionally, too.

STEP 3: PLACE AN ORDER FOR GIFT ITEMS ONLINE

After a quick visit to the Sony ImageStation Web site, the choice was made to order a black 11oz. photo mug. At the time we placed the order, there was a sale on mugs and we were able to order them for $8.00. The ordering process was exceedingly simple.

- Type www.imagestation.com in your Internet browser.
- Choose **mug** as the gift item.
- After you pick a mug, you are given an opportunity to choose one of twelve different layouts. You can choose to have a single panoramic image wrapped around the cup, two large square photos, photos plus text, ten small square photos, three vertically-oriented photos, and more. After clicking a style, you get a Web page similar to the one shown in Figure 27.4. Click **Add or Upload Images** to get a Web page that allows you to browse and select the image files you want to use from your hard drive. After you select the images, you can then click and drag them to the layout. You can also add or delete text boxes or add or delete photo frames. When the mug is as you want it, click **Confirm & Finalize** to get a Web page that lets you save your project and add the mug to your shopping cart.
- After the mug has been added to the shopping cart, you can change the quantity, continue to shop, or check out. The online checkout process is secure and easy and you get a confirmation of your order via e-mail within a few minutes.

27.3

27.2

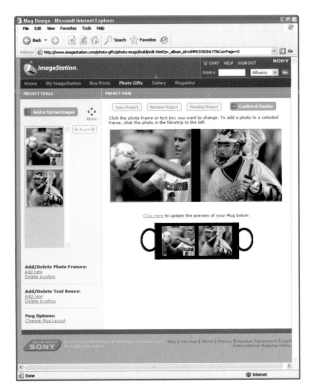

27.4

When we got ready to place an order for a couple of t-shirts, we checked our e-mail and the Web sites of our favorite online printing services to see which ones had a sale. We were fortunate to find that Kodak EasyShare and ImageStation were offering 15 percent and 25 percent discounts respectively. Kodak EasyShare was the only one that was offering t-shirts when we wanted to place an order, so that is where we placed our order. A couple of minutes of online price shopping saved us a few dollars. Placing the order at www.kodakgallery.com was easy. The entire process took less than two minutes to order two different-sized t-shirts with the same photo on them. Figure 27.5 shows the Kodak EasyShare Web page where we specified the size and number of shirts we wanted to order. Figure 27.6 shows one of our "Happiness is a Good Histogram" t-shirts featuring a photo of a turtle that was photographed in the Smokey Mountains in Tennessee.

> **NOTE**
>
> If you have an online photo gallery and you want to make it more well-known, think about how you can order photo gift items that will help you increase the exposure of your gallery and your work. If you enjoy taking sports action photos, order a t-shirt with one of your better photos and add text with the name of your online Web gallery. Digital photography is such an intriguing topic to so many people today you will be surprised how many people will ask you questions about what you do when you wear a shirt, or drink from a mug with a good photo and your Web site address on it. Promoting your work in this way is both fun and it may even help you earn money.

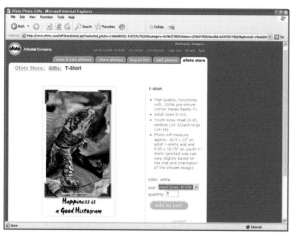

27.5

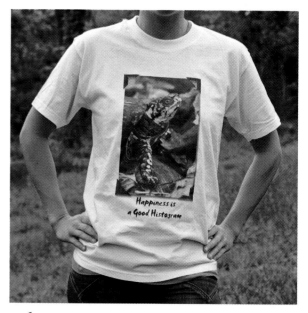

27.6

ORDER A FINE ART PRINT, MAT, AND FRAME ONLINE

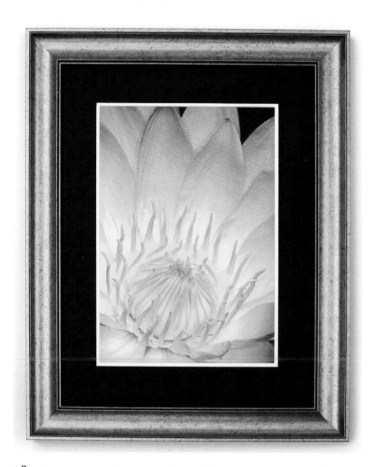

28.1 Get one-stop service at www.pictureframes.com. Upload your digital image file and specify paper, mat, and frame and get the printed, matted, and framed image packaged and shipped to you for a reasonable price.

WHAT YOU'LL NEED

An Internet connection and one or more digital photos that you want to use to make prints to be matted and framed.

I f life were so simple that all our wishes were granted, we would wish that we could upload any image file we want to have printed, matted, and framed to a single Web site — and get a framed print packaged and safely shipped to us, or anyone else that we chose to send it to. On that magical Web site, we would want to be able to choose the kind of fine art matte paper we want to use and we would want to know that the prints are made on a printer that uses an archival ink

197

suitable for selling to customers. Finally, we would want to be able to choose mat colors, easily determine mat border widths, and choose a frame from a large collection — all while being able to see a picture of the specified print, mat, and frame at each step to give us confidence that what we have chosen works and is the correct size. Continuing on with our wish, we would want the framed and matted print to be viewable against a color that matches the wall where we expect the framed print to hang. If you have experience ordering fine art prints online, and you have ordered matted and framed prints, you know how challenging it can be to order and to get what you want done correctly the first time and with no extra expense.

Well, guess what? In the process of researching print and framing services for this book, we found a company that was just launching the printing and framing service of our dreams. The company, PictureFrames (www.pictureframes.com), is part of Graphik Dimensions Ltd, a well-known manufacturer and supplier of picture frames for over 35 years. In this project, you learn how you can get what we wished for: excellent prints, framed, matted, packaged, and shipped wherever you want them to be shipped.

WHAT KINDS OF PRINTERS, PAPERS, AND INKS ARE USED AT PICTUREFRAMES.COM?

If you have any experience ordering high-quality photographic prints or you have made your own using a quality desktop inkjet printer, you will want to know what kind of printer and ink set will be used to make your prints before any consideration is given to placing an order. You probably will also want to know what kind of paper choices you have. Those are good questions for sure.

PictureFrames.com uses Epson 9600 printers exclusively with Epson UltraChrome inks and a variety of high quality papers. The Epson 9600 printers are able to produce amazingly detailed prints of both works of fine art and photographs. The Epson UltraChrome inks guarantee a long-lasting museum quality work of art providing they are used with the right papers. This process results in color resolution that exceeds most other types of image printing and it uses the same materials and processes that are currently being used to create fine art giclée' (a fine artist term for an archival art print) limited editions. Another added feature to this process is a predicted fade resistance of about 75 years, once again, assuming that appropriate papers are used. All their mat boards are acid-free as well.

When this book was written, we were able to choose from the following papers: Epson Premium Archival Matte Paper, Epson Premium Glossy Photo Paper, Epson Premium Semi-matte Paper, Crescent Satin Digital Art Paper, Crescent Velvet Digital Art Paper, Crescent Watercolor Paper, Fredrix Glossy Finish Canvas, and Fredrix Matte Finish Canvas.

STEP 1: PREPARE YOUR IMAGE

When we placed our first order with PictureFrames.com, there was only an option for sending a .jpg file. So, we uploaded the water lily image shown in Figure 28.2. The image was saved as a 1.4MB .jpg file using maximum compression level. The original file was 2,336 x 3,512 pixels and was a 25MB .tif file. We were skeptical, doubtful, and concerned about how well the print would turn out especially because it needed to be enlarged slightly to make a 12" x 17¾" print. In a word — it was wonderful! By the time you read this, you have an option of

loading a non-compressed .tif file. And it is our recommendation that you use that format to get the best possible prints and avoid any image degradation that you can get when using a compressed file format such as .jpg.

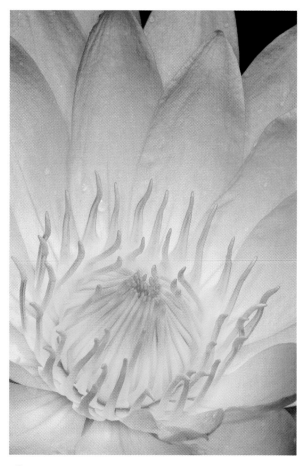

28.2

STEP 2: ORDER PRINT, MAT, AND FRAME

By the time you read this, chances are good that the PictureFrames.com Web site will have changed so we are not going to provide much of a step-by-step set of instructions for using their Web site. In any case, the ordering process is so easy that there is not much point in providing detailed instructions. Instead, we provide a quote from a news release that they provided to us. We also show you a couple of screenshots from their Web site so you can learn about the specification and ordering process. You quickly get the picture — pun intended! PictureFrames.com explains their service as follows:

> "Firstly [sic], at PictureFrames.com the customer can have the unusual yet reassuring experience of 'try before you buy.' With the *Personal Frame Shop* section of our Web site, we've revolutionized the very ordinary process of selecting and purchasing a picture frame by allowing the customer to upload his/her art, combine and view it with thousands of mat (even double mats) and frame combinations – all at real scale and proportions – **and,** with one click of their mouse, they can compare prices among their favorite combinations.
>
> They can play with possibilities, go have some lunch, and play more if they like – all of it is saved for at least one month. And, despite this flexibility, if any hesitation should remain (i.e. I'm an artist and need to be absolutely certain that color is beyond accurate . . .), we offer another unique service: with a click of the mouse, we offer *unconditional and absolutely free (including shipping) samples* of all frame and mat materials."

Ordering from PictureFrames.com is simple — as simple as specifying the image, the paper, the matting, the frame, and placing an order. To place an order from `www.pictureframes.com` you take the following steps.

■ Click **Print & Frame** to get a Web page similar to the one shown in Figure 28.3. To upload an image, you click the **Browse** button at the bottom of the page and select the image. Once the image is selected, you click **Upload My Image** and it displays in the preview box.

■ After an image uploads, you can then edit the image and change the color of the background to match the color of the background where the print will be hung (assuming you know). You can set the image width by clicking in the **Width** and **Height** boxes. You can also crop the image if you choose. If you click **Effects**, you get a Web page similar to the one shown in Figure 28.4 where you can choose any one or more of four tools including **Edges** if you want to apply an edge effect, such as **Sponge**, **Torn**, or **Brush**.

■ Click **Paper** to get a Web page that lets you select the type of paper you want. We chose **Crescent Velvet Digital Art Paper**.

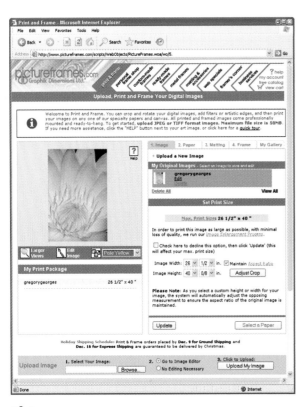

28.3

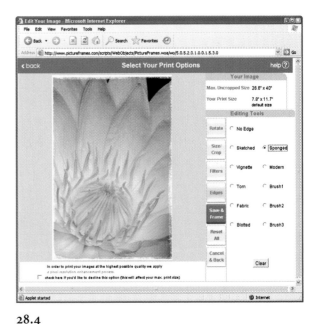

28.4

■ Click **Matting**. After choosing a color for the top and bottom mats and the width of the dimensions and offset for the mats, you have a Web page similar to the one shown in Figure 28.5. Wow, was that easy compared to the process we have been through before. Click **Update** and you can see the price for what you have ordered so far and you can see the image in the mat.

■ Click **Frame** to select a frame. You can choose a frame by doing a search by **Frame Type**, **Color**, **Width**, **Style**, and **Rabbet**. After looking at a few frames, we chose the **AB6-Ambrosia**. When you click a frame you can see the frame on the image, as shown in Figure 28.6. If you want a better view of the image and the frame click **Larger Views** to get a browser window such as the one shown in

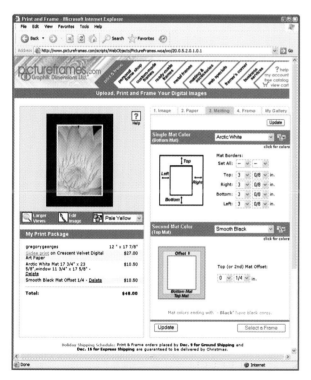

28.5

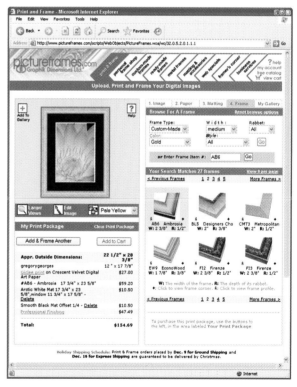

28.6

Figure 28.7. To get a better idea of how the frame looks, click **Frame Close-Up** to get a browser window similar to the one shown in Figure 28.8. With each change you get an updated cost of your print package.

■ To place an order, click **Add to Cart**. You are then presented with your shopping cart and detailed specifications of each project you

specified. To checkout, click **Secure Checkout** and go through a simple and secure Internet checkout process. When checking out, you can choose where you want the print to be sent if it should go to a different address than your own. If you want a gift note sent with it, you can order one to go with the completed project.

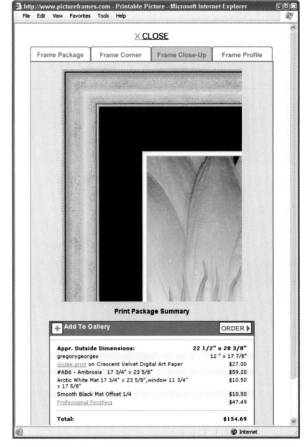

28.7

28.8

After you specify a project, it is saved in a gallery where you can order one or more prints easily. Or, you can change the specifications if needed. We got two framed prints on our first order and they were superbly packaged and there was no damage at all. From the way these prints were packaged, we have full confidence that they are more than likely to get to anyone that we want to send them to in perfect shape. If you can't yet tell, we love this innovative service and the quality-orientation that PictureFrames.com has. We expect to use their services often in the future.

WHAT OTHER SERVICES ARE OFFERED BY PICTUREFRAMES.COM?

PictureFrames.com offers many special services for professional artists, photographers, and businesses that choose to publish their own editions of artwork. Services include: reproducing from any original artwork and a range of media, proofing protocol (1st proof free with the order of an edition), artist signature protocol, laminating, engraving, printing on canvas, print-only services, and flexible inexpensive options on the printing of editions without having to print an entire edition at once. They also offer Web site solutions to support artists and photographers in the marketing of their work.

For those times where you simply want to place an online order for a framed print that will be sent to someone as a gift, you can request to have an appropriate gift card or note sent along with the framed print.

HOW DO YOU MAKE A PHOTOGRAPHIC IMAGE LOOK LIKE ART?

One of the most often-asked online questions is: How can I make my photographic images look more like fine art? When you start printing photos on canvas and watercolor paper, as can be done with many inkjet printers and when using the services offered by companies such as PictureFrames.com, it becomes an obvious question to ask.

You can take many approaches. The most artsy approach is to use a Wacom pen tablet (`www.wacom.com`) instead of a mouse and digitally paint over your photographic images. You can use the brush tools found in most image editors. Undoubtedly, this approach does take some painting skills and the results can be less than desired unless you are a talented artist.

If you are skilled in painting or you intend to develop that skill, the best software to use is the amazing Corel Painter IX (`www.corel.com`). It is billed as "The World's Most Powerful Natural Media, Painting, and Illustration Software" and it is amazing! We both intend to spend considerable time using Corel Painter IX in the future. If you want to try it out, you can download a trial version from the Corel Web site. At $230, you want to try it before buying it. It is a unique product that is way ahead of any other product if you want to paint digitally.

If you have an image editor, you can try one of many different approaches to blurring, blending, and painting images. A few of Gregory's other books, including *50 Fast Digital Photo Editing Techniques with Elements 3.0,* include several of these techniques.

You can also visit `www.google.com` and search for online tutorials and techniques for making art from photographs.

You can get some rather good effects with two software applications that have been purposefully designed to turn digital photographs into fine art. These products are buZZ.Pro 3.0 (`www.fo2pix. com`) and Virtual Painter (`www.livecraft. com`). Both of these products are available as free trial versions from the vendor's Web sites. Figure 28.9 shows a screen-shot of the buZZ.Pro 3.0 plug-in being used inside Elements 3.0. Figure 28.10 shows

28.9

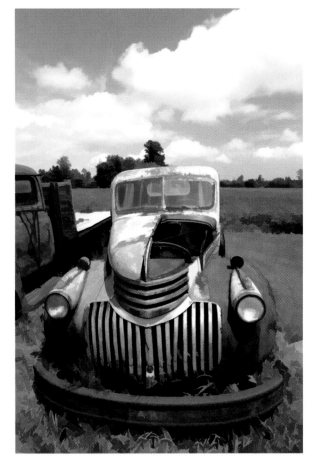

28.10

28.11

28.12

the results of using buZZ.Pro 3.0 on an image of an old farm truck, and Figure 28.11 shows a detail image of the effects. Figure 28.12 shows a screen-shot of the standalone version of Virtual Painter. Figure 28.13 shows the results of applying Virtual Painter to

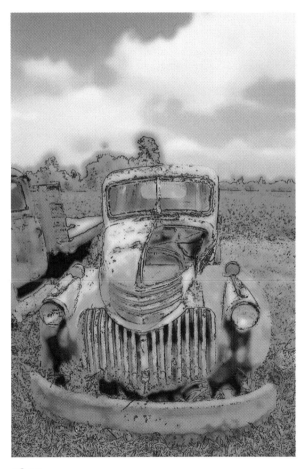

28.13

the same truck image. Figure 28.14 shows a detail view of the effects that were applied to the truck image using Virtual Painter. Both of these products are fun to use and, on images with the right characteristics, they can be used to make wonderful prints.

28.14

> **TIP**
>
> **If you decide to order a framed print from PictureFrames** (www.pictureframes.com), **you can save 15 percent off your first order if you enter the discount code 50FDPP when going through the Web page checkout process. This is a special discount for readers of this book.**

ORDER A LIGHTJET PRINT ONLINE

29.1 For the ultimate photographic print made chemically from one of your digital files, order a Lightjet 5000 print online from a "high-end" photo-processing lab, such as Calypso, Inc. (www.calypsoinc.com).

If you want the ultimate photographic print made chemically from one of your digital image files, then you want a Lightjet 5000 print made on Fuji Crystal Archive photographic paper. These continuous tone photographs are known for their rich blacks, print permanence, and excellent color range. Such prints are the preferred prints of many artists and professional photographers all over the world.

So, why might you want to order a Lightjet print? An expensive Lightjet print is not for everyday purposes unless you have the budget to get the best prints all the time. However, a Lightjet print is the perfect print to order for photo competitions, for those times where you want a superior print, and when you choose to make a print that is to be framed in an expensive frame. It is also a nice print to have made if you sell your work to others as a Lightjet 5000 print has been recognized for many years as one of the best photographic prints you can buy.

While there are over 400 sites worldwide that have Lightjet printers, only a few of those sites keep their printers properly color-managed so that you get consistent prints that match the images on your monitor. Calypso, Inc. (`www.calypsoinc.com`), in Santa Clara, California, is one company that we recommend due to the efforts they take to provide you with color-managed prints. Their focus is on nature, landscape, wildlife, fine art, and travel markets, and they have a list of customers that includes many of the finest photographers in the world.

One additional advantage of using the Lightjet 5000 printing process is that it is wonderful for increasing the size of an image. Several years ago, Gregory had Calypso print a series of increasingly larger prints with the intent of stopping once the image began to show some degradation. Much to his surprise and jubilation, they stopped printing when they got to a 22" x 32" print due to shipping problems and the costs of shipping larger prints — not because of image degradation! If you take into account the distance that you view an image, there was no visible difference between the 11" x 14" print and the 22" x 32" print. Obviously, you stand back a couple of feet when you are looking at a print as large as 22" x 32", which is much further back than if you were looking at an 8" x 10" print. Digital cameras make great images for making large prints. Test one of your images by having a large Lightjet 5000 print made.

Several limiting factors determine how much you can increase the size of a digital photo without it suffering from noticeable image degradation. The quality of lens, image sensor, ISO setting, and the image itself are all important factors. Figure 29.2 shows the 3.1-megapixel image of an iris that was used to make a 22" x 32" print. The iris itself was very sharply focused and the background was softly focused and the Canon D30 digital camera that was used for this photo was set to ISO 100, which meant that the image was virtually free of any digital noise. These characteristics made this photo excellent for making a large print.

29.2

To get prints made at Calypso, you can either upload image files to their FTP site or you can write the image files to a CD-ROM and send them via mail or a courier service. Calypso offers two different pricing plans. The "preferred" pricing plan is for images that have been prepped, color-managed, and profiled directly to the Calypso Lightjet 5000. In this case, you take all the responsibility for color management. Or, you can pay about 30 percent more (for the first print) and have Calypso do some of the work for you and they will be responsible for color-management. Please visit the Calypso Web site and read the Calypso Guide to Color Management on the Lightjet 5000.

To avoid making you overly concerned about what it means to have an image be "profiled," we have listed the steps you need to take to get the preferred pricing of Calypso. However, before you begin converting the profile of an image by following these steps, you must understand that to get the prints you want, your monitor must be properly calibrated. In simple terms, this means that the colors on your screen show as they should. In other words, if your computer screen is properly calibrated, and you have profiled your image with the right color profile, the Lightjet 5000 print will match the colors you saw on your computer screen. Step 2 in Project 18 covers basic monitor calibration. If you choose to profile your own images to get the preferred pricing of Calypso as we always do, you need an image editor that allows you to convert color profiles. Adobe Photoshop versions 5.5 and later allow you to convert color profiles.

STEP 1: DOWNLOAD THE CALYPSO LIGHTJET 5000 ICC COLOR PROFILE

■ To get the Calypso Lightjet 5000 ICC color profile, go to www.calypsoinc.com. In the left frame, click **Lightjet Prints** and then **Preferred**.

In the frame on the right, you should be able to find a link to download Lightjet profiles for PC or Mac. Click the appropriate profile link to begin downloading a ZIP file containing three different color profiles: one each for Matte, Gloss, and Supergloss paper. Additional files may be added when new media becomes available and on occasion, new profiles are substituted for those listed here.

■ After the files are downloaded and unzipped, they need to be copied to the appropriate directory for your operating system. If you are using Windows XP, use Windows Explorer to locate and open the folder where the unzipped files were saved. Press **Ctrl** while clicking each of the three files to select them all. Right-click one of the files to get a pop-up menu; choose **Install Profiles**. Windows XP automatically installs the color profiles for you. If you are using a Mac, the profiles will need to be copied into the ColorSync Profiles folder (HD\Library\ColorSync\Profiles).

STEP 2: CONVERT PROFILE TO CALYPSO LIGHTJET 5000 COLOR PROFILE

■ Launch Adobe Photoshop 5.5 or a later version. For this project we used Adobe Photoshop CS2.
■ Choose **File ➢ Open** (**Ctrl+O/Command+O**) to display the Open dialog box. Double-click the folder containing the image you want to print; then, click the file to select it. Click **Open** to open the file. To order prints from Calypso, the file must be either a Photoshop .psd file or a .tif file and starting with an Adobe RGB (1998) profile is best if you have a choice.
■ To convert color to the Calypso Lightjet 5000 color profile that was downloaded in Step 1, choose **Edit ➢ Convert to Profile** to get the

Convert to Profile dialog box shown in Figure 29.3 Click in the **Profile** box to get a pop-up menu. You should find three profiles names starting with "Calypso"; these are the three Calypso Lightjet files. Choose **Calypso LJ5 SuperGloss v2.icc** (or the name of a newer file if you downloaded a newer color profile) to select the super glossy media profile.

■ Make sure **Engine** is set to **Adobe (ACE)** and that **Intent** is set to **Perceptual**. **Use Black Point Compensation** and **Use Dither** should both be switched off.

■ Click **OK** to convert the profile.

29.3

STEP 3: SAVE FILE

■ You can now save your file by choosing **File ➤ Save As** (**Ctrl+Shift+S/Shift+Command+S**) to get the File Save dialog box. After selecting an appropriate folder, type a name in the **File Name** box so that you don't save it over the original file. Make sure that the **ICC Profile** box is checked in the Color area. It should show the **Calypso LJ5 SuperGloss v2.icc** profile that you selected earlier. Also make sure you are not saving layers.

■ Click **OK** to save the file.

Your file is now ready to be uploaded to the Calypso FTP Web site, or written to a CD-ROM or other removable storage media and mailed to Calypso. Please visit the Calypso Web site to learn more about what storage media is acceptable to Calypso, about getting an FTP site set up for your image files, and additional ordering information. At the time this book was published, Calypso was in the process of implementing a new online order system that will make uploading and ordering prints even easier.

The end of this project is also the end of this chapter about ordering prints online. In the next chapter, you read about five projects for sharing digital photos electronically.

6

SHARING DIGITAL PHOTOS ELECTRONICALLY

In this chapter, you learn how to easily and quickly share your digital photos electronically. Projects 30 and 31 cover three different ways to send e-mail that features digital photos, from simply sending digital photo files as attachments to embedding a Web page featuring digital photos inside an e-mail message. In Project 32, you learn how to exchange digital photos during an online chat session using AOL Instant Messenger. Sharing one or more digital photo galleries with photo-sharing software is the topic of Project 33. Project 34 shows you how to create a digital slide show that is easy to e-mail and fun to view. After completing the projects in this chapter, you will have many more options to consider next time you want to share photos electronically.

SEND DIGITAL PHOTOS USING MICROSOFT OUTLOOK

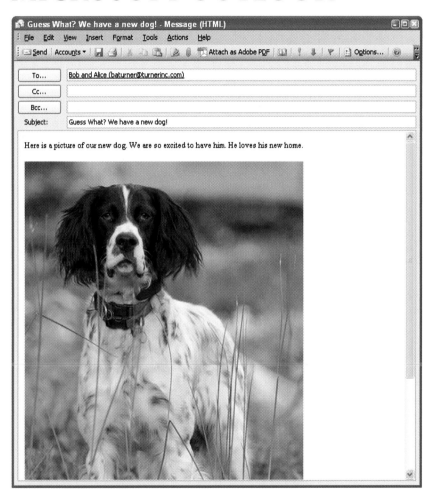

30.1 When sending digital photos via e-mail, make sure they are properly sized and presented well.

Microsoft Outlook 2002 or 2003, an image editor, and a few digital photos

There are good ways and bad ways to e-mail digital photos. If you have ever received an e-mail that included a huge digital photo file that was so large that it took a long time to download and used a large percentage of your available mailbox space, then you know how annoying it can be to receive digital photos that have been sent the wrong way.

In this project, you learn three different ways to include one or more digital photos when sending an e-mail using Microsoft Outlook. First, you learn to send them as an attachment. You then learn to send them embedded in the e-mail. The third method you learn is how you can send a link to a photo that is posted on a Web page. This last method is useful for sending digital photos to those who may not want to receive e-mail with digital photos.

STEP 1: RESIZE DIGITAL PHOTOS TO BE SENT VIA E-MAIL

Before sending one or more digital photos, you should first resize them so that they can easily be viewed on a 1,024 x 768 pixel screen, they require a minimum amount of e-mail box storage space, and are quick to download. Unless you have a reason to send digital photos that are larger than about 700 pixels on the largest side, you should limit the longest dimension to 700 pixels. Why 700 pixels? A 700 pixel wide or tall image can be displayed on monitors that have standard display resolutions of 800 x 600 pixels

and 1,024 x 768 pixels. A file of that size can generally be compressed to be under 70K, a good maximum file size limit to stay under.

Resizing a digital photo file is a simple task if you have an image editor. The following steps show how to resize the dog photo shown in Figure 30.2 using Adobe Photoshop Elements 3.0.

■ After opening the digital photo you want to resize, using the Adobe Photoshop Elements 3.0 Editor, choose **Image ➢ Resize ➢ Image Size** to get the Image Size dialog box shown in Figure 30.3. Make sure a check mark is next to the **Constrain Proportions** box and the **Resample Image** box. Click in the **Resample Image** box to get a pop-up menu; click **Bicubic Sharper**.

TIP

One step you can take to make it easy to send digital photos is to create a folder in your \My Documents folder named \ToEmail. Create a sub-folder named \Sent and one named \ToResize. When you have an image file that you know you want to e-mail and that needs to be resized, you should put it in the \ToResize folder. After you resize the image, you should save it to the \ToEmail folder. After you send the image, you can move the image to the \Sent folder. Using these folders makes it easy to find and send digital photos and to store them in case you decide to send them again as a different size.

30.2

Bicubic Sharper is the best algorithm to use for down-sampling an image (this assumes you started off with a larger image than you need). In the **Pixel Dimensions** area, look to see if the **Width** or **Height** number is larger. Click in the box following the value that is largest and type **700** pixels. Click in the first box following **Resolution** and type **72**. As you see later in this project and the next one, 72 pixels/inch is the value you want to use to properly display the image on a computer screen. Click **OK** to resize the image.

■ Choose **File ➤ Save As** (**Shift+Ctrl+S/ Shift+Command+S**) to get the Save As dialog box shown in Figure 30.4. Click in the **Save in** box and choose the folder where you want to save the file to be e-mailed (for example, **\ToEmail**). Click in the **Format** box and choose **JPEG**.

■ Click **Save** to get the JPEG Options dialog box shown in Figure 30.5. Click the down-arrow after the second box following **Quality** and choose **Medium**. Look in the **Size** area at the bottom of the dialog box. At **56.6 Kbps** the file should ideally be under 70K. There is no hard and fast rule that

30.4

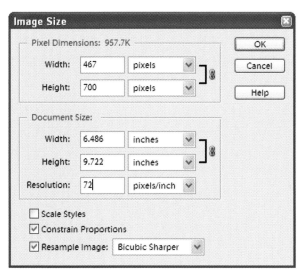

30.3

30.5

says that you should always send digital photo files that weigh in under the 70K limit — it is just a considerate thing to do. If your image file is larger than 70K and you want to keep under that somewhat arbitrary limit, you can lower the Quality setting, or you can reduce the size of the image using Image Resize. If you do choose to resize the image, make sure you use the original photo if it is available. Resizing an image that has previously been saved as a .jpg file can result in unnecessary loss of picture quality. If you put a copy of the original file in the **\ToResize** folder as mentioned earlier, the original is easy to find. Click **OK** to save the file. The file is now ready to be sent via e-mail.

NOTE

When resizing an image for use on a Web page or printed page, setting the Resolution in the Size dialog box to a value that is appropriate for the intended use is best. While this is not essential, it can be helpful when using the image. If you intend to display the image on a Web page, or as an HTML-formatted page in an e-mail message, you should set Resolution to 72 pixels per inch. The majority of computer screens display 72 pixels per inch, which is why you should use a value of 72. Printer resolution varies between printers. Generally, you should use 240 or 300 pixels per inch depending on the brand of your printer. One advantage to using the correct resolution is that you can choose font sizes (for example, 12 pt) and have them display appropriately.

STEP 2: E-MAIL DIGITAL PHOTOS AS ATTACHMENTS

The most common way of sending a digital photo via e-mail is to send it as an attachment. To send a digital photo as an attachment using Microsoft Outlook, perform the following steps.

■ Choose **Go ➤ Mail** (**Ctrl+1**). Choose **Actions ➤ New Mail Message** (**Ctrl+N**) to get a new message dialog box. Type in one or more e-mail addresses in the **To** box. Type in an appropriate subject in the **Subject** box and any message you want to send along with the image.

■ Choose **Insert ➤ File** to get the Insert File dialog box shown in Figure 30.6. Locate the folder that contains the image file you want to send and click the file to select it. If you used the **\ToEmail** folder that was suggested earlier, it is easy to find the file. Click **Insert** to attach the file. You should now see a file in the **Attach** box as shown in Figure 30.7.

■ Click **Send** to send the e-mail and attached digital photo file.

You have now sent an image as an e-mail attachment. Is this the best way to send digital photos? We think there are better ways. The problem with sending an attachment is that you are making the assumption that the recipient of the e-mail will be using a

30.6

computer that has an image viewer that is correctly configured to display the file, or that they know how to use an application that allows them to view any digital photos you send them.

STEP 3: E-MAIL DIGITAL PHOTOS THAT ARE EMBEDDED INTO THE E-MAIL

A better way to send one or more digital photos is to embed them into the e-mail. The one caveat is that there are a few e-mail clients that are not able to display HTML-based e-mail. In those increasingly rare cases, the text shows without the images. To send a digital photo embedded into an e-mail using Microsoft Outlook, perform the following steps.

■ Choose **Go ➢ Mail** (**Ctrl+1**). Choose **Actions ➢ New Mail Message** (**Ctrl+N**) to get a new message dialog box. Type in one or more

e-mail addresses in the **To** box. Type in an appropriate subject in the **Subject** box and any message you want to send along with the image.

■ To embed an image into an e-mail, the e-mail has to be set in HTML format. This fancy acronym-named format is none other than the format that is used for Web pages. Some people set up Outlook to create HTML formatted e-mail messages as the default because you have so many options you don't have when using the more common Plain Text format. To choose the HTML format, choose **Format ➢ HTML** from the e-mail menu bar. If your message is currently set to Rich Text format, you have to change it to Plain Text format before you see an HTML menu option, which you should then select.

■ Click in the text message where you want to insert the digital photo.

30.7

> **NOTE**
>
> When sending digital photos via e-mail, you should work to minimize the size of the image files. Large digital photo files may require more time to download than the recipients of your e-mail may want to spend. If you know that the recipient has a slow Internet connection, keeping the files under 70K is best. Because most e-mail services have limits on e-mail box storage capacity, it is a good idea to keep all digital photos under 70K regardless of the speed of the Internet connection that the recipient may have.

■ Choose **Insert ➢ Picture** to get the Picture dialog box shown in Figure 30.8. Click **Browse** to get the Picture dialog box where you can choose a digital photo file. If you used the **\ToEmail** Folder that was suggested earlier, it is easy to find the file. After clicking the file you want to use, click **Open** to insert the file. You are brought back to the Picture dialog box and the file name should now be shown in the Picture Source box. A few other useful options are in this dialog box such as alignment, spacing, and border thickness in case you want to add a border to your images. Click **OK**. You should now see the image displayed in the text message area, as shown in Figure 30.9. If you want to include one or more photos, you can now insert them in the same way. Add any other text you want and position the cursor where you want an image to be displayed before choosing **Insert ➢ Picture**.

■ Click **Send** to send the e-mail and embedded digital photo file.

You have now sent an e-mail with an embedded photo. Don't you like this approach better than just sending an attached file? Try it. We're betting that those who get e-mail from you will enjoy your e-mail and photos more when you send them in HTML format.

> **TIP**
>
> If you like using HTML-formatted e-mail messages, you should configure Microsoft Outlook to create HTML messages as the default format. To set messages to HTML choose Tools ➢ Options ➢ Mail Format. In the top part of the dialog box you will find a box with the following: "Compose in this message format." Click in the box, choose HTML, and then click OK. From now on your e-mail messages will be formatted in HTML, which makes it easy to embed digital images.

30.8

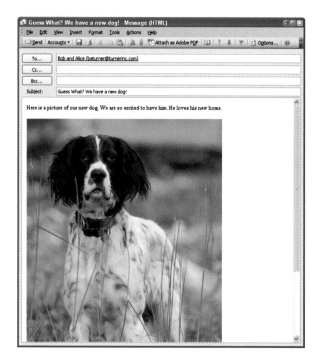

30.9

STEP 4: E-MAIL DIGITAL PHOTOS VIA WEB PAGE LINKS

There are times where you want to send digital photos via e-mail, but it is not appropriate to include them all in the e-mail as an attachment or embedded in the e-mail. Maybe the images are by choice larger than you should put in an e-mail. Or, you may want to send far more images than your recipients may want to receive. In spite of how much one can value one's own photos, it is not always the case where everyone that receives them via e-mail will value them as much. In those and other cases, you may want to put your digital photos on a Web page and send a link to the photos or photo galleries, as shown in the message in Figure 30.10. When you send a link, viewers can view the images on a Web site without having to download them all to get to other e-mail messages.

After you have successfully embedded and sent a few digital photos using HTML-formatted e-mail, you may be wondering what other options are available for making creative e-mail messages featuring your digital photos. In Project 31, you learn other approaches and how to make some of the coolest e-mail messages you've ever seen with Microsoft Word.

> **WARNING**
>
> Before receiving files of any kind, including digital photo files (that is, files with a .jpg file extension), make sure that you have anti-virus software installed and that you are running with all current updates installed. Clever virus creators have figured out how to put a virus in .jpg image files. The best policy is to avoid opening any digital photo files from anyone that you don't know or any source that you don't have a reason to trust. While this is a good policy, don't get so paranoid that you miss out on seeing good photos because of the chance you could get a virus that your anti-virus software won't catch.

30.10

CREATE AN E-MAIL WITH AN EMBEDDED WEB PAGE

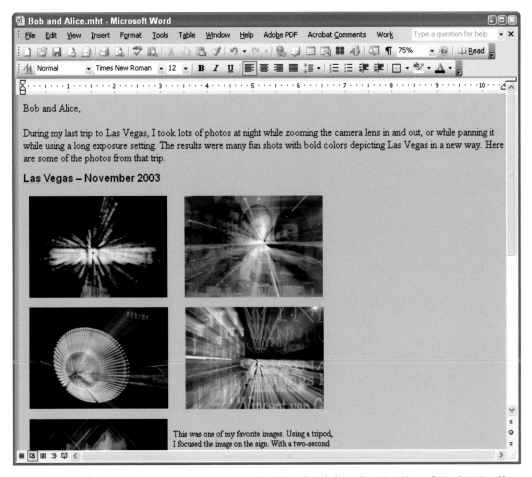

31.1 You can easily create sophisticated e-mail messages displaying digital photos by using Microsoft Word 2003 and by sending them via Microsoft Outlook 2003.

WHAT YOU'LL NEED

Microsoft Word 2003, Microsoft Outlook 2003, an image editor, and a few digital photos

Project 30 showed you three different approaches to creating e-mail featuring digital photos. You learned how to send digital photos as attachments to e-mail, as viewable images that are embedded directly into the e-mail, and as links to images that are displayed on a Web page. In this project, you learn how to take the embedded photo approach even further. You learn about many fancy formatting features found in Microsoft Word that you

221

can use to create awesome e-mail messages that are fun to send. This approach uses Microsoft Word to create an HTML-formatted Web page (a page just like any Web page you can view in an Internet browser) that can be sent as an e-mail message using Microsoft Outlook.

We ought to mention one warning about this approach of creating e-mail. A few e-mail clients are not able to display HTML-based e-mail. In those increasingly rare cases, the text is shown without the images, thus giving the recipient enough information to let them know what you intended to send to them. If they want to view the photos, too, they can reply back to you and let you know that they were not able to view the photos. Otherwise, creating HTML-based e-mail is an excellent way to make your photos look better when presented in an e-mail.

STEP 1: RESIZE YOUR DIGITAL PHOTOS AND SAVE AS .JPG FILES

Before you begin creating an HTML-formatted e-mail, you need to have all the digital photos you want to use edited, cropped, resized, and saved as a .jpg file in a folder. To learn more about resizing digital photos, read the section on resizing images at the beginning of Project 30.

STEP 2: CREATE A WEB PAGE USING MS WORD

Yes, that step heading is really correct! You should use Microsoft Word to create an e-mail message. Why? Because you have more features for formatting a message in Word than in Outlook. For this example, we chose to use a few photos that were taken in Las Vegas. You should follow along with a few of your own photos that you resized so that the longest side is 400 pixels. The goal of this project is to experiment with a few formatting features so that you know what can be done. You can then create your own e-mail messages exactly as you want them.

■ Using Microsoft Word 2003, choose **File ➢ New** and then choose **Web Page** from the palette on the right side of the new document. You should now be looking at a blank document, which is really an HTML page even though it looks like an ordinary Word document.

■ To choose a background color, select **Format ➢ Background** and then click a color you want from the pop-up color palette. We chose a light gray color, as shown in Figure 31.2.

■ Type in any introductory text you want in the message area. Because you are working on an HTML-formatted document, you can choose the font, font size, and font color. However, you should choose a common font, such as Times New Roman or Arial, or you run the risk of creating an e-mail that will look different on your screen than it does on the recipient's screen if they don't have the same fonts installed on their

31.2

computer that you use. Our choice of font is Times New Roman and we use a 16-point font size. Add a title if you want and change the font size of the title text to add emphasis.

■ Place your cursor where you want to insert a photo. To move it down a line, press **Enter**. To move it over a space at a time, press the **Space** bar.

■ To insert a photo, choose **Insert ➢ Picture ➢ From File** to get the Insert Picture dialog box shown in Figure 31.3. Highlight the image file you want by clicking the drop-down arrow in the **Look in** box and navigate to the folder in which the image is stored. After you select it, click **Insert**. The image then inserts into your HTML document. To resize your photo, right-click it and then choose **Format Picture**. Click the **Size** tab to get the dialog box shown in Figure 31.4. Click in the **Height** or **Width** box and type the size in inches you want and then make sure that **Lock Aspect Ratio** is checked before clicking **OK**. Turning Lock Aspect Ratio on will keep you from getting distorted images. Alternatively, you can set a scale percentage to change image size, too. Because you are working in Word, you use a default page size that is 8.5" wide. For the example here, we set **Width** to **3"** as that was sufficiently small to be able to show two images per line.

■ If you want to add more photos, follow the same process for each photo. First, move the cursor where you want the next photo to be inserted. Figure 31.5 shows the e-mail message with a gray background, some introductory text, headline text,

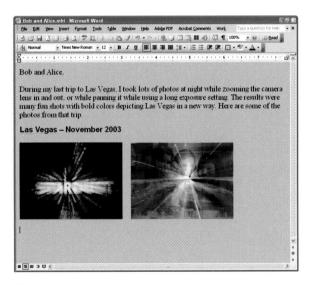

31.4

31.3

and two photos. Press **Return** once or twice and add a few more images as you did the prior two. You can adjust the space between each photo on a row and between rows by adding spaces or inserting lines by pressing the **Enter** key where they are needed. After adding two more images, our e-mail looked like the one shown in Figure 31.6.

If you want to add text to the left or right of an image, you can do that, too. For example, to type text describing a photo after the photo, but in line with the photo, first insert the image. Then, right-click the image to get a pop-up menu. Click **Format Picture** and then click the **Layout** tab to get the dialog box shown in Figure 31.7. Click the **Square** box. Set **Horizontal Alignment** to **Left**; click **OK**. You should now see the text to the right of the image, as shown in Figure 31.8.

31.7

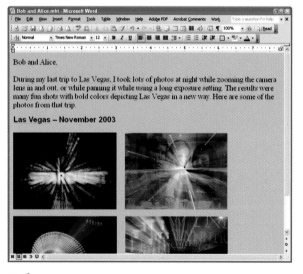

31.6

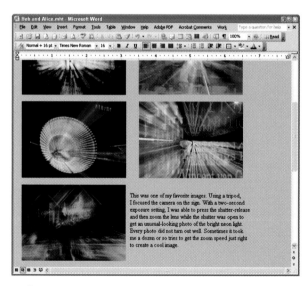

31.8

STEP 3: SEND E-MAIL USING MICROSOFT OUTLOOK

- After you've completed your e-mail message and have formatted it as you want, choose **File ➢ Send To ➢ Mail Recipient**. You now see the e-mail feature embedded into the top of the document, as shown in Figure 31.9. Type in the e-mail address, a subject, and click **Send a Copy** to send the e-mail via Microsoft Outlook. You just created and sent a great-looking e-mail.

You now know how to use Microsoft Word to create an HTML-based e-mail message. If you want to do more fancy formatting, you can take a few minutes and explore many of the menu options in the Format menu and in the Table menu. Tables can be used for arranging images. If you want to create links and bookmarks that work like they do on a Web page, you can also experiment with some of the features you find in the Insert menu.

If you have simple needs when creating an HTML-based e-mail, you may find that you have everything you need in Outlook when you format the e-mail message as HTML. Most of the menu items for the features that are useful for creating HTML-based e-mail are in the Format and Insert menus. On those two menus you can find such features as Background, Picture, Font, Horizontal Line, Picture, and Hyperlink.

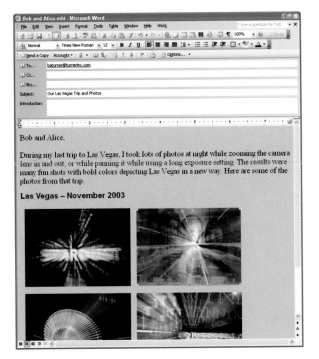

31.9

NOTE

If you enjoy sending digital photos via e-mail but you hate the hassle of resizing, formatting, attaching, or embedding, then you should check out Novatix SendPhotos Gold (www. novatix.com). This $20 software product offers a wizard that makes it simple and quick to create beautiful e-mails featuring your photos. You can choose from over 100 style sheets and many different types of stationery. This is a highly recommended product for those who want to easily e-mail digital photos. If you think it may be something you want to try out, they offer a free downloadable trial version.

EXCHANGE DIGITAL PHOTOS WITH AOL INSTANT MESSENGER

32.1 Use an instant messenger to chat with friends, family members, and co-workers and to share digital photos.

WHAT YOU'LL NEED

AOL Instant Messenger (free download at www.aol.com**) and a few digital photos to share**

For many of today's youth, "IMing" is *the* thing. They study, work, and chill with an Instant Messenger usually running in the background if they want to chat. IMing is also useful and fun for those beyond being called youth. While some people believe that online chatting is a dangerous, obscene activity, and a serious waste of time, it only is if the chats are used in that manner. We are

both here to tell you that using an instant messenger can be a wonderful way to communicate with friends, family, and co-workers, and to share photos with them, too. In this project, you learn how an instant messenger works and how you can share digital photos with AOL Instant Messenger.

Both co-authors of this book have used instant messengers for years. The father-daughter relationship has grown and prospered through good communication including more than a few online chats using an instant messenger. When Lauren was in middle school and high school and studying in her bedroom, occasional chats occurred between her and Gregory in his office, which were only 50 feet apart. Later on, when Lauren was in college in another city, they used an instant messenger as a key way to exchange quick messages and to say hello. Both authors have enjoyed continuous communication over the years with other family members and with friends with an instant messenger.

For the example in this project, we show you a chat where Gregory IM'd Lauren to talk about the soccer game that she played earlier in the day. As you may expect, Gregory takes action photos at all of her college soccer games. So, in this particular chat session, action photos showing Lauren were sent via AOL Instant Messenger. Now, how cool is that? If you want to have better communication with your friends, family members, or work colleagues, then you may want to get connected via an instant messenger and start sharing your best digital photos.

HOW DOES AN INSTANT MESSENGER WORK?

When you use e-mail, you type a message and send it after adding an e-mail address and subject. The message then has to go through your e-mail server and be routed to the recipient's e-mail server. The recipient must then use an e-mail client, such as Microsoft Outlook, to download the e-mail and open it. After the message is read, a reply can be composed and sent, and the same process happens all over again. The amount of time it takes for the message to display on the recipient's computer screen varies between a few seconds and many minutes. If you want to have a quick interactive conversation, this is not the way to have one!

In sharp contrast, an instant messenger is an application that enables you to type a message and click send and the message is sent directly to the recipient's computer where it displays almost instantly. They can type a reply, or even be typing a message to you while you are sending one to them. It is nearly real-time chat if both parties in the chat have a high-speed Internet connection. Some of the instant messengers, such as AOL Instant Messenger, now let you send digital photos as you send messages. This lets you exchange photos and chat about them at the same time.

STEP 1: SELECT PHOTOS AND PUT THEM IN A SEPARATE FOLDER

Before you send a digital photo using an instant messenger, you should first make sure that it has been edited, cropped, resized, and saved as a .jpg file in a folder. You can send large digital images when chatting on an instant messenger, but you are wise to send photos that are 400 to 500 pixels wide and not more than 700 pixels in height. This size digital photo displays full-size in the chat window. To learn more about resizing digital photos, read the section on resizing images at the beginning of Project 30.

IF YOU WANT TO SHARE PHOTOS FROM A FOLDER ON YOUR HARD DRIVE

We recommend that you keep a folder in your **My Documents** folder for digital photos that you may want to share when sending e-mail or when chatting

online using an instant messenger. Having a convenient folder makes it easy to find the digital photos you want to share and allows you to share them quickly when you need them.

IF YOU WANT TO SHARE PHOTOS IN THE "YOU'VE GOT PICTURES PICTURE CENTER"

AOL offers an online "You've Got Pictures Picture Center" that you can use to share photos and to order prints from digital image files. If you use this feature, you can also use the photos you stored on that Web site when chatting online using the AOL Instant Messenger.

STEP 2: INITIATE AND BEGIN CHAT SESSION

■ To initiate the chat session, Gregory right-clicked Lauren's Screen Name (DigitalSherpa2) to get a pop-up menu. He then clicked **Send Instant Message** to open up a chat window.

■ After clicking in the message box at the bottom of the chat window, he typed a message and then clicked **Send** to send it to Lauren. This message and other messages are then displayed in the top window in order of the time each message was sent, as shown in Figure 32.2.

STEP 3: SEND A DIGITAL PHOTO

■ Before you send a digital photo, a direct IM connection must be opened. This is a safeguard that prevents anyone from sending you a photo you have not agreed to accept, and to help prevent you from getting unwanted files that may contain a virus. Either party can open up the direct connection by choosing **People ➤ Open Direct IM Connection**. In this case, Lauren (DigitalSherpa2) made that selection. The dialog box shown in Figure 32.3 then displayed on Gregory's computer.

32.2

32.3

As he wanted the direct connection, he clicked **Accept** in the dialog box. The text in the chat window shows the direct connection is now in place.

■ When Gregory decided to send a photo, he chose **Insert ➢ Picture** to get the **Open Image or Sound File to Insert** dialog box shown in Figure 32.4. After navigating to and selecting the file he wanted to send, he clicked **Open**. The digital photo was then inserted at the bottom of Gregory's screen, as shown in Figure 32.5. After clicking **Send** to send the photo, it then displayed in the text in the top window of Lauren's Instant Message screen, as shown in Figure 32.6. He was then able to type another message in the bottom box and continue the chat. Pretty cool, huh?

STEP 4: LOCATE AND VIEW RECEIVED DIGITAL PHOTOS

After you receive digital photos and you end the chat session, you may find that you want to look at the photos again. AOL Instant Messenger automatically

32.4

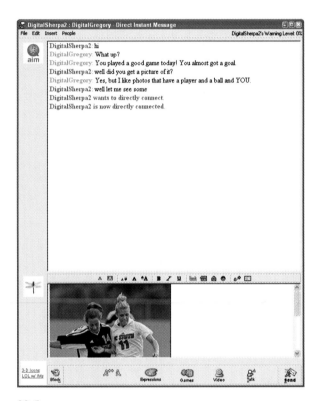

32.5

puts the digital photo files you receive in a folder that is specified in Preferences. To learn the location of the current image file folder, choose **My AIM ➢ Edit Options ➢ Edit Preferences** (F3) to get the Preferences dialog box. Click **File Sharing** in the Category box to get the dialog box shown in Figure 32.7. The Shared File Location box shows the file that contains the image files you received. If you want to change that folder to a new folder, you can do so by clicking **Browse** and choosing a new folder.

Both co-authors can occasionally be reached using AOL Instant Messenger. If you want to chat with one of them, you can find their AOL Instant Messenger Screen Names in the appendix.

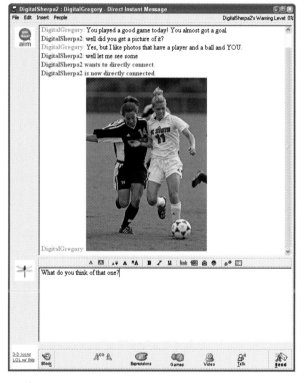

32.6

32.7

TIP

If you use AOL Instant Messenger and you want to avoid getting unwanted images and files, you can set up AOL IM to automatically reject permission to receive files from any users except those of your choosing. To turn this feature on, choose My AIM ➢ Edit Options ➢ Edit Preferences (F3) to get the Preferences dialog box shown in Figure 32.8. Click File Transfer in the Category box to get the File Transfer dialog box. In the Receive File Permission area, make sure there is a check mark in the box next to "Display the Approve Dialog for files from all users". Click OK to apply the settings. When this feature is on, you must accept or reject every request someone sends to you requesting that they be allowed to send you a file. You should then only accept files from people that you know.

32.8

SHARE PHOTOS USING PHOTO SHARING SOFTWARE

33.1

The phrase "a new paradigm" may be the 21st century's most overused phrase. But, we think that it may be the perfect phrase to use to describe a few new software applications that let you share your photo collections with others. These P2P (peer-to-peer) applications let you share digital photos in the same manner as digital music files are shared with P2P music-sharing applications, such as the once very popular early version of Napster.

This means that you are able to share large portfolios of high-resolution photos without having to worry about maximum file size limits that are imposed on many e-mail services. In this project, you learn how to use How2Share PiXPO (`www.pixpo.com`) to share your photos with others without having to create a Web site or send photos via e-mail. You simply create portfolios of your photos and invite others to view them at their leisure. You can even open up a chat dialog box and chat about the photos that are being viewed.

WHAT IS P2P SOFTWARE?

You may be wondering what is so wonderful about P2P software and why it is useful for sharing photos. Peer-to-peer applications are very simple in concept. The idea is that you share files. In this case, you share digital photo files directly with those who want to see them. You do not need to upload them to an Internet server. You simply keep the software running on your computer and invite others to view the photos. When an invited guest views your portfolio in thumbnail form, they can then choose to download the files from your computer to their computer directly. You can choose to share low-resolution files, or you can also share high-resolution files that others can use to make prints. Obviously, both parties need a high-speed connection to the Internet to transfer high-resolution images quickly.

Being able to easily share photos is only part of what PiXPO is about. You can also chat while sharing photos. The chat feature makes it an excellent way to show and talk about digital photos. You can view a thumbnail of the image that is being currently viewed by the other person. This allows you to be able to make comments on the photo they are looking at almost as if you were sitting right next to them viewing the same print. It should be noted that the only time others can view your photos is when you have your computer on, you are connected to the Internet,

and PiXPO is running. When you turn off PiXPO, your photos are no longer available to others unless they have already downloaded them, and in that case they can view them on their computer.

Because PiXPO was a relatively new application when this book was written and because we feel that it should and in fact may become a mainstream application, we decided to include it in this book. However, as we know that many new features are coming and that PiXPO likely will be a much more exciting product by the time you read this, we only show you a few screenshots and let you try the newest version for yourself when you decide to take it for a test-drive.

STEP 1: DOWNLOAD AND INSTALL CURRENT VERSION OF PIXPO

■ Visit `www.pixpo.com` to download the current version of the software. Once you have downloaded the software you will need to install it and set up a basic account to use the free version.

STEP 2: CREATE A NEW PRIVATE PHOTO ALBUM

Before you begin sharing photos, you first need to create an album where the photos are accessible by PiXPO. The photos you add to an album should be edited, cropped, resized, and saved as you want them to be shared. In this example, we show low-resolution .jpg images along with higher resolution .tif images. Sharing both images allows those that simply want to view the image to quickly download a compressed low-resolution .jpg file, or for those that may want to make high-quality prints of your images, they can download a high-resolution .jpg file, or even a .tif or .psd file.

■ To create a new album and add photos, click **Add** to get the Albums dialog box shown in

Figure 33.2. After typing in the name of the album and a description, you can choose a content category that makes it easy for others to search your albums for photos they want to view. You also have the option of keeping the album private, or making it a public album. A private album only gets shared with those that you invite. To add pictures, you click **Choose** and browse to select the image files you want to include. If you want to create a "watched folder," you can do so by clicking **Watch Folder** and choosing a folder. This is a wonderful feature that enables PiXPO to automatically add photos to a PiXPO album whenever you add image files to a specified watched folder. After clicking **Close**, the files display in the main PiXPO screen, as shown in Figure 33.3.

STEP 32: INVITE A GUEST TO VIEW AN ALBUM

■ After you add one or more albums that contain photos, you are ready to invite a guest to view them. After initiating a chat with Keith, a friend

who lives in Ireland, we were able to invite him to take a look at some of the new turtle photos found in the newly added album. Figure 33.4 shows a chat window that includes part of your chat text. Sending a photo or album is easy when chatting. You just click **Send Album** or **Send Picture** at the bottom of the chat window.

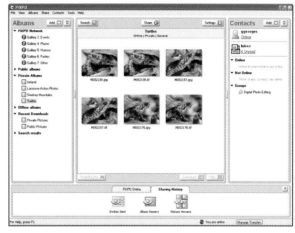

33.3

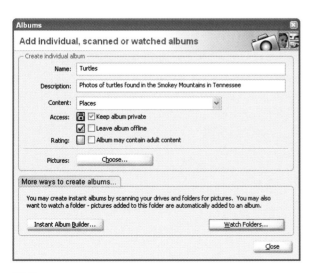

33.2

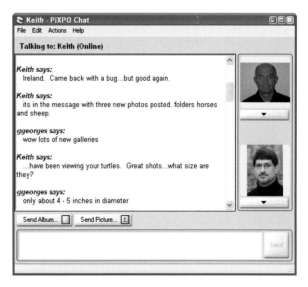

33.4

■ When you or a guest wants to view an album, you can either view thumbnails or view a slideshow, as shown in the middle box of Figure 33.5. Notice that you can see which users are online and which portfolios are available for you to view. In the right window, you can see that Keith created 10 albums. Many of those contain photos of Ireland. We had great fun talking about places we had visited while we were in Ireland.

PiXPO offers a few other useful features that you can enjoy learning about when you try out the software. Our hope is that PiXPO or another photo-sharing application will include a "group sharing" feature that lets you invite an entire group to chat and look at

a photo album. This would be a wonderful way for a camera club to share and discuss photos, for a family to meet and chat about a family vacation photo album, or about any other purpose where a group of people wants to chat in an online group and view photos.

We hope you have the time to try PiXPO or another similar application. Once again, we are betting that PiXPO becomes a mainstream application. We will surely be using it. If you install PiXPO and have an album or two to share, please send us an invite. We would enjoy a short chat and taking a look at your photos. You can learn more about contacting either of the authors in the appendix.

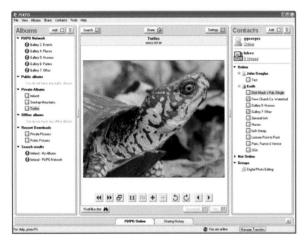

33.5

NOTE

If you want to use a P2P (peer-to-peer) photo-sharing application, you may want to also take a look at Picasa Hello (www.hello.com) in addition to How2Share PiXPO. Hello is a free application that works best when used with Picasa, a photo organizing and editing application.

CREATE AND E-MAIL A DIGITAL PHOTO SLIDESHOW AS A PDF FILE

34.1 Use Adobe Photoshop Elements 3.0 to create a PDF-based slideshow that is easy to e-mail and equally easy for the recipients of your e-mail to view.

WHAT YOU'LL NEED

Adobe Photoshop Elements ($80), Adobe Reader 6.0 (free) for viewing a collection of digital photos

Slideshows have always been and continue to be a fine way to view a collection of photographs. Now that the computer screen has replaced the traditional slideshows that are projected on a screen with a 35mm slide projector, there are more reasons than ever to show your photos in digital slideshows. Using the Internet, you can even send slideshows to people who are not able to view your computer screen. However, depending on how you create the

slideshow the recipient may or may not be able to view it. Different computer operating systems (Windows or Mac) and availability of viewing software can make the goal of sharing slideshows easier said than done. Or, you can use the slideshow creation feature in Adobe Photoshop Elements 3.0 to create a PDF-based (Portable Document Format) slideshow that can be viewed on just about any computer with the free and easily downloadable Adobe Reader.

STEP 1: SELECT, EDIT, CROP, AND SAVE IMAGES IN A FOLDER

Before you begin creating a PDF-based slideshow, you should have all the digital photos you want to use edited, cropped, resized, and saved as .jpg files in a folder. To learn more about resizing digital photos, read the section on resizing images at the beginning of Project 30. For this project, we've chosen a collection of eight landscape photos to use to make a slideshow.

STEP 2: SELECT DIGITAL PHOTOS USING ADOBE PHOTOSHOP ORGANIZER

■ To open the photos you choose to use in a slideshow using Adobe Photoshop Organizer, choose **File ➢ Get Photos ➢ From Files and Folders** (**Ctrl+Shift+G**). After locating the folder that contains the digital photo files, click the first file. Press and hold **Shift** and click the last file to select all the files, as shown in Figure 34.2. Click **Get Photos** to load all of the photos into the Organizer. If you are using a Mac, you must choose the images files directly from the Elements Editor (the Mac version of Elements does not have an Organizer) by choosing **File ➢ Automation Tools ➢ PDF Slide Show**.
■ Choose **Edit ➢ Select All** (**Ctrl+A**) to highlight all the photos, as shown in Figure 34.3.

STEP 3: CREATE SLIDE SHOW

■ Click the **Create** button in the toolbar to load the Creations wizard. Click **Slideshow** and click **OK** to get the dialog box shown in Figure 34.4. This dialog box gives you two options for creating a slideshow. You can create a Custom Slide Show or a Simple Slide Show. Using either one of these options, you can create a slideshow that you can e-mail. However, since it is wise to create a PDF that is as small as possible, you are better off using

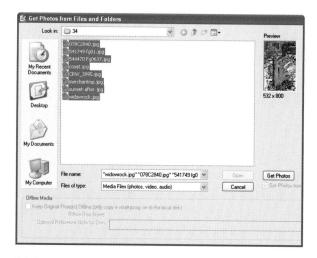

34.2

34.3

Simple Slide Show and avoiding the use of extra features, such as adding music or text, which are options you have in the Custom Slide Show. Click **Simple Slide Show** and then click **OK** to get the Simple Slide Show dialog box.

■ Click in **Transition** and choose **Dissolve** for a simple transition change between slides. Click in **Duration** and choose **5 sec**. This setting displays an image for five seconds before it begins the chosen slide transition. Click in the **Photo Size** box and choose **640 x 480 pixels** to make a small slideshow. If you want the slideshow to loop continuously, you can click in the box next to **Loop after last page**. Make sure a check mark is in the box next to **View Slide Show After Saving**. The dialog box now looks similar to the one shown in Figure 34.5.

■ Click **Save** to get the **Save Simple Slide Show** dialog box. Choose a folder where you want to save the slideshow and type in a filename in the **File name box**. Click **Save** to begin the slideshow creation process and save the file to the chosen folder. After the file is saved, the slideshow automatically displays in Adobe Reader 6.0. The Reader is installed when you install Adobe Photoshop Elements 3.0 unless you chose not to

install it. If it has not been installed, you can install it now from the CD-ROM or you can download the current version from the Adobe Web site (www.adobe.com).

■ The slideshow is initially shown in full-screen mode where you only see the slides. To view the slideshow in the Reader, press **Ctrl+L/ Command+L**. The slideshow now displays in the Reader, as shown in Figure 34.6. After viewing the slideshow, you are ready to e-mail it.

34.5

34.4

34.6

STEP 4: ATTACH SLIDESHOW FILE AND SEND VIA E-MAIL

■ Using Microsoft Outlook 2003, choose **Go ➢ Mail** (**Ctrl+1**). Choose **Actions ➢ New Mail Message** (**Ctrl+N**) to get a new message dialog box. Type in one or more e-mail addresses in the **To** box. Type in an appropriate subject in the **Subject** box and any message you want to send.

■ Choose **Insert ➢ File** to get the **Insert File** dialog box shown in Figure 34.7. Locate the folder that contains the image file you want to send and click the file to select it. Click **Insert** to attach the file. You now see a file in the Attach box, as shown in Figure 34.8.

■ Click **Send** to send the e-mail and attached slideshow. Notice that this e-mail is 662K, or almost ¾ of a megabyte. This is a large file to e-mail. It also means that you would not want to create a slideshow with more than five to seven slides as it likely would exceed the maximum file attachment limit that is imposed on many e-mail accounts. However, if you are exchanging just a few photos via e-mail, it is a good option.

You have now reached the end of Chapter 6 and should be ready to share your digital photos electronically in many ways. We hope you enjoy these new approaches and that you find that your family and friends get pleasure from viewing your photos.

> **TIP**
>
> You can download the free Adobe Reader 6.0 from the Adobe Web site at: www.adobe.com/products/acrobat/readermain.html. When you send an e-mail that includes a PDF file (for example, a file that has an extension ending in .pdf), you may want to provide a note that explains that the file may be viewed using a free downloadable application and then provide the link. While PDF files are used by a growing number of computer users, you should not assume that your recipients have a current version of Adobe Reader or that their system is configured correctly to help them determine how to view the file.

34.7

34.8

DISPLAYING DIGITAL PHOTOS ON THE INTERNET

I t is quite likely that you received Web space for your own Web pages when you signed up for your Internet service. Or, you may have even purchased your own domain name and hosting service with the intention of creating your own Web site. In either case, in this chapter you learn how to display your digital photos using your own Web space. First, in Project 35 you learn how to create the perfect Web image. In Project 36, you learn how to create an entire online photo gallery. For those of you who simply want to share photos using an online photo-sharing Web site, you learn how in Project 37. You learn how easy it is to make a Web page featuring images using Microsoft Word in Project 38. Using an FTP client to upload and manage your digital photos and Web pages is the topic of Project 39. In Project 40, you learn how to use an online photo store to sell your photos at the prices you choose without having to take orders, make the prints, collect the money, or ship the order.

CREATE THE PERFECT WEB IMAGE

35.1 You can use Adobe Photoshop Elements 3.0 or another image editor to create the perfect Web image complete with sharpening, copyright information, and a watermark to protect your image while it is displayed on the Internet.

WHAT YOU'LL NEED

Adobe Photoshop Elements
($80) or other image editor

No doubt about it, you can quickly and easily create an image to place on a Web page using commands, such as Save for Web, or even Save As. But, there is much more to creating excellent images that display well on a Web page than merely saving them as a .jpg image using one of these commands. In this project, you learn all the steps you need to take to make excellent images that have been optimized specifically for viewing on a Web page. Plus, the images include information that identifies the image as yours along with titles, shooting information, and so on.

243

For this project, we use a photo of shrimp boats that have just docked in Tybee Island, Georgia. This image is converted from a RAW format file to a TIFF format and it is edited and resized using Adobe Photoshop Elements 3.0. When the image was converted using Adobe Camera RAW, care was taken not to sharpen the image as you can get better results by applying sharpening after the image has been sized for the Web page. After you do this project, you learn how images should be prepared for projects such as the one shown in Project 36. While we use Adobe Photoshop Elements 3.0, you can take a similar approach with any other image editor.

STEP 1: SIZE IMAGE

One of the first decisions you need to make when preparing images for display on a Web page is how to size them. The two most common computer screen resolutions are 800 x 600 and 1,024 x 768. What you generally don't want to do is make Web images that require the viewer to have to scroll up and down to see the whole image. For this reason, choose a resolution that can be easily viewed on a majority of

35.2

computer screens. A common and easily viewable image resolution is one that is not more than 640 pixels wide and no more than 480 pixels tall. This image size is also good if you want to use the Adobe Photoshop Elements 3.0 Web Gallery feature.

■ After locating and opening the image, the first step is to resize the image to the final size needed for the Web page, which in this case is an image that fits within a 640 x 480 pixel rectangle. Choose **Image ➢ Resize ➢ Image Size** to get the Image Size dialog box shown in Figure 35.2. Make sure that **Constrain Proportions** is checked. Click in the **Width** box under **Pixel Dimensions** and type **640**. Notice that **Height** is automatically changed to keep the height and width proportions the same. You should also set **Resolution** to **72 pixels/inch** as that setting makes it easier for you to pick the font size as Web images display on most screens at 72 pixels/inch.

New to Adobe Photoshop Elements 3.0 is a new interpolation algorithm for down-sampling images. This new algorithm keeps your image sharper when it is down-sampled. Make sure there is a check mark next to **Resample Image** and click in the box to select the new algorithm: **Bicubic Sharper**. Click **OK** to resize the image.

STEP 2: SHARPEN IMAGE

■ Now that the image is at its final size, we can sharpen it. To see the sharpening results and to choose the best settings, choose **View ➢ Actual Pixels (Alt+Ctrl+0 /Option+Command+0)** to view the image at **100%**. Choose **Filter ➢ Sharpen ➢ Unsharp Mask** to get the Unsharp Mask dialog box shown in Figure 35.3. For Web images, start with an **Amount** setting of around **125** to **200** and a **Radius** setting of about **.3** pixels. For this image, we found that the results were good when **Amount** was set to **150%**, **Radius** to **.3**, and **Threshold** to **0** to bring out the detail in the fishing boats. Click **OK** to apply the settings.

STEP 3: ADD A FRAME OR OTHER IMAGE ENHANCING FEATURES

Depending on how you want your photos to look, the design of the Web page or gallery, and the Web page's background color, you may want to add a frame or just a simple line around your image. When you use Adobe Photoshop Elements' Web Gallery feature, you find an option that will automatically add a line around each image. However, if you decide you want to add extra canvas to match the background color of the Web page, as you will learn to do in Step 4, you should first add a border line.

■ If you want to add a single colored line around your image, choose **Select ➤ All** (**Ctrl+A/ Command+A**) and then choose **Edit ➤ Stroke** (**outline**) **Selection** to get the Stroke Dialog box

shown in Figure 35.4. In this dialog box, you can choose the **Width** of the stroke in pixels and the **Color** of the line. Make sure to set **Location to Inside** so the line shows on the image. For this project, assume the image will be placed against a black background, so choose **white** as the color and set **Width** to **1 px**. Click **OK** to add a white line around the image. Choose **Select ➤ Deselect** (**Ctrl+D/ Command+D**) to remove the selection marquee.

> **NOTE**
>
> To improve the way your images display on a Web page, you can add mat borders and even frames that look like real picture frames. Check out the framing choices found in Adobe Photoshop Elements 3.0's Styles and Effects palette. You can choose Simple Outer, Low, Soft Edge, and even Fire frames after first choosing Layer Styles. You can learn more ways to frame an image in Project 11.

35.3

35.4

STEP 4: ADD CANVAS TO PREVENT "IMAGE JUMPING"

If you have viewed a Web photo gallery where the height and width sizes vary between images, you may have noticed text, images, and navigation features "jump" as you move between images. To avoid this annoying jumping, you simply need to add each of your images to a background image that has the width of the widest image, and the height of the tallest image. Again, using the earlier assumption that all images fit within a 640 x 480 pixel square, we need to add this image to a black 640 x 480 pixel canvas.

■ Choose **Image ➢ Resize ➢ Canvas Size** to get the Canvas Size dialog box shown in Figure 35.5. If **pixels** is not the increment setting in the box after **Width**, click in the box and choose **pixels**. Type **480** in the **Height** box. Make sure to uncheck **Relative** — this is very important if you want to end up with a 640-x-480-pixel image! Leave the **Anchor** set to the default center box. Click in the **Canvas extension color** box and choose **Black**. Click **OK** to add black canvas. Your image is 640 x 480 pixels and should now look like the one shown in Figure 35.6. Notice black is added to the top and bottom of the image to make it fit the 640 x 480 pixel space.

35.5

35.6

STEP 5: ADD COPYRIGHT AND OTHER INFORMATION TO THE IMAGE FILE

Anyone with even limited experience of sharing photos on the Internet is aware that images do get copied and used by others without permission. While it is nearly impossible to stop such action, you can at least add your copyright and contact information to each image you post on a Web site.

■ Choose **File** ➢ **File Info** (**Alt+Ctrl+I/ Option**+**Command**+**I**) to get the dialog box shown in Figure 35.7. Here you can add all kinds of information. Many of these fields contain information that can be used with the Web Photo Gallery feature, making it easy to add information to an image once and then have Web Photo Gallery automatically place it on a Web page. You can add any information you like at the top, but each time you post images to a Web site, you ought to set **Copyright Status** to **Copyrighted** and type copyright information in the **Copyright Notice** box. To insert a © symbol, press and hold **ALT** while typing **0169** (On the Mac, press **Option**+**G**). Then, add a year and your name. It is also wise to add your Web site address if you have one. Click **OK** to place this information into the image file.

When you set the **Copyright Status** to **Copyrighted**, many imaging applications indicate that the image is copyrighted by showing the © symbol in the application title bar, as shown in the Adobe Photoshop Elements 3.0 title bar in Figure 35.8. Notice the tiny © symbol just to the left of the file name.

STEP 6: ADD A VISIBLE WATERMARK OR COPYRIGHT TEXT TO THE IMAGE

You can add two types of watermarks to your images. You can view an invisible watermark, such as those embedded into the image by the Digimarc plug-in, a service provided by **Digimarc**, by visiting `www.digimarc.com`. Or, you can add a visible watermark or text to your image. Adobe Photoshop Elements 3.0 Web Gallery has a feature that automates

35.7

35.8

the process of placing text on each image. However, this feature is automated and it does not let you change text color or text location. Therefore, you may find that the text either distracts the viewer from viewing your image or it is not visible because it is a color that blends in with the image color.

- To add text to an image, click the **Horizontal** (or **Vertical**) **Text tool** (**T**) in the **Toolbox**. Click in the text Options bar and choose the font type, color, and size you want. For most Web images, a font size of around 10 points is sufficiently large. Click the image where you want the text and type. After you complete the text, click the **Commit** icon in the Options bar. You can choose the **Move tool** (**M**) and click and drag your text to be exactly where you want it. Choose **Layer ➢ Flatten Image**.

STEP 7: SAVE THE IMAGE AS A .JPG FILE

- Choose **File ➢ Save As** (**Shift+Ctrl+S/ Shift+Command+S**) to get the Save As dialog box shown in Figure 35.9. The Save As feature was chosen over the Save As Web feature because the Save As Web feature strips the metadata we added in Step 5. Make sure you check the box in the **Color** area to choose **ICC Profile: sRGB**. Click in the **Format** box and choose **JPEG**. Click **Save** to get the JPEG Options dialog box shown in Figure 35.10. Click in the **Quality** box and choose **Medium**. Click **Baseline Optimized** and you can see that the file size is 51K. Click **OK** to save the file.

No doubt about it, taking all these steps for each of your images is time-consuming work. However, it is well worth your time as your images will look better, they will download faster, and they will be more protected from copying than if you simply saved them using Save As or Save for Web. If you create lots of Web images, you may want to consider upgrading to the full version of

35.9

Photoshop as it offers Actions, which are similar to macros. All the steps you need to take to create Web images can be automated and saved as an Action and then run against an entire batch of images all at once. Actions can save you a tremendous amount of time and increase accuracy.

35.10

CREATE AN ONLINE PHOTO GALLERY

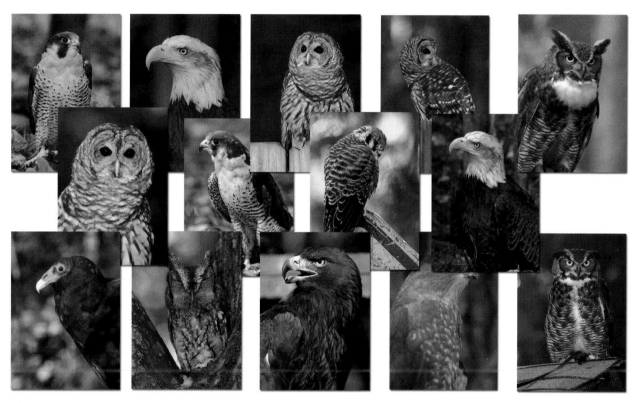

36.1 In just a few minutes you can create an online photo gallery for digital photos such as these raptor photos using Adobe Photoshop Elements 3.0's Web Photo Gallery feature.

WHAT YOU'LL NEED

Adobe Photoshop Elements ($80) and a few of your own digital photos

I n this project you learn how to use Adobe Photoshop Elements 3.0 Web Photo Gallery feature to create an online gallery for the 14 raptor photos shown in Figure 36.1. These perfectly posed raptors were all photographed at the Carolina Raptor Center during a fund-raising event, which was limited to photographers. Before reading any further, you may want to take a quick look at the completed gallery so that you can understand more about the many options that are available when using Web Photo Gallery. Launch your Internet browser and type www.reallyusefulpage.com/galleries/raptors in the Address box. The photo gallery should now be viewable in your Web

browser, as shown in Figure 36.2. After seeing how a photo gallery works, you are ready to follow the steps and create a Web photo gallery of your own using your own digital photos.

STEP 1: RUN WEB PHOTO GALLERY

You can run the Adobe Elements 3.0 Web Photo Gallery feature from either the Editor or from the Organizer. We prefer using the Organizer as it enables you to first select the photos you want to include in the new photo gallery.

■ Launch the Organizer and then choose **File ➢ Get Photos ➢ From Files and Folders** to get the Get Photos from Files and Folders dialog box. After locating the files you want and selecting them, click **Open** to display them as thumbnails in the Organizer. Choose **Edit ➢ Select All** (**Ctrl+A/Command+A**) to select and highlight all of the images as shown in Figure 36.3.

■ In the Organizer menu, choose **File ➢ New ➢ Web Photo Gallery** to get a dialog box similar to the one shown in Figure 36.4.

36.3

36.2

36.4

■ Click in the **Gallery Style** box to get a pop-up menu listing 33 different Web page styles. If you click any one of these styles, a small thumbnail image displays that shows how a Web page would look using the selected style. For this project, choose **Classic** as the Gallery Style.

■ Click the **Banner** tab. Type in a **Title** and **Subtitle**. If you want to display a clickable e-mail address on your Web page, click in the **E-mail Address** box and type your e-mail address.

■ In the **Destination** area, click **Browse** and locate the folder where you want to create the files for the Web gallery. Type in a **Site Folder** name, such as **raptors**.

■ Click the **Thumbnails** tab. Set **Thumbnail Size** to **Medium**. You can now click next to **Filename**, **Caption**, and **Date** to select one or more of those items to display below each thumbnail. We chose to only display **Filename**. The Thumbnails tab portion of the Web Photo Gallery dialog box should now look similar to the one shown in Figure 36.5.

■ Click the **Large Photos** tab. This is where you specify the size of the image. If you have taken the time to edit, resize, sharpen, add copyright information, and more to each of your images, as covered in Project 35, you should make sure to uncheck **Resize Photos**. This forces the Web Photo Gallery to use the images as they are. For

this project, we selected large .tif files and used the power of the Web Photo Gallery feature to automatically resize each photo. So, check **Resize Photos** and click in the box to choose **Medium**. Slide the **Photo Quality Slider** almost all the way to the right. Place a check mark next to **Filename**. If the file contained caption information, you can also check **Caption** and have the caption information placed below each gallery image. The Large Photos tab portion of the Web Photo Gallery should now look similar to the one shown in Figure 36.6.

■ Click the **Custom Colors** tab. Here you can choose colors for the background, banner, text, and links. For this project use the default settings, as shown in Figure 36.7.

36.6

36.5

36.7

■ Click **Save** to begin creating the photo gallery. After the Web page is complete, the new raptor photo gallery home Web page loads and displays. It should look similar to the one shown in Figure 36.2. After you click one of the images, you get a Web page with an enlarged image, as shown in Figure 36.8. This simple and clean Web page design features navigation buttons that allow you to move forward or backward one image, or go to a thumbnail page.

36.8

36.9

USE AN ONLINE PHOTO-SHARING SITE

37.1 Sharing your digital photos online with an online photo-sharing service such as Smugmug is both easy and fun, plus your visitors can order prints, too.

If you take digital photos that you know others would enjoy seeing, you ought to choose and use an online photo-sharing service. An online photo-sharing service makes it easy for you to share your photos with anyone in the world with a computer and Internet connection within a few minutes of your having taken the photos. Most online photo-sharing sites let you create more than one gallery and you can usually make each gallery a public gallery or a private gallery. Photos displayed in a public gallery may be viewed by anyone that attempts to view the gallery, while private galleries may be viewed only by those to whom you allow access. Most of the better online photo-sharing sites also allow visitors to order prints and other photo gift items using the images in your galleries.

While there are still a few free online photo-sharing sites around, our suggestion is that you sign up and pay for one that charges for their services. Such sites are likely to be around longer than those that are free as many of us learned when all of a sudden our galleries disappeared from the Internet when many online photo-sharing Web sites went out of business.

In this project, you learn how easy it is to upload and share your digital photos in galleries using the Smugmug online photo-sharing service. With so many choices of online photo-sharing services, you may wonder why we chose Smugmug. Our choice was based on our strong bias for simplicity and because Smugmug has the few key features we wanted at a reasonable price. With a paid annual subscription, you can use the service and visitors to your gallery can view your photos without any ads or annoying banners — they just see your photos. Password protection allows you to limit your private galleries to be seen by only those who have the password.

If you would like to view two of Gregory's galleries on Smugmug, visit `www.reallyusefulcontent.smugmug.com`. You can access the Cats & Dogs gallery directly. To access the Ireland gallery, you need to enter the password "ireland" to gain access, as it is password protected.

STEP 1: CHOOSE EDITED IMAGES TO UPLOAD

As is the case for many of the projects in this book, choosing the photos you want to use may be the hardest part of the project. After you choose the photos you want to display, you can either upload them as they are or edit them with an image editor to make them look as good as possible. The files do need to be saved as .jpg files. You don't need to worry about the size of the images you upload because Smugmug resizes your images to make preview images and thumbnails. And, if prints are needed, having large image files is better than if you down-sampled the images before uploading them. If you have a slow Internet connection, or you don't plan on allowing others to make high-quality prints, you may want to reduce the image size before uploading them.

STEP 2: UPLOAD PHOTOS

Before you can begin uploading photos, you must sign up for a trial membership or have a paid membership to Smugmug at `www.smugmug.com`. After you have a membership you will first need to sign into your account before you can begin the upload process.

■ To upload photos to a new gallery, you must first create a new gallery by clicking **Your Photos**, and then on **Create New Gallery** to get the Web page shown in Figure 37.2. Enter a **Category** and **SubCategory** if desired, then type the **Title** of your new gallery. Click **Create**.

■ Click **Add Photo**. Smugmug offers five different ways for uploading digital photos; two of those ways are for Mac OS X. To choose the Windows Drag & Drop option, click the **Windows Drag & Drop** link. You then get a Web page such as the one shown in Figure 37.3. You can now select the image files you want to upload with an image manager such as ThumbsPlus Pro or Windows

37.2

Explorer. After selecting the images you can drag and drop them onto the box in the browser window. Clicking **Upload!** begins the upload process. After all the photos upload, you get a Web page notifying you that the upload is complete and that you need to wait for a minute or two while they are processed. That is it!

STEP 3: CUSTOMIZE GALLERY

After you create a gallery and upload digital photos to it, you can customize it.

■ To customize your new gallery, click the gallery to select it and then click **Customize Gallery**. You then are presented with a long Web page full of checkable options. Here you can change the title of the gallery, add a description, add keywords, or even a password. You can also make the gallery public or private, allow others to add comments or not, enable or disable the printing of photos, choose a sort order, make camera information visible, and much more. After you finish customizing your gallery, click **Update**.

■ You can also customize your gallery by clicking in the box below the preview image to get the pop-up menu shown in Figure 37.4. Using these menu items, you can make your gallery just as you want it by adding captions, sorting your gallery, adding color effects, and much more.

STEP 4: VIEW GALLERY

Your gallery is now viewable. To learn more about how you can share the gallery, all of your galleries, or a specific photo, click **Share with Friends & Forums**. You are then presented with a Web page where you send an e-mail inviting friends and family to view your photos. Toward the bottom of the page, you find a list of links that you can copy and paste into other documents directing people to your galleries, a specific gallery, or even a specific photo.

37·3

37·4

For example, to see the photo of the dog on the front of Gregory's Cats & Dogs gallery as shown in Figure 37.5, you use the following link: `http://reallyusefulcontent.smugmug.com/gallery/362591/1/14421801`.

After visitors find a photo they like, they can order a print or one of the many photo gift items, such as refrigerator magnets, photo tote bag, photo desk clocks, and much more. Visit `www.smugmug.com/prints/catalog.mg` to see a full list of available photo gift items.

What can your visitors do when viewing your photo gallery at Smugmug.com?

1. View all the photos in the galleries that you allow them to view in a variety of sizes (depending on the size you uploaded).

2. View digital photos as a slideshow, as thumbnails, as thumbnails and a preview, in a journal style, and more.

3. Make comments for an entire gallery or on a photo-by-photo basis.

4. Rate each photo using a 1- to 5-star rating system.

5. Order prints and photo gifts at competitive prices online.

6. With permission, they can download print-sized images to use to make prints on a desktop printer.

7. Add special effects and crop to suit their tastes.

8. Send links to others for specific galleries or specific photos.

9. Search for photos based upon keywords (assuming you add keywords to your photos).

37.5

> **NOTE**
>
> **Other excellent photo-sharing Web sites you may want to consider are:** `www.clubphoto.com`, `www.fotki.com`, `www.funtigo.com`, `www.hello.com`, `www.neptune.com`, `www.kodakgallery.com)`, `www.pbase.com`, `www.photosite.com`, `www.shutterfly.com`, `www.webshots.com`, **and** `www.zorpia.com`.

CREATE A WEB PAGE USING MS WORD

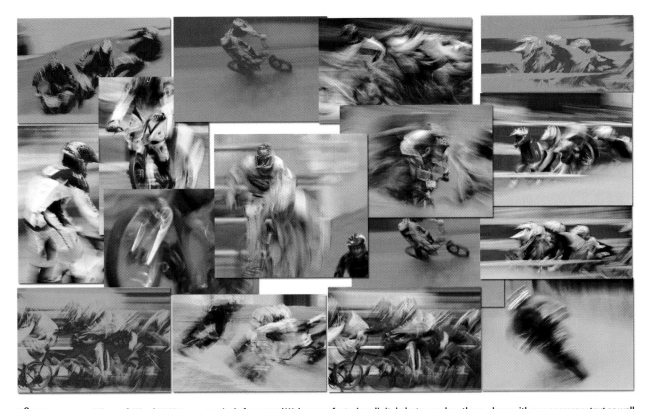

38.1 You can use Microsoft Word 2003 to create nicely formatted Web pages featuring digital photos, such as these, along with any necessary text as well.

WHAT YOU'LL NEED

Microsoft Word 2003 www. microsoft.com **($230, $110 upgrade) and a few digital photos and some text**

Every digital photographer is likely to need to create a Web page featuring digital photos every now and then. Maybe you want to create a step-by-step list of instructions for a favorite new Photoshop technique. Or, you may want to create a Web page featuring photos with lots of textual comments. Whatever the reason you have for creating a simple Web page, you can do so using nothing more than Microsoft Word 2003. While most Web pages get created with a tool specifically designed for creating Web pages, such as Adobe GoLive, Macromedia Dreamweaver, or Microsoft FrontPage, you do not need one of these expensive and sophisticated Web page development tools to create relatively simple Web pages.

In this project, you learn how to use Word 2003 to create a Web page that tells how to create a painterly effect by reducing the shutter speed so that

259

moving subjects get intentionally blurred. You can view this Web page at: www.reallyusefulpage. com/50fastpp/painterly-effect.htm.

STEP 1: CREATE WEB PAGE DOCUMENT

■ To create a Web page document using Microsoft Word 2003, choose **File ➢ New** and then choose **Web Page** from the New Document palette. You are now ready to add text and images to the Web page.

STEP 2: PREPARE IMAGES

Before you can insert a digital photo into a Web page created in Microsoft Word 2003, you should first resize the image to fit on a Web page and save it as a .jpg file. To learn more about how to do this, read Project 35. Unless you want those viewing your Web page to have to scroll to view an entire image, you should limit the width to about 500 to 800 pixels. Small image files are quicker to download so you should not make them any larger than necessary.

STEP 3: ENTER TITLE, DESCRIPTIVE TEXT, AND DIGITAL PHOTOS

■ Click in the document window and type the title: **Creating Intentional Camera Blur to Show Action and Create a Painterly Effect**. Click in the **Style** box in the Styles and Formatting icon menu and choose **Heading 1** to format the text as heading text. To put a soft-break (i.e., start the next word on the next line) after **Show**, press **Shift** and **Enter** to begin a new line.

■ Press **Enter** to drop down one line and then type a copyright date and name. To make a © symbol, type **Alt+0169** on a PC (**Option+G** on the Mac). If you are using a PC, make sure to use the numbers at the top of your keyboard — the numbers in the number pad do not work. Click in the **Style** box in the Styles and Formatting icon menu and choose **Heading 3** to format the text as level 3 heading text.

■ Press **Enter** twice to drop down two more lines.

■ Type the introductory text: **When you use a shutter speed that is sufficiently slow to capture movement you can get some wonderfully artistic, almost painterly images as shown here. All you need to do is pick a slow ISO setting, such as ISO 100, choose shutter speed priority, and manually set the shutter speed to around 1/15th of a second. Depending on the speed and direction of your subjects, you may need to vary the shutter speed to get the effect you want. If the subject is coming straight towards you, you may want to use a slower shutter speed than if you are panning with the subjects. Experimentation is important. The more you experiment, the more you will be likely to get an image that makes an exceptional print.**

■ Press **Enter** twice more to drop down two more lines.

■ You can now place an image by dragging and dropping the chosen image from your image manager or Windows Explorer or by choosing **Insert ➢ Picture ➢ From File** and choosing the image file using the displayed dialog box. After the heading text, some introductory text, and one image are placed, the Word 2003 document looks like the one shown in Figure 38.2.

■ You can now place other images and text where you choose to complete the page.

Some of the many formatting features found in Microsoft Word 2003 translate well to a Web page; others don't. Be careful to choose features that view as you want them to in commonly used Internet browsers, such as Microsoft Internet Explorer, Netscape Navigator, and Mozilla Firefox.

STEP 4: SAVE FILE AS A WEB PAGE

After your Web page is complete, you must save it as an HTML-formatted Web page.

■ To save your document as a Web page, choose **File ➢ Save As Web Page** to get the dialog box shown in Figure 38.3. In the **File Name** box type the filename you want to use. It should be a short and simple filename that is somewhat descriptive of the Web page you created.

■ Click **Change Title** and enter the title you want to display on the title bar of any Internet browser that displays the Web page.

■ Click in the **Save as Type** box and choose **Web Page**. Make sure you do not select Single File Web page. This format creates a Web page that can only be viewed using Internet Explorer.

■ Click **Save** to save the HTML Web page and all the necessary graphic files. After the files are saved, you can view them using Windows Explorer or another Internet browser. You find that there is a file with an .htm extension and a folder that was named with the file name plus "_files". In this folder, you find all the necessary graphic files. All of these files are necessary to properly display the Web page you just created. If you want to upload the Web page or make the Web page available from a CD-ROM or other type of removable media, you need to copy all of the files.

38.2

38.3

STEP 5: TEST YOUR WEB PAGE

■ To test the completed Web page, double-click the Web page using Windows Explorer and it opens and displays in your default Web browser. If you used any Word 2003 formatting features and you want to make sure that your Web page looks as you want it, you should also try the Web page in other Internet browsers, too.

Your Web page is now ready to upload to a Web site. To learn more about using an FTP utility to upload files to a Web site, read Project 39. After the Web page is uploaded, you can view it. The Web page example from this project is shown in Figure 38.4.

38.4

UPLOAD DIGITAL PHOTOS AND PHOTO GALLERIES TO A WEB SITE

39.1 Uploading and managing digital photos such as these taken in the Smokey Mountains to your Web space using FTP client software, such as WS_FTP, is quick and easy.

Have you ever created a Web photo gallery using software such as Adobe Photoshop Elements 3.0 Web Photo Gallery and then were completely baffled about how to get that wonderful photo gallery onto your Web site? To make images and Web pages viewable from the Internet, you must upload them to a Web site where they all have unique Web addresses. In this project, you learn how to make your Web page creations such as the ones shown in Projects 35, 36, and 38 accessible from your Web space.

The simple way to upload files from your computer to a Web site is through a software utility that uses the standard File Transfer Protocol (FTP) to transfer files. Using an FTP utility is not much more difficult than

263

using Windows Explorer to transfer files from one drive to another: you simply transfer files from your computer's hard drive to an Internet Web server via the Internet. While we recommend the feature-rich and more costly WS_FTP Professional from Ipswitch, Inc. (`www.ipswitch.com`), you have plenty of other choices. Check with your ISP (Internet Service Provider) to learn what FTP client they recommend and if they provide one free of charge. Many ISPs do provide a free tool for uploading files. A quick visit to `www.cnet.com` and a search for FTP clients results in a list of many FTP clients. If you don't want to use the software provided by your ISP or WS_FTP, we also recommend CuteFTP 6.0 Home from GLOBALScape (`www.globalscape.com`), which is $40.

STEP 1: CREATE A FOLDER FOR IMAGES AND FILES TO BE UPLOADED

To make the upload process as easy as possible and to ensure that you upload all the necessary files, you should store them all in a folder. Ideally, this folder should be a "mirror" of the files you have on your Web site. We suggest you name the folder with a recognizable name such as **/Web** files.

STEP 2: SET UP YOUR FTP CLIENT SOFTWARE

Installing and setting up your FTP client software is a pretty easy process. To get access to your Web space, you need to learn your Host Name, User ID, and password; you enter this information using an FTP site setup feature. This information is usually provided to you when you sign up for an Internet service or a Web hosting account.

STEP 3: SELECT FILES TO UPLOAD AND BEGIN UPLOAD PROCESS

After you have all of the files you want to upload in a folder and you have all of the necessary access information, you can begin the file selection and upload process.

■ Using WS_FTP Pro, you simply click the files you want to upload on the left side of the application window and then click the folder you want to use to upload the files on the server. One more click on the Upload arrow and the uploading process begins. Figure 39.2 shows the WS_FTP Pro client set up to upload a slideshow photo gallery of the Smokey Mountains created with Adobe Photoshop Elements 3.0 Web Photo Gallery feature to a folder on the server named /www/galleries/smokies.

STEP 4: LAUNCH WEB PAGE

After you upload your files, you should take a few minutes to view all of the pages and images with your Internet browser to confirm that everything is working as expected. And, that is all there is to uploading files to a Web site to make them available to anyone in the world with a computer and connection to the Internet.

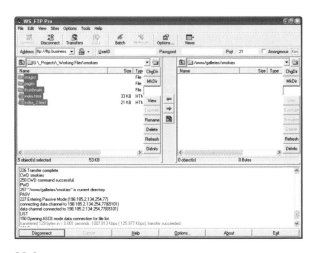

39.2

SELL YOUR PHOTOS FROM AN ONLINE PHOTO STORE

40.1 Selling sporting event photographs, such as action photos taken of a lacrosse game, can be done with little effort if you use one of the online photo store's services such as the Shutterfly Pro Gallery service.

WHAT YOU'LL NEED

Internet connection, free Shutterfly Express software, and a Shutterfly Pro account ($100 to $200 per year)

How good is your photography? Can you take photographs that are good enough to sell to others? If you have a digital camera and the skills to take photographs at sporting events, birthday parties, family reunions, or similar events, you may be able to make money by selling your photographs. If they are good, it is not as hard to make a few dollars as a photographer as you might think.

When you begin selling photographs, you quickly learn that it takes very little time to take photographs, and *way too* much time along with too much aggravation to take orders, make prints, deliver the prints, and collect money. That is, unless you take photographs and upload them to an online

265

photo store. One of a growing number of online photo-processing services that provide a service where you get your own online storefront is Shutterfly, the same company that makes wonderful prints for a low price on a retail basis. Read Project 22 to learn more about their retail printing service.

The Shutterfly Pro Gallery service lets you do the shooting and they do the rest! As the Web site says, they will "handle the order taking, billing, high quality printing, shipping, and frontline customer service for you." With the fast turn-around service, you also get printed reports of your sales.

One of the most appealing aspects of the Shutterfly Pro Gallery service is that you can set your own retail prices on a gallery-by-gallery basis. For example, you may want to charge higher prices for photos you take at sporting events than you do at a family reunion where you will be selling photos to your own family members. Or, you may just make the prices for prints in some galleries higher because they are exceptional photographs. In this project, you learn how to sell your photos from an online store using the Shutterfly Pro Gallery service.

STEP 1: SIGN UP FOR A SHUTTERFLY PRO GALLERY

■ Visit www.shutterfly.com and click **Pro Gallery** (you find a clickable link at the far bottom of the Web page). Click **Sign Up** for a Shutter Pro Gallery. Signing up is an easy online order process. You need a credit card to place your order.

At the time this book was written, Shutterfly offered three different gallery plans, one for $100, one for $150, and one for $200. With the more expensive plans, you get a larger discount on the print price, plus you get more storage space. You have to decide how much you think you may be using the service and how much you will mark up the price of the photos to your customers. The cost of the least expensive service ($100) can be recouped by selling twelve photos for $15 each with the discount you get at that

level. If you pay for the more expensive service ($200), you get a far larger discount on the print price and you only need to sell sixteen 8"x10" photos for $15 to recoup the cost of your Pro Gallery.

STEP 2: DOWNLOAD AND INSTALL SHUTTERFLY EXPRESS SOFTWARE

■ After you sign up for a Shutterfly Pro Gallery, you need to download the free Shutterfly Express software from www.shutterfly.com. After it is downloaded, you need to install it by simply running the downloaded file.

STEP 3: SELECT PHOTOS TO UPLOAD

Any professional photographer can tell you one story after another about how they are surprised by the photos that their customers choose. When you start selling your photos, you too will learn that there is no way to predict which photos will be bought. Some of our best photographs don't get purchased while some we weren't sure if we should even add to a gallery sell in more than one size. The lesson to be learned here is to upload all of the photos you take unless they are poorly taken, or if they might embarrass someone in one of the photos.

STEP 4: PREPARE PHOTOS TO UPLOAD

If you are shooting an event where you have several hundred photos to offer for sale, you are not likely to want to take the time to crop, edit, and sharpen each photo. In fact, if you have taken good photos, you can generally rely on the Shutterfly print service to make a good print. Shutterfly uses a proprietary print technology called VividPics that generally does a wonderful job at making a pretty good print.

On other occasions, you may be offering just a few pictures that may be purchased by many people. For example, we have taken group prom pictures that feature three or more couples. In those cases, we have taken the time to carefully edit the photos and to crop them to be a 5" x 7" or 8" x 10". With this approach

you know that the photos will be excellent and that helps build your reputation as a talented photographer.

After you have picked the photos you want to sell, you need to put them in a folder to be uploaded. They should be saved as .jpg files and you do not need to worry about cropping the photos as the customers can choose the print size themselves when they place an order.

STEP 5: UPLOAD PHOTOS TO SHUTTERFLY

■ To upload the photos to your Shutterfly storefront, you need to launch Shutterfly Express. Click **Get Pictures** to get the Get Pictures dialog box shown in Figure 40.2. After finding and opening the folder that contains the pictures you want to upload, click **Get These Pictures**.

■ You now see thumbnail images in the Shutterfly Express application. Click **Select All** to select all of the images. You should now see a check mark in each box found in the thumbnail images. You

should also see a count of how many images you have selected, as shown in Figure 40.3. In this case, we selected 17 photos to upload to our online store.

■ To begin the upload process, click **Upload**. You are then presented with a screen where you can enter your **e-mail address** and your **password** to your Shutterfly account. Click **Next** to get a dialog box where you can add a name for a new album. We typed "**2005-02-01 Lacrosse**" to indicate the date of the lacrosse game as shown in Figure 40.4.

40.3

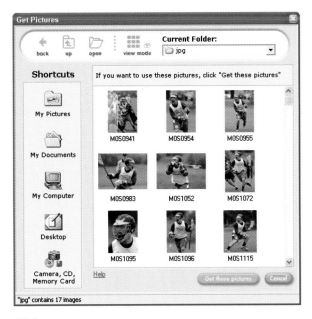

40.2

40.4

Click **Next** to get a dialog box that shows a progress bar indicating how much time remains before the upload process is complete. Using a DSL Internet Connection, we were able to upload 17 8-megapixel images in less than three minutes. After all of the images upload, you are presented with a dialog box that asks what you want to do next. Your choices are **Return to The Application and Close This Window**, or **Go to the Shutterfly Website and View my Pictures**. Choose the second option to view the pictures, as shown in Figure 40.5.

STEP 6: MOVE PHOTOS TO STOREFRONT

■ You now have to move the gallery containing the photos you just uploaded to your storefront. To do that, click **My Shutterfly** and then click **Manage My Galleries** beneath the Shutterfly Pro Galleries heading.

■ Click **Add a New Gallery** to get a Web page similar to the one shown in Figure 40.6. Here you name the gallery, specify the gallery title, add a gallery description, and choose a password if you want the gallery viewable only by those with a password. And, you can specify which print sizes you will sell and how much they will cost. Because we felt that we took exceptionally good photos of this game, we chose to only sell 5" x 7" photos for $15 and 8" x 10" photos for $20. Both size photos can be ordered in a Matte and Glossy finish. We also turn on the Watermark setting so that images are only displayed with a copyright mark that prevents them from being copied and used to make prints without payment.

■ After the Web page is complete, click **Save Now** to get another Web page. Click **Add New Albums** and then click the Albums you want to add to the gallery. Click **Next** to get a summary of the albums that are included in the gallery. You are also given

40.5

40.6

a Web address for the gallery. You need to provide this address to those to whom you want to sell photos. You are now ready to start selling photos!

STEP 7: PROMOTE YOUR GALLERY

If no one knows about your gallery, you will have sales of $0. The corollary is that the more visible your online gallery is, the more likely you are to sell photos providing that they are good photos and there are people who would like to buy them. You can take a look at the lacrosse gallery by visiting `www.shutterfly.com/pro/GregoryGeorges/chlax050201`.

When asked for a password, you need to enter "lax". Figure 40.7 shows what the completed gallery looks like for a visitor. Ordering is an easy process for your visitors and they can even order while viewing a slideshow as shown in Figure 40.8.

With the knowledge you have gained from completing the six projects in this chapter for displaying digital photos on the Internet, you are ready to make your photographic skills known to all who visit your Web pages. In the next chapter, you read about six projects for creating digital albums and slideshows.

40.7

TIP

If you plan on selling photos taken at an event such as a family reunion or a sporting event, you should create and print out a business card that has the exact Web address of the Web page where a visitor may view the images. If you hand these out during the event, you are more likely to have people buy photos from your online store. To get a Web address you should first set up a gallery for the event on Shutterfly Gallery Pro before the event. That way you are sure to have the correct gallery Web address.

40.8

8

CREATING SLIDESHOWS & DIGITAL ALBUMS

One of the best ways to show your digital photos to a group is to make a slideshow. Slideshows can be shown in many ways, including being projected with a digital slide projector. In Project 41, you learn how to create a slideshow using only the features found in Windows XP. You learn how to use the free downloadable Microsoft Photo Story 3 to create a photo story in Project 42. Creating the ultimate digital photo show is the topic of Project 43. Project 44 covers creating and putting a photo album on a CD using FlipAlbum. Building a DVD photo story to display on a TV is the focus of Project 45. The chapter ends with Project 46 where you learn how to create an HTML-based photo gallery for sharing photos on a CD.

USING WINDOWS XP TO CREATE A SLIDESHOW

41.1 You can easliy create slideshows and screen savers featuring your favorite digital photos with Microsoft Windows XP features.

Windows XP has many useful features that you can use to view your digital photographs. Surprisingly, not many people know they are there or how to use them. In this project, you get a quick tour of some of the features that are useful to digital photographers. First, you learn how you can change settings in Windows Explorer so that you can view image files as thumbnail images. Next, you learn how to view your images as a slideshow within Windows Explorer and as a full-screen slideshow. Finally, you learn how to create a screen saver that you can set up to display your favorite digital photos.

273

The good news about all these features is that they are built in to the Windows XP operating system and they are free and available on any Windows XP computer. After you know how to access these features, you can feel comfortable sending digital photos to others and know that you can help them view the photos you send to them without forcing them to buy software to view your images. The techniques you learn in this project are useful to everyone.

TO VIEW THUMBNAIL IMAGES

When using Windows Explorer, you have a number of ways you can choose to view folders and files. One of those ways is to view each image file as a thumbnail image. For the tasks in this project, we use a set of photos created with an intentional blur. These photos were created using the lowest possible ISO setting and a very slow shutter speed. The camera was then panned, zoomed, or moved in some pattern while the image was being exposed to create impressionistic images that make wonderful prints and screen savers.

■ In the **Folders** window in Windows Explorer, click the folder that contains the image files you want to view. Click the **Views** icon in the icon bar and choose **Thumbnails** to get thumbnail images, as shown in Figure 41.2. Windows Explorer

cannot be used to view many of the growing number of RAW camera file formats. It can, however, display thumbnails for files with .jpg, .tif, .bmp, and .psd file extensions.

TO VIEW IMAGES AS A SLIDESHOW

Occasions may arise where you will want to open a folder of images and view them in a small window. On these occasions, you may want to use the Windows Explorer Filmstrip feature.

■ Using Windows Explorer, click a folder containing images that you want to view. Click the **Views** icon in the icon bar and choose **Filmstrip** to get thumbnail images, as shown in Figure 41.3. You can now step through each slide by pressing the **Right Arrow** key to go forward, or the **Left Arrow** key to go back. Alternatively, you can click the **Next Image** or **Previous Image** buttons just below the large image.

TO VIEW A FULL-SCREEN SLIDESHOW

If you want to get a full-screen view of the image files in a chosen folder, you can do so using Windows Explorer.

41.2

41.3

■ Using Windows Explorer, click a folder containing images that you want to view. If the Folders icon in the icon bar is depressed, meaning that the Explorer is in Folders view, click **Folders** to get the task view shown in Figure 41.4.

■ If one or none of the image files is selected, all of the images will be shown in the slideshow. If two or more image files are selected, only the selected images will be displayed. To select all of the images in the folder, type **Ctrl+A**. To select a subset of images in a folder, press and hold **Ctrl** while clicking the images you want to display. Pressing **Ctrl** and clicking a selected image deselects it.

■ After you have selected the images you want to display, to begin the slideshow, click the **View as a slideshow** link found beneath **Picture Tasks**. The slideshow reduces images that are larger than the screen resolution to display on the screen. Images smaller than your screen resolution display at 100 percent. To control the slideshow, press **Spacebar** to get the slideshow control bar. Other keyboard shortcuts are shown in Table 41.1.

41.4

TO USE YOUR PHOTOS AS A SCREEN SAVER

We are not sure if screen savers are in or out these days, but we really enjoy creating and using them and think you will, too, after you know how to create a

TABLE 41.1

SLIDESHOW KEYBOARD SHORTCUTS

KEYSTROKES/KEYSTROKE COMBINATIONS	SLIDESHOW ACTION PERFORMED
Left Arrow, Page Up, or Up Arrow	Go to the previous image in a folder.
Right Arrow, Page Down, or Down Arrow	Go to the next image in a folder.
Ctrl+K	Rotate the image by 90 degrees clockwise.
Ctrl+L	Rotate the image by 90 degrees counter-clockwise.
Spacebar	Switch between playing and pausing the slideshow.
Enter	Go to the next image.
Esc	Exit the slideshow.
Tab	Turn the slideshow toolbar on or off.

screen saver. A few years back, you could walk around most offices and see all kinds of different screen savers on computer screens. One of the favorites for years was a screen saver that made a computer screen look like a fish aquarium. You could actually see fish swimming around in the water with bubbles coming from their mouths. If you want to use some of your photos as a screen saver, read on.

■ Collect all the photos you want to use in your screen saver and copy them into a new folder. Ideally, all the images are edited and saved as .jpg images. Files saved in the .jpg format load faster than non-compressed file formats, such as .tif and .bmp. Additionally, if you want the images to fill the entire area of your computer screen, you should crop and size them to be the exact size of your screen. The Windows screen saver floats

41.5

1

TIP

There are times when you want a little security. If you want to be able to leave your computer for a few minutes and ensure that others do not use it while you are away, you can set up your computer to require a password at the Welcome screen. You can read more about how to do this using Windows XP's Help feature. Just click the Start menu and then choose Help and

Support. You can type in the keywords "Welcome screen password" in the Search box at the top-right corner and press Enter. Choose Create a user password from the list of subjects on the left-hand side and follow the self-help instructions on the right-hand side to set up your account password.

After you have set up your account to require a password at the Welcome screen, you can elect to use the screen

images that are smaller than your screen resolution around the screen in an annoying manner. You can learn what your screen resolution is by right-clicking on your desktop and choosing **Properties** from the pop-up menu. Click the **Settings** tab. Look in the **Screen Resolution** box to see the resolution you have. Figure 41.5 shows the Settings tab for Gregory's 24" Sony CRT. It shows Screen Resolution as 1,920 x 1,200 pixels. So, that is the size he needs to have for a full-screen image screen saver. Click **OK** to close the Properties dialog box.

■ To set up the screen saver, right-click again on the desktop and choose **Properties** from the pop-up menu. Click the **Screen Saver** tab to get the dialog box shown in Figure 41.6. Click in the **Screen Saver** box and choose **My Pictures Slideshow**.

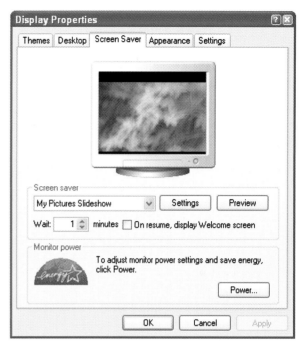

41.6

saver feature that requires password entry when an activated screen saver is deactivated by mouse movement or keystroke. To do this, right-click the desktop and choose Properties. Click the Screen saver tab. Make sure the box next to On resume, display Welcome screen shows a check mark as shown in Figure 1.

■ Click **Settings** to get the My Pictures Screen
Saver Options dialog box shown in Figure 41.7.
Using the first slider, you can set the time each
picture displays from six seconds to three minutes.
The second slider lets you choose how large the
picture should be in terms of a percentage of the
original size. As the goal is to display an image that
fills up the entire screen, set the slider to the far
right to 100% of the screen. Click **Browse** and
choose the folder where you stored your edited,
cropped, and sized image files. You can choose a
few other self-evident settings in this dialog box.
Click **OK** to return to the Screen Saver tab. You
can click **Preview** to display your screen saver. To
stop the preview, press any key or move your
mouse. In the Wait box, click the arrows to set the
amount of time you want the computer to remain
idle before it begins to display the screen saver.
Click **OK** to close the dialog box.

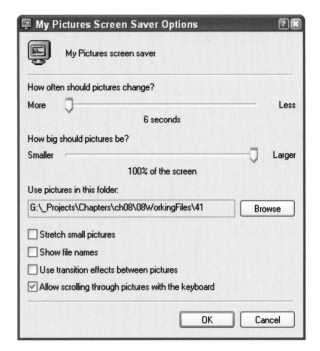

41.7

CREATE A PHOTO STORY

42.1 Tell a story using your photos that are narrated with your voice and supported by background music, slide transitions, and moving still images. It is all possible with the free Microsoft Photo Story 3.

WHAT YOU'LL NEED

Windows XP, the free downloadable Microsoft Photo Story 3, a few digital photos, and an optional microphone or music files

Telling stories with photos has been done for as long as cameras have been around. However, telling stories with digital photographs, sophisticated software, and sound files makes it possible for you to present your story electronically in an increasingly innovative manner. In this project, you learn how to use the free downloadable Microsoft Photo Story 3 to create a photo story that you can display on a computer screen. In addition to displaying your photo stories on a computer screen, you can send Photo Story 3 photo stories via e-mail or display them on a TV or portable device.

To get a free copy of Photo Story 3 go to: www.microsoft.com/windowsxp/using/digitalphotography/photostory. To use Photo Story 3, you must have Microsoft Windows XP Home Edition, Windows XP Professional, Windows XP Media Center Edition, or Windows XP Tablet PC Edition.

STEP 1: COLLECT AND ORGANIZE YOUR PHOTO FILES

The first step you need to take to create a photo story is to collect and organize the photo files you want to use. After you select all the photos you want to use, you should rename the files so that they are named in the order that you want to display them. For example, for the photo story we created about a lacrosse player, we named the photos: lax-01.tif, lax-02.tif, lax-03.tif, and so on.

STEP 2: EDIT AND CROP IMAGES

Ideally, your photos should be edited to look as good as possible, and they should be cropped to have a 4:3 aspect ratio (that is, 4 to 3 width-to-height ratio). However, if you don't have an image editor, or you prefer not to take the time to use an image editor to edit and crop each photo, you can use a simple set of features in Photo Story 3 to perform minor image edits and to crop the photo as needed. If you choose not to do any editing or cropping, you can still create a photo story. Photo Story 3 either adds a black space to the image or crops the image to get the necessary aspect ratio.

To make your story as good as possible, starting with well-edited images that have a 4:3 aspect ratio is best. You can crop an image to have a 4:3 aspect ratio with a crop tool found in most image editors, such as Adobe Photoshop Elements 3.0. Before cropping, set the Width and Height values to four and three respectively. After you crop your images, you should also resize them to be the size of the largest Photo Story 3 show you want to create. Your choices of show size are shown in the Photo Story 3 options menu

shown in Figure 42.2. For computer screens, your choices range from 320 x 240 to 1,024 x 768. If you want to create a show for DVD, for e-mail, or a portable device, you have other choices as well.

Photo Story 3 can import image files that have file extensions of: .jpg, .tif, .bmp, and .psd. In the process of creating a small photo story, Photo Story 3 resizes (if your image files have a larger resolution than the show) and compresses them, so it is best to edit your files and save them in a non-compressed format, such as .tif. This minimizes image degradation that occurs when you repeatedly compress an image file. We edited, cropped, and saved the files we wanted to use as .tif images that were 1,024 x 768 pixels.

STEP 3: RUN MICROSOFT PHOTO STORY 3

■ Launch Microsoft Photo Story 3. After being presented with the first dialog box, choose **Begin a New Story.** Click **Next** to get the dialog box shown in Figure 42.3. Click Import pictures to get a File Browser where you can select the folder that contains the digital photo files you want to use. To select all of the images, click on the first image while holding down the Shift key; then, click on the last image. You can also add or subtract one image at a time to the selected images group by pressing and holding **Ctrl** while clicking an image. The selected images should now be displayed in the dialog box.

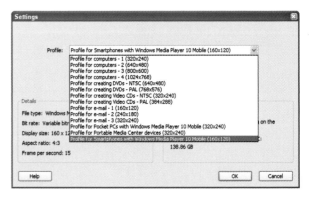

42.2

■ Click **Next** to get a dialog box that lets you add text to any image and to apply one of ten different image effects. We chose to use the **Black and White Effect** and to add red text to the image to make a title photo, as shown in Figure 42.4. You can click through all the images and add text where needed or change the image effect. You can also reorder the images by clicking the thumbnails and dragging them to where you want them to be.

■ Click **Next** to get the dialog box shown in Figure 42.5. You can now make notes to use when you show the slideshow, or you can record your

voice using a microphone so that your show is narrated on a photo-by-photo basis even if you are not around when the show is viewed. The other really cool feature you can access from this dialog box is found by clicking **Customize Motion** just below the large preview image.

■ Figure 42.6 shows the Motion and Duration tab where you can specify how your image displays. In this case, we chose to start with a full view of the lacrosse player and then over five seconds zoom in on the player's face. This is known as the "Ken Burns Effect." Ken Burns is a documentary film

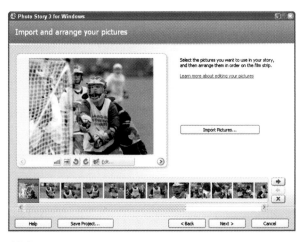

42.3

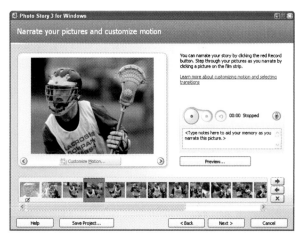

42.5

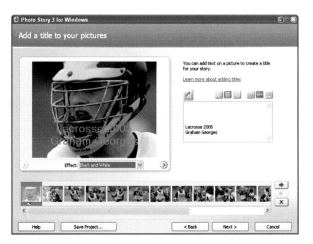

42.4

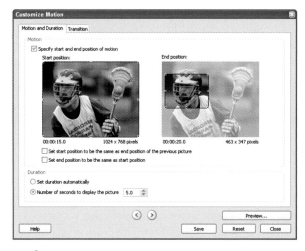

42.6

producer who extensively used this technique to make movies from still photos. Click **Preview** to get a small preview window that shows the effect you selected.

■ Click the **Transition** tab to get the dialog box shown in Figure 42.7. Here you can choose from 48 different slide transitions. After you have set all the transitions you want, click **Close**.

■ Click **Next** to get to the **Add Background Music** dialog box shown in Figure 42.8. You can either select a music file from your hard drive, use the **Create Music** feature to create your own mathematically created music, or add voice narration.

■ Click **Next** to choose how you want to present your story. For our example, we chose **Save your story for playback on your computer**. You can also specify where you want to store your story by clicking the **Browse** button and choosing a folder. Click **Settings** to get the dialog box shown earlier in Figure 42.2. Choose the size of show you want to create. The dialog box should now look similar to the one shown in Figure 42.9. Click **Next** to begin building your story.

■ Click **View Your Story**. Figure 42.10 shows the story being displayed in the Windows Media Player. After viewing the story, you can click **Save Project** to save the project if you plan on making changes to your story at a later time. Click **Exit** to close Photo Story 3.

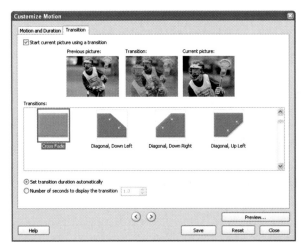

42.7

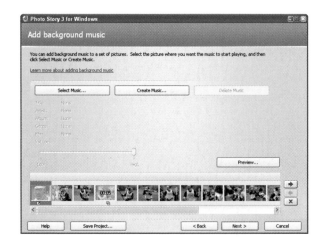

42.8

With a few good photos, a little effort, and some experimentation, you can make outstanding photo stories that are fun to view. The lacrosse show we created featured 17 photos, a background song, and several transition effects. After making a show to display as a 1,024 x 768 pixel show, we also created a 240 x 180 pixel show to e-mail. The file was about a half a megabyte, which is well within the limits of many of today's e-mail servers. Much to our surprise, the music file took very little space. If you like what you can do with the free Photo Story 3 application and you want to create even more brilliant photo stories, read about creating a photo story with ProShow Gold in Project 43.

> **NOTE**
>
> Microsoft Power Toys for Windows XP are a set of free programs that you can download from `www.microsoft.com/windowsxp/downloads/powertoys/xppowertoys.mspx`. **HTML Slideshow Wizard, Image Resizer, and CD Slideshow Generator are three of the available programs that are useful to photographers. These tools are for Windows XP only and they are not part of Windows and are not supported by Microsoft.**

42.9

42.10

CREATE THE ULTIMATE SLIDESHOW

43.1 Create the ultimate slideshow with slide transition effects, sound tracks, voice annotations, captions, and "Ken Burns style" still photo video effects using ProShow Gold and then, output your show to a computer screen, TV, Web site, or portable device.

WHAT YOU'LL NEED

ProShow Gold $80 ($70 for download version; ProShow $40, $30 for download version) and optional microphone or music files and a few of your own digital photos

When we first decided to add a chapter on creating slideshows, we knew our biggest challenge was going to be to find an application that would do what we wanted. We had visions of doing a slideshow that filled any computer screen size we wanted to fill. The show would have to be shown in a video format so that we could have perfectly smooth panning, zooming, and special effects. We also wanted to have enough control that we could time the sound files to begin and end with any slide or slides that we chose, and we wanted to add voice annotations to any image — even over any background music or sound. Finally, the software would need to be able to allow us to create a show once and output it in as many different formats as we could think of for display on a computer screen, on a TV, on a Web page, or on any one of the many portable devices. And, we wanted to be able to create small videos that could be e-mailed intact with music files and voice annotations. We didn't think we were asking much because we had seen each of these capabilities in one or more software programs. The problem was we had not seen them all in one single, affordable package.

After considerable searching and spending a considerable (as in too much) amount of time trying a dozen products, we found what we were looking for. In a sentence, the Photodex Corporation ProShow Gold (`www.photodex.com`) is that product and more. In this project, we give you a simple tour and a high recommendation to buy the product if your goal is to create the best possible slideshow you can create. This is one way-cool application.

Just to be clear about what you learn in this project, the goal is to create a slideshow that can be run on a Windows notebook attached to a projector so that the show can be displayed to a large audience. The show can be displayed at a 1,024 x 768 resolution, which is the maximum resolution of the projector we use. We also intend to make the show as exciting as possible and, therefore, we select all settings to give us a very high-quality show.

STEP 1: SELECT DIGITAL PHOTOS AND PLACE THEM IN A FOLDER

The first step you need to take to create a photo story using ProShow Gold is to select the image files you want to use. Believe it or not, we found this step to be the most difficult and time-consuming step of the whole process. Having some experience using ProShow Gold, we were able to create a wonderful show featuring the same photos of the lacrosse player that were used in Project 42.

ProShow Gold is able to import nearly all image files (not RAW camera files), music files, sound files, and video files — and they can all be integrated into a single show. Ideally, the image files you choose to use have an aspect ratio that is equivalent to the aspect ratio of the device that is used to display the show.

STEP 2: RUN PROSHOW GOLD AND CREATE SHOW

■ Launch ProShow Gold to get the application window shown in Figure 43.2. Click in the **Folders** box and select the folder where you stored the images you want to use. After selecting all of the thumbnails, drag them onto the filmstrip at the bottom of the window to add them to the show.

■ After you have all the images loaded onto the filmstrip, you can click an image and drag-and-drop it where you want it. This makes it easy to order your slides. Click the **Transition** icon between the images to get the **Choose Transition** dialog box shown in Figure 43.3. With over 280 choices, you ought to be able to find a transition that works well for each and every one of your images. After clicking a transition, you return to the main application window.

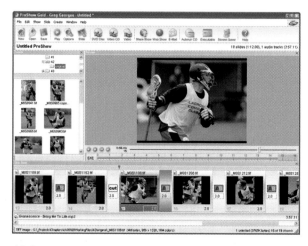

43.2

■ To set the motion effects for an image, double-click a thumbnail and click **Motion and Effects** to get the dialog box shown in Figure 43.4. This powerful feature lets you precisely control how a slide is panned, zoomed, or rotated. The image on the left shows the full image, and the image on the right shows the image as we want it to end. When the slideshow is run, you get video-quality zoom and pan that starts with the full-size image and zooms in to a close-up of the lacrosse player's face. This feature is known as the "Ken Burns effect" and it can be used to turn ordinary slideshows into videos. Click **OK** to apply the settings.

■ If you want to add sound effects to a slide, you click the slide to select it and then double-click it to get the Slide Options dialog box. Click **Slide Sounds** to get the dialog box shown in Figure 43.5. Here you have many settings to control how sound is added to the slide. You can even add voice annotations over background music. Fade in, Fade out,

volume, and timing are just a few of the available settings. Click **OK** to close the dialog box. One nice feature allows you to pick a song and then have ProShow Gold automatically time all the images to display so that the last image is displayed as the song ends.

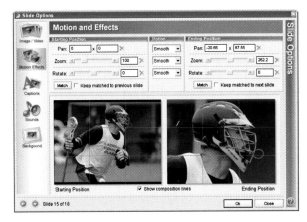

43.4

43.3

43.5

■ You can add text to any slide using the Captions dialog box. As you may expect, you have all kinds of options for displaying text. Besides being able to choose fonts and font colors, you can also apply motion and special effects to your text. Figure 43.6 shows the choices you have in the Captions dialog box.

STEP 3: CREATE SHOW

At any time during the show creation process, you can preview your show or just one or more selected slides. After your show is as you want it, it is time to save the show in the format or formats in which you intend to display the show.

■ To save your show, choose **Create** to get the menu shown in Figure 43.7. Using this menu, you can choose from nine different categories of show formats including: DVD, CD, video file, autorun CD, executable, screen saver, Web show, e-mail, and online show. As our initial goal for this project was to create a slideshow to display on a computer screen at 1,024 x 768 pixels, you now see how to create an executable file for that purpose. The executable feature creates one relatively small file that can be run without requiring any special software. You can copy an executable file and give it to anyone who wants to view your show. This option will not work if you intend to give it to someone who uses any kind of computer other than one running Microsoft Windows. In those cases, you want to choose another, more universal format.

■ Choose **Create Executable** to get the dialog box shown in Figure 43.8. After setting the show settings to 1,024 x 768 and choosing **High Resolution** and **High Quality**, the show is ready to be created. While there are other options in this dialog box, the default settings are perfect for our intended use. After clicking **Save**, the Executable File dialog box is displayed. This dialog box lets you choose a folder and file name for the file. Click **Save** to begin the save process. Within a few seconds, the show is ready to be run or shared with others.

43.6

43.7

In this project, you learned how to create a slideshow to display on a computer screen. However, one of the strengths of ProShow Gold is that it can be used to create a slideshow and then used to output the show into many different formats. By choosing **Create ➢ Send as E-mail**, you can save the same show as a small file to e-mail or by choosing **Create ➢ Create DVD**, you can create a DVD to play on a DVD player, including one that is connected to a TV. Figure 43.9 shows the Create DVD Disc dialog box and the options that are available. Click **Menus** to get the dialog box shown in Figure 43.10. Using this feature, you can add multiple videos to a single DVD and create a front menu screen used to select the videos just like you do when using movie DVDs. If you use a digital video camera, you can even add videos to a DVD and have them be accessible via menu items on the same DVD where you have your still photo shows.

43.8

43.9

TIP

After creating a ProShow Gold photo show, you can upload the show to the free www.photodex.com Web site where you can make your shows available to family and friends. To upload your show using ProShow Gold, choose Create ➢ Share Show Online and choose Upload to Photodex Web site. The Web site frequently offers slideshow competitions and you can view other public slideshows created by other ProShow users. Recent competitions include: autumn, pet, family, nature, and summer contests. You can also upload any show you create to your own Web site as well.

43.10

CREATE A PHOTO ALBUM TO SHARE ON A CD

44.1 If you like viewing photos in an album with pages that you can turn, you should create a FlipAlbum. A FlipAlbum lets you digitally show photos on a page along with captions, sound files, and voice annotations.

WHAT YOU'LL NEED

FlipAlbum 5 Pro $100 (FlipAlbum 5 Standard $20) and a few digital photos

Ever since FlipAlbum (www.flipalbum.com) was first introduced many years ago, it has been a unique product used to display digital photos in a fun and realistic page-turning manner. Accepting default settings, you can create a FlipAlbum as fast as you can select a folder of digital images. After you select a folder, FlipAlbum automatically creates an album

complete with a desktop, an album, covers, table of contents, and an index. To view the photos in the album, you just click a page and the page turns with a sound that mimics a paper page being turned. We have always liked this product and have used it to share photos with hundreds of people.

In this project, you see what steps are taken to create a FlipAlbum that features a series of iris photos that were taken over a few summers. You learn about the options you have for making your album exactly as you want it and how you can share FlipAlbums with others.

STEP 1: CHOOSE AND PLACE DIGITAL PHOTOS INTO A FOLDER

The first step to creating a FlipAlbum is to choose the photos you want to use and place the image files in a folder. FlipAlbum is able to import many standard image file formats including .jpg, .tif, .bmp, and .psd. While you should use photos that are edited to look good, they do not have to be resized unless you find that they are so large that the file size slows down the use of the albums.

STEP 2: CREATE A FLIPALBUM

- After launching FlipAlbum, choose **Folder ➢ Open Folder** to get the Browse for Folder dialog box. After selecting the folder that contains the image files you want to use, click **OK** to load the photos into the album. The album now has as many pages as you have photos and it has a cover, table of contents, and index. Click the left side of the first page to flip to the cover.
- Right-click the cover to get a pop-up menu; click **Edit Annotation** to get the dialog box shown in Figure 44.2. You can now type in any text you want on the front cover and choose the font size, font style, font color, and how you want the text to be aligned. Click the cover to close the dialog box and display the cover text.

- Click the upper-right corner of the cover to display the inside cover that shows thumbnails and the Contents page, as shown in Figure 44.3. From here you can click any content item and go directly to that page. If you click a thumbnail, the page containing that photo will be displayed.
- Choose **Options ➢ Book Options** to get the Set Book Options dialog box shown in Figure 44.4. Click the **Book Cover** tab to choose an image, color, or texture for the cover. If you want to choose a theme, click the theme you want. Additional themes may be purchased on `www.flipalbum.com` that are appropriate for travel, weddings, baby showers, and more.
- To play music while the album is being used, click the **Audio** tab to get the dialog box shown in Figure 44.5. Besides choosing a music file, you can also turn on or turn off the page flipping sound that you hear each time a page is turned. The other tabs offer additional ways to customize your album. After you choose the settings you want, click **OK** to apply them.

44.2

44.3

You can further customize your FlipAlbum pages by adding text, colored tabs, image effects, book markers, resize images, add borders or frames, and more as seen in Figure 44.6. After you complete the album, you should save it to your hard drive.

STEP 3: SHARE FLIPALBUM

After you create and save your FlipAlbum, you can take the steps you need to take to share the album the way you want to share it. You can share a FlipAlbum by writing the files to a CD, uploading it to a Web page, sending it as an e-mail, adding it to the free FlipAlbum Web site, and exporting the album to view on a TV screen.

■ One of our preferred ways of sharing FlipAlbums is to write the files to a CD. To create a FlipAlbum CD, choose **CD-Maker** ➤ **Create Album CD** to begin the Create Album CD process. Figure 44.7 shows some of the setting choices you have. Click the **Security** tab to get the

44.4

44.6

44.5

44.7

dialog box shown in Figure 44.8. Here you can set a password used to view the album. You can also choose an expiration date and determine if the viewer can print and save pictures from the album. There is even a watermark option that you can use to add copyright information to each photo in the album. These features make FlipAlbum a useful product for photographers who earn money from their photography. Click **OK** to create the files that later need to be copied onto a CD.

■ Figure 44.9 shows how the album is displayed when it is played from a CD. Notice that a good subset of the features are found in the FlipAlbum software. Viewers can choose some settings to determine how the album is viewed and they can add bookmarks to their favorite photos.

One year, after Gregory had taken action photos at most of the lacrosse games that were played at a local high school, Lauren selected, edited, and created a FlipAlbum featuring nearly a thousand photos. She added tabs to make it easy to choose photos for a spe-

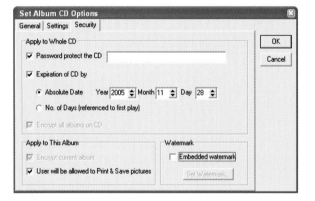

44.8

44.9

cific game. Music was added and the CDs were sold to the players' families to raise money for the team. Figure 44.10 shows the CD that was created and the label that was printed and placed on the CD. For several years, we have heard from players how much they enjoy the CDs and looking at all the action photos that were taken in a year where they won the state high school lacrosse championship.

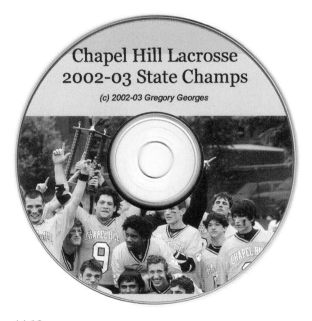

44.10

> **TIP**
>
> **E-Book Systems Incorporated** (`www.flipalbum.com`) **offers many innovative products that feature their clever "page-turning" photo albums. Besides offering FlipAlbum 5 Pro, they also offer: FlipAlbum 5 Standard, FlipAlbum 5 Suite, CD Shopping Cart, Mac FlipAlbum, Mac FlipAlbum 3 Suite, Mac FlipAlbum 3 Pro, and FlipPublisher. Additionally, they offer design libraries and an innovative hardware product that you can use to show page-flipping photo albums on your TV using a remote control device. To learn more about these products, visit their Web site where you can also join a FlipPhoto Community and view FlipAlbums.**

BUILD A DVD PHOTO SHOW
FOR VIEWING ON A TV

45.1 Create one or more digital photo slideshows and then create a DVD for displaying them on a TV. You can create a menu page that allows users to select the show they want to view just as they would select various menu items on a video DVD.

WHAT YOU'LL NEED

Ulead CD & DVD PictureShow 3 ($35) and a few digital photos

I f you spent good money on a high-resolution digital camera and you work hard to edit your photos to make high-quality photographic prints, you may think we are both crazy for having a project in this book for displaying low-resolution photos on a TV. Initially, we thought it was kind of crazy to create a DVD for a TV, too. But after having created a couple of them and having watched how much grandparents, kids, and others enjoyed seeing the photos on a TV screen, we realized that slideshows on a DVD for display on a TV do have a purpose. Many people are far more interested in the subject or scene shown in a photograph than they are the technical merits of a high-resolution image. They are also used to viewing images on a TV screen. Furthermore,

297

it is easier for a group of people to see photos on a TV than it is for them to view small prints or to look at them on a computer screen. Before you simply dismiss the idea of creating a DVD show, try creating one. Before we forget, we should also mention that any DVD show can be shown on a computer screen if the computer has a DVD player. So DVD slideshows are good for more than just watching on a TV.

While you can use many software products to make DVD-based slideshows, we chose to use the Ulead CD & DVD PictureShow 3 because it is a simple-to-use product that offers just what you need to make a DVD that has one or more slideshows or videos. We also admit to being fans of most of the products that Ulead makes.

STEP 1: CHOOSE THE PHOTOS YOU WANT TO USE

The first step to creating a picture show with CD & DVD PictureShow 3 is to choose the photos you want to use and place the image files in a folder. CD & DVD PictureShow 3 is able to import many standard image file formats including .jpg, .tif, .bmp, and .psd. For this project, we chose a small set of photos of dragonflies and a second set of photos of pelicans that were flying around a few shrimp boats as they came to dock in a harbor near Savannah, Georgia. The goal is to create a two-show DVD that can be played on a DVD player and displayed on a TV. To make the loading of the two separate shows quick and easy, we created two separate subfolders in the "nature1" folder named "dragonfly" and "pelican".

STEP 2: CREATE SHOWS

If you are not sure that the Ulead CD & DVD PictureShow 3 is the right program for you or that it will do everything you want it to do, you can download a free trial version from www.ulead.com. The trial version is limited to displaying ten slides per show.

■ Launch CD & DVD PictureShow 3. Click the **New Show** icon and choose **Batch Collect** to get the Batch Collect dialog box shown in Figure 45.2. After locating the folder that contains the two subfolders of photos that you are to use for the two slideshows, click in the box next to the folder. Make sure that **Default duration** is set to **3 seconds**. With this setting, all of the slides initially set to show for 3 seconds. Click **OK** to import the photos. After the files are imported, you see two folders, one for each of the two shows. You can click each show to view the images that are in the show as seen in Figure 45.3.

■ To add text or props to a photo, double-click the photo to get the dialog box shown in Figure 45.4. After choosing the settings you want and adding any desired text, click **OK**. From this dialog box you can change the order of the slides, add blank slides, rotate images, adjust images, and more.

45.2

45.3

45.4

45.5

■ To choose a theme, click the **2 Theme** to get the dialog box shown in Figure 45.5. Click any title text that you want to change and type in new text. If you want to change the theme you can do so by clicking in the theme box and choosing a new theme.

■ Click the **Menu** tab to get the dialog box shown in Figure 45.6. Choose any background music file you want to use or background image file for the menu page.

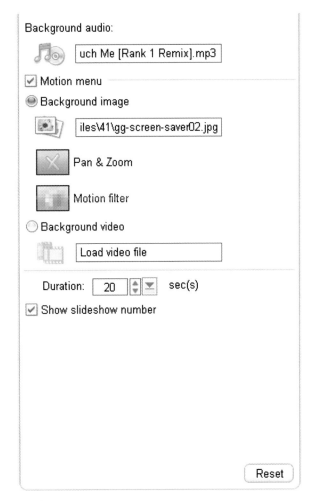

45.6

■ Click the **Slideshow** tab to get the dialog box shown in Figure 45.7. This dialog box gives you many more settings that you can use to get the effects you want on a slide-by-slide basis. Clicking **Transition Effect** gets the dialog box shown in Figure 45.8, which allows you to choose how one slide transitions to the next slide. A similar feature is available for determining Pan & Zoom.

> **WARNING**
>
> Because of evolving and conflicting DVD and CD standards, you may find it challenging to create a DVD on your computer that plays on a specific DVD player connected to a TV. You must get five details right! You need to use the right kind of software, use the correct software settings, write to the right kind of DVD media, use the right kind of DVD writer in your computer, and have the right kind of DVD player connected to the target TV. Before spending too much time making DVDs, you should check the documentation that came with your DVD writer in your computer and with the DVD player you intend to use to determine what media should be used. The newer your software and hardware is, the more likely you will enjoy success. Don't let this warning stop you from creating your own DVD slideshows. Everything may work on your first attempt!

STEP 3: BURN FILES TO A DVD

■ To burn the files to a DVD, insert a blank DVD into your DVD burner. Click the **3 Burn** tab to get the dialog box shown in Figure 45.9. Type in the

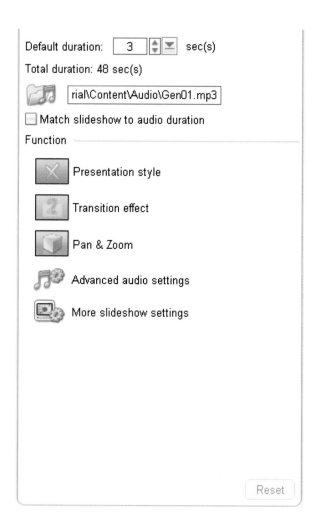

45.7

name of the show in the **Disc Volume Label** box. Make sure the correct DVD drive is showing in the **Drive** box. Set the **number of copies** to **1**. Click **Burn Now** to begin burning the files to the DVD. While the files are being burned, two progress bars display. Depending on the number of files you have and on the file size, you may need to have patience, as it can take a considerable amount of time to create the video files that are needed.

TIP

Before spending money on a program to create DVD-based slideshows, you should carefully check to see if there is a feature in any software that you currently have that can do what you want to do. Adobe Photoshop Elements 3.0 (www.adobe.com), ProShow Gold (www.photodex.com), Ulead PhotoImpact Album (www.ulead.com), Paint Shop Photo Album 5 (www.jasc.com), and many other products have some features that you can use to create a slideshow that can be put on a DVD and viewed on a TV screen.

45.8

45.9

CREATE AND SHARE AN HTML-BASED PHOTO GALLERY ON A CD

46.1 When you want to provide a universally viewable slideshow on a CD, a good approach is to create an HTML slideshow that can be viewed on any computer that has a Web browser, such as Microsoft Internet Explorer or Netscape Navigator.

WHAT YOU'LL NEED

Adobe Photoshop Elements ($80) and a few digital photos

Any time you need to create a slideshow and deliver it to someone you don't know, you may run the risk of providing him or her with a show they can't view. If your slideshow was created on a PC using Windows software that requires a Windows application and the intended viewer or viewers run an operating system other than Windows, they will not be able to view the show. Or, maybe you use a Mac and the goal is to provide the slideshow on a CD to someone using a PC running Windows. If you use Mac-only software, those running Windows will be unable to view the show.

To avoid problems such as these, you should consider creating your slideshow with any application that creates a show using HTML (Hyper Text Markup Language), which is the language that is used for creating Web pages and is read by Internet browsers.

Once again, you are faced with the choice of many, many different software tools that you can use to create an HTML-based slideshow. For this project, we use Adobe Photoshop Elements 3.0 to create a slideshow of 66 nature photos. In Project 36, you learn how to create a Web photo gallery; so, the goal of this project is not to spend time on the details of creating the gallery. Rather, you learn about the files that are created and how to get them onto a CD using Windows XP.

STEP 1: CHOOSE PHOTOS AND PUT THEM INTO A FOLDER

The first step to creating a slideshow using Adobe Photoshop Elements 3.0 is to choose the photos you want to use and put them into a folder. The images should be edited and cropped and saved in a file format readable by Adobe Photoshop Elements 3.0, such as .bmp, .jpg, .tif, or .psd. The Elements 3.0 Create tool used to create Web shows can use photos in their original size if they have been sized for the intended use, or it can resize them to meet your specifications when the show is created.

STEP 2: LAUNCH ADOBE PHOTOSHOP ELEMENTS 3.0 AND CREATE SHOW

■ After launching Adobe Photoshop Elements 3.0, click the **Create** icon in the icon bar to get the Creations Setup screen. Click **Web Photo Gallery** and then on the **OK** button to get the Adobe Web Photo Gallery dialog box shown in Figure 46.2. After adding the photos, you need to make any

setting changes to the Banner, Thumbnails, Large Photos, and Custom Colors tabs. To learn more about these settings, read Project 36.

■ You are now ready to specify where the HTML files and image files should be saved. In the **Destination** box, click **Browse** to get the Browse for Folder dialog box shown in Figure 46.3. Click the folder where you want to place the destination files. It does not matter where you choose to place the destination files other than the fact that if you put them in a folder in your My Pictures folder, it makes it easier to burn the files to a CD, as you learn in Step 3. If you need to make a new folder, you can do so by clicking **Make New Folder** and typing the name of the new folder. After you have selected the folder, click **OK**. You now need to name a site folder. Type a name for the Web site in the Site folder box. The name of the folder you type here will be part of the name of the URL (that is, Web address) that you need to access the photo gallery.

46.2

A good choice is a descriptive name, but one that is short. We used "nature1" as the name of our nature photography gallery.

■ To create the gallery, click **Save** to create all of the necessary files and save them to the specified folder. As soon as the gallery is complete, a Web browser displays the gallery. The fourth page of six pages of our nature photo gallery is shown in Figure 46.4. That is all you need to do to create the HTML code and all necessary images. You can now close Adobe Photoshop Elements 3.0 as it is no longer is needed.

STEP 3: BURN FILES TO A CD

■ The last step is to burn the files to a CD. Insert a blank, writable CD into your CD burner.

46.3

■ Using Windows XP, launch Windows Explorer by right-clicking on **Start** and choosing **Explore**. With the **Folders** icon depressed, as shown in Figure 46.5, click the folder you specified in Step 2 in the **Destination** box. For a small laugh, you can count the hard drives we have on our computer.

46.4

46.5

If you are compulsive about backing up your photos (as you should be and we are) and you take lots of photos using high-resolution digital cameras in RAW mode, the storage space requirements can get a bit crazy.

■ With the folder you want to copy in the right window selected, click the **Folders** icon in the icon bar to show the task view that is shown in Figure 46.6. Click **Copy to CD** to get the **Copying** dialog box shown in Figure 46.7.

■ After the files are copied, you need to burn them to the CD. Click **My Computer** in the **Other Places** area of Explorer and then double-click the **CD drive** where you inserted a disk in Step 2. The Windows Explorer dialog box should now look similar to the one shown in Figure 46.8. Click **Write these Files to CD** to get the CD Writing Wizard dialog box shown in Figure 46.9. Type in a name in the CD Name box and click **Next**. You now get the CD Writing Wizard progress bar shown in Figure 46.10. After your disk is burned, it ejects and you get the dialog box shown in Figure 46.11. If you want another CD created, you can click in the box next to **Yes, write these files to another CD**; otherwise, click **Finish** to close the wizard.

46.8

46.6

46.7

46.9

STEP 4: CONFIRM YOU HAVE WRITTEN THE FILES YOU NEED FOR THE SLIDESHOW

Whenever you create a CD, it is always wise to confirm that you have burned all of the files you intended to put on the CD. You can do this by using the **Properties** dialog box and checking to see that there are as many files and megabytes in the source folder as there are on the CD. You can also test the show out to make sure it works.

- To get a count of the number of files in the source file, right-click the folder and choose **Properties** to get a dialog box such as the one shown in Figure 46.12. Note that there are 183 files in three folders for a total of 4,882,288 bytes. Do the same process for the folder on the CD. If the numbers match, you have copied all of the files.

46.10

46.11

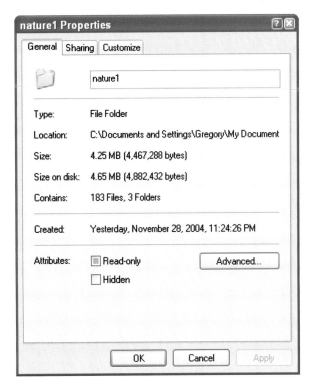

46.12

■ To test the slideshow, insert the CD into the CD reader and double-click the folder that contains the files. Click **index.html** to display the Web page in your default Internet browser.

You have now created a Web photo gallery that you can display on any computer using an Internet browser, and you have burned all of the necessary files to a CD.

You have now reached the end of Chapter 8 and there is one more chapter remaining — a chapter about getting more enjoyment from digital photography.

TIP

Web-based photo galleries can be created by many software products. Adobe Photoshop CS and Elements 3.0 (www.adobe.com), Ulead PhotoImpact XL (www.ulead.com), Paint Shop Pro (www.jasc.com), Microsoft FrontPage (www.microsoft.com), and Macromedia Dreamweaver (www.macromedia.com) are just a few of the applications that are available.

CHAPTER 9

GETTING MORE ENJOYMENT FROM DIGITAL PHOTOGRAPHY

J ust about when you think you can't have much more fun — you learn you can! Entering photo competitions and photo challenges can be loads of fun. In Project 47, you learn about the best Web sites to visit to enter your photos into competition. When you have a photography-related question, or you want to learn more about a particular photography topic, Project 48 takes you on a guided tour to some of the best places on the Internet to get answers to your questions and get educated on photographic topics. Project 49 provides you with lots of useful information about matting and framing your photos so that they look incredible. The last project of the book, Project 50 shows you many ways to make a portfolio for your best work. In this chapter, you find many valuable resources to keep your interest in photography high and your photography skills growing.

ENTER AN ONLINE PHOTO CONTEST OR PHOTO CHALLENGE

47.1 A Web site worth visiting is PhotoBlink.com, which offers photo competitions, forums, tips and tricks, photo contests, photo galleries for members, and much more.

The magic of photography is that it is possible and more than likely that different people will have different opinions on the relative merits of any photograph. Yet, we all are eager to learn what others think of our work. Is it good? Is it bad? If so, why is it good or bad? Most of us want answers to these questions. One of the best ways to get feedback on your photos is to submit them to an online photo contest, photo challenge, or to a photo critique Web site.

311

A growing number of Web sites have been designed to give you feedback in a variety of ways. On some Web sites, your photographs simply get number ratings or accumulate points. Many sites also allow viewers to enter their comments or critiques. A few distinguished photographers even provide critiques for a small portfolio of your photos if you have the money and inclination to learn more about your work from an expert. In this project, you learn about a few of our favorite Web sites that offer photo contests, photo challenges, and photo critiques. The goal is not to provide you with an exhaustive list of Web sites; rather it is to give you good examples of some of the more useful Web sites.

ENTER A PHOTO IN AN ONLINE PHOTO CONTEST

We love PhotoBlink (`www.photoblink.com`)! It is an excellent example of a good photo contest Web site *and* photo challenge site. However, in this project, we just look at what it takes to enter a photo competition. Before we get into entering a competition though, we tell you a little more about the site.

You should take at least an hour to tour PhotoBlink, if not several hours or even more for so many reasons. This remarkable Web site has so many features that it is hard to list even the most important ones. The most impressive feature about PhotoBlink is the incredible quantity *and* quality of photos that get posted by members. Very few Web sites on the Internet offer so many outstanding photographs in such high resolution (up to 800 x 900 pixels and up to 140KB). You can view these photos many ways. You can view them in streams, which we cover in a moment. You can also view photos by photographer,

by subject, by viewer ratings, by contest winners, by photo of the day, by PhotoBlink Honor Portfolio, and in many other ways. As soon as you visit and start viewing photos, you will unquestionably be inspired by the incredibly talented photographers who shoot all kinds of subjects and scenes, and who live all over the world. Some of the photographers are professionals, but most photographers are simply people who are fanatical about photography and shoot for the fun of it. They use PhotoBlink to share their view of the world and to view work done by others.

What is unique about the site is how you post images and how they get displayed. To be able to post images, you have to become a member. There are several different kinds of memberships including the Basic membership, which is free. The other memberships cost $30, $50, and $70 per year. As you would expect, you get more options if you pay for one of the upgraded memberships. After you are a member, you can submit photos into a stream. A *stream* is a continuous flow of photographs that are displayed in the order that they are submitted. However, to be able to submit a photo, you must first vote for eight photos. The sophisticated voting process is what makes this such a fun site. When your photos are good enough to catch the eye of the viewers, you get ratings for your work and often times viewers post their comments. If you submit photos that accumulate enough points, your work gets ranked and you can make it on to a Photo of the Day list. If you submit many photos that get high ratings, your entire portfolio can get added to the PhotoBlink Honor Portfolio list.

PhotoBlink also offers photo contests that are submitted by members with specific requirements for entering photos. For example, one contest was titled, "Pictures in Paradox." The objective was to

"Photograph things out of place, such as an airplane on the interstate, or a car in the river, or a cat in a doghouse, or a pelican in a shopping mall." Other PhotoBlink features include: forums, member portfolios, articles, a PhotoBlink mall where you can buy gifts, and even a statistics tool that can be used to study photo ratings. If you want to view Gregory's PhotoBlink member portfolio, visit: `http://gregorygeorges.photoblink.com`.

Figure 47.2 shows the PhotoBlink home page where you can see the latest photos submitted to the "Pictures in Paradox" contests, the latest stream of photos, a highly-rated photo, and a couple of images from some "cool member galleries."

Okay, get your most competitive photo out and enter it into competition! The steps for entering a photo into competition are easy. For this example, we use the picture shown in Figure 47.3 of a rather aggressive turtle we found on the Tennessee side of the Smoky Mountains.

- Before you can enter a photo into competition, you must first register for one of the memberships.
- Prior to uploading your photo, you must edit it, crop it, and prepare it to look as good as it can on a Web page. To do this, use an image editor, such as Adobe Photoshop Elements 3.0, and save the file as a .jpg. PhotoBlink has varying maximum file size specifications that you must abide by in order to upload your images. We have also learned to increase the saturation slightly before saving the image as a .jpg. When it gets displayed on a Web

47.2

47.3

page, the saturation level looks as you intended it to look, slightly less saturated than the over-saturated image. Some experimentation may be required to get the image saturated as you want.

■ Click **Send a Photo** in the menu on the left of `www.photoblink.com` to get to the photo upload page shown in Figure 47.4.

47.4

■ Type in a title for your image in the **Title** box. Add any technical comments or other information you want to contribute in the **Comments** box. Click an appropriate subject. Click **Browser** to select the prepared file to upload. Click **Send** and your file uploads into the current stream. It is that easy.

After entering one of your photos into the stream, it shows up on the front page as you can see in Figure 47.2. Notice our turtle photo at the left in the Latest Streamline Photos box. When you sign up to be a member, you are given the option to have viewers' comments sent to you via e-mail. Within a few hours of having submitted the turtle photo, we received over a dozen e-mails. This photo did not fare too well in the ratings. So, feeling a bit challenged, we sent in another image to see if we could do any better. An image of the glowing water lily photo shown in Project 28 was submitted. Figure 47.5 shows the ratings and a few of the comments for that photo, which got a Top 100 rating and a Hot Image rating that meant that it was displayed on the home page as a

47.5

candidate for Photo of the Day. Ah, now that we have a taste of low ratings and high ratings, we'll be entering more photos in the future.

We hope you find a few good photos to submit and we wish you good luck in the competition. In any event, as you rate photos submitted by others in order to be able to submit your own, you learn what works photographically and what does not. Competitions like this one are well worth your time as they are an excellent learning experience. If you get poor ratings as we did on our first submission, get back on the Web site and keep submitting photos whenever you take good ones.

ENTER A PHOTO IN AN ONLINE PHOTO CHALLENGE

Photo challenges are slightly different than photo competitions. In a photo challenge, you are given some specific requirements as to what kind of photo you should submit. Or, you are given a photo and you must edit the photo to meet some objective. Photo challenges are good learning experiences as you see how other photographers use the same tools as you do, but end up with entirely different photos when given the same set of objectives. If you are into photo challenges, the site to visit is www.dpchallenge.com. Their challenges are fun and they bring out some fantastically creative entries. For example, one challenge was to "Take a photograph where smoke plays a major role in your composition." This challenge had 99 awesome submissions and there were almost 900 comments posted about those submissions. Most challenges have between 70 and over 400 submissions on Dpchallenge. Figure 47.6 shows a list of the winning entries for a challenge titled, "Music."

Another Web site that offers challenges is www.fredmiranda.com. If you click Forum, you find topics that list Assignments and Critiques for Weekly Assignments, Monthly Assignments, and Photo Critique.

WARNING

Before posting images to any Web site, including those that offer competitions, photo challenges, or critiques, you should take the time to first read any documentation on the Web site that tells you how those photos can be used. A few Web sites have text that states after you post an image to their Web site, they have copyrights to your photo! While it is worthwhile to be mindful of copyright issues, you should not become so paranoid about losing your images that you refuse to upload your photos to any Web site. Generally, you will not be giving up much if you only post tiny Web-page-size images.

47.6

UPLOAD A PHOTO TO GET IT CRITIQUED

If you would prefer to get your photo critiqued without the ratings, rankings, or grades and simply want good feedback, you should look for a good photo critique Web site. An excellent example of a photo critique Web site for nature photographers is NatureScapes.net (`www.naturescapes.net`). After uploading a photo, it gets listed with a thumbnail image, as shown in Figure 47.7.

If the Web sites we provide here are not to your liking, you should visit an appropriate forum to post a question that clearly explains what you are looking for. You can also use Google (`www.google.com`) or another Internet search engine to help you search for the kind of site you want.

47.7

LEARN MORE ABOUT PHOTOGRAPHY ONLINE

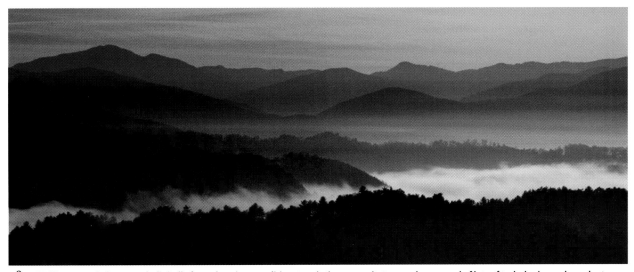

48.1 Making a good photograph digitally from shooting, to editing, to printing necessitates good command of lots of technlogies and good art sense. The Internet can be one of the best resources for learning more about making better photographs.

WHAT YOU'LL NEED

A Web browser and a connection to the Internet (preferably a fast connection)

I n the fast-moving world of digital photography, it is not easy for anyone that writes content to be printed (that is, authors like ourselves who write books, or writers who write for magazines) to write good content and get it published and available to readers before the content is outdated. Because of the need for vendors and content providers to get information out quickly, the Internet is increasingly becoming the best source for current information.

The goal of this project is not to provide you with an exhaustive list of Web sites that are related to photography. Rather, the goal is to present to you some of the better Web sites. With these Web sites as examples, you will know what to search for.

WEB SITES THAT OFFER USEFUL PHOTOGRAPHY-RELATED CONTENT

In true Internet fashion, the number of Web sites featuring photography-related content has grown to the point where the biggest challenge is finding what you need. We did our best to distill all those sites we know about into a list of what we consider to be the 10 most useful sites for photographers. We recommend visiting these sites in the following order.

- `www.luminous-landscape.com` – An exceptional Web site that has so much useful content that every photographer should visit at least once to see what is available. Michael Reichmann deserves many thanks for having contributed over 2,000 articles, tutorials, product reviews, and photographs, all without any advertising. If you only visit one Web site, this is the one to visit.
- `www.dpreview.com` – If you are in search of a new digital camera, then this is a "must visit" Web site. Just about every digital camera made is reviewed on this site. If you are considering several different cameras, you can choose the cameras and see the specifications side-by-side. The forums are some of the busiest on the Internet. Dpreview is one of the best sites to visit to learn about new digital photography product announcements and photography industry news.
- `www.robgalbraith.com` – This Web site is particularly useful for those who use digital SLRs and for those who are very serious about photography or shoot professionally.
- `www.fredmiranda.com` – Fred Miranda has created an "all-around" good Web site for photographers with lots of features for sharing information, displaying photos, selling and buying camera gear, and much more.
- `www.photo.net` – This was one of the first photo-oriented Web sites with wonderful content and photo galleries. It also features lists of those that sell and buy camera gear online so you can get an idea of who you are buying from and if they

are trustworthy. There is also a forum where buyers can rate their transactions with online stores.
- `www.creativepro.com` – A useful site featuring high-quality news, features, and reviews.
- `www.artshowphoto.com/resources.htm` – Larry Berman's useful Web site for all kinds of content for photographers and artists who sell their work at art shows. If you sell your work at art shows, you should visit this site.
- `www.adobe.com` – If you use an Adobe product such as Adobe Photoshop, then this is a site worth touring. Some of the best instructional content found on the Internet for users of Photoshop may be found on this site.
- `www.wilhelmresearch.com` – The Web site to visit if you are interested in learning more about print longevity. Henry Wilhelm is an expert on the topic and his test results are available free of charge.
- **Vendor Web sites** – Tenth on the list of ten valuable Web sites for photographers are the vendor Web sites of the products and services that you own or use. A quick visit to the vendor's Web site of the camera you own may reveal that there is a new firmware upgrade that solves a problem you have had with your camera. Or, after visiting the Web site of a paper vendor that makes inkjet paper that you use, you may find they offer a free color profile, which can be used to get much better prints than you currently get.

GET INSPIRED BY VISITING A FEW ONLINE PHOTO GALLERIES

The number of online photo galleries has grown exponentially over the past few years. There are so many of them now that it is as hard to find good ones as it is to find the proverbial needle in a haystack. One good approach to finding good galleries that may be of interest to you is to look up the Web sites of a few of your favorite photographers. Quite often photographers list the addresses for the online photo galleries they like.

To get you started, we recommend a visit to the following Web sites.

- `www.normankoren.com` – Norman's Web site offers extensive lists of Web sites featuring well-chosen online photo galleries and useful content, too. To find the list of photo galleries, scroll down on the home page and look for the link: Photographer / Galleries Links.
- `www.naturescapes.net` – The NatureScapes Web site offers online forums for nature photography discussion and image critique. Most of the photographers who post images on this site have their own Web sites and you can usually find links to them on this site. Following links from here keeps you looking at nature photo galleries for hours. Figure 48.2 shows a Web page in the Birds forum. Most submitted photographs usually receive at least three or more comments.
- `www.utahpictures.com` – This interactive animated Web site that features music not only displays wonderful photos, but it also shows you what you can do if you have Web design talent or can afford to have it done for you.

48.2

JOIN AN ONLINE E-MAIL GROUP

If you want to read and send e-mail to a group of people that share your interests, then you may want to join one of the many e-mail groups that discuss photography-related topics. When you join an online e-mail group, you get an e-mail sent to you each time someone sends a message to the group. If you reply to the message, the message goes to everyone in the group. If you want to minimize the number of e-mails you get from the group each day, many e-mail group services offer a daily digest that includes all of the e-mail in a single message. You can also turn on and turn off the messages any time you choose.

Gregory has hosted a forum for those interested in digital photography and digital photo editing for a number of years. To learn more about joining that group, see Appendix A. To find more forums that suit your interests, visit `www.yahoogroups.com`. You can enter a topic and get a list of appropriate forums. If you want to start your own group, you can do that, too! Being a member of an e-mail group on Yahoo! Groups or hosting a group is free. Some of these groups can have several thousand members. If you want to learn more about using your specific printer model, or your camera, or maybe how to mat frames, find an online e-mail group to ask your questions. It is surprising how helpful many group members can be.

READ AND POST COMMENTS TO A WEB-BASED DISCUSSION FORUM

A Web-based discussion forum is similar to an e-mail group except that you access all the postings, make your own posts, or reply to a post from a Web page. You do not get e-mail messages as you would when you join an e-mail group. The forums found on `www.robgalbraith.com` are some of the best you will find. Figure 48.3 shows a Web page from the Canon EOS 20D, 10D, D30, D60 and Digital Rebel forum. Thousands of people read and post to these

forums. If you have a question and you want quick answers, this is one of the quickest ways to get a good answer — or in some cases more than one answer. Another good set of general forums can be found on `www.dpreview.com`.

Gregory, Richard Lynch, and several other authors have created a Web site especially for users of Adobe Photoshop Elements. Take a few minutes to visit that Web site at `www.elementsusers.com`. The site includes an active forum where you can ask questions and get good answers on a wide variety of digital topics. If you don't want to ask questions, you can still read the questions and answers and learn while doing so.

If you are a nature photographer, we highly recommend the discussion forums oriented to serious nature photographers at `www.naturescapes.net`. No matter what you enjoy shooting, with a little research you will be likely to find a forum that you'll enjoy reading.

48.3

JOIN A PAY-FOR-VIEW WEB SITE

Creating and running a profitable "pay-for-view" Web site is the goal of many photographers and writers. Sadly, to date there have been few successes. Imaging Review (`www.imagingrevue.com`) was one that looked to be *the* pay-for-view Web site every dedicated photographer would join. At the time this book was being written changes were underway and we can only say it still may be worth your time to take a look at the site as it may be thriving and offering superior content and services by the time you read this. We are both rooting for their success.

TAKE AN ONLINE PHOTGRAPHY CLASS

We expect to see a good number of quality online photography classes in the future. For now, we can only recommend `www.photoworkshop.com`. This Web site, which is sponsored by a number of vendors, offers a growing body of useful content, forums, and galleries. Some of the content is only viewable by members who pay for the member-only content. A one-year subscription costs $125. The animated content and videos necessitates a high-speed connection to the Internet. In terms of applying new Internet technologies as teaching aids, this site is likely to be a leader.

SELL YOUR CAMERA GEAR ONLINE

Do you have some camera gear you want to sell? Or, do you want to save some money and buy used camera gear? While Amazon (`www.amazon.com`) may be the online auction site where most photography gear is sold and bought, an excellent alternative is the For Sale forum on `www.fredmiranda.com`.

MAT AND FRAME YOUR PHOTOGRAPHS

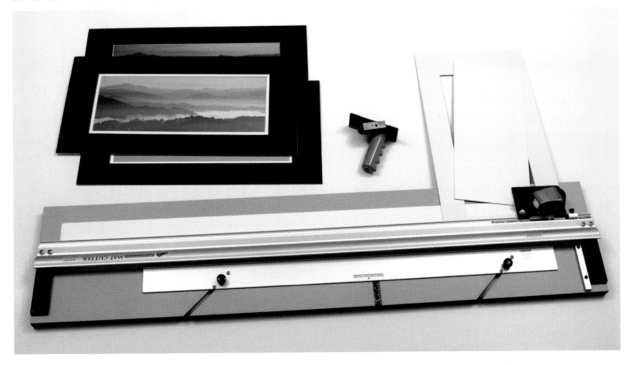

49.1 A mat cutter like the Logan 450 makes it easy and relatively inexpensive to cut custom mats for your photographic prints.

If there is anything that we dislike about photography, it is that good picture frames and mats cost so much money. Frames can easily cost many times more than the cost of the print and can be so expensive that it makes selling inexpensive framed photos with a profit tough to do. Yet, we'll be the first ones to admit that a well-chosen mat and a good frame can make an exceptional photograph even more outstanding, and it can even make a mediocre photo look better. In fact, we claim that framing is an art form in itself.

Unhappily, we have to admit that we have no magical way to make the framing part of photography less costly, nor more enjoyable. If you have ever cut your own mat and built your own frame, you will know why it costs so much money to have someone do it for you. In spite of the cost and aggravation, many photographers frame their own photographs because it does give them more profit on each print they sell and it allows them to mat a photo without delay. In this project, you learn enough to make good decisions about how you should frame your photographs, and whether you should be cutting your own mats.

WHEN YOU NEED MATS AND FRAMES, WHERE SHOULD YOU GO?

Can you buy frames for less money at one of the nationwide art and craft supplies stores, from a local frame shop, or from an online store? If only life were so simple that there were straightforward answers to questions like that one. Life is not that simple and the best place for you to get your photos framed depends on what help you need, what kind and size of frame and mat you want, how many mats and frames you need, and where you live.

The only good advice we can offer is to shop around and compare prices. If you are a professional photographer and you resell your photos with frames, many manufacturers and stores will sell to you at a "professional" or wholesale discount and they do not charge tax if you have a resale license number. If you do not have a resale license, then you have to buy retail and pay the higher prices. In general, there are three kinds of stores where you can get your photos framed: small local specialty framing stores, national chains (for example, Michaels or A.C. Moore), and online stores.

USING A SMALL, LOCAL, SPECIALTY FRAMING SERVICE

Most cities have one or more specialty framing shops. These can be wonderful places to get your photos matted and framed as they usually have incredibly talented staff that excels at helping you choose mats and frames. The premium price you pay may well be worth it when you get your framed prints back. As we said earlier, framing is an art form and those with talent can make a better mat and frame, which can make your photo look better. The old adage, "you get what you pay for" is more often true than not.

BUYING FROM LOCAL ART SUPPLY AND FRAMING STORES

Nationwide chains of arts and crafts supply stores can be a good place to get your photos framed. They offer a wide range of standard-sized photo frames, they can cut mats as you want, and make custom frames, too. These stores can be expensive in spite of the "wholesale" price appearance. It is not uncommon for these stores to run 50 percent off sales on matting and framing. Watch your local newspapers for ads or call them and find out when a sale will be in effect. The one downside to buying during one of their sales is that it may take a long time to get your framing done due to the large volume of orders they take during a sale. The Web sites for the three largest chains are listed here. Each of these Web sites has a page where you can find the store closest to you.

- www.michaels.com
- www.aaronbrothers.com
- www.acmoore.com

ORDERING FRAMES ONLINE

If you have ever been to a store and ordered a custom mat and frame, you know how many options there are for matting and framing a print. So, would you think it would be possible to do all of that online and feel comfortable about your order? Much to our surprise, there is an online framing service that is so easy to use that it may be easier to order on the Internet than it is to order when you can look at and touch all of the mats and frames in a local store. Project 28 covers the progressive matting and framing services, *and* printing services offered by Graphik Dimensions Ltd. (www.pictureframes.com). Yes, you can even

upload your digital photo files so that they can print, mat, and frame your work. Our bet is we will see more online services working hard to compete with their service in the future.

SHOULD YOU BE CUTTING YOUR OWN MATS?

Depending on the quantity of mats you need, it may be a good decision to purchase a mat cutter and buy mat boards in a quantity sufficiently large enough to get a good discount. Other considerations include the amount of time you have, the amount of room you have to use a large mat cutter, and the amount of space you have to store the mat cutter and mat boards. Or, you may find that it is simply a service that you want to offer if you sell your photographs. Being able to mat and frame prints can be a sales advantage, or simply a convenience that you may want.

What about the economics of cutting your own mats? Is there a break-even point that applies to you? To get a better understanding of the math behind the mat board cutting, we decided to cut mats to use for the box portfolio in Project 50. It included cutting twenty 14" x 18" mat boards with a single window. We found out that we could make a perfectly cut mat in ten minutes, which includes a small amount of setup time. At this rate, we could have completed 20 mats in 200 minutes or about 3.5 hours. When ordering the custom mats from Light Impressions, we paid $4.75 for each of the 20 mats just for cutting the mat with the beveled window; not the mat board itself. Total cost for all 20 mats was $95. Yes, the math suggests that our time would be worth $27 per hour at that rate. Assuming that a mat cutter would cost

around $200, we could pay for the cutter after cutting around 40 mats. If we were to add in the savings that we would get from buying and cutting our own mat boards, the break-even point may be as little as 20 to 30 mats. Plus, we would have all the extra cut mat board pieces remaining for other projects. The simple conclusion is that it is not a bad decision to buy your own mat cutter if you don't mind doing the work.

WHAT MAT CUTTER SHOULD YOU BUY?

The choices of mat cutters may boggle your mind as there are a considerable number of vendors that offer many different mat cutters. Some work extremely well and some of them are hard to use if your goal is to cut perfect mats. Our experience and the experience of many others confirm that Logan Graphic Products, Inc. (www.logangraphic.com) makes some of the best mat cutters money can buy. After a short tour of the Web site, you learn that they offer many, many products for cutting mat boards and making frames.

If you are ready to place an order for a mat cutter, you should consider the Logan Intermediate Plus Model #450 shown in Figure 49.1. The 450 can be used to cut 40" x 60" mat boards, which is a good size to buy to get a good price especially if you buy them in packs of ten or twenty-five. After you use it a few times, you can cut perfect mats every time. If you have a slightly greater budget, you may want to consider the Logan 750 SimplexPlus. It offers a few more features that make it easier to cut more mat boards more quickly.

You can buy Logan mat cutters at many professional photography stores, art supply stores, arts and crafts stores, and online stores. The Logan Web site has a page that helps you find one of the thousands of

authorized dealers that sell their products worldwide. B&H Photo Video (`www.bhphotovideo.com`) offers some of the best prices for Logan mat cutters we have been able to find on the Internet. You should be able to purchase the 450 for around $185 depending on where you buy it. The 750 will likely be around $250.

> **TIP**
>
> If you cut your own mat boards and frame your photos yourself, you can do certain things to minimize the framing cost. Order framing materials in the largest quantity that makes sense for you to get the best volume discount. If you have sufficient storage space, you should order 40" x 60" mat boards as they cost less than smaller boards. If you purchase large mat boards, you need to buy a sufficiently long mat board cutter. When possible, try to frame your photographs with standard size frames as they are less expensive, or less work, if you plan on assembling your own frames.

MAKE A PORTFOLIO TO SHOW YOUR BEST PHOTOS

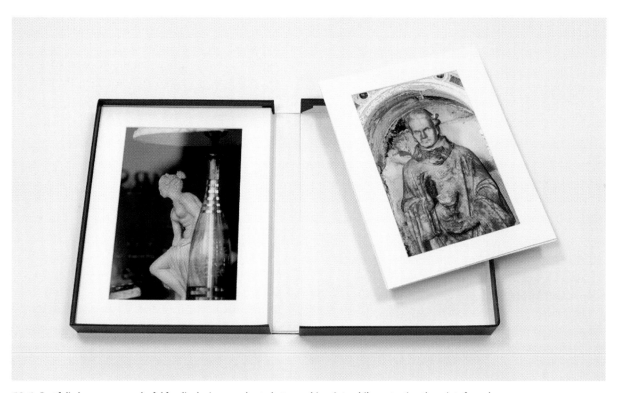

50.1 Portfolio boxes are wonderful for displaying your best photographic prints while protecting the prints from damage.

W hile there are many, many wonderful ways of sharing digital photos electronically, a good photograph often looks best when it is printed and displayed well. After you have a dozen or more photos that you are proud to have created, you should make a portfolio of one kind or another that makes it easy to show your photographs while protecting them from damage. In this project, you learn about several different approaches to creating a portfolio. You also learn where you can get the products that you need to make a portfolio that you will enjoy using.

WHICH PHOTOS SHOULD YOU SELECT FOR YOUR PORTFOLIO?

Choosing the photos you include in your portfolio is important. Picking the photos that you consider to be your best ones is not necessarily the way to go. The best portfolios are often those that feature a "body of work" with some similar characteristics. For example, you can include only photos of iris, or black and white photos, or photos toned in a certain color, or photos from Ireland. Viewers will appreciate that your portfolio represents a consistent and intentional work, rather than simply a random set of photos that you think are your best.

MAKING PRINTS FOR YOUR PORTFOLIO

One of the first decisions you need to make when getting ready to create a photo portfolio is how large the prints should be. Portfolios with prints that are too small keep your photos from looking as good as they should. Likewise, a portfolio made with prints that are too large can be difficult to use to show the prints and the overly enlarged prints may diminish the impact of your photos. Getting the right size print is a bit like Goldilocks trying each bowl of porridge in *Goldilocks and the Three Bears*. The porridge in one bowl was too hot; it was too cold in the second bowl, and just right in the last bowl. Selecting the right print size depends on many variables, including the size of the original digital photo, the quality of the photo, how you intend to use your portfolio, and how much money you can budget for your portfolio. Another key decision you must make has to do with whether you are willing to crop your images to fit in standard-sized mats and frames, or if you must order or make custom mats and frames. Custom mats and frames always cost more than standard-sized ones.

WARNING
Considerable damage may occur to your photographic prints if you keep them in stacks and you slide one across another as you view them. This is especially true for prints made with a pigment-based inkjet printer such as the Epson 2200/1800. The sliding of the papers smoothes out the ink that "sits" on top of the paper and it makes a smooth shiny surface, usually ruining the print. After you make a print on an inkjet printer, you should let it lay out for a day to completely dry. It should then be properly stored in a photo album, photo portfolio box, or inserted into protective sleeves or envelopes. If you must stack your prints, you should lay interleaving tissue between the prints to ensure that minimal damage will occur.

DECIDING ON A BUDGET FOR YOUR PORTFOLIO

Well-crafted portfolios that display first-rate photographic prints can be surprisingly expensive. The size of the portfolio is one of the factors that can dramatically increase the cost of your portfolio. You therefore should do a little math before you make or order your portfolio prints.

The two portfolios we created to show in this project feature photos that were taken with an 8-megapixel camera. Because the image size is 2,336 x 3,504 pixels and we used an Epson 2200 inkjet printer to make prints at 240PPI, we chose not to crop the photos and to frame them as full-size images. At full-size, the images make prints that are 9.75" x 14.6". In order to display the photos properly they were printed on 13" x 19" paper for the portfolio album, which left about 2" of border around the photo. For the box portfolio, we printed the photos on smaller,

and therefore less expensive, 11" x 17" high-quality fine art matte paper because the prints were displayed behind mat frames. Itemized lists for both albums are shown here.

20 Print Portfolio Album for 13" x 19" paper

Album for 20 13" x 19" photographic prints (10 preserver sheets included)	$ 60
20 Pages of 13" x 19" 300# fine-art matte paper	75
Approximate inkjet printer ink cost for 20 prints	50
Total for album portfolio	**$185**

20 Print Box Portfolio for 14" x 18" mat boards

14" x 18" Portfolio box	$ 45
20 Pages of 11" x 17" 300# fine-art matte paper	55
Approximate inkjet printer ink cost for 20 prints	50
20 14" x 18" 4-ply custom mat boards	150
20 14" x 18" 2-ply backing boards	35
20 Interleaving tissues to protect print surface	10
Acid-free tape for mounting prints and hinging boards	5
Total for portfolio box	**$350**

SELECTING AND MAKING A PHOTO ALBUM PORTFOLIO

After you decide on the size of print you want to display in your portfolio, you are ready to pick an album. There are a growing number of manufacturers and suppliers of photo albums and of course the better albums cost more money. No surprise there. In fact, some of the best-looking albums cost a lot of money! After considerable searching, we chose the beautiful padded matte black portfolio album sold by Print File (www.printfile.com) shown in Figure 50.2. The Print File Archival Presentation Albums are available in four sizes: 8" x 10", 8.5" x 11", 11" x 14", and 13" x 19". They include 10 polyester archival preservers (4 mil) with taped-in, black-hinged, acid-free paper inserts. The albums can be expanded to a total of 30 preservers, which would allow 60 prints if you place a print on both sides of the preservers. After you have an album, it is a simple task to slide the prints inside the preservers and your album is complete.

Other suppliers of photo albums are listed here.

- www.albumsinc.com
- www.albumsource.com
- www.archivalsuppliers.com
- www.artleather.com
- www.artsuppliesonline.com
- www.artzproducts.com
- www.centuryphotoproducts.com
- www.lightimpressions.com
- www.redrivercatalog.com

50.2

SELECTING AND MAKING A PHOTO PORTFOLIO BOX

A good alternative to placing your photos in a photo album is to create a photo portfolio box such as the one shown in Figure 50.3. Photo portfolio boxes have a lot of advantages over album portfolios, we think. First, if you properly mat your prints using a 4-ply mat board for the front board and a 2-ply backing board, and you use interleaving tissue, which is a soft, thin piece of tissue paper that you place between each photo, your photos will be well protected. More importantly, because there is not any material covering the print, such as plastic page protectors, your prints will show much better. You won't have to worry about reflections, cracks, or a diminished view of your prints. A portfolio box makes it very easy to organize your photos as well as add new prints and remove prints.

Our portfolio box was designed to use a standard-size mat board (with a custom window opening) so that the mats could be placed in a frame anytime they needed to be displayed in a frame. If you take this approach, you can easily remove a few photos from your portfolio box and place them in frames that you hang on your wall. This gives you the ability to rotate your framed photos with any of those in your portfolio box without having to worry about changing mat boards.

If you use a portfolio box, you can take out one or more photos and display them at camera club meetings, in your friend's home, on the dining table, or just about anywhere else you would like to display them. This makes it much easier for more people to view your photos than if the photos were all in one portfolio album. So, we say, make a photo portfolio box. You're likely to love having one!

OTHER WAYS TO DISPLAY YOUR PHOTOS

If for one reason or another you are disinclined to make a portfolio album or box, we have a few other suggestions for you.

PROTECTIVE SLEEVES OR ENVELOPES

One good way to store photos, to sell photos, or to share photos is to put them in a protective sleeve or envelope. Some of the better products are made with materials that are very transparent, enabling you to easily see the enclosed print with a minimum of reflection. For a relatively small amount of money, you can buy a package of protective sleeves or envelopes that have archival properties especially for photographic prints. You can buy protective sleeves and envelopes from many different sources, including our favorites noted here.

- `www.archivalsuppliers.com`
- `www.lightimpressionsdirect.com`
- `www.printfile.com`

50.3

UNIQUE PHOTO ALBUMS YOU OUGHT TO KNOW ABOUT

During the process of researching ways to make photo albums we found several outstanding albums that we are not only using for our own portfolios, but we also sell them to our customers filled with their sports photos. We love Moab Paper's (`www.moabpaper.com`) Chinle Digital Book. The luxurious leather bound albums come in a variety of sizes. You make the prints on fine art paper such as the excellent Entrada Fine Art paper, which comes with holes pre-drilled. Once you add the prints to one or both sides of the pages, you insert the photos into the album using well-hidden screw posts. Figure 50.4 shows a Chinle Digital Book that has an 8" x 8" printable area on each page.

Another excellent leather bound album is the ArtZ Coffee Table Book shown in Figure 50.5. It has a nice indentation on the front cover where you can attach a photo and add some album title text. You must print on their special paper, which has adhesive strips on each side of one edge. Once you have all of your album pages printed, you simply stick each page to the next until you have a complete album. This unusual approach makes a very nicely bound album; however, it does not allow you to go back and make changes to album pages as you can do with other albums that use a screw post.

One other quality screw-post album that uses pre-hinged pages is the Stonehenge System from Stone Editions (`www.stoneeditions.com`). Figure 50.6 shows a gray cloth covered version that has 12" x 12" pages. In addition to the album and album pages, you can also purchase translucent interleaves and metal edge preservation boxes. Stonehenge System albums may be found at some professional camera stores and you can order online from their Web site.

50.5

50.4

50.6

Some of the most popular albums are those made by Art Leather (`www.artleather.com`). They offer dozens of styles that may be viewed on the Web site. Figure 50.7 shows the I-Mount Book style that features 15 thick rigid pages that are permanently bound. Each side of each page has a full-page self-mount adhesive, which is accessed by peeling off a protective sealing. Simply press down your photograph and the page is complete.

Another album worth considering is the Custom Book Making Kit from Red River Paper (`www.redrivercatalog.com`). These high-quality leather bindings come with everything you need. In addition to the excellent binder shown in Figure 50.8, you also get 20 Flex Hinges and 22 Translucent Interleaving Sheets. Using this system, you can use your favorite paper and insert the pages into the album using the pre-drilled hinges, which attach to the paper by peeling away the backing to expose the glue.

At the time this book was published, Epson (`www.epson.com`) just introduced a new album that looks to be worth considering. It is called the Story Teller - Book Creator, which is a kit that comes with software, paper, a book, and a glossy cover. The software has professionally designed templates that enable you to quickly and easily lay out the pages. You can even print on the glossy cover. See Figure 50.9.

PHOTO DISPLAY STANDS

If you are creative, you should be able to find other ways to display your best photographs. For example, a woodworking magazine had plans for a magazine stand. After taking a quick look at it in the magazine, it seemed like it would make a brilliant stand for storing photographic prints that are either matted or in protective sleeves. After building one, the stand, which is shown in Figure 50.10 found a home in our living room where it remains full of photos. This stand is similar to those that many poster and print stores use to display artwork. To view the art you just flip through the prints. Guests to our home enjoy perusing the stack to see if there is a print they may like. We have never turned down a good offer to purchase a print from the stand and because they are already enclosed in a protective envelope, they are ready to be taken by their new owner in exchange for some money. If you prefer purchasing such a display stand over making one yourself, you can choose from several different models at United Mfrs. Supplies, Inc. (`www.unitedmfrs.com`).

50.7

50.8

50.9

50.10

Furniture stores and specialty stores such as Organized Living (www.organizedliving.com) carry photo wall screens, bookstands that make nice displays for a stack of photos, and other products that may suit your needs. As the growth in digital photography continues you will see more products made for displaying photos.

You have now reached the end of Chapter 9 and the end of the book. We doubt that many readers will read all the projects in order or that many readers will even read all of the projects. Rather, we expect you to have read the projects that you are most interested in completing. Our wish is that you have had, or will have, success with any of the digital photo projects you set out to complete and that you get more enjoyment out of photography each and every day. Enjoy capturing the light, and, then — sharing it with others!

CONTACTING THE AUTHORS

Join an online forum

Gregory Georges created and has hosted an online forum since 2000 at Yahoo! Groups for readers of his books, as well as anyone else who has an interest in digital photo editing. To join, visit:

`http://groups.yahoo.com/group/digital-photo-editing`

 Subscribe to the e-mail service to participate. You can post images and share tips and techniques with other readers of this book. Gregory, along with author Richard Lynch and others, hosts a forum for users of Adobe Photoshop Elements on the Web site:

`www.elementsusers.com`

Contact the authors

Gregory welcomes comments and questions from readers. He may be contacted by e-mail at: `ggeorges@reallyusefulpage.com`.

While he reads all e-mail, the heavy volume makes it difficult to respond to all messages immediately, but he works hard to answer them when time is available.

Gregory's AOL IM Buddy Name is: **DigitalGregory**.

His PiXPO name is **GregoryGeorges**.

Gregory has two Web sites: `www.reallyusefulpage.com` and `www.gregorygeorges.com`

Although Lauren Georges also welcomes comments and questions from readers, her schedule makes it more difficult for her to reply. She may be contacted by e-mail at `laurengeorges@reallyusefulpage.com`.

INDEX